Enterprise and He

Enterprise and Heritage

Crosscurrents of national culture

Edited by
John Corner and Sylvia Harvey

London and New York

First published 1991
by Routledge
11 New Fetter Lane, London EC4P 4EE

Simultaneously published in the USA and Canada
by Routledge
a division of Routledge, Chapman and Hall, Inc.
29 West 35th Street, New York, NY 10001

© 1991 John Corner and Sylvia Harvey

Typeset in 10/12pt Times by
Witwell Ltd, Southport
Printed in Great Britain by
Clays Ltd, St. Ives plc.

British Library Cataloguing in Publication Data
Enterprise and heritage: crosscurrents of national culture.
1. Great Britain. Social history values
I. Corner, John II. Harvey, Sylvia
303.372

Library of Congress Cataloging in Publication Data
Enterprise and heritage : crosscurrents of national culture / edited
by John Corner and Sylvia Harvey.
p. cm.
Includes bibliographical references and index.
1. Great Britain—Cultural policy—History—20th century.
2. Cultural property, Protection of—Economic aspects—Great
Britain. 3. Historic sites—Conservation and restoration—Economic
aspects—Great Britain. 4. Arts—Great Britain—Marketing.
5. Tourist trade—Great Britain. I. Corner, John, 1943- .
II. Harvey, Sylvia.
DA589.4.E57 1991
306′.0941—dc20
90-24528
CIP

ISBN 0-415-04702-1
ISBN 0-415-04703-X pbk

Contents

Notes on contributors

Yasmin Ali teaches and researches in the Race Equality Unit at Lancashire Polytechnic. She has written for the *New Statesman* on some of the implications for socialism and for feminism of the *Satanic Verses* debate. She is currently researching the politics of race and the issue of ethnic mobilization in Britain's Asian communities.

Franco Bianchini is Research Associate at the Centre for Urban Studies at the University of Liverpool, where he is working on a comparative study of the dynamics of urban regeneration in the US, Britain and other West European countries, sponsored by the Leverhulme Trust. He has written extensively on urban cultural policy in Italy and Britain in the 1970s and 1980s and has collaborated with Comedia (London) on a variety of studies reports on urban economic development, arts policy, tourism and quality of life.

John Corner is a lecturer in the School of Politics and Communication Studies at the University of Liverpool. He co-edited *Communication Studies* (Edward Arnold, third edition, 1989) with Jeremy Hawthorn, edited *Documentary and the Mass Media* (Edward Arnold, 1986) and co-authored *Nuclear Reactions* (Libbey, 1990). He has published widely in books and journals on topics in media analysis and media history and is an editor of *Media, Culture and Society*.

Sylvia Harvey teaches in the School of Cultural Studies at Sheffield City Polytechnic and is the author of *May '68 and Film Culture*. She has published various articles on documentary film, British independent cinema and contemporary British television. She is

currently involved in researching the cultural industries and in work on broadcasting policy.

Robert Hewison is the author of *The Heritage Industry* (1987) and *Future Tense* (1990). He has published four books on Ruskin, and a three-volume study of the arts in Britain since 1939, *Under Siege, In Anger* and *Too Much*. He writes on theatre for the *Sunday Times*, and is the regular presenter of the 'Issues' edition of Third Ear, on Radio 3.

Maureen McNeil is a lecturer at the Cultural Studies Department, University of Birmingham. Her publications include: *Under the Banner of Science: Erasmus Darwin and His Age* (Manchester University Press, 1987) and the edited collection *Gender and Expertise* (Free Association Books, 1987). Her current working interests revolve around gender relations, knowledge, work, science and technology, and popular culture.

Adrian Mellor is Senior Lecturer in Media and Cultural Studies at Liverpool Polytechnic and a member of the editorial collective of the *Magazine of Cultural Studies*. He has published articles on social theory, popular fiction and the Heritage industry, and has broadcast on radio for the Open University.

Kevin Robins works at the Centre for Urban and Regional Development Studies at the University of Newcastle. He is co-author of *Information Technology: A Luddite Analysis* (Ablex, 1986) and *The Technical Fix* (Macmillan, 1989) and is co-editor of *Cyborg Worlds: The Military Information Society* (Free Association Books, 1989). He is currently researching broadcasting policy in Britain.

Bill Schwarz teaches in the Department of Cultural Studies in the Polytechnic of East London, and chairs the M.A. in Cultural Studies: history and theory. Currently he is editing a collection on ethnicity and empire in the nineteenth century, *The Expansion of England*. He is a member of the editorial collective of *History Workshop Journal*.

Hermann Schwengel teaches sociology at the Free University of Berlin. His most important work, *Der kleine Leviathan*, on the American path to modernity in contrast especially to the German-European experience, was published in 1988 (Athenaum/ Frankfurt). He has recently written on the enterprise culture in

Britain and Germany and on the Europeanization process.

Judith Williamson is the author of *Decoding Advertisements* and *Consuming Passions*. She was film critic for the *New Statesman* from 1986 to 1988 and now writes regularly for the *Guardian*. She also works freelance in film and television and teaches at Middlesex Polytechnic.

Tana Wollen was a schoolteacher in London before joining the British Film Institute's Education Department in 1986. She is now Head of the Television and Projects Unit at the BFI. She has written and edited extensively on media education topics. This includes co-authorship of *Learning The Media* (Macmillan, 1987).

Ken Worpole is a writer and adviser on arts and cultural policy. He has written a number of books including *Dockers and Detectives* and (with Geoff Mulgan) *Saturday Night or Sunday Morning?*, and is currently working on issues to do with the public realm and civic culture, particularly at local and regional levels.

Introduction:
Great Britain Limited

John Corner and Sylvia Harvey

> The organisation of society on the principle of private profit, as
> well as public destruction, is leading both to the deformation of
> humanity by unregulated industrialism, and to the exhaustion of
> natural resources . . . a good deal of our material progress is a
> progress for which succeeding generations may have to pay
> dearly.[1]
>
> T. S. Eliot, 1939

STERLING VALUES: CULTURE AND ECONOMY IN THE 1980s

In any period of human history a culture and society are partly
sustained by the tension between that which is thought to be of value,
inherited from the past, and that which is the product of energetic,
dynamic, and deliberate innovation. This book explores some of the
characteristics of British culture in the 1980s in terms of this tension
between inherited values and practices, and those which are created
afresh, appropriate for the new times. The key words which we have
chosen for this exploration are those of 'heritage' and of 'enterprise'.
And while we have no doubt that the agenda, pace, and direction of
change in this decade have been largely set by the radical Right –
Conservative and pro-capitalist – none the less the meanings of these
terms, and of other key words of the decade: 'choice', 'freedom',
'community', and 'competition', have been at times bitterly con-
tested. Moreover, what by the mid-eighties might have looked like an
irreversible break with the past, appeared by the end of the decade to
be a vigorous but not wholly successful challenge to the post-war
principles of social justice and collective provision.

Marked by a process of challenge and counter-challenge, the first century of universal suffrage in Britain has established neither a 'natural party of government' (in Harold Wilson's words) nor a final balance sheet on the respective merits of free markets and competition as against regulated markets and co-operation. The shifts in public policy and in cultural values have been major but not irreversible, and it may be useful in this respect to contrast the implacable hostility of the Conservative government towards the National Union of Mineworkers during the 1984–5 miners' strike, with the assumption of a permanent shift towards the Left made by the Labour politician Anthony Crosland some thirty years earlier. In 1956 Crosland wrote:

> One cannot imagine today a deliberate offensive alliance between Government and employers against the Unions on the 1921 or 1925–26 or 1927 model, with all the brutal paraphernalia of wage-cuts, national lockouts and anti-union legislation; or, say, a serious attempt to enforce, as so often happened in the 1920s, a coal policy to which the miners bitterly objected.[2]

The extensive mobilization of state resources, the unprecedented level and type of policing during the 1984–5 strike, and Prime Minister Margaret Thatcher's reference to this section of organized labour as the 'enemy within', all offered clear evidence of the revival of an 'offensive alliance', albeit newly inflected in the context of a nationalized industry.

However, just as Crosland's account of an irreversible, left-oriented consensus was proved to be incorrect, so the right-wing claims of the 1980s concerning the death of socialism, the terminal decline of the Labour Party and the triumphant instatement of 'popular capitalism' have proved inaccurate. Evidence of this second misjudgement can be found in the field of popular responses to public service provision. Here, after a decade of Conservative government advocacy of individual responsibility and private provision, a poll conducted early in 1990[3] indicated that 71 per cent of those questioned wanted to see services extended, even if this meant an increase in taxes. This is in rather remarkable contrast to 1979 when, as the Conservatives entered office, only 37 per cent of those questioned favoured this option. It is perhaps one of the key paradoxes of the Conservative 1980s that support for collective provision, paid for by the public purse, has in fact increased.

Within this broader sketch of the diversity and volatilily of public policy and of cultural and political values over the last fifty years, it remains important to identify the distinctive features of the 1980s. This period has often been referred to as the 'Thatcherite' decade, a periodization likely to be consolidated by Mrs Thatcher's resignation in 1990. The process of identifying salient features should neither exaggerate the nature and extent of the Thatcher 'revolution', nor minimize the changes of attitude and outlook, institutional practice, and cultural habit that this has brought about. It has become a commonplace of analysis that this decade, dominated by three successive Conservative administrations, has marked a radical break with the consensus politics of the mixed economy and the welfare state. Certainly the language of reform and revolution, for so long associated with the Centre or Left, has now been claimed by the radical and free market Right, and mobilized as part of its fervent moral and political crusade to restructure the British economy, its society and culture. The ideas of the Adam Smith Institute, for example, have become increasingly influential, outlining the aims of the Right: to 'roll back' the state and public sector, to reduce public spending, to minimize both public provision and public intervention in the market, and to return all profitable enterprises to the ownership and control of private shareholders through an extensive programme of denationalization. While these ideas may have been out-of-step with the traditions of European and British social democracy, they have made an important contribution to the process of the international restructuring of capitalism. Their adoption in Britain has facilitated (among other things) a decrease in manufacturing industry, growth in the financial and leisure services sector, growth in the proportion of self-employed in the workforce, a growing trade gap, mass unemployment, and the development of a low-wage sector of the economy.

A few statistics may serve to highlight some of these changes. Unemployment, at its highest in Britain since the 1930s, rose from 5.7 per cent of the workforce in 1979 to its peak of 13.6 per cent in 1986 reducing to 6.9 per cent by the end of the decade.[4] The figures for self-employment increased from 7.7 per cent of the workforce in 1979 to 12 per cent in 1988.[5] In the first half of the decade national income rose by 14 per cent but this was differentially distributed, as the top 10 per cent saw their earnings rise by 22.3 per cent, and the bottom 10 per cent saw them rise by only 3.7 per cent. Moreover

standard of living and quality of life were not only sharply affected at the extremes of the income spectrum, for by 1986 almost half the British workforce (42.3 per cent) fell below the Council of Europe's minimum 'decency threshold' for wages.[6] But at the same time that many individuals and families were struggling to make ends meet, others were benefiting from the purchase of council houses or the purchase (and often swift re-sale) of shares in some of the major and previously nationalized industries – British Airways, British Telecom, British Gas and others. Wider share-ownership, though no very significant change in the *concentration* of ownership, was a feature of the decade; 7 per cent of the population held shares in 1979, but this had increased to 20 per cent by 1989. Whether celebrated from the Right as the age of popular capitalism or attacked from the Left as the decade of growing inequality, the dominant values and practices of British culture for the 1980s seemed light years away from the visions of social justice, full employment and universal welfare imagined and fought for by the protagonists of the 'people's war' of 1939–45.[7]

The process of economic restructuring, although informed by different goals and priorities, has been a feature of both capitalist and socialist economies in the 1980s. And if the most visible feature of this process in the west has been mass unemployment, in the east it has been, at the end of the decade, the very public crisis of the Communist Parties. It is this broader map of global economic restructuring which provides some distinctive and challenging points of reference for charting the complex progress of the concepts of enterprise and heritage in Britain. Thatcherism, taken as a shorthand term for the programme of the New Right, has not been alone in the western world in being confronted with the difficulties stemming from an international capitalist recession. As an economic and political philosophy informing a set of practical policies, it has been impelled by the same set of imperatives – restructuring to secure profitability – which have been a key feature of western economies since the mid-1970s. It is important to note that this period of economic crisis in the west has also seen an alarming slide into economic stagnation in the USSR, as the growth rates of the latter (which at 3.5 per cent between 1973 and 1978 had outstripped those of the USA at 2.5 per cent and Britain at 2 per cent) began to fall.[8] Consequently the process of restructuring, and its necessarily attendant project of mediating tradition and modernity, has become a feature of both capitalist and socialist

cultures and societies. In Britain, the Russian term 'perestroika', given popular international currency by Mikhail Gorbachev, has become surprisingly familiar in English usage.

In the west, the thinkers and politicians of the New Right have undergone significant changes in their ways of responding to and representing the socialist states. The early part of the decade in both the USA and Britain saw the emergence of a new and virulent anti-communism with Ronald Reagan's specification of the USSR as the 'evil empire', and with the introduction of cruise missiles into Britain by the 'iron lady', Margaret Thatcher.[9] The development of a new cold war in foreign affairs by these two right-wing and nationalistic leaders can be seen both in terms of principled political opposition and as one convenient measure for coping with internal economic problems, by focusing the minds of the destabilised and disquieted at home on the actual and supposed deficiencies of the socialist states to the east. Ushered in by the incursion of Soviet troops into Afghanistan (December 1979), the first half of the decade was characterized by a number of military solutions to political problems, from Britain's war against Argentina over the Falklands/Malvinas (1982) and the US invasion of Grenada (1983), to the US bombing of Libya, using planes stationed in British bases (1986), and the continuing US support for the war of the Contras against the Nicaraguan government.

But the early 1980s were also characterized, especially in Western Europe, by a new resurgence of the anti-nuclear movement. The year 1983 saw the British Campaign for Nuclear Disarmament (CND) mobilize an anti-Cruise demonstration of nearly half a million people; large demonstrations also took place in France and West Germany, and the women's peace camp at Greenham Common attracted international media attention. Two key events of the mid-1980s signalled the beginning of important changes in international relations and in home affairs: 1985 saw the appointment of Gorbachev as General Secretary of the Communist Party of the Soviet Union, and 1986 brought the highest levels of unemployment in Britain; subsequently unemployment began to fall. By the end of 1987, and after the inconclusive negotiations at Reykyavik, a new period of *détente* in east–west relationships had begun, offering the unprecedented spectacle of Reagan and Gorbachev, together in Washington, signing a major arms limitation treaty. Although claimed as a victory of western diplomacy, bargaining from a position of strength, it has arguably been the

language and logic of Gorbachev – given a surprisingly wide circulation by western publishers and news agencies – that has won widespread, popular support:

> Reykyavik mapped out a route by which humankind can regain the immortality it lost when nuclear arms incinerated Hiroshima and Nagasaki. . . . We are all passengers aboard one ship, the Earth, and we must not allow it to be wrecked. There will be no second Noah's Ark.[10]

The new Soviet emphasis on seeking diplomatic not military solutions to political problems and, furthermore, on releasing resources from military spending in order both to assist internal economic development and to begin, at a global level, to address the issues posed by debt, hunger, and underdevelopment in Asia, Africa, and Latin America, has sketched out a new agenda, a new landscape for the conduct of international affairs.[11] Interestingly, and by contrast, one of the two areas where Thatcherite reconstruction in Britain has succeeded in cutting public spending in real terms is overseas aid. The other is housing.[12]

If Gorbachev's restructuring, and his rejection of the old, 'command style' centralized economy and of the use of force in foreign affairs, has been undertaken in the name of socialism, Margaret Thatcher's restructuring, her rejection of a welfarist solution, her advocacy of individualism and free enterprise, were clearly undertaken in the name of capitalism. The ghosts that have haunted reformers in the east have been those of Stalinism and of the deeply unpopular Soviet interventions in Europe, in Hungary in 1956, in Czechoslovakia in 1968; the ghosts haunting Thatcher's reforms were those of socialist economic and social intervention:

> I used to have a nightmare . . . that the British sense of enterprise and initiative would have been killed off by socialism. . . . By prices and income policies, by high taxation, by nationalisation, by central planning.[13]

Yet, as we noted earlier, Thatcher's mission to free the market, realized in many respects, was none the less hampered by a continuing attachment from the voters to the principles of public provision, and this despite the claim that enterprise culture has provided all the necessary ladders of opportunity.

The historical irony at the end of the decade was perhaps that while Thatcherism had been able to claim the sweeping changes in

Eastern Europe and the Soviet Union as a victory for western-style democracy, and as evidence of the superiority of the capitalist market, at just this point in time her own political fortunes began to wane, as public opinion seemed to favour again the virtues of intervention and regulation both to maintain the standard of living of the majority and to improve the position of an impoverished minority. A comparable irony and tension emerges from contrasting the New Right celebration of a European *market* with its rejection and dread of European 'interventionism' in setting minimum social standards. As provisional accounts begin to be delivered on a decade in which extremes of wealth and poverty grew, unemployment rose to previously unimaginable levels, cold war gave way to *détente*, and the opening of the Berlin Wall in the 1989 'year of revolutions' signalled the appearance of a new Europe, it may be that the critique of centralized state planning in the east is matched in the west, and in Britain in particular, by calls for increased state planning, both centralized and localized, in the public interest.

However this may be, a sense of historical irony, and of the possibility that social democracy may be on the way to achieving a more stable and popular identity within a transformed Europe, must not be allowed to hide the distinctive and transformative project of Thatcherite culture and politics in Britain. And it has clearly proved difficult to manage this change, and to find the right language and imagery for projecting it. For there is a way in which the creation of a pro-capitalist enterprise culture by the New Right constitutes at least as much of a challenge to certain aspects of British Conservatism as it does to the ideas of the Left and of social democracy. One example of the project and of its difficulty can be found in an interview given by Prime Minister Margaret Thatcher to the *Daily Express* in the summer of 1982, shortly after the celebration of military victory in the Falklands:

> We are looking for self-starters. We are looking for princes of industry, people who have fantastic ability to build things and create jobs.[14]

Some of the key elements of the enterprise paradigm are to be found here: the importance of 'standing on your own feet', taking the initiative, getting things done. 'Self-starters' make their own luck and are vigorous individualists, they thrive on the excitement of competition and the stimulus of commerce. They are practical

and positive, building industries, creating wealth, and providing jobs. These 'self-starters' are a modernized version of Samuel Smiles' 'self-made men' of the mid-nineteenth century;[15] like their precursors they refuse the complacent certainties of the old patrician aristocratic order, they overturn the stately world in which everyone knows their place and they challenge, in the process, the rules of *noblesse oblige*. Here, the impatient rejection of paternalistic 'caring', as well as the tone of pushy, meritocratic and self-serving populism, grate against the traditions of honour and service of old and aristocratic conservatism. The advocacy of self-starters, who come, as it were, 'from nowhere', and make it to the top, clearly also grates against the egalitarian tradition which proposes collective provision for general human advancement. Unfortunately, what the Left has too often shared with the old Right is a snobbishness about industry and commerce, a hesitancy about both individual initiative and technological innovation, and a paternalism about knowing what's best for other people. Thus the challenge from the New Right to the Left is to provide the conditions for further individual independence, initiative, and ambition but to ensure that this is not only for the white, the male and the middle class, and that one person's initiative and ambition is not another person's exploitation and suffering.

The phrase 'princes of industry', used in place of the more familiar 'captains of industry', is perhaps a rather unsatisfactory attempt by the New Right to accommodate traditional conservatism, recognizing the presence of continuities, managing the conflict of old and new. The imagery of 'princes' is ambivalent and uneasy in an age of democracy, meritocracy, and increasing sensitivity to women's rights. But it has the value of signalling, if not making explicit, a continuing commitment to concepts of 'natural superiority', with associated distinctions between leaders and led, managers and workers. And while the New Right has been concerned to shake up, modernize and transform the practices of British managers, it has also been concerned to prevent any increase in workers' rights and to pre-empt any claim for workers' control, substituting the promise of (very minority) shareholding for that of rights in the workplace.

Indeed, the issue of wider share-ownership has provided the necessary populist front or façade behind which it has been possible to mount sustained attacks on individuals-as-workers and on their representative organizations, the trade unions. The advocacy of

share-ownership and wider home-ownership have been key ele-
ments within the ostensibly democratic programme of the new
Conservatism. As the 1987 Conservative Election Manifesto puts it:
'Ownership and independence cease to be the privilege of a few and
become the birthright of all.' The unspoken corollary of this
statement is that those who do not own cannot be independent.
And while much public advertising imagery has been produced by
the government, announcing the sale of shares in previously
nationalized industries and encouraging and celebrating the right to
buy these shares, this has gone hand-in-hand with the erosion of
rights in other areas. Thus, for example, the decade has seen the
abolition of wages councils, the rejection of arguments for mini-
mum-wage legislation, the selective removal of collective bargain-
ing rights (from the teachers) and of the right to belong to a trade
union (at the GCHQ security headquarters), and the prevention of
solidarity strikes through the ban on 'secondary action'. In addition
a climate has been created in which the wholesale sacking of
workers taking strike action has been tolerated, and the unions
have not been able to win reinstatement. Examples here would be
the sacking of printers working on News International newspapers
and of the television technicians working at TV AM. Combined
with high levels of unemployment, and with the casualization that
inevitably flows from a more widespread practice of sub-contract-
ing, these measures have replaced that other 'birthright', the right to
work, with widespread feelings of insecurity. This creation of a less
confident, less demanding, more fearful workforce has been a key
element in the restructuring of the British economy.

So the philosophy of enterprise has allowed the New Right both
to challenge older conceptions of order and hierarchy and to
introduce new ones in their place. The managing of heritage, of the
meaning of values inherited from the past, has been perhaps less
forceful and less innovative; although here too there has been a
creative reworking of old themes in the context of new realities and
imperatives. The key project has been the re-presentation of
national identity for a post-imperial age. The 'special relationship'
with the United States and in particular the cordial relationship
between Thatcher and Reagan, allowed some retention of at least
the appearances of world power status and influence, though this
special relationship was certainly tried by Britain's war with
Argentina over the Falklands/Malvinas in 1982 (a war potentially
damaging to US interests in the southern hemisphere). The Argenti-

nian invasion of the islands allowed Thatcher to assume the anti-fascist mantle of Winston Churchill, mobilizing in the process much of the 'fighting for freedom' rhetoric of the Second World War, and arguing that the 'spirit of the South Atlantic' had made Britain great again. Victory in the Falklands allowed the Conservative Party to attempt a new consolidation of national identity, rooted in the sort of double moral and military success which had been denied it some twenty-five years earlier during the Suez crisis. The continuity of grandeur was asserted against those faint-hearts whose secret fear that 'Britain was no longer the nation that had built an Empire and ruled a quarter of the world' was (it was argued) now proved to be wrong. In Thatcher's words: 'The lesson of the Falklands is that Britain has not changed and that this nation still has those sterling qualities which shine through our history.' [16] These 'sterling qualities' had for centuries involved the deployment of superior military force against colonial subjects or colonial rivals. They seemed to many, both inside and outside Britain, inappropriate for a post-imperial age. And if Britain was 'great' again, the advantages of its victory seemed, increasingly, strictly limited. Moreover, by the end of the decade the rise in interest rates and the increasing unhappiness of home-owning mortgage payers gave a new and ironic significance to talk of 'sterling qualities'.

If the issues of national sovereignty and the strong state sit uneasily with the increasingly multinational character of finance capital and with the advocacy of *laissez-faire* and freedom of choice, so too the celebration of an older (and white) imperial identity is in tension or open conflict with the values of a multiracial and multicultural society. In the 1980s the New Right has had to manage some of these contradictions and difficulties. One of the legacies of Britain's colonial past has been the assertion of white supremacy and its expression through deep and continuing forms of racism. The peoples of the old empire or new commonwealth, settled in Britain, have been subject to discrimination in many fields, in employment, education, housing, and policing (in 1985 the figure for black unemployment was almost double that for white unemployment). [17] In the first half of the decade this discrimination was challenged through a series of major civil disturbances in Brixton and Toxteth in the spring and summer of 1981, and in Handsworth in the autumn of 1985. The initial response of Conservatives was to condemn these activities, and Thatcher herself had established an implicitly racist paradigm for response in a

speech delivered in 1978, expressing the fear that 'this country might be rather swamped by people with a different culture'.[18] But by the second half of the 1980s a more respectful, integrationist and populist line was developed, very much in keeping with the general populist invitation to all people of 'substance' to join the property-owning democracy. Thus the 1987 Conservative Election Manifesto argued:

> Immigrant communities have already shown that it is possible to play an active and influential role in the mainstream of British life without losing one's distinctive cultural traditions.

In the project of reconstituting national identity for a multiracial and multicultural era, an era of differences, the emphasis on the mainstream, and the emphatic rejection of any minoritarian approach, offers a key to one of the most distinctive features of Thatcherism: its populism. In rejecting older forms of deference and older hierarchies of taste and status, the modernizing impulse of the New Right instates the market, itself colour-blind, as the key location for identity formation. Freedom and independence derive not from civil rights but from choices exercised in the market. The sovereignty that matters is not that of the king or queen, the lord or the white man, but the sovereignty of the consumer within the market-place. It may be some time before there is a full popular understanding of the converse of this proposition, namely, the 'slavery' and indignity of poverty, the imposed loss of identity, the almost 'no person' status of those not able to make meaningful market choices or even present themselves as potential buyers.

The same popularizing tendencies are to be found in the new leisure worlds of heritage culture with their projection of a common and shared inheritance, available to all for the price of a ticket on a Sunday outing. Here again there is a challenge to traditional Conservatism, whether this is trying to maintain the sacred aura that supposedly attaches to being born white, or born of noble blood. For the new popularizers of capitalism (the twentieth-century followers of Adam Smith), independence, status, and even identity are a function of the cash nexus, of the ability to spend. With money in our pockets we are all free and equal now. Only some of us (in the words of that famous anti-communist text, *Animal Farm*) are more equal than others.

The reworking of sovereignty and status is a necessary part of the reconstitution of capitalist values and markets in the late

twentieth century, a necessary concomitant of this thoroughly internationalized phase of capital flows and investments. But British Conservatism, even in its New Right variant, still manifests some attachment to the more ancient values and prerogatives of the nation state. Here, one of the most obvious contradictions of Thatcherism concerns its welcoming attitude to Japanese and American finance capital on the one hand, and, on the other, its jealous guarding of the sovereignty of the British Parliament in the context of moves towards European unification. In a speech to Conservative Members of the European Parliament, the then Chairman of the British Conservative Party, Kenneth Baker, said: 'We will not agree to Westminster being reduced to being a glorified County Council.' [19] For a government that had had many years' experience of removing powers from oppositional local councils and, finally, civil rights from local authority officers,[20] the development of federal powers at European level was, understandably, to be feared, based as it was on the assumption that higher-level bodies disempower lower-level ones. What is striking about this statement is perhaps the contrast it suggests between a sophisticated, popularizing and innovative language of markets on the one hand, and a fearful and traditionalist approach to the process of political representation on the other. This declaration also indicates one of the other central contradictions of Thatcherism: the free market, released, unbound, deregulated, alongside a heavily centralized and frequently authoritarian state. Thus a common market in Europe is acceptable when common political institutions are not; the nation-state is still seen to be the unique repository or source of political authority. We are still a long way from being, in the words of the poet John Donne, 'all of us a part of the continent, a piece of the main'.

The term 'Great Britain', referring ambiguously to geographical extensiveness (a collection of islands), military power and moral authority, has become more and more problematic in the course of the decade. Traditional assumptions about national identity and unity, based on the assumed superiority of the values of white, western Christendom, of England over Ireland, Scotland and Wales, of men over women, of the metropolis over the regions, have become less and less tenable. For increasing access to education in the post-war period, and the circulation of information and ideas by a public service broadcasting system committed (at its best) to the principles of free inquiry, have created social space for the

recognition of differences: of language, of culture, of class experience and values, of family and domestic life experienced as differentially restful or laborious. The construction of this public space has sketched in the limits of the older, imperially based and pre-democratic concept of 'Great Britain', offering a modest challenge to its sway.

The identity of Great Britain has, increasingly, to be placed and understood in terms of international developments and the ebb and flow of capital investment at international level. While capitalism as an economic system has brought development and many material benefits to western, industrial societies, it has not proved able to tackle the problems of underdevelopment and extreme poverty in many parts of the world, and even its 'heartlands' (including Britain and the United States) are characterized by extremes of wealth and poverty. Some figures for the widening gap in incomes in Britain were given earlier in this introduction. At global level, the gap is as striking and, in an era of universal suffrage and increasing literacy, alarming and untenable. For the recognition of wide disparities of income and the inability of some nation states to meet even the most basic needs of their people, is likely to result, increasingly, in political insecurity and instability. Moreover the debt crisis in a number of poorer countries, who find it impossible to feed their people and to make debt repayments to the economically advanced countries, threatens the economic stability of these advanced countries too. If the rapid spread of communications and the emergence of new forms of international diplomacy have made us, increasingly, citizens of 'one world', the briefest acquaintance with the realities of economic inequality dispels this illusion of oneness. A comparison of some figures for Gross National or Gross Domestic Product, expressed on a per capita basis, can make this point in a vivid way. The figures, per capita, for Japan are $25,990, for Britain $16,300, for Poland $1,157 (Net Material Product), for India $350.[21]

The challenge for critics of capitalism, for socialists and for social democrats at the end of the Thatcher decade in Britain, is to combine policies aimed at realizing a decent standard of living for the majority at home, with urgent measures designed to improve the material position of the desperately impoverished at home and abroad. For as long as there are significant numbers of people suffering and hungry in Europe and (to a greater extent) in the poorer countries of the world, there can be no long-term political

and economic security. It is this important dimension of an insecure and unequal world order which Thatcherism, with its emphasis on self-help, and its somewhat inward- and backward-looking character, has found it difficult to confront. The New Right values of enterprise and heritage have not recognized the pertinence for *national* development of inequality and underdevelopment at an *international* level.

None the less the new Conservatism has made its own particular and ambitious contribution to the process of restructuring Great Britain. Through a number of different and sometimes conflicting strategies, it has at once challenged, popularized and commodified the values of a more ancient, patrician and rural Conservatism. At the same time, it has selected and projected a new vision of Britain, a new heritage, rooted in the memory of the great industrial entrepreneurs of the nineteenth century. A complex and purposefully selective process of historical recollection is apparent in this project, which involves reviving the ideals of eighteenth-century free-market capitalism, for popular participation and consumption in the age of multinational corporations, but through a celebration of the values of the Victorian age. This is an eclectic historical project, but a philosophically consistent one; as would be any left-wing or socialist counter-history involving the ideals of the seventeenth-century British 'Commonwealth', the egalitarianism of the French Revolution and the Welfare Statism of the 1939-45 'People's War'. The point of these various examples is that 'heritage', that which is inherited from the past, can be inflected in a variety of different political directions. Thus, far from our future being *given* in our past, the past suggests a variety of possible and different sources of action, including economic innovation that refuses the principles of the 'free' market.

In the late twentieth century there are no more far-flung 'new worlds' for old empire-builders and their urban poor to conquer or inherit, only the work of patient and principled reconstruction of the lands where we live now. In this reconstruction the vision of a world in which the free development of each is a condition for the free development of all, is not lost. It is an alternative vision, which offers a society which is more equal and participatory, rejecting the 'rationality of self-conscious elites',[22] and combining national planning and international awareness with local accountability and decentralized decision-making, the availability of decent housing, education and healthcare for all, the right to work and rights at

work, respect for the rights of minorities, and the development of policies and facilities to ensure a more equal sharing of childcare and domestic labour.

One of the lessons of the 1980s, internationally, has been that a combination of determination, popular support, and political power makes the work of cultural and social transformation possible. In the work of *economic* reconstruction, however, it is important to realize that the 'revolution' or, from a democratic perspective, the 'counter-revolution' of the New Right has been in tune with the imperatives of capitalist investment, seeking cheaper and more flexible workforces at international level. A government whose programme of economic reconstruction recognized that, while capital investment is necessary, wealth is in fact generated by, and should be shared by, all who work to produce it, would encounter great difficulties. These difficulties could only be resolved through a combination of popular understanding and support, together with new international alliances which break the moulds both of isolationism and empire and move outside the boundaries of 'Great Britain Limited'. The determination to challenge established practices, the unlocking and mobilizing of histories of struggle for a better life, the ability and confidence to take the initiative through the emergence of a newly democratic 'enterprising spirit', will be vital here. Memories of the past and a determination to innovate are key elements for this other agenda: a programme of economic and cultural development rooted in the principles of social justice.

READING THE EIGHTIES: CULTURAL HISTORY AND CULTURAL ANALYSIS

In this section we offer a brief overview of some of the problems of cultural analysis and an outline of the issues raised in the various contributions to the book.

The emergence of modern cultural studies as a degree-level subject and as a research perspective can be seen to be a consequence of the continued post-war growth of mass media, the increasing commodification of the worlds of leisure and cultural production, and the extension of access to higher education at a time when interdisciplinarity, both for institutional and intellectual reasons, was becoming attractive. Arising out of nineteenth-century debates about the consequences of industrialization, this is also a

subject developed in relatively rich societies, where it has been possible to allocate resources to study the making and circulation of meanings, in addition to the more apparently useful studies of medicine, science, biology, computing, and engineering. But if the world is to be measured in human terms, cultural studies also has a use in analysing and assessing the meanings and values that inform daily life and the more specialized realm of cultural production. In its analysis of the social location of ideas and cultural forms, and in its search for the patterns that characterize what Raymond Williams called the elements in a 'whole way of life', it has become a necessary luxury: the study of values, goals, and priorities, and of the different definitions of what it means to be human at different historical periods and in different social contexts.

It has become a commonplace that cultural studies involves the analysis of institutions and texts, discourses and readings, and that all four are best understood in their social and historical context. But it is this very issue of 'context' which both motivated the distinctive challenge to older, often exclusively text-based forms of study in the humanities (Art History, English Literature), and also raised questions for the definition and coherence of cultural studies itself. The very plurality of the term is revealing: are these studies more properly classified as specialized branches of history, sociology and anthropology, political science or political economy? Should they be confined to the post-industrial forms of communication (cinema, radio, recorded music, television) and to the study of popular forms of culture? These are issues of definition, of legitimate scope and content. Even more troubling have been the theoretical issues of coherence. In the debate concerning the relationship between cultural texts and practices and their contexts: what might a social history of art and culture look like? What are its proper methodological characteristics? Are cultural texts, like the societies which produced them, 'determined' by a particular mode of material production? Can cultural forms be seen as the property and product of particular social classes (is opera bourgeois and bingo working class?), or, more usefully, as differentially understood and 'consumed' by different social classes? Does the particular character of language itself, the internal coherence of discourse and, as some have argued, its non-referential properties, demand an approach to the study of cultural forms that is not and cannot be historically contingent or rooted? Is *EastEnders* better understood as part of the history of soap opera than the history of

Thatcherism? If this concrete example makes it easier to see that the answer to the question is that both approaches are useful, this does not solve the problem of the incompatibility of certain paradigms within the cultural studies field.

It seems important here to make a distinction between those forms of cultural analysis drawing on concepts and methods of semiotics which are compatible with an historical approach, and those which have drawn mainly on ahistorical paradigms. Some types of discourse theory, in rejecting the referential dimension of language, have also rejected the possibility of locating cultural texts in any meaningful and theoretically consistent way within their historical moment. Against this, we would argue for cultural studies as an historically rooted project.

All of the contributions to this book make some assumptions about meaningful relationships between the process of economic restructuring, the emergent politics of the New Right and the articulation of the various discourses of enterprise and heritage in Britain. But while there is a general concern to specify the distinctive and dominant trends that shape both cultural production and everyday life, it is not assumed either that the economy exerts a determining force on all aspects of culture, or that this culture is monolithically constituted by the priorities and perspectives of Thatcherite Conservatism. The rise and fall of the Centre parties, the reshaping of Labour, divisions among the Communists and Conservatives and the emergence of the Greens all testify to a society in transition, and to a continuing process of both ideas and material interests in tension or open conflict. The availability for peak-time television viewing of the disparate iconographies and sets of values of the working-class world of *EastEnders* on the one hand, and the sharp young executive 'yuppie' lifestyles of *Capital City* (1989) on the other, signal perhaps a comparable pluralization in the sphere of representations.

The concepts of pluralization, diversity, fragmentation, and contradiction are familiar features of the landscape of cultural analysis in general and theories of the postmodern in particular. Some theorists of postmodernism have also associated themselves with the idea of the 'end of history', the celebration of 'difference' and the discrediting of Enlightenment rationality with its attendant 'grand narratives' and their all-encompassing explanatory frameworks. For us the rejection of Enlightenment rationality and its associated 'grand narrative' of human emancipation is both theor-

etically and politically unacceptable. Whatever its motivation, it is likely in practice to result in the sort of radical relativism that is too often complicit in the reproduction of inequality, and in the suppression of the idea of progress. It is, perhaps, not surprising that the concept of progress disappears or is viewed with cynical detachment in a society that offers lower levels of public provision, higher levels of profitability, more insecurity and more pressure at work, and the advocacy of 'sound money' as the supreme goal of political policy. But the critique of simplistic notions of historical evolutionism does not require us to bury the idea that human societies should move forwards in meeting the basic materials needs of all their citizens, and in ensuring their cultural and political rights. The ideal of progress and the advocacy of universal human rights are not easily set aside in those parts of the world where hunger or tyranny are ever present threats, and should not be set aside in the economically advanced and constitutionally democratic societies.

The postmodern recognition of 'difference', and of the specific inequalities that stem from white and from male supremacism, cannot substitute for, though it must refine, a predominantly class-based analysis. Moreover the positive celebration of those differences of perception constituted and reproduced through language can be unhelpful or irrelevant to the process of rebuilding *just* forms of social solidarity, and in producing the kinds of shared knowledge required in the continuing struggle for human emancipation. Much postmodern theory has endeavoured to understand and to map the contours of a restructuring capitalism, its ever-expanding realm of commodified culture and its often fragmenting effects on individual human consciousness and cultural practice. But the theory seems to us to be at its weakest in those variants which reject or ignore the possibility of historical analysis and the unity (even if complex and contradictory) of culture, society and economy.

The chapters which follow seek to unravel some of the complexities of British culture in the 1980s. Kevin Robins places the changes in British culture, and in particular the crisis over post-imperial identity, in the context of broader processes of economic and social restructuring at global level. His chapter explores the modernizing, transformative process of international capital flows and the emergence of new methods of production and new international divisions of labour, together with the consequences of such historical innovations for the complex process of re-articulating individual

and national identity in its attachment to place and locality. John Corner and Sylvia Harvey offer a framework for assessing the 'visionary discourses' of heritage and enterprise, exploring various examples of official and unofficial culture, their diverse celebrations of the past and programmes for transforming the present, and arguing that the two terms signal a set of interconnected and deeply rooted tensions informing the process of change.

Bill Schwartz and Adrian Mellor present two case studies in urban redevelopment. The first examines London Docklands with its sharply differentiated worlds of yuppie 'palaces in the air', and the street-wise and threatened working-class culture of the East End. Mellor's case study explores the visual and cultural diversity of Liverpool's renovated Albert Dock, where chic boutiques and wine bars, an art gallery, museum and television studio, create an urban leisure attraction whose meaning and significance for its many users cannot be easily or simply designated. In the next chapter Maureen McNeil posits the idea of the 'information revolution' and the discourses of information technology as key elements in the Thatcherite programme of reconstruction, arguing that in the carefully elaborated official language of IT we find a celebration of Britain's entrepreneurial past, a challenge to the supposed anti-industrialism of the 'British disease' and the deployment of a set of apparently neutral and scientific concerns behind which new relations and concentrations of power are consolidated. Finally, in this sequence of chapters dealing primarily with aspects of the enterprise culture, Ken Worpole offers some facts and figures on the 'retail revolution', an exploration of the pleasures and pitfalls of shopping, and some reflection upon the potentially negative consequences of both privatized city-centre spaces and the new emphasis on costly and non-participatory forms of leisure provision. Judith Williamson complements the preceding chapters with a textual and ideological analysis of those popular Hollywood films which represent the world of big business and which manifest a continuing attachment to the values of authenticity, decency and 'ordinariness', while celebrating success, glamour and the extraordinary.

The following three chapters all address issues of heritage and national identity. Robert Hewison explores the new relations of commerce and culture through the changing values and priorities of official museum culture. Tana Wollen examines a dominant strain of nostalgia in the cycles of popular fictions dealing with 'Raj

Revivalism' on the one hand, and the seductiveness of English aristocratic country life on the other. Yasmin Ali considers some of the complexities and ironies involved in the process of transforming older discourses of race and national identity, arguing that the Conservative Party has vigorously addressed these issues in the 1980s, across the terrain of education in particular, as part of its populist bid for electoral support. She argues that, while the Left has often failed to keep pace with the nature and scale of change, none the less a politics of representation has emerged affirming a new, cosmopolitan Britain. Finally, Franco Bianchini and Hermann Schwengel return us to some of the issues of urban and cultural change raised in the earlier part of the book, and sketch both the threat of impoverishment and disenfranchisement signalled by the idea of the 'inner city', and the promise of a different, and 're-imagined city', as the place of popular recreation and participation.

Chapter 1

Tradition and translation: national culture in its global context

Kevin Robins

> Where once we could believe in the comforts and continuities of Tradition, today we must face the responsibilities of cultural Translation.
>
> Homi Bhabha

This chapter is about changing geographies – particularly the new forces of globalization that are now shaping our times – and what they mean for the economic and cultural life of contemporary Britain. It is in this global context, I think, that we can begin to understand the emergence, over the last decade or so, of both enterprise and heritage cultures. It is also in this context that the problem of empire, for so long at the heart of British national culture and identity, is now taking on a new significance.

TRADITION AND TRANSLATION

Recent debate on the state of British culture and society has tended to concentrate on the power of Tradition. Accounts of the crisis of British (or English) national traditions and cultures have described the cultural survivalism and mutation that comes in the aftermath of an exploded empire. As Raphael Samuel argues in his account of the pathology of Tradition, the idea of nationality continues to have a powerful, if regressive, afterlife, and 'the sleeping images which spring to life in times of crisis – the fear, for instance, of being "swamped" by foreign invasion – testify to its continuing force'.[1] It is a concern with the past and future of British Tradition that has been central to Prince Charles's recent declamations on both enterprise and heritage. A 'new Renaissance for Britain' can be

built, he suggests, upon a new culture of enterprise; a new business ethos, characterized by responsibility and vision, can rebuild the historical sense of community and once again make Britain a world actor. What is also called for, according to the Prince's 'personal vision', is the revival and re-enchantment of our rich national heritage. As Patrick Wright argues, the Prince of Wales has been sensitive to 'the deepest disruptions and disappointments in the nation's post-war experience,'[2] and his invocation of so-called traditional and spiritual values is again intended to restore the sense of British community and confidence that has collapsed in these modern or maybe postmodern times.

This prevailing concern with the comforts and continuities of historical tradition and identity reflects an insular and narcissistic response to the breakdown of Britain. In a psychoanalytic account of early human development, Barry Richards describes a state of narcissistic omnipotence. It involves

> protective illusions which can stand in the place of the over-whelming anxieties to which we would be subject if the full helplessness of our condition were borne in upon us as infants. We can abandon these imperial illusions only to the extent that we can face the world without them, having been convinced that it is a sufficiently benign place for our weakness not to be catastrophic, and having gained some faith in our growing powers of independent functioning.[3]

Protective illusion, I am going to suggest, has also been central to the obsessive construction of both enterprise and heritage cultures in these post-imperial days. The real challenge that I want to consider is about confronting imperial illusion (in both fantasy and literal senses). It is about recognizing the overwhelming anxieties and catastrophic fears that have been born out of empire and the imperial encounter. If, in psychoanalytic terms, 'a stable dis-illusionment' is only achieved 'through many bruising encounters with the other-ness of external reality'[4] then in the broader political and cultural sphere what is called for is our recognition of other worlds, the dis-illusioned acknowledgement of other cultures, other identities and ways of life.

This is what I take Homi Bhabha to mean by the responsibility of cultural Translation. It is about taking seriously 'the deep, the profoundly perturbed and perturbing question of our relationship

to others – other cultures, other states, other histories, other experiences, traditions, peoples, and destinies'.[5] This responsibility demands that we come to terms with the 'geographical disposition' that has been so significant for what Edward Said calls the 'cultural structures of the West'. 'We could not have had empire itself,' he argues, 'as well as many forms of historiography, anthropology, sociology, and modern legal structures, without important philosophical and imaginative processes at work in the production as well as the acquisition, subordination, and settlement of space.'[6] Empire has long been at the heart of British culture and imagination, manifesting itself in more or less virulent forms, through insular nationalism and through racist paranoia. The relation of Britain to its 'Other' is one profoundly important context in which to consider the emergence of both enterprise and heritage cultures. The question is whether, in these supposedly post-imperial times, it is possible to meet the challenge of Translation; whether it is now possible for Britain to accept the world as a sufficiently benign place for its weakness not to be catastrophic. The challenge is not easy, as the Rushdie affair has made clear, for 'in the attempt to mediate between different cultures, languages and societies, there is always the threat of mis-translation, confusion and fear'.[7] There is also, and even more tragically, the danger of a fearful refusal to translate: the threat of a retreat into cultural autism and of a rearguard reinforcement of imperial illusions.

THE MAKING OF GEOGRAPHY

Geography has always mattered. For many, it matters now more than ever. Edward Soja, for example, suggests that we are now seeing the formation of new postmodern geographies, and argues that today 'it may be space more than time that hides consequences from us, the "making of geography" more than the "making of history" that provides the most revealing tactical and theoretical world'.[8] I want, in the following sections, to explore the spatial context in which enterprise and heritage cultures have been taking shape.

Geographical reconfigurations are clearly central to contemporary economic and cultural transformation. If, however, there is such a phenomenon as the postmodernization of geography, then what is its organizing principle? How are we to make sense of these

complex spatial dynamics? What is needed is an understanding of the competing centrifugal and centripetal forces that characterize the new geographical arena. On this basis we can then begin to explore the implications for cultures and identities. More particularly, we can consider the significance of these developments for the geographical disposition that Edward Said sees as so much at the heart of western dominion. Are they likely to reinforce, to recompose, or perhaps even to deconstruct, the geographical disposition of empire? My central concern is whether the 'making of geography' can be about the 'remaking of geography'.

It is clear that geographical transformations are now being brought about through the international restructuring of capitalist economies. This has been associated with a changing role for the nation state (though in precisely what sense it is being transformed remains to be clarified). At the same time there has been a consolidation of supra-national blocs (such as the European Community) and a new salience for sub-national territories (regions and localities). The reorganization of the international economic order has also changed the nature and role of cities, bringing about new and direct confrontations between city administrations and transnational corporations, and stimulating global competition between cities to attract ever more mobile investors. It has created new centres and peripheries, and also new territorial hierarchies. It has produced new relational contexts and configurations. Regions, for example, are now assuming a whole new significance in the context of a 'Europe of the regions'.[9] And, beyond this, there is the overarching global context: 'regional differentiation becomes increasingly organised at the international rather than national level; sub-national regions increasingly give way to regions of the global economy'.[10]

This process of international restructuration is bringing change not only to the space economy, but to imaginary spaces as well. As territories are transformed, so too are the spaces of identity.[11] National cultures and identities have become more troublesome (though they have a long and potent half-life). For many, European culture has offered a more challenging and cosmopolitan alternative, even if there are real difficulties here, too, in exorcising the legacy of colonialism, and even if recent events in Central and Eastern Europe raise questions about what Europe really means.[12] Local and regional cultures have also come to be revalued (as is apparent in the growth of the heritage industry), and there is now a

renewed emphasis on territorial locations as poles of identity, community and continuity.[13]

The organizing principle behind these complex transformations, both economic and cultural, as I shall argue in the following sections, is the escalating logic of *globalization*.[14] More precisely, as I shall then go on to make clear, the so-called postmodernization of geography is about the emergence of a new *global–local nexus*. Historical capitalism has, of course, always strained to become a world system. The perpetual quest to maximize accumulation has always compelled geographical expansion in search of new markets, raw materials, sources of cheap labour, and so on. The histories of trade and migration, of missionary and military conquest, of imperialism and neo-imperialism, mark the various strategies and stages that have, by the late twentieth century, made capitalism a truly global force. If this process has brought about the organization of production and the control of markets on a world scale, it has also, of course, had profound political and cultural consequences. For all that it has projected itself as transhistorical and transnational, as the transcendent and universalizing force of modernization and modernity, global capitalism has in reality been about westernization – the export of western commodities, values, priorities, ways of life.[15] In a process of unequal cultural encounter, 'foreign' populations have been compelled to be the subjects and subalterns of western empire, while, no less significantly, the west has come face to face with the 'alien' and 'exotic' culture of its 'Other'. Globalization, as it dissolves the barriers of distance, makes the encounter of colonial centre and colonized periphery immediate and intense.

GLOBAL ACCUMULATION

Enterprise and heritage cultures must both be seen in the context of what has become a globally integrated economic system. What is new and distinctive about global accumulation, and what differentiates it from earlier forms of economic internationalization? Globalization is about the organization of production and the exploitation of markets on a world scale. This, of course, has long historical roots. Since at least the time of the East India Company, it has been at the heart of entrepreneurial dreams and aspirations. What we are seeing is no more than the greater realization of long historical trends towards the global concentration of industrial and

financial capital. Transnational corporations remain the key shapers and shakers of the international economy, and it is the ever more extensive and intensive integration of their activities that is the primary dynamic of the globalization process: it remains the case, more than ever, that 'size is power'.[16] What we are seeing is the continuation of a constant striving to overcome national boundaries, to capture and co-ordinate critical inputs, and to achieve world-scale advantages.

But if this process is clearly about the consolidation of corporate command and control, it is none the less the case that, to this end, we are now seeing significant transformations and innovations in corporate strategy and organization. The limitations of nationally centred multinationals are now becoming clear, and the world's leading-edge companies are seeking to restructure themselves as 'flexible transnationals' on the basis of a philosophy and practice of globalization. These companies must now operate and compete in the world arena in terms of quality, efficiency, product variety, and the close understanding of markets. And they must operate in all markets simultaneously, rather than sequentially. Global corporations are increasingly involved in time-based competition: they must shorten the innovation cycle; cut seconds from process time in the factory; accelerate distribution and consumption times. Global competition pushes towards time-space compression. Globalization is also about the emergence of the decentred or polycentric corporation. As business consultant Kenichi Ohmae points out, global operations require a genuine 'equidistance of perspective', treating all strategic markets in the same way, with the same attention, as the home market. He sees Honda, operating in Japan, Europe and North America, as a typical case:

> Its managers do not think or act as if the company were divided between Japanese and overseas operations. Indeed, the very word 'overseas' has no place in Honda's vocabulary because the corporation sees itself as equidistant from all its key customers.[17]

This whole process has been associated with a corporate philosophy centred around the 'global product'. A universalizing idea of consumer sovereignty suggests that as people gain access to global information, so they develop global needs and demand global commodities, thereby becoming 'global citizens'. In his influential book, *The Marketing Imagination*, the pioneer of this approach, Theodore Levitt, forcefully argues that the new reality is all about

global markets and world-standard products. This is, of course, no more than a continuation of mass production strategies which always sought economies of scale on the basis of expanding markets. However, whilst the old multinational corporation did this by operating in a number of countries and by adapting its products to different national preferences, today's global corporation operates 'as if the entire world (or major regions of it) were a single, largely identical entity; it does and sells the same things in the same single way everywhere'. Transcending vestigial national differences, the global corporation 'strives to treat the world as fewer standardised markets rather than as many customised markets'.[18]

Of course, there is both hype and hyperbole in this.[19] There has been a tendency to overemphasize the standardization of products and the homogenization of tastes. None the less, it would be a mistake to dismiss this globalizing vision as simply another empty fad or fashion of the advertising industry. Levitt's position is, in fact, more complex and nuanced than is generally understood. What he recognizes is that global corporations do, indeed, acknowledge differentiated markets and customize for specific market segments. The point, however, is that this is combined with the search for opportunities to sell to similar segments throughout the globe. These same insights have been taken up in Saatchi & Saatchi's strategies for pan-regional and world marketing. Their well-known maxim that there are more social differences between midtown Manhattan and the Bronx than between Manhattan and the 7th Arrondissement of Paris, suggests the increasing importance of targeting consumers on the basis of demography and habits rather than on the basis of geographical proximity; marketing strategies are 'consumer-driven' instead of 'geography-driven'.[20] What is at the heart of this economic logic of world brands remains the overriding need to achieve economies of scale, or, more accurately, to achieve both scale and scope economies – that is, to combine volume and variety production – at the global level.

Globalization also demands considerable changes in corporate behaviour; the flexible transnational must compete in ways that are significantly different from the older multinational firm. In a world of permanent and continuous innovation, a world in which costs must be amortized over a much larger market base, a world in which global span must be combined with rapid, even instantaneous, response, the global corporation must be lean and resourceful.

In order to ensure its competitive position it must ensure a global presence: it must be 'everywhere at once'. This is bringing about significant changes in corporate strategy, with a huge burst of activity centred around mergers, acquisitions, joint ventures, alliances, inter-firm agreements and collaborative activities of various kinds. The objective is to combine mobility and flexibility with the control and integration of activities on a world scale. The global corporation seeks to position itself within a 'tight-loose' network: tight enough to ensure predictability and stability in dealings with external collaborators; loose enough to ensure manoeuvrability and even reversibility, to permit the redirection of activities and the redrawing of organizational boundaries when that becomes necessary.

Truly global operations imply a quantum reduction in time-space distanciation. Global production and marketing depend upon a massively enhanced 'presence-availability', and this has been made possible by new computer-communications systems. On the basis of an electronic communications network, the global corporation organizes its activities around a new space of information flows. Through the use of these new technologies, corporate activities are organized, not in terms of an aggregate of discrete functions, but rather in terms of a systemic continuum. Through this cybernetic aspiration, the 'network firm' strives to articulate the spatial and temporal co-ordinates of its operations. In this process, the decentred and deterritorializing corporation transposes a new and abstract electronic space across earlier physical and social geographies. Globalization is realized through the creation of a new spatial stratum, a network topography, an electronic geography.[21] The strategic nodes of these electronic grids are the financial centres and skyscraper fortresses of 'global cities' like New York, Tokyo and London. These world cities are the command and control centres of the global economy.[22]

GLOBAL CULTURE

The historical development of capitalist economies has always had profound implications for cultures, identities, and ways of life. The globalization of economic activity is now associated with a further wave of cultural transformation, with a process of cultural globalization. At one level, this is about the manufacture of universal cultural products – a process which has, of course, been

developing for a long time. In the new cultural industries, there is a belief – to use Saatchi terminology – in 'world cultural convergence'; a belief in the convergence of lifestyle, culture, and behaviour among consumer segments across the world. This faith in the emergence of a 'shared culture' and a common 'world awareness' appears to be vindicated by the success of products like *Dallas* or *Batman* and by attractions like Disneyland. According to the president of the new Euro Disneyland, 'Disney's characters are universal'. 'You try and convince an Italian child', he challenges, 'that Topolino – the Italian name for Mickey Mouse – is American.'[23]

As in the wider economy, global standardization in the cultural industries reflects, of course, the drive to achieve ever greater economies of scale. More precisely, it is about achieving both scale and scope economies by targeting the shared habits and tastes of particular market segments at the global level, rather than by marketing, on the basis of geographical proximity, to different national audiences. The global cultural industries are increasingly driven to recover their escalating costs over the maximum market base, over pan-regional and world markets. They are driven by the very same globalizing logic that is reshaping the economy as a whole.

The new merchants of universal culture aspire towards a borderless world. Sky and BSB (which merged their activities in October 1990) beam out their products to a 'world without frontiers'; satellite footprints spill over the former integrity of national territories. With the globalization of culture, the link between culture and territory becomes significantly broken. A representative of Cable News Network (CNN) describes the phenomenon:

There has been a cultural and social revolution as a consequence of the globalisation of the economy. A blue-collar worker in America is affected as much as a party boss in Moscow or an executive in Tokyo. This means that what we do for America has validity outside America. Our news is global news.[24]

What is being created is a new electronic cultural space, a 'placeless' geography of image and simulation. The formation of this global hyperspace is reflected in that strand of postmodernist thinking associated particularly with writers like Baudrillard and Virilio. Baudrillard, for example, invokes the vertigo, the disorientation, the delirium created by a world of flows and images and screens.

This new global arena of culture is a world of instantaneous and depthless communication, a world in which space and time horizons have become compressed and collapsed.

The creators of this universal cultural space are the new global cultural corporations. In an environment of enormous opportunities and escalating costs, what is clearer than ever before is the relation between size and power. What we are seeing in the cultural industries is a recognition of the advantages of scale, and in this sphere too, it is giving rise to an explosion of mergers, acquisitions, and strategic alliances.[25] The most dynamic actors are rapidly restructuring to ensure strategic control of a range of cultural products across world markets. America's largest broadcasting company, NBC, is now, in the words of its vice-president, keenly 'developing global partnerships' and 'encouraging those companies in Europe and Japan who are interested in working in a partnered or allied way'.[26]

The most prominent example of conglomerate activity is, no doubt, Rupert Murdoch's News Corporation, which has rapidly moved from its base in newspapers into the audiovisual sector. Through the acquisition of Fox Broadcasting, 20th Century Fox and Sky Channel, an (eventually unsuccessful) attempt at a joint venture with Disney, and now a renewed interest in the acquisition of MGM/UA, Murdoch is striving to become involved at all levels of the value chain. The most symbolic example of a global media conglomerate, however, is Sony, which is now 'buying a part of America's soul'. From its original involvement in consumer electronic hardware, Sony has diversified into cultural software through the recent acquisitions of CBS and Columbia Pictures. The Sony–Columbia–CBS combination creates a communications giant, a 'total entertainment business', whose long-term strategy is to use this control over both hardware and software industries to dominate markets for the next generation of audio-visual products.[27] What is prefigurative about both News International and Sony, is not simply their scale and reach, but also the fact that they aspire to be stateless, 'headless', decentred corporations. These global cultural industries understand the importance of achieving a real equidistance, or equipresence, of perspective in relation to the whole world of their audiences and consumers.

If the origination of world-standardized cultural products is one key strategy, the process of globalization is, in fact, more complex and diverse. In reality, it is not possible to eradicate or transcend

difference. Here, too, the principle of equidistance prevails: the resourceful global conglomerate exploits local difference and particularity. Cultural products are assembled from all over the world and turned into commodities for a new 'cosmopolitan' market-place: world music and tourism; ethnic arts, fashion, and cuisine; Third World writing and cinema. The local and 'exotic' are torn out of place and time to be repackaged for the world bazaar. So-called world culture may reflect a new valuation of difference and particularity, but it is also very much about making a profit from it. Theodore Levitt explains this globalization of ethnicity. The global growth of ethnic markets, he suggests, is an example of the global standardization of segments:

> Everywhere there is Chinese food, pitta bread, country and western music, pizza, and jazz. The global pervasiveness of ethnic forms represents the cosmopolitanisation of speciality. Again, globalisation does not mean the end of segments. It means, instead, their expansion to worldwide proportions.[28]

Now it is the turn of African music, Thai cuisine, Aboriginal painting, and so on, to be absorbed into the world market and to become cosmopolitan specialities.

Jean-Hubert Martin's recent exhibition at the Pompidou Centre, *Magiciens de la Terre*, is an interesting and significant barometer, in the world of high art, of this new climate of cultural globalization.[29] In this exhibition, Martin assembles original works by one hundred artists from all over the world: from the major artistic centres of Europe and America, but also from the 'margins' of Haiti, Nepal, Zaire and Madagascar. Here the discourse of high art converges with that of ethnography, the work of the Euro-American avant-garde is contiguous with that of Third World 'primitives'. Hubert's aim in developing 'the truly international exhibition of worldwide contemporary art' was to question the 'false distinction' between western cultures and other cultures, to 'show the real difference and the specificity of the different cultures', and to 'create a dialogue' between western and other cultures. *Magiciens de la Terre* brings 'world art' into being. Artistic texts and artifacts are pulled out of their original contexts and then reinserted and reinterpreted in a new global context. The global museum is a decentred space: Hubert cultivates an 'equidistance of perspective' in which each exhibit, in equal dialogue with all the rest, is valued for its difference and specificity.

Is *Magiciens de la Terre* about something more than simply absorbing new products into the international art market? 'What is it', in the words of Coco Fusco, 'that makes ethnicity attractive and marketable at a particular moment such as ours?' [30] Why does it resonate so much with the times? At one level, the project is genuinely exciting and challenging. This kind of cosmopolitanism is to be preferred to parochialism and insularity. There is indeed an immediate pleasure and exhilaration in seeing such a juxtaposition of diverse and vibrant cultures. But the exhibition touches deeper and darker chords. In its preoccupation with 'magic' and the 'spirituality' of Third World art, *Magiciens de la Terre* seeks to expose a certain emptiness, a spiritual vacuum, in western culture. There is, of course, something very suspect and problematical about this western idealization of 'primitiveness' and 'purity', this romance of the 'Other'. The exhibition in no way confronts or handles this inadequacy. None the less, even if there is no resolution, it does pose important questions about the nature of cultural identity, and about its relation to 'Otherness'. How do we now define ourselves as western? And how does this western identity relate to 'other', non-western, identities in the world?

If the global collection and circulation of artistic products has been responsible for new kinds of encounter and collision between cultures, there have also been more direct and immediate exchanges and confrontations. The long history of colonialism and imperialism has brought large populations of migrants and refugees from the Third to the First World. Whereas Europe once addressed African and Asian cultures across vast distances, now that 'Other' has installed itself within the very heart of the western metropolis. Through a kind of reverse invasion, the periphery has infiltrated the colonial core. The protective filters of time and space have disappeared, and the encounter with the 'alien' and 'exotic' is now instantaneous and immediate. The western city has become a crucible in which world cultures are brought into direct contact. As Neil Ascherson argues,

> the history of immigration into Europe over the past quarter century may seem like the history of increasing restrictions and smaller quotas. Seen in fast forward, though, it is the opposite: the beginning of a historic migration from the South into Europe which has gained its first decisive bridgehead.

It is a migration that is shaking up the 'little white "christian"

Europe' of the past.[31] Through this irruption of empire, the certain and centred perspective of the old colonial order is confronted and confused.

Time and distance no longer mediate the encounter with 'other' cultures. This drama of globalization is symbolized perfectly in the collision between western 'liberalism' and Islamic 'fundamentalism' centred around the Rushdie affair. How do we cope with the shock of confrontation? This is perhaps the key political agenda in this era of space/time compression. One danger is that we retreat into fortress identities. Another is that, in the anxious search for secure and stable identities, we politicize those activities – religion, literature, philosophy – that should not be *directly* political. The responsibility of Translation means learning to listen to 'others' and learning to speak to, rather than for or about, 'others'. That is easily said, of course, but not so easy to accomplish. Hierarchical orders of identity will not quickly disappear. Indeed, the very celebration and recognition of 'difference' and 'otherness' may itself conceal more subtle and insidious relations of power. When Martin turns world art into a spectacle in *Magiciens de la Terre*, might this not simply represent a new and enhanced form of western colonial appropriation and assimilation?

GLOBAL-LOCAL NEXUS

Globalization is about the compression of time and space horizons and the creation of a world of instantaneity and depthlessness. Global space is a space of flows, an electronic space, a decentred space, a space in which frontiers and boundaries have become permeable. Within this global arena, economies and cultures are thrown into intense and immediate contact with each other – with each 'Other' (an 'Other' that is no longer simply 'out there', but also within).

I have argued that this is the force shaping our times. Many commentators, however, suggest that something quite different is happening: that the new geographies are, in fact, about the renaissance of locality and region.[32] There has been a great surge of interest recently in local economies and local economic strategies. The case for the local or regional economy as the key unit of production has been forcefully made by the 'flexible specialization' thesis. Basing its arguments on the economic success of the 'Third Italy', this perspective stresses the central and prefigurative import-

ance of localized production complexes. Crucial to their success, it is suggested, are strong local institutions and infrastructures: relations of trust based on face-to-face contact; a 'productive community' historically rooted in a particular place; a strong sense of local pride and attachment.[33] In Britain this localizing ethos, often directly influenced by the 'flexible specialization' thesis, was manifest in a number of local economic development strategies undertaken by local authorities (notably the Greater London Council, Sheffield City Council and West Midlands County Council).[34]

In the cultural sphere too, localism has come to play an important role. The 'struggle for place' is at the heart of much contemporary concern with urban regeneration and the built environment. Prince Charles's crusade on behalf of community architecture and classical revivalism is the most prominent and influential example. There is a strong sense that modernist planning was associated with universalizing and abstract tendencies, whilst postmodernism is about drawing upon the sense of place, about revalidating and revitalizing the local and the particular. A neo-Romantic fascination with traditional and vernacular motifs is supposedly about the re-enchantment of the city.[35] This cultural localism reflects, in turn, deeper feelings about the inscription of human lives and identities in space and time. There is a growing interst in the embeddedness of life histories within the boundaries of place, and with the continuities of identity and community through local memory and heritage. Witness the enormous popularity of the Catherine Cookson heritage trail in South Tyneside, of 'a whole day of nostalgia' at Beamish in County Durham, or of Wigan Pier's evocation of 'the way we were'. If modernity created an abstract and universal sense of self, then postmodernity will be about a sense of identity rooted in the particularity of place: 'it contains the possibility of a revived and creative human geography built around a newly informed synthesis of people and place'.[36]

Whilst globalization may be the prevailing force of our times, this does not mean that localism is without significance. If I have emphasized processes of de-localization, associated especially with the development of new information and communications networks, this should not be seen as an absolute tendency. The particularity of place and culture can never be done away with, can never be absolutely transcended.[37] Globalization is, in fact, also associated with new dynamics of *re*-localization. It is about the

achievement of a new global–local nexus, about new and intricate relations between global space and local space.[38] Globalization is like putting together a jigsaw puzzle: it is a matter of inserting a multiplicity of localities into the overall picture of a new global system.

We should not idealize the local, however. We should not invest our hopes for the future in the redemptive qualities of local economies, local cultures, local identities. It is important to see the local as a relational, and relative, concept. If once it was significant in relation to the national sphere, now its meaning is being recast in the context of globalization. For the global corporation, the global-local nexus is of key and strategic importance. According to Olivetti's Carlo de Benedetti, in the face of ever-higher development costs, *'globalisation* is the only possible answer'. 'Marketers', he continues, 'must sell the latest product everywhere at once – and that means producing *locally.*'[39] Similarly, the mighty Sony describes its operational strategy as 'global localisation'.[40] NBC's vice-president, J. B. Holston III, is also resolutely 'for localism', and recognizes that globalization is 'not just about putting factories into countries, it's being part of that culture too'.[41]

What is being acknowledged is that globalization entails a corporate presence in, and understanding of, the 'local' arena. But the 'local' in this sense does not correspond to any specific territorial configuration. The global–local nexus is about the relation between globalizing and particularizing dynamics in the strategy of the global corporation, and the 'local' should be seen as a fluid and relational space, constituted only in and through its relation to the global. For the global corporation, the local might, in fact, correspond to a regional, national or even pan-regional sphere of activity.

This is to say that the 'local' should not be mistaken for the 'locality'. It is to emphasize that the global–local nexus does not create a privileged new role for the locality in the world economic arena. Of course local economies continue to matter. That is not the issue. We should, however, treat claims about new capacities for local autonomy and proactivity with scepticism. If it is, indeed, the case that localities do now increasingly bypass the national state to deal directly with global corporations, world bodies or foreign governments, they do not do so on equal terms. Whether it is to attract a new car factory or the Olympic Games, they go as supplicants. And, even as supplicants, they go in competition with

each other: cities and localities are now fiercely struggling against each other to attract footloose and predatory investors to their particular patch. Of course, some localities are able successfully to 'switch' themselves in to the global networks, but others will remain 'unswitched' or even 'unplugged'. And, in a world characterized by the increasing mobility of capital and the rapid recycling of space, even those that manage to become connected in to the global system are always vulnerable to the abrupt withdrawal of investment and to disconnection from the global system.

The global–local nexus is also not straightforwardly about a renaissance of local cultures. There are those who argue that the old and rigid hegemony of national cultures is now being eroded from below by burgeoning local and regional cultures. Modern times are characterized, it is suggested, by a process of cultural decentralization and by the sudden resurgence of place-bound traditions, languages and ways of life. It is important not to devalue the perceived and felt vitality of local cultures and identities. But again, their significance can only be understood in the context of a broader and encompassing process. Local cultures are overshadowed by an emerging 'world culture' – and still, of course, by resilient national and nationalist cultures.

It may well be that, in some cases, the new global context is recreating sense of place and sense of community in very positive ways, giving rise to an energetic cosmopolitanism in certain localities. In others, however, local fragmentation – remember the Saatchi point about the relationship between populations in midtown Manhattan and the Bronx – may inspire a nostalgic, introverted and parochial sense of local attachment and identity. If globalization recontextualizes and reinterprets cultural localism, it does so in ways that are equivocal and ambiguous.

It is in the context of this global–local nexus that we can begin to understand the nature and significance of the enterprise and heritage cultures that have been developing in Britain over the past decade or so. I want now to explore two particular aspects of contemporary cultural transformation (each in its different way centred around the relationship between Tradition and Translation).

ON NOT NEEDING AND NEEDING ANDY CAPP

Why discuss enterprise and heritage together? Is there really any connection between the modernizing ambitions of enterprise culture and the retrospective nostalgia of heritage culture? The argument put forward in this section is that there is in fact a close and *necessary* relation between them. The nature of this relationship becomes clear, I suggest, when we see that each has developed as a response to the forces of globalization. Insight into this relational logic then helps us to understand the neurotic ambivalence that is, I think, at the heart of contemporary cultural transformation.

Enterprise culture is about responding to the new global conditions of accumulation. British capital must adapt to the new terms of global competition and learn to function in world markets. It must pursue strategic alliances and joint ventures with leading firms in Europe, North America, and Japan. In all key sectors – from pharmaceuticals to telecommunications, from automobiles to financial services – 'national champions' are being replaced by new flexible transnationals. In the cause of global efficiency, it is necessary to repudiate the old 'geography-driven' and home-centred ethos, and to conform to the new logic of placelessness and equidistance of perspective. The broadcasting industries are a good example. In the new climate, it is no longer viable to make programmes for British audiences alone. One way of understanding the debate around 'public service versus the market' is in terms of the displacement of nationally centred broadcasting services by a new generation of audio-visual corporations, like Crown Communications and Carlton Communications, operating in European and global markets. As the recent White Paper on broadcasting makes clear, television is 'becoming an increasingly international medium' centred around 'international trade in ideas, cultures and experiences'.[42] The consequence of these developments, across all sectors, is that the particularity of British identity is de-emphasized. In a world in which it is necessary to be 'local' everywhere – to be 'multidomestic' – certain older forms of national identity can actually be a liability. The logic of enterprise culture essentially pushes towards the 'modernization' of national culture. Indeed it is frequently driven by an explicit and virulent disdain for particular aspects of British culture and traditions. This scorn is directed against what the self-styled 'department for Enterprise' calls 'the

past anti-enterprise bias of British culture'.[43] The spirit of enterprise is about eradicating what has been called the 'British disease': the 'pseudo-aristocratic' snobbery that has allegedly devalued entrepreneurial skills and technological prowess, and which has always undermined Britain's competitive position in world trade.[44]

If enterprise culture aims to refurbish and refine national culture and identity, there are, however, countervailing forces at work. Globalization is also underpinned by a quite contrary logic of development. As Scott Lash and John Urry argue, the enhanced mobility of transnational corporations across the world is, in fact, associated with an increased sensitivity to even quite small differences in the endowments of particular locations. 'The effect of heightened spatial difference', they suggest, 'has profound effects upon particular places . . . contemporary developments may well be heightening the salience of localities.'[45] As global corporations scan the world for preferential locations, so are particular places forced into a competitive race to attract inward investors. Cities and localities must actively promote and advertise their attractions. What has been called the 'new urbanity'[46] is very much about enhancing the profile and image of places in a new global context. It is necessary to emphasize the national or regional distinctiveness of a location. As Margit Mayer points out, 'endogenous potentials' come to be cultivated: 'cities have come to emphasise, exploit and even produce (cultural and natural) local specificity and assets. . . . In this process, place-specific differences have become a tool in the competition over positional advantages.'[47] In this process, local, regional, or national cultures and heritage will be exploited to enhance the distinctive qualities of a city or locality.[48] Tradition and heritage are factors that enhance the 'quality of life' of particular places and make them attractive locations for investment. An emphasis on tradition and heritage is also, of course, important in the development of tourism as a major industry. Here, too, there is a premium on difference and particularity. In a world where differences are being erased, the commodification of place is about creating distinct place-identities in the eyes of global tourists. Even in the most disadvantaged places, heritage, or the simulacrum of heritage, can be mobilized to gain competitive advantage in the race between places. When Bradford's tourist officer, for example, talks about 'creating a product' – weekend holidays based around the themes of 'Industrial Heritage' and 'In the Steps of the Brontës',[49] he is underlining the importance of place-making in placeless times,

the heightened importance of distinction in a world where differences are being effaced.

In the new global arena, it is necessary, then, simultaneously to minimize and maximize traditional cultural forms. The North-East of England provides a good example of how these contradictory dynamics of enterprise and heritage are developing. In this part of the country, it is over the symbolic body of Andy Capp that the two logics contest. 'Andy Capp is dead – Newcastle is alive' [50] – that is the message of enterprise. The region no longer has a place for Andy or for other cloth-capped local heroes like the late Tyneside comedian, Bobby Thompson. 'The real Northerner is no relation to Bobby or Andy', local celebrity Brendan Foster tells us.[51] The 'Great North' promotional campaign puts great emphasis on 'enterprise' and 'opportunity' and tries to play down the heritage of the region's old industrial, and later de-industrialized, past.[52] Newcastle City Council has recently employed J. Walter Thompson to change the city's image and to get rid of the old cloth-cap image once and for all. In order to position itself in the new global context, the region must re-image and, ultimately, re-imagine itself. The increasing Japanese presence in the region (around forty companies at the present moment) has become a key factor in this strategic identity switch. Japan is the very symbol of enterprise culture. In a little paean to Japanization, Labour MP Giles Radice invokes the buzz-words of 'quality', 'flexibility' and 'teamwork' to convey the benign influence of these foreign investors.[53] Japan is the key to constructing the new model Geordie. The region's history is now being reassessed to emphasize the special relationship between Japan and the North-East. 'The North-East aided Japan's progress towards modernisation in the late nineteenth and early twentieth centuries', we are told, whilst, 'today Japanese investment is contributing to the revitalisation of a region that followed a very different course in the post-war period.' We must, it is stressed, 'adapt to changing times'.[54]

If the spirit of enterprise wants to kill off Andy Capp, there is, however, a counter-spirit that keeps him alive. The region's industrial past is its burden, but it is also its inheritance. It is clear that history can be made to pay. Beamish, The Land of the Prince Bishops, Roman Northumberland and Catherine Cookson Country are all heritage assets that can be exploited to attract tourists and investors alike. But if heritage is to be marketed, it becomes difficult to avoid the reality that the North-East was once a region

of heavy engineering, shipbuilding and coal mining. And around these industries there developed a rich working-class culture. For many in the region, the conservation of local culture and traditions is extremely important. The photographic work of Newcastle's Side Gallery, and also the productions of film workshops like Amber and Trade, have paid great attention to working-class heritage. The work of writers like Jack Common, Sid Chaplin or Tom Hadaway has also contributed to the creation of a distinctive identity for the region.[55] Footballer Jackie Milburn is another powerful symbol of working-class heritage. And so too is the 'little waster', Bobby Thompson, whom Brendan Foster sees as so much the embodiment of the Andy Capp myth. As Leslie Gofton argues, 'it is this image, and the perverse attachment of the people to the life which goes with it, which is being attacked by entrepreneurs such as John Hall'.[56] Yet it is a strangely irrepressible image, now resurfacing in Harry Enfield's character Buggerallmoney and in the comic magazine *Viz*. And it is also in many ways an affirmative image. The gritty and anarchic humour of Andy and Bobby distinguishes the region, gives it a positive sense of difference.

My objective is not to enter into a detailed account of enterprise and heritage cultures in the North-East, but rather to emphasize how the region's new global orientation is pulling its cultural identity in quite contradictory directions: it involves at once the devaluation and the valorization of tradition and heritage. There is an extreme ambivalence about the past. Working-class traditions are seen, just like 'pseudo-aristocratic values', as symptoms of the 'British disease', and as inimical to a 'post-industrial' enterprise ethos. But tradition and heritage are also things that entrepreneurs can exploit: they are 'products'. And they also have human meaning and significance that cannot easily be erased. At the heart of contemporary British culture is the problem of articulating national past and global future.

THE BURDEN OF IDENTITY

I want, finally, to return to the question of what postmodern geographies might imply for the question of empire. Post-modernism, as Todd Gitlin argues, should be understood as 'a general orientation, as a way of apprehending or experiencing the world and our place, or placelessness, in it'.[57] Globalization is profoundly transforming our apprehension of the world: it is

provoking a new experience of orientation and disorientation, new senses of placed and placeless identity. The global–local nexus is associated with new relations between space and place, fixity and mobility, centre and periphery, 'real' and 'virtual' space, 'inside' and 'outside', frontier and territory. This, inevitably, has implications for both individual and collective identities and for the meaning and coherence of community. Peter Emberley describes a momentous shift from a world of stable and continuous reference points to one where 'the notions of space as enclosure and time as duration are unsettled and redesigned as a field of infinitely experimental configurations of space-time'. In this new 'hyperreality', he suggests, 'the old order of prescriptive and exclusive places and meaning-endowed durations is dissolving' and we are consequently faced with the challenge of elaborating 'a new self-interpretation'.[58]

It is in this context that both enterprise and heritage cultures assume their significance. Older certainties and hierarchies of British identity have been called into question in a world of dissolving boundaries and disrupted continuities. In a country that is now a container of African and Asian cultures, the sense of what it is to be British can never again have the old confidence and surety. Other sources of identity are no less fragile. What does it mean to be European in a continent coloured not only by the cultures of its former colonies, but also by American and now Japanese cultures? Is not the very category of identity itself problematical? Is it at all possible, in global times, to regain a coherent and integral sense of identity? Continuity and historicity of identity are challenged by the immediacy and intensity of global cultural confrontations. The comforts of Tradition are fundamentally challenged by the imperative to forge a new self-interpretation based upon the responsibilities of cultural Translation.

Neither enterprise nor heritage culture really confronts these responsibilities. Both represent protective strategies of response to global forces, centred around the conservation, rather than reinterpretation, of identities. The driving imperative is to salvage centred, bounded and coherent identities – placed identities for placeless times. This may take the form of the resuscitated patriotism and jingoism that we are now seeing in a resurgent Little Englandism. Alternatively, as I have already suggested, it may take a more progressive form in the cultivation of local and regional identities or in the project to construct a continental European identity. In each case, however, it is about the maintenance of protective

illusion, about the struggle for wholeness and coherence through continuity. At the heart of this romantic aspiration is what Richard Sennett, in another context, calls the search for purity and purified identity. 'The effect of this defensive pattern', he argues, 'is to create in people a desire for a purification of the terms in which they see themselves in relation to others. The enterprise involved is an attempt to build an image or identity that coheres, is unified, and filters out threats in social experience.' [59] Purified identities are constructed through the purification of space, through the maintenance of territorial boundaries and frontiers. We can talk of 'a geography of rejection which appears to correspond to the purity of antagonistic communities'.[60] Purified identities are also at the heart of empire. Purification aims to secure both protection from, and positional superiority over, the external other. Anxiety and power feed off each other. As William Connolly argues,

> When you remain within the established field of identity and difference, you become a bearer of strategies to protect identity through devaluation of the other; but if you transcend the field of identities through which the other is constituted, you lose the identity and standing needed to communicate with those you sought to inform. Identity and difference are bound together. It is impossible to reconstitute the relation to the second without confounding the experience of the first.[61]

To question empire, then, is to call into question the very logic of identity itself. In this context, it is not difficult to understand the anxious and defensive efforts now being devoted to reinforce and buttress 'traditional' cultural identities.

Is it, then, possible to break this logic of identity? How do we begin to confront the challenge of postmodern geographies and the urgent question of cultural Translation? British enterprise and heritage cultures are inscribed in what Ian Baruma has called the 'antipolitical world of *Heimat*-seeking'.[62] Against this ideal of *Heimat*, however, another powerful motif of the contemporary world should be counterposed. It is in the experience of *diaspora* that we may begin to understand the way beyond empire. In the experience of migration, difference is confronted: boundaries are crossed; cultures are mingled; identities become blurred. The diaspora experience, Stuart Hall argues, is about 'unsettling, recombination, hybridization and "cut-and-mix" ' and carries with it a transformed relation to Tradition, one in which 'there can be no

simple "return" or "recovery" of the ancestral past which is not re-experienced through the categories of the present.'[63] The experience of diaspora, and also of exile, as Edward Said has powerfully argued, allows us to understand relations between cultures in new ways. The crossing of boundaries brings about a complexity of vision and also a sense of the permeability and contingency of cultures. It allows us 'to see others not as ontologically given but as historically constituted' and can, thereby, 'erode the exclusivist biases we so often ascribe to cultures, our own not least'.[64]

The experience of diaspora and exile is extreme, but, in the context of increasing cultural globalization, it is prefigurative, whilst the quest for *Heimat* is now regressive and restrictive. The notion of distinct, separate, and 'authentic' cultures is increasingly problematical. A culture, as Eric Wolf argues is 'better seen as a series of processes that construct, reconstruct, and dismantle cultural materials'; 'the concept of a fixed, unitary, and bounded culture must give way to a sense of the fluidity and permeability of cultural sets'.[65] Out of this context are emerging new forms of global culture. There is, to take one example, a new cosmopolitanism in the field of literature. Writers like Isabel Allende, Salman Rushdie or Mario Vargas Llosa are recording 'the global juxtapositions that have begun to force their way even into private experience', 'capturing a new world reality that has a definite social basis in immigration and international communications'.[66] For Rushdie, these literary exiles, migrants or expatriates are 'at one and the same time insiders and outsiders', offering 'stereoscopic vision' in place of 'whole sight'.[67]

The point is not at all to idealize this new cosmopolitanism (the Rushdie affair is eloquent testimony to its limits and to the real and profound difficulties of cultural Translation). It is, rather, to emphasize the profound insularity of enterprise and heritage cultures and to question the relevance of their different strategies to re-enchant the nation. As Dick Hebdige emphasizes, everybody is now 'more or less cosmopolitan'; "mundane" cosmopolitanism is part of "ordinary" experience'.[68] If it is possible, then it is no longer meaningful, to hold on to older senses of identity and continuity. In these rapidly changing times, Hanif Kureishi writes, the British have to change: 'It is the British, the white British, who have to learn that being British isn't what it was. Now it is a more complex thing, involving new elements.'[69]

The argument of this chapter has been that the emergence of

enterprise and heritage cultures has not been a matter of the purely endogenous evolution of British culture, but rather a response to the forces of globalization. If, however, over the past decade or so, both of these cultural developments have been provoked and shaped by those forces, neither has been open to them. The question for the 1990s is whether we will continue to insulate ourselves with protective and narcissistic illusions, or whether, in the new global arena, we can really find 'a new way of being British'.

Chapter 2

Mediating tradition and modernity: the heritage/enterprise couplet

John Corner and Sylvia Harvey

The 1980s has seen a radically conservative attempt to restructure British capitalism and to do so within the contexts of a restructured international economy. As infrastructural change has become more international in character, a resurgent nationalism has emerged partly as a political response to the perceived diminution of national identity, and the 'trauma' of loss of empire and incorporation into the European Economic Community. Not only *British* national identity has had to confront a crisis as new forms of multinational networking, based in part upon the new technologies for information processing, have created novel economic and cultural connections at and across sub-national (regional and local) and supra-national levels. National identity and self-sufficiency have become vulnerable to the new supremacy of global information flows, and the power of increasingly multinational grids of investment, production and marketing.[1]

We are arguing, throughout the design of this book and specifically here in this chapter, that the meanings and projections of both 'heritage' and of 'enterprise' have a nodal significance for this much broader process of *transition*. For in a number of contradictory ways, 'heritage' and 'enterprise' have been officially mobilized to provide the imaginative dynamics by which transition might be managed at the level of national culture and its attitudinal deep structure. Although both notions led an active political and ideological life before the 1980s, the decade saw them extensively reorganized as they were semantically recharged within the force-fields of national politics. More specifically, it saw them *interconnected* as related elements of Thatcherite reconstruction. One cultural aspect of this process was the emphatic projection of new perspectives upon the national past and future, involving new ways

of relating imaginatively to *continuity*, whilst admitting new principles of economic and cultural *change*. Both terms are thus, in contemporary usage, enlisted as devices of ideological mediation in a political project which needs not only to redesign the dominant versions of 'tradition' and of 'modernity', but to readjust the relationship between them. In this sense, heritage and enterprise form together a key mythic couplet for preserving hegemonic equilibrium and momentum during a period of major national reorientation. To see them as self-evidently in opposition on account of the different directions – backwards and forwards – of their visionary discourse, is to underestimate the powerful inter-articulation of past, present and future in them both.

Their mutual supportiveness can be observed at a number of levels. Most obviously it is there in the extent to which what has come to be called 'the heritage industry' is itself a major component of economic redevelopment, an 'enterprise', both in terms of large-scale civic programmes and the proliferation of private commercial activity around 'the past' in one commodified form or another. But it is there at a more general and more strategic level in the way in which remodelled versions of 'identity' and 'belonging' have been projected by heritage. These have been offered as *compensatory* in relation to the undertones of destabilization and fragmentation carried by the enterprise imperative, along with its official melodies of opportunity and progress.

Yet it is immediately easy to see how the ideological project suggested here might in practice be hard to achieve. Especially so when we note the diversity and variety of heritage culture and the relative absence of those tight bureaucratic controls exerted, by contrast, over the official refashioning of enterprise. Nationalist nostalgia might well serve to construct, via sentiments of *inheritance*, a sense of the National Present perfectly suited for use as a departure point for an 'enterprising' National Future, through, for example, the celebration of nineteenth-century industrial entrepreneurship. But it is equally possible to imagine a heritage whose (unintended) effects would include encouraging people to call into question precisely those values towards which free-market enterprise points. We explore such questions in more detail below. Of course, even within the operation of the two terms considered separately, a total coherence of meanings, a fixed signification, is impossible to deliver. In respect of enterprise, for instance, the apparent singularity of the term and of the kind of society which it

connotes cannot hide the continuing conflict between the values of 'one-nation' and 'free-market' Toryism. In 1990, this continued to disturb the unity of Cabinet policy and to trouble the response of Conservative supporters nationally. Moreover, free-market theorists do not enjoy exclusive use of the term, since it has also been taken up and mobilized in the service of socialist reconstruction, by Gorbachev in the USSR, and by some European socialists.

Projections of British heritage, however bland the mythification, have not been able entirely to avoid awkward issues surrounding the very idea of a national 'inheritance' and its relation to widespread perceptions of both past and continuing inequalities. These popular perceptions do not usually work with the categories of class, race and gender and are likely to be selective in their recognition of inequality and its causes. Nevertheless, such recognition may be sufficient to offer continued, if selective, resistance to ideas of a transcendent national unity.

In what follows, we explore the two concepts separately. However, in a final section we return to a consideration of the links between them.

HERITAGE: IDENTITY, PLEASURE AND THE IMAGINARY PAST

You know that Summer has really arrived when the open-air concerts begin. And English Heritage can offer such enchanting surroundings – the sun setting over the lake at Kenwood, the boats passing on the Thames at Marble Hill and this year for the first time, the Grandeur of Audley End House.

English Heritage brochure, 1989

You will see how people lived a hundred years ago, and where they worked. You can eat what they ate, smell what they could smell and drink what they drank. You can see how their candles, their shoes, their woodwork and their printed paper were made.

Guide to Blists Hill Open Air Site, The Ironbridge Gorge Museum (declared a World Heritage Site, 1987)

During the 1980s, the word 'heritage' has become the principal label for a variety of often very different evocations, projections and embodiments of national and local 'pastness' and pride.[2] It has become the keyword in organizing, and frequently in institutional-

izing, that intensified concern with historical reference which characterizes the decade at many levels of its political, cultural and economic formation and which has given rise to an astonishing growth in historical tourism. The National Heritage Acts of 1980 and 1983 sought in different ways to secure further funding for increased activity in the preservation, restoration and display of historic properties whilst at the same time providing 'heritage' projects more generally with a new (and a commercially aggressive) public philosophy. Out of the 1983 Act a new public body, English Heritage, was formed to oversee the management of buildings and monuments and to co-ordinate and fund schemes of preservation and redevelopment across the board ('the whole pageant of English history is in our care', its Handbook observes). In 1982, the Heritage Educational Trust was set up to 'promote the serious educational use of historic houses and other heritage properties'.[3] It promotes the inclusion of heritage awareness in the curriculum and holds regular conferences and dayschools to this end. Of course, the most established institution of the British national heritage is the National Trust, which has exerted a managing influence on both physical and cultural manifestations of the notion since 1895, though not without several shifts in the direction and scope of its custodial duties.[4] As with the newer institutions of heritage however, in comparison with what we have argued is the institutionally-led cultural revolution of 'enterprise', the 'top-down' effects of official bureaucracies upon the broad range of national 'heritage' developments have been less unified and direct. The use of the term 'heritage' also extends to an increasing number of periodicals variously concerned with conservation, redevelopment, tourism or, indeed, with all three. For example, *Heritage: The British Review* is an illustrated magazine of ardent, right-wing nationalism, designed primarily, perhaps for an expatriate readership, whilst *Heritage Outlook* is the periodical of the Civic Trust and *English Heritage Monitor* an annual publication of the English Tourist Board. At regional and local level too, the heritage concept appears in many cases to have reorganized the projection of tourist appeal, penetrating quickly down from official brochures and visitors' guides through to shops, gifts and a whole variety of leisure pursuits.

The new terms of this popular, recreational engagement with the past have created a changed context for the traditional function of museums. Established institutions have frequently felt it necessary to rethink their principles of exhibition in relation to a public

constituency responsive to a 'livelier' approach to display and interpretation. At the same time, they have been joined both by new and specialized kinds of civic collections and by a massive increase in private museums, mostly developed as part of the tourist economy and creating within the heritage idea strong cross-generic connections with fun-fair and theme park.

It can therefore be quite easily established that 'heritage' is the term most frequently used in current popular mediations of history and that under this label there has been mobilized throughout the 1980s an unprecedented degree of activity in the 'recovery' and contemplation of the past as this is seen to inhere within buildings, artefacts, and reconstructed action. Television and, to a lesser extent, sections of the magazine industry, have acted both as agencies of stimulation and of integration in this process. They have inserted 'pastness' into the popular by narrative representations which have drawn on, and then re-enhanced, the periods, events, characters, costumes, and activities forming heritage's intertextual grid.

But how coherent, across the proliferating usages and instances, are the *meanings* and *values* generated by the term? And how directly and effectively do these meanings and values relate to those dominant forces of economic and political conservatism within whose force-field most developments have been initiated and managed? It is possible to identify a number of common and related themes at work in manifestations of heritage culture and it may be useful to address questions of this kind through a closer consideration of the thematic significances which constitute heritage's appeal.

A nation in community and communion

Working behind every use of 'heritage', however locally inflected and circumscribed, there is necessarily a sense of an *inheritance* which is rhetorically projected as 'common', whilst at the same time it is implicitly or contextually closed down around particular characteristics of, for instance, social class, gender, and ethnicity. As we suggested in our introductory essay in this volume, an intensified rhetoricization of heritage is one response to the perceived threat of weakened group identity in the changing contexts of Europe and of global finance. More positively, the intensified national self-consciousness occasioned by the Falklands/Malvinas

conflict of 1982 provided an opportunity for an early mapping of several 'official' heritage themes on to a (temporary and perhaps febrile) mood of assertive confidence. However, the push towards a reaffirmed, 'tightened' indentity may have to take account of certain *differences* so awkward as to be unnegotiable. For example, Welsh, Northern Irish and Scottish 'heritages' cannot easily be rendered explicitly within the terms of an English one, making the very notion of 'British heritage' an imprudent rhetorical device for many purposes. Even at the level of a proclaimed 'English heritage', for instance, the basic meaning, of something in common owner-ship received from the past, is highly ambitious in its persuasive aims. It attempts to promote the dissolution, or at least the temporary forgetting, of radical differences and inequalities and to do so in the interests of celebrated unity. In this connection, it is worth noting that heritage appeals tend to differ from those of patriotism in so far as the latter require a sense of *loyalty* rather than of *possession* to be the primary focus of feeling and action, and they can therefore work more freely alongside a popular recognition (and acceptance) of established structures of difference.

The unity which heritage celebrates is both historical and there-fore a focus for *contemplation* (England is connected-in-unity with the past and its values) and contemporarily *active* (the English have certain central responsibilities and delights in common – 'Explore the past, enjoy the present and protect the future' enjoins the English Heritage membership campaign).[5]

The highly intractable fact that most English people do not own the land or properties forming most of the official heritage and that, in so far as public trusts and state ownership *do* allow a limited idea of common property to be employed, this is of quite recent origin, can be negotiated by heritage discourse in a number of ways.

Of these, perhaps the most familiar is that which strategically suggests a sufficient *discontinuity* with the past to permit *increased access* to be marked as part of the exciting *promise* of heritage ('We are determined to share our pleasures and our responsibilities', *English Heritage Guidebook 1989/1990*). Here, the inheritance is offered as attractive partly because one (large) group of 'inheritors' might have only just realized they had one (indeed they might have only just been given it!). Clearly, this offering cannot involve the kind of detailed examination of the changed conditions of owner-ship that might threaten the imaginative appeal of inheritance as *continuity*.

Heritage pronouncements also vary in the extent to which it is primarily landscape, architecture, artefacts, or *values* which are being appealed to as common stock. More often than not, a strategic *indivisibility* is seen to be at work, subsuming awkward differences within larger continuities. The implication that while the property may, in most cases, remain in private ownership, the values it represents are 'public', is frequently to be found. A much-cited passage from Patrick Cormack's preservationist polemic *Heritage in Danger* (1976) is a good example of the carefully selective 'visionary list':

> When I am asked to define our heritage I do not think in dictionary terms, but instead reflect on certain sights and sounds. I think of a morning mist on the Tweed at Dryburgh where the magic of Turner and the romance of Scott both come fleetingly to life; of a celebration of the Eucharist in a quiet Norfolk Church with the mediaeval glass filtering the colours, and the early noise of the harvesting coming through the open door; or of standing at any time before the Wilton Diptych. Each scene recalls aspects of an indivisible heritage, and is part of the fabric and expression of our civilisation.[6]

This is heritage at its most pretentiously reverential, drawing on art, religion and rurality in ways which are unlikely to connect fully with a broad popular response, despite their continuing potency within the codes of narrower (though influential) versions of national identity. Such versions, in their High Victorian-style confidence, often have strong imperialist assumptions built into their ideas of 'The Nation', giving their rhetoric a white racial character which either ignores, or openly rejects, the nature of Britain as a multi-ethnic society.

In the course of our discussion below, we note the manner in which, by being extended out beyond the splendid and the exalted to the humble, the ordinary and the working, the Heritage idea has broadened its ideological reach at the same time as it has also, perhaps, been modified in its focus and force by other, connecting and sometimes conflicting, discourses.

In the heart of the country

Although the idea of heritage is now used to describe and promote an increasing number of urban, industrial sites and exhibitions, an

emphasis on the countryside, on the natural order and on rural life (a *naturalized* order) remains central to most heritage culture. The contiguity of rural social history with the enduring or cyclical features of the natural world produces that sense of a 'timeless past' of hallowed custom and habit which then makes possible the displacement of the specificities of social history by myths of social organicism. Patrick Wright suggestively employs the notion of 'Deep England' to catch at this particular set of meanings.[7]

There are nevertheless two distinct aspects to the emphasis on the countryside, which we might call the *aristocratic* and the *rustic*.

The aristocratic provides the focus for a mythology of the social order which is one of the most established in national ideology – that of the country house, with its serenity, family continuities and apparently unlegislated harmony of environmental and human relationships.[8] Among recent commentators, both Wright and Hewison have shown very clearly just how dominant an element the 'country house' version of heritage has been in the work of the major public bodies, particularly the National Trust. Moreover, the geographic distribution of such properties in the Midlands and the North, as well as the South, has helped to prevent that sense of *regional* division which might have been thought to follow from so clear a class emphasis. It is also likely that the highly popular television series *Brideshead Revisited*, adapted from Evelyn Waugh's novel and transmitted on the ITV network in 1981, served to give the expression of 'country house' values a degree of cultural rehabilitation and resonance and to reactivate them within newer and much broader formations of anxiety, sentiment and fantasy.

Part of the traditional aura and allure of the houses clearly resides in their distinctive, if now reworked, 'exhibition aesthetic'. Wright notes the increasing importance of personal 'clutter' and household implements as domestic life, framed within naturalistic, narrative principles (the *story* of the house and its occupants), has begun to appear alongside, and then even to displace, the older emphasis on the display of art and finery. The properties and grounds also clearly offer unique opportunities for popular imaginative play on the pleasures of spaciousness, tranquillity, status and order, providing opportunities for visitors to experience briefly at least the first of these.

The *rustic* is often found as an exhibited appendage to conventional 'country house' culture. Here, it is usually located in the display of 'servant's quarters' (now, significantly, attracting more

guidebook and visitor attention than formerly), at the estate farm, or in the backcloth which the 'village' provides to the presentation of life at 'the hall'. However, the dominant influence on the growth of this aspect of contemporary heritage culture has been the idea of the folk-museum and the widespread interest in rural crafts and skills and in traditional materials. Developments in this area have often been informed by a scholarly concern with the details of agricultural method and rural artisanry, though rarely has the social history of labour been introduced very far into the picture. Unlike the exhibition and interpretation of *industrial* pastness, where the history of exploitation and dispute is hard to ignore (though not necessarily all that hard to 'treat'), the depiction of rural labour often elides specific social and economic relations altogether. Skilled craftsmen figure against a generalized setting of the local ('community') and the national ('the people') and are often appropriated for heritage by having their imposed toil displaced and naturalized as displays of individual resourcefulness and quiet fortitude.

Work and play

Previously a term with a rather dated and fulsome ring to it, heritage has now emerged as a central enabling concept within national and regional redevelopment, related directly to the growth in tourism and leisure investment.[9] It is this connection more than any other which has brought heritage initiatives their success ('Heritage can be fun', North Western Museums and Art Galleries brochure).

Given this leisure-centredness, it may therefore seem at first paradoxical that one of the most significant new ingredients in the heritage mix is the inclusion of the *industrial* past and with it, inevitably, industrial working practices and routines. Examples include the Kelham Island Industrial Museum in Sheffield, Quarry Bank Mill at Styal in Cheshire and the Merseyside Maritime Museum in the newly redeveloped Albert Dock complex at Liverpool. But perhaps the most extensive and celebrated site of this kind in Britain is the Ironbridge Gorge Museum complex, near Telford in Shropshire.[10]

Not only is the popular use of leisure time to consider the depicted working life of the past in itself novel, the social class characteristics of such engagement are quite new within the specta-

torial relations of historical tourism. For instead of that look across both time *and* class which is offered by the visit to the stately home or the medieval castle, the imaginative connection of the industrial museum (though it still might be *offered* as one with 'the people of a bygone age') is with the same class formation from which are drawn a majority of the visitors. In so far as display is organized around *technology* (most accessibly, as 'old machines'), questions of working experience and its economic and social relations can be displaced to the periphery of concern. Quarry Bank Mill, in many respects a worthy example of an attempt to balance historical integrity with 'leisure' potential, shows how this displacement can work. Entrance tickets are provided in the form of 'clocking on' cards which can later be inserted and stamped in a machine, though this moment of imaginary identification with the workforce is not connected with much else in the projection of the site. Where the display *does* engage directly with the *social* relationships of mill work, it tends to do so in a way which naturalizes these as mirroring the site's *physical* presence: 'Two hundred years after its foundation, Styal still provides an unspoilt example of a *factory community*, the surviving buildings reflecting earlier social ties.' [11] Here 'community' strategically connects across both descriptive and evaluative meanings (as indeed does the notion of 'unspoilt'). Elsewhere, the same display reveals the framework of assumptions upon which its projection partly rests: 'Labour Relations at Styal seem to have been good. There is little record of any trades-union activity.' The judgement offered on working conditions inclines towards the equivocal ('Mill-owners saw the benefit of strict discipline') and it is only when visitors pass through a shed full of working looms, registering the overwhelming sense of noise and perhaps of risk, that some of the *force* of the labour experience erupts into a visitor experience otherwise organized predominantly in terms of technology, architectural interest and rurality.

In depictions of past labour, it is clearly the case that the potential for imaginary *class* alignment varies with the degree of 'remoteness' attaching to popular framings of the period depicted. Conversely, the reclamation for heritage of the more recent industrial past may prove troublesome among the affected local community. David Lowenthal reports on an American example in the 1970s when several historic cotton mills were, after a 'heritage' bid for their preservation, demolished to general local satisfaction, Lowenthal comments:

the dust, noise, bad smells, hard labour and other forms of exploitation associated with these kind of places made preservation ludicrous. 'Preserve a steel mill' people say, 'It killed my father, who wants to preserve that.' [12]

Yet in their attempts, not to preserve, but to *resurrect* a more distant working past, many of the new industrial museums in Britain have started to 'fill-out' scenarios of human and occupational experience within which their technological exhibits can be set. They have often done so by the use of theatrical, audio-visual and narrative devices whose precise aim seems to be to establish empathy with at least some of the terms of the 'life' behind the 'work'. In a discussion of the displays at Ironbridge Gorge, Bob West draws on his own working experience to comment critically on the forms of appropriation and misperception which he sees are involved:

> I went to work in the sawmills because I was desperate, the wage form was exploitation, every day was purgatory, but there was no other local alternative. How do you make a museum of an experience like that? What angered me about the sawmill and the woodworking shop was that the 'reality' it produced actively disorganised and thus rendered illegitimate, any alternative account of what this experience of work amounts to. Up to a point I felt silenced by it and, in the absence of anything more relevant, felt drawn to identify with the tools, the noise and the smell. But isn't this what dominant memory always does? A museum like this with its professional-managerial assumptions provides a very partial framework for personal experience, and one which constantly threatens to compromise those visitors who want to sustain their own distinctive and opposed perspectives to the exploitation of waged work. [13]

This *re-animation* of the working past, received within, but perhaps also sometimes resisted by, the experience and dispositions of working-class visitors from different generations, constitutes one of the key ideological features of the heritage industry as it moves into the 1990s. Related to it is the representation of the *domestic past*, often implicitly counterposed to 'work' but only by a naturalization of domestic labour within dominant, male terms of the home as 'leisure space'. There is a clear exception to this in the representation of *waged* domestic labour in the kitchens and servants'

quarters of stately homes and country houses, where the significa-
tion is clearly of 'work' comparable with that of male employees. In
both cases, the *interaction* between the terms of display and the
(gendered) terms of visitor interpretation becomes of especial
significance.

Sensing the past: from things to experiences

The re-articulation of the 'historical' within the established institu-
tions of public display and within the newer 'heritage centres' has
entailed, as we have already noted, a move away from the
presentation of objects isolated within the categories of scientific
classification, and towards their inclusion within naturalized *mise-
en-scène*, tableaux or dramatic reconstructions. This is a move
which can be discerned across the full chronological range of
'heritage' representation, from displays of life on the Home Front in
the Second World War to depictions of Roman or Viking society
(part of that 'ancient' heritage whose special, mystical and exotic
allure has provided its own distinctive opportunities for historical
marketing).

In a manner which connects well with Raymond Williams's
comments about the cultural circumstances of a 'dramatised
society',[14] *scenes* rather than *things* are becoming the principal unit
of exhibition by which the past is rendered. Such dramatization is
applied not only to small-scale portrayals of commercial,
occupational, and 'everyday' life but also to the *in situ* display of
large items of machinery and to whole industrial spaces (e.g. engine
sheds, docksides).[15] Although 'frozen interiors' – scenes of work-
place or of home fully re-created in their local detail and peopled by
costumed dummies – remain for practical reasons the most
common form by which the visitor becomes a 'witness' to the past,
there is now a marked shift towards, as it were, 'putting the viewer
in the frame'. This requires a total dramatization of the terms of
display, which may then naturalize the viewer's presence within the
exhibit as the result of some kind of time-travel. The provision of
thematically organized experiences of 'witnessing' or, indeed, of
participation, replace the traditional fetishistic pleasures of the 'old
object' as the primary source of popular delight, and a new kind of
sentimentalism and whimsy is introduced into the visiting and
viewing relationship. The past becomes essentialized around cos-
tumed characters in self-contained and entertaining narrative

episodes. The most common claims made by the newer heritage displays, that they either 'bring the past back to life' or allow visitors to 'step back into' it, are ones which now have to work within a strongly competitive sense of the levels of vivacity and sensation expected by those who pay to enter.[16]

There is a danger here, though, of working with too unified a notion of heritage, and of citing the license and sensationalism of the historical theme-parks (routinely typified as 'Disneyland' in recent critique) as if they were unproblematically representative of all the newer types of historical projection on offer.[17] The often conflicting range of influence and inflections, both 'serious' and 'light', currently at work in the production of heritage representations suggests that a unitary emphasis may take both understanding and criticism wide of the mark, a point we return to below.

Heritage and the politics of pastness

We have noted some of the key themes which have developed and become interrelated in representations of heritage. Whilst indicating the increasing looseness and the sometimes contradictory contents of heritage as a category, we have commented on the degree to which many of these themes cohere within the terms of a dominant cultural formation. Diverse and sometimes highly localized versions of the past are connected back to central ideas about nationality and often serve to mediate that antagonistic interplay between modernization and tradition in the resolution of which the rhetoric of 'enterprise' has also been active. Robert Hewison's and Patrick Wright's studies, though they remain the most sustained and useful accounts of the heritage phenomenon available to date, were written in the context of a marked industrial decline which was seen as the primary determining factor. 'Heritage culture is the ugly product of social failure', claimed a preview of Hewison's book,[18] whilst he himself declared that 'Instead of manufacturing goods, we are manufacturing Heritage.'[19] However, in the context of 1990 (and whilst recognizing the continuing problems of the manufacturing economy) it was the connections between the celebration and marketing of a selective past and a real, if limited, economic and commercial expansion which seemed more apparent.

Wright's suggestion that heritage is not to be regarded simply as politically strategic false-history but as a version of something

rather different – 'the past' – may be a useful one in these changed circumstances:

> This, after all, is the area not just of publicly installed illusion and ideology but also of everyday historical consciousness – of stories, memory and vernacular interpretations which differ (sometimes in fully conscious opposition) from that superior 'History' which, while it has always spoken with easily assumed authority, is distinguished not just by its laurels but also by the difficulty it experiences in achieving its gloriously neutral 'truth'.[20]

Although this way of putting it appears to under-acknowledge the theoretical and methodological distinctiveness of historical *inquiry* as opposed to a more popular *consciousness* of the past, attempts to rework or to replace the presently dominant and successful forms of heritage will have to offer more than alternative, 'real' histories. They will have to speak to that much broader restructuring of identities, desires and social relationships to which we have earlier referred and within whose terms imaginative projections and apprehensions of the past form a powerful authenticating and positioning element.

If the concept of 'heritage' involves the construction and recon-struction of Britain's past, the idea of 'enterprise' promises all of the excitement of contemporaneity, modernity, and a vision of the future. Whether mobilized from the Left or the Right, 'enterprise' is a term signifying action, transformation and change. However, as we examine the emergence of the term as one predominantly organized from the Right, certain patterns emerge. In Britain in the 1980s the term was principally motivated by, and designed to further, the principles of free-market Conservatism. The following sections of this chapter explore both the key characteristics of this concept of enterprise, and some instances of its manifestation in particular institutions and practices.

ENTERPRISE: THE DECONSTRUCTION OF THE WELFARE STATE

The construction of a successful enterprise culture, underwritten by the principles of the capitalist free market, was one of the key political and ideological projects of the Thatcher governments of

the 1980s. Policy initiatives across a variety of fields, from local government and education to industry, the arts, and broadcasting, as well as the launching of a number of vigorous advertising and publicity campaigns, have had the aim of creating and sustaining the values and cultural forms appropriate to the new age of private enterprise. This militantly individualistic culture has been designed to replace the philosophy of collectivism and the practice of public provision, challenging the established consensus of the post-war welfare state, and opposing (in theory at least) almost all forms of public intervention, planning, ownership, or control.

Socialism, with its language of rights, entitlements, redistributionism, and publicly resourced welfare provision, has been regarded as the great enemy of individual responsibility and enterprise. Socialism and social democracy are seen by the New Right as the forces sapping the will and diminishing the vigour of the capitalist enterprise culture. As one Conservative theorist wrote, the 'politics of compassion' had turned the British population into:

> a collection of noisy corporate children crying 'it's not fair' as they all roll up their sleeves, not to do something for themselves but to display their sores and scars.[21]

The lack of sympathy and respect for those with economic or physical problems marks this position as coming from the New Right, though its imagery of the state infantilizing the people shares some elements of the left-wing critique of the paternalism of the welfare state. Margaret Thatcher's own account of the forces threatening enterprise culture, which we referred to briefly in our introductory essay, was equally vivid:

> I used to have a nightmare . . . for the first six years in office that, when I had got the finances right, when I had got the law right, the deregulation etc., that the British sense of enterprise and initiative would have been killed by socialism. . . . My agony was: had it been killed? By prices and income policies, by high taxation, by nationalisation, by central planning?
>
> But then it came. The face began to smile, the spirits began to lift, the pride returned.[22]

In other famous and criticized speeches, Margaret Thatcher had spoken of the welfare state as a smothering mother, overprotective and taking away people's sense of independence and ability to show initiative, and had criticized as 'Moaning Minnies' those who make

extensive and unpatriotic complaints in public, instead of taking action to solve their own problems.

In the New Right vision of enterprise culture, enterprise is the enemy of regulation, red tape and bureaucracy, of stagnation, welfarism, and elitism. There is, it is argued, equality of opportunity if not of outcome on the ladders to success. The enterprising spirit is believed to be at odds with the collectivist philosophy; it is competitive, flexible, innovative, bold, confident and risk-taking. It is a pre-condition, its advocates argue, for the creation of wealth, and its best manifestations are to be found in the qualitative growth of small businesses, and in the wider share-ownership of privatization and 'popular capitalism'. Critics of this vision argue that it favours the aggressive and marginalizes the weak, advances self-interest and selfishness, encourages increased differentials of wealth and poverty and the continuing exploitation of labour, replaces planning with anarchy, ignores the tendency to monopoly and hides the concentrations of power and ownership in capitalist societies.

Like the blue streak in the Department of Trade and Industry television advertisement, which bursts magically through boardrooms and offices, signifying the inspiration of radical right solutions, the spirit of enterprise as represented by its advocates removes all blockages. It is dynamic, problem-solving, forward-looking. And it creates the new conditions of modernity, insisting upon the relevance of practical knowledge (for example, in the school and college curriculum), and on discovering the opportunities for putting ideas into practice. What is interesting about some of these characteristics is that they are not necessarily opposed to collectivist and socialist philosophies. Some of the same arguments, principles, and terms, in particular the emphasis on flexibility, initiative, and innovation, are present in the case for restructuring the socialist economy. This is apparent, for example, in Mikhail Gorbachev's *Perestroika* where arguments are advanced for 'a socialist enterprising spirit' and for 'the highest possible level of initiative and independence at the local level'.[23] Herein lies something of the current complexity of the term 'enterprise' internationally, as it has been mobilized within different and competing political discourses. The British Conservative variant, with its emphasis on removing powers from local *Labour* authorities in particular, does not include in any significant way this devolutionist impulse. The logics and imperative of pro-capitalist enterprise culture unfold largely untouched by principles of democracy and

local accountability. In the four examples which follow, these imperatives are traced, both through the official discourse and practices of state institutions, and as circulated, and sometimes challenged, in the spheres of advertising and of popular fiction.

Enterprise culture: four instances

Government schemes in industry, training and education

One of the most consistent and committed advocates of the enterprise culture, one for many years closely associated with Margaret Thatcher, was Lord Young of Graffham, former Deputy Chairman of the Conservative Party, Chairman of the Manpower Services Commission (MSC), and Cabinet Minister for the Department of Trade and Industry (DTI), subtitled 'The Department for Enterprise'. The militant spirit of enterprise, unlocked through the provision of various material bases, can be traced in its major manifestations across these two key sites.

The MSC has been one of the most significant institutions of the Thatcher years. It has managed and (through the provision of various work-related training schemes) substantially reduced the numbers of people officially registered as unemployed. In addition, it has developed programmes of assistance to small businesses, including the Enterprise Allowance Scheme, which has had a crucial cultural and ideological as well as economic function. In a period when government has been committed to cuts in public spending, the budget of the MSC has increased by around 500 per cent, from something over £0.6 billion in 1979–80 to over £3.1 billion in 1986–7.[24] Within the MSC, expenditure on the Enterprise Allowance Scheme (which was begun in 1983, the year of the first re-election of a Thatcher government) went up from £23.2 million in its first year to £200 million by 1987.[25]

The Enterprise Allowance Scheme (EAS) was established to encourage unemployed people to set up their own small businesses. It had, for its proponents, the double advantage of removing numbers from the unemployment register and advancing both the values of entrepreneurship and self-reliance and the practice of self-employment. There is no doubt that real shifts in employment practices have occurred in the 1980s. And although the rate of business bankruptcies has significantly increased, it is still the case that many people have chosen, or been pressured into, self-

employment. In 1979, 7.7 per cent of the workforce were self-employed, by 1988 this had risen to 12 per cent; a shift occurring at least partly because large companies found it more profitable to subcontract services and activities which previously they would have provided internally.[26] By 1989 the preferred slogan for the EAS was 'Be Your Own Boss', although the risk element in setting up in business was also being referred to by the final 'word of caution' in the publicity material for the scheme. This element of risk, the Stock Market crash of 1987 and the failure-rate figures for the scheme, have cast some doubt on its effectiveness as a means of demonstrating the values of the free market. Figures from one study undertaken for the MSC indicate that 66 per cent of these small companies were still trading eighteen months after starting on the scheme, and that 56 per cent were still in business three years after start-up; these are, respectively, failure rates of 34 per cent and 44 per cent. What these statistics cannot reveal is either the resilient scepticism of those who entered the scheme as a way of escaping the constraints of life on social security, and who never expected to create small businesses or, among the scheme's well-disposed applicants, the unhappiness and devastating loss of confidence caused by unexpected bankruptcy. For the proponents of the scheme, its success is marked not just by the numbers of successful small businesses created, but equally by the contribution it makes to establishing a set of values supportive of private enterprise.

While the clear cultural and ideological aims of such schemes must be noted, it is not at all clear that this considerable expenditure has resulted in the creation of a social climate overwhelmingly favourable to the values of capitalist enterprise. Indeed it could be said that this 'hegemonic bid' to establish generally current social values has been limited and diminished by a certain public scepticism towards anything that is perceived to be government propaganda. This has been especially true of public perceptions of Youth Training Schemes as not offering 'proper jobs'. One of the MSC's own commissioned studies notes in its conclusion that there has been 'a good deal of criticism of MSC literature from all quarters' and that:

> more care should evidently be taken to tailor this literature to the needs of its intended audience and to ensure that it is perceived as honest information without overtones of propaganda.[27]

In the development of schemes and programmes designed to foster

enterprise culture, the economic and ideological aspects are inextricably and necessarily connected. This is particularly apparent from the way in which the principles behind, for example, the EAS have been encouraged to 'migrate' into and to imbue the fields of training and education. So the MSC's 'Enterprise in Higher Education' scheme, which was launched in 1987 in the wake of the third successive Conservative election victory, was intended 'to encourage the development of qualities of enterprise amongst those seeking higher education qualifications'.[28] In the first round of applications for money to implement this scheme a number of higher education institutions helped to 'flesh out', to give more substance to, the concepts and principles suggested by the scheme. One polytechnic argued that:

> enterprising people are recognised by their vision and drive, their creativity and motivation to achieve, in both their personal and professional development,

and went on to outline the aims of the scheme thus:

> Characteristics of enterprise which the Polytechnic seeks to support are the ability to take the initiative, make decisions, manage resources, influence others, and exhibit drive and determination.[29]

One awkward question emerging in response to the establishment of the scheme has been the extent to which it leads educational providers into the controversial territory of personality formation, and the advocacy of views associated with one political party, the party of government. Undoubtedly some of the scheme's defenders will argue that these qualities are not politically partisan and that they can be employed to advance a variety of economic and social principles. All of this finally returns us to the knot of contradictions and conflicts associated with the use of the term 'enterprise' in British culture in the 1980s.

A much larger and generally more pervasive scheme has been the MSC's 'Technical and Vocational Education Initiative' (TVEI) which has grown from twenty-one pilot projects in 1986, to a situation in 1989 when all Local Education Authorities (LEAs) either had pilot projects or were actively extending the scheme. As LEAs budgets have been reducing, the new monies for this project, designed to bring the world of school and the world of work closer together, have been routed into schools, not through the traditional

channels of the LEA and the Department of Education and Science, but through the MSC. The very extensiveness of the scheme has perhaps toned down its more ideologically militant and specific aspects. A 1989 leaflet lists six aims for TVEI including the acquisition of 'skills and qualifications of direct value at work' and the application of 'skills and qualifications to real life problems'. Only the fifth of the listed aims refers to 'an emphasis on initiative, motivation, enterprise and other areas of personal development'.[30] Such a formulation might be allowed to validate the skills of nurturing parents as well as those of thrusting business people, though the rather 'tacked on' feel of the reference to 'personal development' may indicate some concern about the traditional linking of enterprise skills with masculinity, not femininity. A rather more focused aim emerges in the wording of an initiative aimed at the world of business and private enterprise. Thus the DTI's 'Enterprise and Education Initiative' of 1988 offers companies:

> the chance to influence the attitude and outlook of young people before they leave school. . . . The idea is that all children should be offered the opportunity of working in a firm before leaving school. In addition 10% of teachers each year will gain first hand experience of the world of business.[31]

What is proposed here is a large-scale, state-initiated programme of (in effect) social engineering intended to transform social values, labour relations, and, ultimately, economic practices.

Funding local government: the 'poll tax' and enterprise culture

The enterprise ideology variant that involves 'standing on your own two feet', 'looking after yourself and your family' and 'not expecting the state or society to provide for you' strongly informs the thinking behind the 1988 Local Government Finance Act. This is the legislation which replaces the old property-based rates system for raising local government finance with a new Community Charge (referred to as the 'Poll Tax' by its opponents). The Poll Tax is based on the principle that, with a few exceptions for the very poor, all adults living in a city or district pay an equal, fixed sum to cover the costs of locally provided services. The distinctive feature of the new tax is that it is not related to socially situated income and ability to pay, but is a flat-rate charge, fixed at the same level for all

individuals. Thus it departs radically from the modestly redistribu-
tionist principles of the post-war welfare state, which assumed that
the rich as individuals should contribute rather more than the poor,
or those on average or low wages, to the cost of public services. A
possible connection with the ability to vote in local and national
elections has also been noted by critics of the new system. For
although rebates are available for the poor and students, it seems
likely that many young people in particular, seeking to avoid the
charge and wishing to 'disappear', will be reluctant to put them-
selves down on the electoral register in the place where they live,
and will therefore be unable to vote. The old historical principle of
'no taxation without representation' is thus reversed into 'no
representation without taxation'. Advocates of the tax argue a
positive relationship between voting and paying, on the grounds
that all local voters will have an increased and direct interest in
keeping down local public spending, and in voting out 'high
spending' councils; an argument and strategy clearly directed at and
against local Labour councils.

Equality of taxation where there is no equality of income is
viewed by many as a deeply unjust policy. And it is especially
remarkable in a period marked by increasing income differentials:
between 1979 and 1986 the top 10 per cent saw their earnings rise by
22.3 per cent while the bottom 10 per cent saw them rise by 3.7 per
cent.[32] Or, as one commentator writing in 1987 observed:

> The figures for those living at or below the Supplementary
> Benefit level were around 6.1 million in 1979, and are now
> almost 12 million. The size of Britain's 'underclass' has nearly
> doubled, amounting to-day to almost a fifth of the population.[33]

Critics of the Community Charge argue that it will hit hardest the
unemployed, the dependent and the low-waged.

In a radically different vision from that suggested by the ideals of
social security and collective provison, the enterprise culture envis-
ages individuals competing against each other for individual bene-
fits, with the state interfering as little as possible as some win and
some lose. This culture requires that poor and middle-income
groups pay the full cost of the services they need while the rich forge
ahead, increasing personal not social wealth. As Nicholas Ridley,
the minister then responsible for Local Government and for
introducing the new law, put it:

in terms of local authority services, people should be paying for what they get. It has nothing to do with how rich you are. In this country we are too sold on the idea that the rich should be made to pay for other people's services.[34]

A final, pertinent feature of the legislation is that it constructs the local voters and citizens, who benefit from local services, primarily as individual *consumers*. The emphasis is thus on individuals paying for what they individually consume. As one member of Parliament argued in the debate about the new legislation:

If the dustman uses the same services as the millionaire – he probably uses them more – it is fair that both should contribute towards paying for those services.[35]

What this statement avoids saying is that those who earn less will be paying far more, as a proportion of their income. The fundamental issue of taxation as a redistributionist measure, and of whether or not this is a fair and just measure, will inevitably be the subject of much sharper public debate in the 1990s. A key concept of the 1980s has been that the enterprising individual will not require the safety net of public provision, since all services can be acquired in the market, on market terms.

It may be also worth noting, in terms of the tensions within Conservative thinking, that this emphasis on individual responsibility and liability to pay may cut across the more traditional Conservative values of family life. For dependent spouses or partners, and dependent young (and old) adults are all required to pay the 'Poll Tax' *as individuals*. They are no longer covered by the family rates bill, and this could result in pressure on some to move out of the family home.

The arts and broadcasting

Of course, for the advocates of a free-enterprise culture, the freedom of the market is believed to be the foundation stone of all other significant freedoms. So, while the radical free marketeers equate state funding of the arts with state control of ideas, critics of the free market argue that the latter's principal guarantee is of continuing economic, political, and educational inequality and that, conversely, only the public purse can ensure the conditions for freedom and diversity of expression. While British culture in the

1980s has been characterized by the continued rumbling of these disputes, it should be noted that a decade of government advancing the principles of the free market has not yet brought about the abolition of public funding for the arts, or the ending of some measure of public regulation of broadcasting. However, the ways in which things are described, understood and, even more significantly, *assumed*, has changed in some significant respects since the days of cross-party consensus on social and cultural welfare. The proliferation of studies on the *economic* case for the arts would be a case in point.

In the cultural field, policy initiatives from the Right have often been designed to destabilize or erode public provision and to replace it, where possible, with private provision. So, for example, the Arts Council has rather unhappily accepted the 'gearing' of significant amounts of annual grant-aid to the raising of private individual or corporate sponsorship. Organizations on the receiving end of these policy changes have now had some experience on which to base judgements about the relative enabling and censoring functions of the public and private sectors. In general, corporate sponsorship has tended to flow towards high-prestige art forms, and high-profile national art institutions, while more local and 'grassroots' initiatives have found it difficult or impossible to attract sponsors.

As enterprise ideology has sought to secure the definition of freedom as the freedom to buy, to make choices in the market-place, so the traditional conservative view that the arts enshrine non-material and enduring human values has rather gone by the board. A sterner, price mechanism-oriented philosophy has sought to replace it. Thus the then Minister for the Arts, Richard Luce, argued in 1987 that

> if it is any good people will be prepared to pay for it. . . . The only real test of our ability to succeed is whether or not we can attract enough customers.[36]

In the field of broadcasting also, the policy emphasis from government has been on the individual user of the service as a *customer*, a consumer rather than a citizen. This has resulted in strenuous attempts being made to downgrade the public service and public information aspects of broadcasting, and to foreground the way in which a consumer's relationship to a commodity (or service) is established through a price mechanism. Increased choice is offered

not through a system of redistributive taxation deployed to provide an improved public service, but through acts of choice in the market-place, made by those who can afford the price. It is this latter philosophy which explains the enthusiasm in the 1988 White Paper on Broadcasting for the introduction of cable and satellite subscription services, and the proposal that the BBC should move towards subscription and away from its present method of funding: the universal licence fee. Pay-per-view is another and more obvious example of the attempt to establish price mechanisms in broadcasting, analogous to the introduction of meters in charging for water consumption. The introduction of price mechanisms is regarded as necessary by free-market philosophers, because it is the choices made by 'sovereign consumers' in the market-place (choosing between differently priced goods) that provides the regulatory dynamic for the whole capitalist system. Without such price mechanisms, it is argued that the free market cannot work, and there is no incentive to produce goods in cheap and efficient ways. Conservative government policy on broadcasting has been torn between continuing to express some support for the internationally prestigious British public-service broadcasting system, rooted in principles of the 'public good' and of public regulation, and the desire to establish a new, open and 'free' audio-visual market, where enterprising individuals and companies deliver products to consumers at competitive prices. The difficulty here, for government, concerns the degree of openness with which it is possible to state that public provision must first be dismantled for free-market provision to flourish. What we have argued to be the positive values and the significant social and cultural advances brought about through the post-war consensus on social regulation and high quality public provision, may prove especially resistant to challenge and eradication in the sphere of broadcasting.

Images, advertising and story-telling

The three instances or manifestations of enterprise ideology explored above, all deal with the discourses produced and circulated as a consequence of direct government intervention. They exemplify the ideas and values informing the new routine practices of various institutions. This fourth cluster of examples is designed to explore, briefly, some of the ways in which enterprise

culture is produced, reflected, and sometimes criticized in visual and imaginative texts.

Striking, though of uncertain effect, within this realm is the iconography produced in television and print advertising. One of the most interesting issues raised by the advertising campaigns developed for the MSC, and for its successor body the Training Agency, involves the question 'to whom are these advertisements addressed?' Advertisements in the campaign to recruit young people to the Youth Training Scheme (YTS) are fairly clearly addressed to the young people concerned. These commercials typically involve young people, male and female, black and white, directly addressing the camera about the good experiences that they have had on the YTS. But the 1986–7 'Action for Jobs' campaign which was *ostensibly* addressed to the unemployed with the slogan 'helping you to help yourself', has subsequently been criticized on the grounds that it was in fact primarily directed at employed and well-off 'opinion formers', and designed to persuade them that the government was solving the problem of unemployment. The TV commercial shows a person on a collapsing staircase, needing to (and about to) benefit from one of the government's training schemes. The campaign cost around £9 million to run, and took place in the run-up to the 1987 General Election. Its critics have argued, on the basis of a study of the placement of the commercials within typical high-income viewing rather than typical low-income viewing slots, that the true purpose of the campaign was party political propaganda, not information for the unemployed. The same critics also pointed out the very large rises in government spending on publicity, an increase from £35 million to £150 million in the decade between 1979 and 1989.[37] Certainly the MSC's own *Annual Report* for 1986–7 indicates that publicity campaigns 'accounted for about 1% of its total programme expenditure',[38] or just over £27 million in that year.

Advertisements and promotional literature addressed at employers, rather than at unemployed, have (understandably) a very different tone from the YTS advertisements mentioned above. The new Employment Training (ET) scheme of 1988–9 ran the 'Square Peg' television commercial, which shows a great, oblong block of granite which is pushed, pulled and worked on by teams of ant-like people and high-technology equipment, until (finally reshaped) it fits into a round hole in the ground. The accompanying slogan: 'Train the Workers without Jobs to do the Jobs without

Workers' is clearly addressed at employers. But its appearance on television, with millions of viewers, may have had unintended adverse consequences in its representation of the workforce as a block of inert, unfeeling and stubborn physical matter. Other promotional print materials in the campaign, showing only half-humanoid figures struggling to chisel themselves out of blocks of granite in an eerie and empty desert plain, may also have unhappy and discomforting connotations for both employed and unemployed people.

The political dimension of promotional imagery perhaps emerges most clearly in some of the literature and commercials produced by the DTI. It is, of course, no accident that the blue streak of enterprise in the TV commercial and on the cover of DTI pamphlets asserts the true blue colour of the Conservative Party. And a vivid image produced for the DTI's publication *Single Market News*, illustrating an article entitled 'Removing red tape', shows both Britain and the continent of Europe uncomfortably bound up in (socialist) red tape, but also being happily released from these bonds by little men and women vigorously snipping away with their scissors.[39]

Finally, in the realm of narrative, in novels, television drama and documentary, the values of the enterprise culture have been reflected and explored. Examples here would include the network drama series produced by Euston Films for Thames Television, *Capital City* (1989), which draws on the lives, loves and conflicts of the young and rich, working in the heady and dynamic world of the financial institutions in the City of London. And, with a deeply contrasting tone and approach, there was the elegiac documentary, *Living on the Edge* (Michael Grigsby, 1987), screened as part of ITV's 'Viewpoint '87' series. This film is structured around a series of interviews with individuals and families, ranging in tone from quiet desperation to militant anger. It attempts through a montage of archive images and sounds an ambitious and reflective overview of the historical 'structures of feeling' of post-war Britain. Here, Grigsby explores the other side of enterprise – lives lived in the shadow; subordinated and bereft in the wake of the onward march of free enterprise economics.

Two novels which try in rather different ways imaginatively to re-create the lived experience of enterprise culture are David Lodge's *Nice Work* (1988) and Zoe Fairbairns's *Closing* (1987).[40] Lodge's novel, in bringing together the lives of a male industrialist and a

female university lecturer, sent to 'shadow' him as part of her university's 'Industry Year' activities, offers a kind of updating of Mrs Gaskell's novel *North and South* (1855). In Lodge's novel different sets of values clash and interact as the relationship between the two protagonists unfolds. And a nice, though ultimately evasive, sense of irony underpins the sketch of the awkward encounter between ivory tower academicism and the practical imperatives of manufacturing.[41] But the 1988 'happy ending' sees the woman more firmly wedded to her work, while the man is more firmly wedded to his wife as well as having more fulfilling work to look forward to. The man's improved marriage is a consequence of the shock of unemployment, but the real 'happiness' comes as the woman lecturer hands over to him an unexpected legacy which will allow him to set up his own small business in the area of high technology invention. The 'dream' or resolution of this ending seems to involve the unlikely re-creation in the late twentieth century of the conditions for the first industrial revolution.

Entrepreneurial activity, in its positive and negative aspects, is explored rather more sharply in *Closing*. The four women who are at its centre make very different moves down the pathways of enterprise culture. The novel ends, bleakly, with the most free-market oriented of the women leaving Britain to sell unsafe milk to African mothers and their children on behalf of an American corporation.[42] By contrast, the conclusion of *Nice Work*, though self-consciously utopian, seems to offer a rather too comfortable 'Little Englandism', within whose terms we could all live together, happily and inventively, on this island of ours. There is little questioning here of who wins or of who loses in the game of enterprise.

ENTERPRISE AND HERITAGE: DIRECTION, MANAGING AND REPRESENTING CHANGE

The post-war consensus concerning the principles and institutions of the welfare state developed as a response to the economic crisis, and the experience of mass unemployment and bitter poverty, of the 1930s. This consensus was effectively and radically challenged by the three successive Conservative Governments of the 1980s – although it had become apparent by the end of the decade that some of the key propositions of that consensus, for example the

need for a well-resourced National Health Service, remained popular and intact. The Conservative Manifesto of 1987 argued the value of 'wider ownership and greater opportunity' in this way:

> There has been a surge of home-ownership, share-ownership, and self-reliance. . . . State power is checked and opportunities are spread throughout society. Ownership and independence cease to be the privileges of a few and become the birthright of all.
>
> In this way One Nation is finally reached – not by a single people being conscripted into an organised socialist programme but by millions of people building their own lives in their own way.[43]

Such a hegemonic bid, a claim to be representing the interests of the nation as a whole, was a characteristic feature of populist Thatcherism. And while political manifestoes inevitably express a series of rhetorical moves, it is important not to underestimate the real changes that took place in British society and culture in the course of the decade: by 1987 almost two-thirds of households were owner-occupied, and individual share-ownership had increased from 7 per cent of the population in 1979 to nearly 20 per cent in 1989. There are, however, a number of outstanding problems confronting such a bid. The first concerns the extent to which wider share-ownership can be taken to represent an understanding of, and assent to, economic *principles*, as well as the rather misleading way in which such percentage figures hide the continuing and massive concentrations of share-ownership in relatively few hands. The second concerns the persistent and growing numbers of the 'have-nots' – the presence of beggars on the streets, young and old people homeless and 'sleeping rough'. Such a growth is documented by the increasing quantity of statistics on poverty, deprivation, and deteriorating public services and it is a key factor behind the widespread perception of Britain as an unacceptably divided nation.

As our discussion above has shown, if the spirit of enterprise offers itself as the motor of change, innovation, and development, the spirit of heritage offers the reassurance of continuity with a shared past. However, the very popularizing of this past as an element within a growing and almost always commodified leisure culture, has necessitated its representation in more lively and engaging relationships with popular pleasures, aspirations and interests in

the present. Thus, the ideas, experience, and desires of thousands of day-trippers can be seen, in practice, to have eroded (though by no means entirely discredited) the traditional-deferential versions of the past which so dominated history teaching and museum culture. While much popular story-telling about the past is sustained on the basis of fascination with the deeds of the powerful and the extravagant and sensuous pleasures of the rich, the introduction of 'downstairs', 'kitchen' and industrial history potentially raises some awkward questions about the social distribution of pleasure and satisfaction. And if these questions begin to connect with issues of differential power and privilege in the present, and outside the turnstiles of the historical-leisure sites, a more democratic history may gradually and indirectly be in the making. Moreover, a greatly increased 'reading' and 'consuming' of the past takes place in the context of the growing aspirations of women for equality, a place, and a voice, and an increasing tendency on the part of women, and some men, to notice and challenge the subordination of women in whatever arena this occurs. In parallel to this social and cultural change is the emergence in public and political discourse of the confident and critical voices of second generation members of British Afro-Caribbean and Asian communities. This new black generation has challenged the racist dimension of the language of heritage, and the many complacencies of predominantly white histories, making it increasingly difficult to hide the history of slavery and of international pillage behind a celebration of European civilization and British empire.

To the constant re-presentations and re-framings of the British past within the sphere of largely commodified leisure culture must be added other public discourses of history (for example, on television, in the richly researched and thoughtful Channel 4 series on the histories of Wales, of Vietnam and of contemporary Greece), as well as changes in the teaching of history in schools, involving a more critical account of Empire and a more internationalist and multicultural perspective on Britain's past. Since there is as yet little research on visitor interpretations and assessments at British heritage sites however, it is difficult to trace and substantiate the interconnections made between the discourses of school and television, guidebook and spectacle as they inform specific readings.

The contribution that a commodified heritage culture had made to the Thatcherite programme is, to a considerable extent, an economic one. But its ideological contribution is troubling and

contradictory for the radical Right. For the patrician values of 'one nation' Toryism, and its emphasis on rural order, stability and continuity, co-exist uneasily with the more militant nineteenth-century values of entrepreneurial endeavour and its associated images of industrial transformation and of a degraded urban environment.

The values of enterprise too, which partly involve a struggle over the meaning and significance of the Victorian and industrial past, are contradictory. In their anti-egalitarian and anti-welfarist variants the emphasis is upon individual success and the personal and private accumulation of wealth. The inevitable concomitant of this, its critics argue, is public squalor and high levels of poverty and deprivation.[44] But the 'other side' of enterprise, its emphasis on innovation, efficiency and the effective use of human and natural resources, is entirely compatible with social democratic, socialist and welfarist goals and priorities. In Britain in the 1980s, the term has principally and officially been mobilized in defence of free-market values. But capitalism has undergone many changes since its Victorian variants. For some thirty years it has incorporated, if only in part, the settlement of 1945, with its vision of social justice, social security and full employment. The subsequent restructuring of the capitalist economy, world-wide and in Britain, has challenged this settlement. As we approach the end of the century, in this still young era of universal suffrage, the same great question forces itself upon capitalists and socialists, east and west, north and south. What practical measures must be adopted to ensure plane-tary survival *and* a decent standard of living for all? And what are the precise kinds of markets and public policies able to produce and implement these measures? In global terms, we are not so far from the question which Chateaubriand asked of Europe in 1834:

A society in which individuals may possess incomes of two millions while others are reduced to living in hovels on heaps of decayed matter alive with worms . . . can such a society remain stationary on such foundations in the midst of the advance of ideas?[45]

The 'balance sheets' of enterprise and heritage are complex; our accounts can only be provisional. But from our critical analysis of their development as two nodal points of dominant culture in eighties Britain, we find enough in each, despite present inflections,

to sustain resistance to exclusively free-market solutions and to connect with alternative visions of society: more equal, more generous and more humane.

Chapter 3

Where horses shit a hundred sparrows feed: Docklands and East London during the Thatcher years

Bill Schwarz

Historically the division of the metropolis between east and west has always been imbued with the greatest symbolic significance. A hundred years ago it was usual to find East London represented as the racial other, a place of darkness and barbarism. Its unknowability, in common with the oriental East, was projected through a highly fantasized and eroticized system of images. The degenerate inhabitants of the East, it seemed, were themselves carriers of contagion – disease, anarchy, wantonness – and always on the point of engulfing the civilization of the West. The most dramatic instance when something like this did occur was in February 1886 when rioting East Enders – with a happy appreciation of where the institutions of civilization were indeed located – merrily stoned the Carlton Club, smashing every one of its windows, and for good measure looted shops in Piccadilly, singing all the while snatches from 'Rule Britannia'. In the aftermath of this crisis, the traffic in missionaries and explorers from West to East increased precipitously, while in popular fiction the special aptitudes of the sleuth were now required to decode the new and illegible urban environment. High-minded young Anglican men from Balliol chose to live in settlements in the East End (the image of the frontier never far away), while later one Clement Attlee opened a boys' club to teach the dispossessed to straighten their backs, to breathe through their noses and to keep their hands out of their pockets – and in this way was born his vision of socialism. Gradually, through patient expertise, the East came to be known. It was found not to contain, after all, an undifferentiated mass of the dissolute. Vice was specific, and so, on the terrain of the East End itself, were invented the categories of the hooligan, the incorrigible loafer, the destitute alien and so on. Special agencies sprang up to deal with each of

these in turn. In this way, dependent on more complex systems of power than hitherto, came light and democracy to the East, just as it did to more distant lands. The higgledy-piggledy frontier dividing East from West – in some places a mere few yards separating the imposing counting houses of the City from the tenements of the slums – could thus be relaxed, allowing a greater measure of human transaction in both directions.

The fear now, of course, is precisely reversed. People who consciously possess an unassailable identity as East Enders are fearful that their civilization is being overrun by the new hooligans of the eighties – lager louts and yuppies – spilling over from their traditional habitats of the City and the West. East Enders, who have spent a lifetime confronting, bribing, outwitting, circumventing or simply ignoring the various local agencies of the state, now believe they face an unprecedented catastrophe. The physical environment of the old communities, which gave material form to the lived cultures of East London, have been razed to the ground. Colossal movements of capital have created, as if from nothing, what is in effect a vast bright new city which can only appear alien to those who had formerly lived in what were once the dark corners of the metropolis.

This reversal, then, of perceptions – who is invading whom – is not entirely symmetrical for, as we would expect, the disposition of power was, and is, considerably more concentrated in the West. But nor is the situation today entirely new. A constant dynamic reproduced for at least the past century in the culture of East London has been the perception that the old ways are in decay, on the cusp of total elimination. These perceptions have been accurate enough, for land speculation, immigration, too much or too little capital and war have all been decisive in destabilizing and re-forming local cultural relations. Political intervention, too, has been critical, each phase of state development producing the impetus for politicians to attempt yet another mission to civilize the population of East London. At the turn of the century Beveridge, Attlee and the rest learned all they knew in what they saw as the social laboratory of the East End. With the accumulation of human misery so intense and the circulation of capital and labour in the free market so palpably blocked, a new collectivism was devised in order to give the hidden hand a jolt. The young idealists dreamt that one day the East End would be in the van of a new collectivist civilization. This of course was not to be. In the desolation of East

London the collectivist dream transmogrified into a new parasitism, held in place by the dead hand of Tammany politics. Then, in turn, Mrs Thatcher's bright-eyed underlings saw their opportunity. Bulldoze away the collectivist past and create in microcosm the Thatcherite future. 'Perhaps one day', claims one such breathless enthusiast, 'Heron Quay, Mudchute and Canary Wharf will be names as well known worldwide as Trafalgar Square, Marble Arch and Charing Cross.' [1] What a vindication for Mrs Thatcher this would be if prosperity and a half-decent environment could lift East London out of its seemingly perpetual cycle of impoverishment! This time round, though, high-mindedness and philanthropy have been jettisoned and the free market reinvented.

But it is clear that much of this – its visionary quality most obviously – trades on images as much as it does on more tangible commodities. In this, as well, the Thatcherites have the greater resources of power. By and large they have endeavoured to construct not only an entire new Docklands development, but to deploy a very particular idea of what, now, the East End is. Much of this, again as we might expect, is pretty spurious, while some is simply mendacious. On the other hand, contending images of the East End, drawing from a long repertoire of oral tradition, custom and knowable communities are certainly mythic, in the way that many oppressed cultures forge epic and imagined histories out of the grind of their subordination. Contrary to what we have come to expect from government press offices, however, these images are neither spurious nor are they calculated lies, though often they are embellished and interwoven with an agreeable element of fantasy: in effect, they dramatize a real process of dispossession. Yet these symbolic forms are decisive in themselves, whether it be the vision of a glamorized Thatcherite future or ideas of the traditional community, for they actively constitute the current terrain of the politics of the East End.

The twin themes of enterprise and heritage play across these contending images in complex ways. The Thatcherites, obviously, are determined entrepreneurs, yet they also invest heavily in the idea of heritage. The East End, on the other hand, while spawning a range of defensive organizations which aim to contain the current incursion from outside, at the same time is renowned for having created some imaginative versions of the free market and small business.[2] In fact enterprise and heritage are combined, in different forms, in both the Thatcherite model of the East

End and in its more traditional variants.

This points to the difficulty in thinking in binary terms – the essentialism of East or West – for these divisions are continually cross-cut, by race and class, gender and generation, producing a fair measure of yuppie East Enders who couldn't give a toss if the community of their grandparents goes down the tube, and a number of outsiders drawn to East London to preserve an older way of life they can only have known in their imaginations. Thus it might be worth deconstructing somewhat the central category and identifying some dominating geographies of the East End, some more exclusively products of the imagination than others.

The first – which cannot be discounted – is entirely fictional, but at its peak in the mid-1980s it touched the imaginations of very nearly half the national population. We're talking, predictably, about Albert Square and *EastEnders*. It's instructive that the primary creators of the programme, Julia Smith and Tony Holland, were in the first instance reacting against the neo-privatized, Wimpey ethos of *Brookside*: they were in search of 'history' and 'culture'. Brookside, complained Holland, 'has no history. . . . You need a society that has a background, a history, a culture.' Well, if the problem can be posed like *that* the neatest of tautologies is constructed at once. There can (I'll exaggerate a touch) be only one answer: the East End, accommodating the wishes of TV producers as effortlessly as Pickwick coaching inns and Elizabethan banqueting halls enthral wide-eyed visitors from North America or Japan. Overcoming his professional resistance to setting a soap in the south ('a kind of mega banana skin') a senior BBC manager sanctioned the programme on account of his discovery that the East End would provide 'roots . . . identity . . . an attractive folklore and a sense of history'. Smith and Holland, like old-fashioned social investigators, were duly dispatched to the unknown vicinities of 'Dalston and Hackney' (a strange confusion of terms this, as Dalston is in Hackney and neither is in the East End) in order to study the indigenous population; Julia Smith thereafter jetted to Lanzarote in order to invent the programme's characters. I must admit I like this idea of the personalities of Albert Square coming to life off the coast of West Africa. This predilection notwithstanding, it all smacks of a rather heavy-handed process of mediation, in which the construction of historical identity acquires an external, autonomous dynamic of its own. The structure of feeling which lies behind this is difficult to fathom. But just as in 1960 *Coronation*

Street brought to a national public the culture of a particular working-class formation – two-up-two-downs, football and the dogs, the corner pub and so on – at the very moment when it had all but disappeared as a dominant form, so perhaps in the 1980s the media construction of *EastEnders* cultivates a curiously anachronistic idea of a collective identity, in which Albert Square casts a magical spell of cohesion on all its otherwise diverse inhabitants.[3]

Even so *EastEnders* attempts to purvey its own version of traditional East End identity and combine it with a dramatization of the various forces threatening upheaval. In this lies one axis of its appeal. Its impact is difficult to assess, and no hard-boiled recourse to simple mimesis – reality on the one side, its representations on the other – can help much, for both the TV programme and the lived community culture depend upon an imaginative or fictive component, and each informs the other. However the programme has been significant in bringing public light to bear on the East End at a time when traditional boundaries dividing the metropolis between East and West are being radically redrawn. Moreover, in becoming the object of heightened media attention, a new phase in the cultural construction of East London has begun. By the thirties or forties the contagious subject of the late nineteenth century had ceased to be dominant, giving way to a less immediately threatening, comic figure. With *EastEnders* and its like it is as if the inhabitants of East London have at least been recognized as citizens of the broader national cultural community. Here the mass media mimics the protracted development of mass universal politics in Britain: first the Archers and Dales in the counties, then the petty bourgeois and respectable working Mancunians of Coronation Street, belatedly followed by the more hapless, transient figures of the East End. In achieving this curious accolade of cultural enfranchisement East London now hovers on the lip of incarnation as *modern*.

The notion of a modern East End sounds like an oxymoron. Furthermore, we can easily appreciate that the term modernity is ideologically loaded, serving all kinds of purposes. Once the preserve of State Department ideologues, philanthropically lending a hand to those backward nations not yet blessed with the level of civilization upheld by the USA, and now present within a particular strand of British Conservatism, it also currently functions as a favoured term within critical cultural theory. Yet we cannot hope to understand the process which it aspires to describe unless we take

full notice of the dynamic of combined and uneven development which guides it. Just as an uneven cultural process organized the trajectory of regional representation in the staples of the radio and TV soaps, so uneven development is what is at issue in the East End of the 1980s and 1990s. And recourse to the classic formulation of combined and uneven development, descriptive though it is, reminds us that the advance of one sector reproduces backwardness in another.

At this point we have to move from the wholly imaginary world of *EastEnders* to a more prosaic and bureaucratic reality: those areas within the boroughs of Tower Hamlets and Newham which have been untouched (or more accurately, apparently untouched) by the frenzied transformation of Docklands itself. *This* sector within East London has no unity, imagined or otherwise, except in one respect: as the adjacent riverside areas undergo a new and enchanted existence, so those districts which haven't received commensurate bounty sink ever deeper into a cycle of decline. As extraordinary new buildings sweep the skyline by the river, creating a fairy-tale city as if from nothing more than air, a few blocks away cardboard shanty dwellings rise as testament to an unseen misery. I shall return to this later.

Another contemporary East End of some current cultural and political significance doesn't actually exist in geographical East London at all, but thrives in the reaches of Essex; yet in terms of what we might call the Thatcherization of the East End its import is central. I'm thinking of those white, upwardly mobile working-class emigrants originally from the inner East End who – in reaction to immigration from the Indian sub-continent – are now concentrated in the redoubts of Thurrock, Basildon and Billericay. Political expression of this displaced *émigré* culture can be found in the extreme Tory Right: Harvey Proctor, Tim Janman and Teresa Gorman, all at one time local MPs. The syntax of this community is still in structure and consciousness recognizably of the East End. But in this case, as in the racism manifest in the streets of geographical East London, we witness a popular tradition impossibly turned in on itself, harbouring a fantasized nostalgia for times past, for the pure community and dreams for a resurgent white vigilantism for the future. Those who despair at the destruction of the old community – on the Isle of Dogs, for example, the scene of the most spectacular transformations – should recall that in the local elections of May 1978 16 per cent of the residents supported

the National Front, one of the party's highest concentrations of votes in the entire East End. A decade earlier we can suppose that some of these same people, including erstwhile Labour voters, would have been counted in the ranks of those dockers and Smithfield meat-workers who marched to Westminster in support of Powell, participating in that other '68. In the eighties the electoral presence of the far Right has diminished, though not racist violence. The white *émigrés* on the Essex borders provide one powerful version of a Thatcherite East End: they are not the glitzy rich of the riverside, but Thatcherites of a different hue, closer to the populist sentiments of Grantham than to the hedonism of the new young things.

And there is Docklands itself – oasis in the urban desert of East London, or mirage?

The reification of the current designation – Docklands – is in its way perfect, for it mystifies the history of the riverside in East London by eliminating reference to one of its central constituents, the human labour of the dockers. The *place* – archetypal, rooted in the first Elizabethan age, boasting the oldest pubs in the land, etc. – predominates over the human, transmuting in the process to heritage. One of the more notable victories for the Thatcherites in the eighties lay not only in the final liquidation, as a historic force, of those unions based on the old staple industries of the first industrial revolution but also in effectively expunging even their memory from public comment. After their respective campaigns of the early- and mid-eighties, the steelworkers and miners disappeared from the headlines. In 1989, a fortnight before the carnival celebrating the centenary of the Great Docks Strike, the dockers caved in. Defeat brought the end of that cornerstone of historic labourism, the National Dock Labour Scheme, in place since 1947. The closures, from the East India Dock in 1967 to the Royal Docks in 1981, had prefigured the diminishing significance of the London dockers. The process has been protracted. The strikes of 1972 and 1975 were successful, the former memorably so. But for the dockers and their families a key moment in the realization of what was upon them occurred early in 1970 when, re-staging in spirited vernacular the Ealing epic *Passport to Pimlico*, the islanders on the Isle of Dogs declared UDI, announcing that from midnight, 8 March a citizens' council would take charge of the island's affairs.[4] Perhaps this was quixotic, but it marked the end of an era: no docks, no dockers – merely docklands (not yet upper

case). In the pit villages ageing silicotic miners have none but their own to haunt. In East London broken-backed dockers of a certain age possess that distinctive hunch which, when they walk, makes them roll from side to side, like the ships they once serviced; these days they can be observed sitting in fold-up chairs on little squares of grass, gently nodding to the rhythmic thud of pile-drivers. Unless they can dance a jig or produce a quick line in the muvver tongue they are *not* Heritage.

From the West, though, a different view presented itself. As the cranes rusted and decay set in, the problem came to be seen as one of environment, or in more profane but accurate terms, property. The process was gradual, successive Environment ministers trying their hands. Peter Walker and Geoffrey Rippon, in turn, initiated the process during the Heath years. The opening of the Tower Hotel in September 1973 (complete with the Band of the Grenadier Guards) provided an inkling of future prospects – as did, around this time, the conflagration of an adjacent warehouse belonging to Slater-Walker, a company not too distant from the interests of one Peter Walker.[5] However, the great push awaited the beginning of the Thatcher period and the appointment of Michael Heseltine as minister. High on his success in selling off council houses Heseltine turned his attention to the docklands of East London, and to what had been, in the words of *The Times*, 'a major eyesore and headache' for successive governments.[6] 'The area displays more acutely and extensively than any other area in England', declared Heseltine, 'the physical decline of the inner city. It represents a major opportunity for the development that London needs over the last twenty years of the twentieth century.'[7]

Five years later, Heseltine having departed in somewhat unorthodox manner and a more gristle-brained Thatcherite having won the Environment portfolio in the person of Nicholas Ridley, joyous Tories could be told:

> Take a trip around London Docklands and see what has happened. In five years it has been transformed from a desert of dereliction to a showpiece of British building, design, architecture and business. It has created thousands of jobs by stimulating private enterprise. Homes have been built and refurbished. I cannot tolerate similar dereliction elsewhere.[8]

After time immemorial, light and civilization, of distinctly Tory hue, penetrates the East End.

The means by which this was achieved, accepting at face value for the moment the minister's hyperbole, was the LDDC – the London Docklands Development Corporation, set up by Heseltine in 1981. This is not essentially a Thatcherite institution, in the sense of Thatcherism redeeming the ideals of Smith and Ricardo; it bears much more the stamp of derring-do interventionism, reflecting Heseltine's hankering for active state leadership in the economic sphere. The idea was simple. A state-appointed quango would usurp the powers held by local government and in the process (to adopt Tory backbench parlance) knock the shit out of the local councils. Politics of the *diktat* would ensure that all the messy, complicated requirements of the town hall would simply be by-passed. Clearing away the rubble of bureaucracy and pumping in sufficient cash to underwrite, in part at least, any new business venture would together construct a favourable little niche in the market. For Docklands this meant destroying the initiatives which had already been set in motion, since 1976, by the three local Labour boroughs: Tower Hamlets, Newham and Southwark. The LDDC was invested with an extraordinary degree of planning authority; it could, entirely free from negotiation, appropriate at will any publicly owned land which fell within its bailiwick (which in fact amounted to 80 per cent of the total Docklands area); and then, having gained this land, sell it off to private developers. In this way the LDDC won control of some 5,000 acres and 55 miles of waterfront property – or as an LDDC 'Design Guide' hyped this particular feature, 'the exposed imminence of wet water – the edge situation'.[9] Private enterprise could thus purchase for development what had previously been public properties, at knockdown prices, with a moratorium on rates and with the offer too of heady tax concessions. Not surprisingly a stupendous inflation in land prices resulted, rocketing from £70,000 an acre when the LDDC was set up in 1981 to some £4 million six years later. As in all such speculative ventures, once the pump was primed investors came to be mesmerized by their own prognostications; the extraordinary escalation in prices gazumped all relation to use-value, the very outrageousness of the costs determining the desirability of the commodity.

If we discount for a second this small matter of use-value, the effects were immediate and staggering. The docks themselves – long before the appearance of the LDDC – do constitute a dramatic spectacle: their scale alone is breathtaking, exemplifying the tech-

nological achievements of what was barely an industrialized econ-
omy. When combined today with vast tranches of speculative
capital and the desire by developers to compete in prestige con-
structions, the result has been extraordinary. Week by week the
landscape has been transformed, from Tower Bridge to the Isle of
Dogs and beyond, inducing in some of us who have witnessed it a
queasy vertiginous admiration for the technologies of capitalist
modernity which, even in simple physical terms, have been able to
turn huge expanses of mud and concrete waste into a chaotic high-
rise skyline of shimmering glass and steel. Moreover the building of
the government-funded railway, constructed way above ground
level like the metropolitan railways of the late nineteenth-century
city, transporting its passengers as if it were some urbane high-tech
roller-coaster, has conspicuously added to the dramatic excitement
of this modernizing impulse.[10]

All the same the motive force behind this transformation has
been clear enough, comprising both the geographical expansion of
the City, bursting out from its traditional square mile, and more
importantly, its recent economic take-off. The East End has always
been an imperial, or international, enclave: historically as entrepôt,
linking the Atlantic economies to the Indian sub-continent (a
connection which only became *visible* in the 1950s and 1960s when
Indians and West Indians came to live in the streets of East
London, many of which bear the names of the ports and cities of
their homelands), and now in the late twentieth century, as the site
of North American and Japanese *zaitech*. *Zaitech*, simply, com-
prises the strategy of using financial technologies to shift cash-flow
from production to speculation, particularly in the field of office
construction. Two decades of expensive money have resulted in a
huge increase in financial services. The decline of the old mass-
consumption and high-wage industrial economy has been accompa-
nied by the globalization of finance and the notable rise of luxury
consumption. Overaccumulation in banking and real-estate capital
requires a greater concentration of mental workers and low-paid
service industries. On the one hand the opening up of the City after
the Big Bang effectively allowed the London financial houses to
function as a collective sub-branch for New York and Tokyo in the
late capitalist system of 24-hour global banking. On the other hand,
riverside East London provided both a convenient annexe for the
overcrowded square mile, and an equally convenient outlet for
foreign capital eager to invest in the one bit of Thatcherite Britain

which appears, by its own logic, to be working.

Government incentives, the emergence of an overall urban infrastructure, and the lead provided by the financial institutions were sufficient to launch the first stage of Docklands.[11] Its consolidation required the attraction of residents. The LDDC encouraged the building of houses and apartments, again partitioning the land among – for the most part – private developers. The developers were only too keen to join the boom, eager for quick profits accruing from a new class of purchaser. Until 1981 virtually all the housing in the dock areas belonged to the local authorities; in Tower Hamlets 90 per cent of *all* housing was public. Politicians and the leaders of the LDDC promised from the very outset that a measure of public housing would be maintained; that a high proportion of houses would be available for rent; and that a number of those sold would be priced at less than £40,000 and thus categorized by the LDDC as affordable for local residents.[12] In the event few of these aspirations were realized. Between 86 and 90 per cent of residential property in Docklands was sold in the open market, directly overseen by the LDDC; in the first instance the houses could not be sold quickly enough, prompting even Heseltine to note the presence of a 'short-term goldrush'.[13]

Despite the *dirigiste* temper of the LDDC in its earliest incarnation, on one matter it adopted a policy of total *laissez-faire*: the design and aesthetics of all buildings were left solely in the hands of the individual architects.[14] This was an architect's dream: plentiful cash and precious few restrictions. Indeed by all accounts it appears as if the LDDC was rather bemused by recent architectural developments – 'I have some difficulty with postmodernism', admitted the LDDC's first chief executive – content only for buildings to look prestigious.[15] As it turned out, most architects chose to shun the neo-classicism of Quinlan Terry, exemplified by that other notable Thames development, Richmond Riverside, and have gone for a more playful, vernacular style where more is, well, more.[16] Some of the individual buildings are monstrous; the whole is chaotic, severely circumscribing the opportunities for thinking imaginatively about public space; and while the corporate offices gleam and glitter, as one might suppose would occur in any goldrush, the private residences, on close inspection, though seemingly stylish, have been constructed on the cheap, such that many already have the distinct look of shabby jerry-buildings.

The *mélange* of architectural style, the roller-coaster railway and

the provision of wet water now give the Isle of Dogs, in particular, the feel of a theme park – in the same way that whole cities (York is a good example) have been reconstructed as open museums, the tourist and the shopper becoming one. This recomposition and expansion of tourism also reflects the shift away from manufacture to service industries, in which heritage plays a central role.[17] An important local impetus behind this development in Docklands has been the destruction of the miles of walls which traditionally enclosed every dock: wives and daughters of dockers might have gone their whole lives never actually *seeing* the docks. The LDDC has also encouraged a number of heritage initiatives, happy to promote a version of East London in which the ideological relations projecting a high-tech future *produce* the commodified retro-chic of roots and folklore which proves so appealing to BBC managers. This Disneyworld dimension, with tourists schlepping around Millwall, represents a dramatic shift – but not, I believe, a reversal – in the historic relations dividing East from West. A shift from philanthropy to spectacle does little to ensure that the populations of East London gain a jot more agency in determining their own destinies.

Yet the developments which have appeared so far are all rather lack-lustre compared to the future Canary Wharf project, which promises to be the most expensive, the most colossal and the most glitzy of all. The gamble could not be bigger. The corporate power behind the project is the vast Toronto conglomerate, Olympia & York. The company first made its mark in 1977 by buying eight Manhattan office blocks for some $320 million at a time when New York's financial crisis was at its height and the city's future looked bleak. A decade later the value of these properties had risen to an astonishing $3 billion and Olympia & York were established as New York's largest commercial landlord. Its empire included the World Financial Center – providing offices for Merrill Lynch, American Express and Dow Jones – and the beginnings of an even bigger venture, gobbling up the old rail yards on the western side of Manhattan. The figure who headed the New York operation, Michael Dennis (an erstwhile Toronto city housing commissioner who defected to O & Y), is succinct about the company's objectives: 'We manufacture office space and provide it to a rapidly growing market, the financial services business.'[18] In the summer of 1987, O & Y repeated the tactic in Britain, staging an eleventh-hour buyout of the ailing £3 billion Canary Wharf project in Docklands. After

his success in Manhattan, Dennis came to Britain to oversee the new investment, declaring: 'I would be very surprised if we stop at Canary Wharf.' The construction, now under way, covers 71 acres, will provide 12 million square feet of office space accommodating some 60,000 employees, and is estimated to cost some $7 billion. It will boast the tallest buildings, the most spacious piazzas and the greatest variety of shopping malls. There has hardly been a planner in sight who has a good word for it, overawed by its unashamed subservience to Mammon. It won't be long before we will be able to see.

Whatever we might make of the aesthetics, the reference to Mammon makes a deal of sense. Indubitably Docklands in the eighties signified wealth, and an appropriate term was coined to describe the new young rich – yuppies. The most vigorous adulation for this new entrepreneurial figure can be found, appropriately, in *The Times*, most particularly in a leader which took for its title 'In defence of yuppies'. Here the editors praised to the skies the new Docklands and the yuppies who now inhabited them. Yuppies 'create wealth . . . anyone can join'.

> As for young Cockneys in the East End tower blocks over-looking Docklands, the message to them should be clear. Don't resent your yuppie neighbours; join them. Not that they need telling. Very many of them have already done so. If there is anything more encouraging than a yuppie, it is a Cockney yuppie.[19]

Such sentiments were common during the dawning of Docklands. 'I can't understand why there is so much resentment about investors', claimed one 29-year-old computer firm manager. 'We will improve the whole quality of life in the area when the restaurants and shops follow. It is probably just envy.' Jonathon Pratt-Walker had a similar view:

> We yuppies have contributed more to the Isle of Dogs economy in the past five years, thanks to Mrs Thatcher's inspired policies, than most of these moaning real-cloth-cap locals ever have. . . . We will be here for longer than the moaning minnies on the council estates.[20]

Not all those who benefited from the early goldrush would have held such views, nor would all fall into the conventional category of yuppie. But in connecting the idea of the yuppie with Docklands

The Times, as ever on such matters, was alert, for it is difficult to think in any other terms of this new cultural formation.[21] A high proportion of new residents – so far as the evidence goes – do appear to work in financial organizations or their offshoots; the residential organization of the entire Docklands development provides virtually no space for children – while there is a private hospital, there are no schools; and, by definition almost, those who have moved into the new apartments are wealthy, some conspicuously so. The glitz attracts those seeking 'lifestyle'. This can take many different forms. As the tourist boats ply up and down the Thames the houses of the rich and famous are pointed out – Michael Crawford, David Lean, Pet Clark, David Owen – all apparently personifying eighties lifestyle. And then of course there is the 'edge situation' – windsurfing to the pub, dropping into The Spinnaker for the early evening cocktail, rendezvousing in St Katherine's Yacht Club, and for those still with surplus cash, the plethora of marinas in which to moor the boat: this attraction to yacht culture – Lillywhite's mariner outfits and the appropriate lingo – has traditionally run deep within a certain sector of the English middle classes, bestowing an aura of status on those who embrace it.

All this testifies to the fact that living in Docklands is *special*. From the moment the prospective purchaser steps into the estate agent's office he or she will be sold Docklands in terms of its *not* being 'the East End' – not black, not impoverished, not violent; or (as on one occasion) all this can be condensed into the most dreadful euphemism – 'This area has the highest population of real English people.' Thus it is not just in the imaginations of the dispossessed onlookers that the new residents live a segregated existence. Segregation is the cost which must be paid by those newly arrived to protect them from the old. In part this is no more than a simple defence of privilege and luxury. The old dock walls may have been demolished but at every turn one discovers that 'the edge situation' has diligently been privatized, allowing only the most limited public access. But more than this the extensive security systems which surrounded each new complex – the alarms and electronic surveillance, the dogs and private guards – suggest that the deep, historic fears of the East End, palpable and undisguised in the 1880s, are still present, if generally less openly expressed, in the 1980s.

However much Nicholas Ridley or *The Times* may enthuse there

is no indication that class divisions have lessened one iota. In fact there is every reason to believe that social division has deepened – the wealthy and the poor being brought together in a new proximity – and that the privilege accorded those new waterfront residents is at the direct cost of the bulk of the population in East London. While Tower Hamlets now boasts windsurfing and yachtspeople it also has indices of tuberculosis six times that of the national average.[22] Housing waiting-lists of the three Docklands boroughs exceed 25,000, while between 1981 and 1986 homelessness increased by 81 per cent. Unemployment throughout East London has continued to rise, and on the Isle of Dogs it is close on 30 per cent. According to government figures, by March 1987 3,355 jobs had been lost as a result of firm closures in Docklands. The new firms that have moved in have not compensated for these losses. Although 7,897 jobs have been created, 5,059 are transfers from outside Docklands. Only 2,838 are new jobs. So by the government's own reckoning there has been a net job loss of more than 500 local jobs since the LDDC was created.[23] The LDDC, along with the Merseyside Urban Development Corporation, have been criticized by an all-party committee of MPs for their failure to employ or train their respective local populations.[24] All that has appeared so far has been the emergence of a new service class, anticipating a bleak future in class relations. Nor has there been any attempt to reverse the abrogation of democratic controls. A range of impressive, grassroots campaigns has emerged throughout the eighties, many of which have proposed careful, reasoned economic and social alternatives for the region.[25] The success of these alternative proposals has not been great, indicating just how much power has been invested in the LDDC by central government and also, in these conditions, the power of market forces. Similarly, imaginative bargaining by the local boroughs – in effect, working with the LDDC in order to encourage development, but requiring in turn a high measure of social regulation and provision – has had precious little effect, and the LDDC has proved notorious in previously abandoning 'agreements' and 'understandings'.[26] As one of the more active, populist local campaigners puts it: 'We survived Hitler's bombs but we're not sure we'll survive the bulldozers.'[27]

There are however other possibilities. The Docklands project accords closely to what Stuart Hall once termed 'regressive modernization'.[28] But like any modernization programme it produces its own contradictions and carries its own gambles. First and

foremost, there exists the systematic underdevelopment of the areas adjacent to Docklands. But, as I have suggested, even the glitzy vision which has been held for so long in the public eye may yet turn out to be a mirage. Commenting on the Canary Wharf development a Morgan Grenfell property analyst noted: 'O & Y's expertise is second to none. But their presence does not preclude the possibility of a white elephant', a possibility brought closer by the fact that the company's debts are currently running to more than half their assets.[29] Those who once had disposable cash ready for speculation are now few and far between. The City paid dearly for Black Monday, the redundancies belatedly hitting hard – 3,000 of the 40,000 jobs in the securities industry going in a single month.[30] The LDDC not only faces a financial crisis, contending with increasing deficits, but has earned a public reputation for shady dealing and the attraction of officials who seem less than scrupulous, prompting from the Labour Party a commitment to its abolition.[31] Even the railway, badly handicapped by its appalling undercapacity, now constantly breaks down (ten times a month on average) leaving passengers stranded high above ground level for hours on end.[32]

It now looks as if Docklands is a place where the discriminating wealthy choose not to live. High interests rates have bitten deep, and signs of the slump are clearly visible – the weeds and the for-sale signs accumulating in equal measure. Incoming residents have complained of those in nearby council housing whose children are 'noisy and dirty', forcing them to resort to founding tenants' associations – a nice paradox this. The goldrush has ended and the speculative boom seems part of history, even while new developments are still being planned and built. The basis is precarious, constituting a classic crisis of overproduction. As a senior merchant banker from Kleinwort Benson lamented, the fear is evident: 'The risk and nightmare is that a ghost city is being created in Docklands.'[33]

Catastrophes may indeed come. Speculative ventures on this scale always produce a number of casualties, some of which may yet prove to be startlingly dramatic. But politically and financially too much has been invested to allow the whole thing to collapse. If necessary, compromises will be found and political deals struck. Yet the final outcome does little to vindicate Docklands as the triumph of Thatcherism. The proximity of the very wealthy and the very poor is all too evident of the miserable injustices perpetrated by the new breed of sleek and urbane Tory. Turn away from the

Chapter 4

Enterprise and heritage in the dock

Adrian Mellor

These are, we are told, New Times: post-industrial, post-Fordist, post-narrative, post-Enlightenment, post-structuralist, post-class, post-class war, post-Cold War, post-post Second World War – in short, postmodern. Almost everyone agrees. We are at a moment of rupture. All previous certainties are in flux, old verities dishonoured. As our fingers slip from the handrail of History, we fall free of the past and into the postmodern. Almost everyone agrees. The unbelievable has happened: the clerks have reached a conclusion, and so has just about everything else.

They are times of omens, portents and signs, these New Times. You can't walk through a shopping mall, watch late-night TV, attend a seminar, buy a sweater, or spend the day out at Wigan Pier, without comets splitting the heavens and meta-narratives dying at your feet. On each side, prophets and soothsayers pluck at your sleeve, proclaiming that the end is not only nigh, but now. Evil Empires are crumbling, free markets prevailing; Socialism, Philosophy, Truth, and Ideology have all been certified brain-dead (none of them for the first time); and in their places we have Play, Pastiche, Depthlessness, and Style.

There is, of course, some confusion. Not all these sirens are singing the same song. Just an Ides of March or so ago, the deputy director of the US State Department's planning staff announced the end of History and the triumph of Hegel.[1] He had apparently misheard or ignored those professors from Vincennes to Nanterre who were insisting that the triumph of the postmodern necessarily meant the abandonment of Hegelianism and all the other *grands récits* by which the nineteenth and early twentieth centuries had tried to understand the logic of history, the nature of Truth, and the meaning of life, the universe and everything.[2] 'The owl of Minerva

spreads its wings only with the falling of the dusk,' Hegel had said, offering his own two penn'orth of insistence that we really can understand things, even if only after the event.[3] Little wonder that, according to Casca, '. . .yesterday the bird of night did sit,/Even at noon-day, upon the market-place,/Hooting and shrieking.' Redundancy is known to induce insomnia, even in philosophical owls.

Not all of this is nonsense, of course. It would be silly to suggest that the events of 1989 in Eastern Europe did not, in some very strong sense, mark the end of the post-war European (and global) political settlement. And nobody who has spent the last dispiriting decade working in British education is going to deny that Thatcherism has, during that time, successfully imposed an agenda of privatized, free-market affluence and public-sector parsimony and squalor. But these are manifest *political* changes (and even so, their longer-term effects are unclear). What concerns us here is the way in which contemporary cultural analysts, historians and philosophers are arguing that these political upheavals are the visible index of a profound cultural change that has already occurred in every element of contemporary consciousness ranging from formal philosophy to everyday lived culture. There is a general consensus, shared by an otherwise heterogeneous collection of poststructuralist, post-Marxist, and postmodernist thinkers (with the addition of a contingent of rather pre-modern cultural elitists) that we are the victims/beneficiaries of an epistemic shift: a profound alteration, not only in the way in which we understand and explain the world, but in the very reality which we inhabit.

I want to question this – not by denying that we are living through a period of significant social and cultural change, but by denying that every single aspect of these changes can be related to each other in a seamless, essentialist, web. In particular, I want to suggest that 'ordinary culture', 'everyday consciousness' is both resistant to this alleged epistemic shift and diverse in its modes of resistance. Ordinary people, going about ordinary lives, do not feel themselves to be part of 'the postmodern condition'.[4] They do not see their everyday cultural practices as evidence of 'fragmentation' or 'depthlessness'. They do not frame contemporary popular cultural products with notions of 'pastiche' and 'nostalgia'. When they go shopping, they stubbornly insist that they are buying something to wear, rather than constituting their subjectivity. One may, of course, suggest that they are wrong: that (to borrow a term

from a now-transcended meta-narrative) they are suffering from 'false consciousness'; and I should be the last to argue for the simple transparency and straightforward validity of common sense. People's own understandings of what they are about are often unreliable. They don't always say what they mean; they don't always understand what they say. Meanings and frameworks available to some, entirely elude others. People's accounts of their lives and culture don't simply speak for themselves; they require interpretation and understanding.

In the bad old days, when cultural studies still retained, as one of its contributing strands, some of the traditions of European sociology, cultural analysts used to engage periodically with this difficult task of trying to understand what ordinary people made of their own cultural practices. What has changed since then has been the way in which textual analysis has become the central component of cultural studies, displacing – or at least, demoting – other contributing disciplines. There are understandable reasons for this shift, some of them intellectual, others brutally material. During the last decade, literary theory has simply been more exciting, challenging, and open to dialogue with other disciplines than has sociology. At the same time – and sociology's intellectual decline is, at least in part, a result of this – a sustained government attack on the institutional base of the social sciences, particularly in research funding, has made it difficult to carry out proper social inquiry. Put bluntly, polytechnic and university teachers who are now chronically short of both time and money find it easier to engage in textual analysis than to undertake field research amongst audiences. There have been exceptions – the field of television studies being the most notable – but in the study of 'lived cultures', we have increasingly developed a one-sided approach to cultural analysis, in which texts are (valuably) explored, but in the absence of any real check on their reception by lay audiences. This has led to a paradoxical determinism – 'paradoxical', because the main thrust of all of the newer theories has been to deny previous forms of determinism – in which the meanings produced by texts are simply assumed to be shaping the consciousness of audiences.

Given that many of the meanings which academics discover in contemporary cultural texts, particularly in those of 'popular culture', are profoundly disheartening, this has led some (again, not for the first time) to fear for our culture and society. Although few these days explicitly invoke either the British cultural critics from

Arnold to Leavis, or their Marxist counterparts in the Frankfurt School, one can still hear spoken the accents of a cultural elitism – of a disdain for, and fear of 'mass culture' and 'the consciousness industry'. Others, delighted by their discovery that the polysemy of language relieves one of the onerous search for truth, have assumed that persons sitting on the Clapham omnibus have experienced a similar epistemological liberation, and are cheerfully exploring the possibilities offered by a cultural terrain from which the maps and signposts have disappeared.

Both these options appear equally unlikely. They smell of 'projection' (to use a term from yet another discredited meta-narrative). They are the sound of intellectuals uneasy in their own times, and who are either roundly blaming everyone else or whistling very loudly to keep up their spirits. Stauth and Turner seem to have it right:

> The cultural elite, especially where it has some pretention to radical politics, is . . . caught in a constant paradox that every expression of critique of the mass culture of capitalist societies draws it into an elitist position of cultural disdain and refrain from the enjoyments of the everyday reality. To embrace enthusiastically the objects of mass culture involves the cultural elite in a pseudo-populism; to reject critically the objects of mass culture involves distinction, which in turn draws the melancholic intellectual into a nostalgic withdrawal from contemporary culture. Since in postmodern times probably all culture is pseudo-culture, it is invariably the case that all intellectuals are melancholics.[5]

Now it is a well-known fact that melancholics are self-obsessed, constantly ruminating on their own condition, and seeking of others only confirmation that they, too, are depressed – so it is salutary to be told that the melancholia of intellectuals may be characterized by 'nostalgic withdrawal', because if a single notion dominates the accounts of postmodern popular culture, then it is that of 'nostalgia'.

In just the past few years, a minor academic industry has developed around the critical analysis of what is claimed now to be a major cultural enterprise: 'the nostalgia business' or 'the heritage industry'. At first, the products of this academic firm were distributed through the pre-modern medium of print, but following a

rapid modernization some of the more important contributions have been broadcast on BBC2 and Channel 4 television.[6]

The 'heritage industry' which has been the focus of these concerns is by no means as unified an entity as some would have us believe, but it includes the marked recent growth in museums and 'Heritage Centres' in this country – a new one opens every week or so, we are told[7] – along with an equally marked growth in the cult of the country house, National Trust membership, a penchant for Laura Ashley-style shopping, and fond memories of those key texts of pre-deregulated quality television: *The Jewel in the Crown* and *Brideshead Revisited*.

The common complaint of heritage industry critics has been that we are, as a nation, living on 'fantasy island': wallowing in nostalgia, inhabiting a fake past, unable to tell the difference between real history and a romantic construction of it. The common explanation for this malaise is that the real history through which we have just lived has been so disruptive and painful that we have turned away from it. In our collective experience of national decline and communal powerlessness, we have abandoned the attempt to remake our society and reached instead for a bottle of historical Valium, dragging our kids around theme parks and heritage centres of a Saturday afternoon, remembering 'The Way We Were' when the sun never set on change from half-a-crown and you didn't have to lock the back door of your Empire when you went out.

By the late 1980s – judging by the sheer volume of articles in the quality press and weekly magazines – the omnipresence of 'nostalgia' had become the prime focus of educated concern, and was serving the current generation of the chattering classes in much the same way as their forbears had been served by the evils of gin, the decline of religious belief, horror comics, and juke-box boys.

But, now as then, this moral panic has both properly registered real cultural changes and identified legitimate areas of concern. It is quite true that deceitful and/or prettified images of our national past are now everywhere around us. Any visit to the tourist information office produces an armful of town criers, Roman soldiers, poke bonnets and steam-engines – with many of these being explicitly identified as 'Heritage Attractions'. The brochures which are before me as I write include references to the 'Liverpool Heritage Walk'; 'Textile Heritage' (Helmshore); 'Heritage Six' (North West Museums and Art Galleries); 'the country's first Urban

Heritage Park' (Castlefields, Manchester); 'Maritime Heritage' (Lancaster and Liverpool); and 'Railway Heritage' (Greater Manchester Museum of Science and Industry). There is the Lowry Heritage Centre in Salford, the Port Sunlight Heritage Centre in Port Sunlight, and the Wigan Pier Heritage Centre at Wigan Pier. And those are the less 'touristy' bits of the North-West; life is too short to open the folder marked 'Chester'.

It is certainly true that 'heritage' has become a little too inclusive; and it is no less true that what 'heritage' excludes (or more often sanitizes) is often as significant as what it endorses. One has to look quite hard for that rather important bit of Liverpool's heritage called the slave trade (although it gets a mention in the Maritime Museum), and I have yet to find a tourist feature on Manchester which stars Engels (although I bet there is one). Equally, the back-breaking labour of women and domestic service is still too often sidelined in presentations of the country houses: 'Notice the flagstone floor along the servants' corridor,' says Cheshire County Council's guide to the Mansion at Tatton Park, 'the stone was easily kept clean by scrubbing, a job for the maids.'[8]

Nor can one deny that this efflorescence of heritage-consciousness is in some general way related to broader social changes, and more particularly to changes in the economy. We can see that this is the case, because this postmodern phenomenon has happened before – not once, but twice. As David Cannadine explains:

> Since the 1870s, the British economy has experienced three major downturns, each one known to contemporaries as the 'great depression': during the last quarter of the nineteenth century, between the end of the First World War and the beginning of the Second; and in the long, lean years after 1974.[9]

Each of these periods was marked by similar kinds of social and political response, argues Cannadine: urban and industrial unrest; a political shift to the Right (consequent upon splits in the Left); and a reaction to economic uncertainty and anxiety which produced a new mood of retrenchment, conformity and self-interest. More than this, he adds, each of these depressions in turn engendered a distinctive cultural climate. The late nineteenth century saw the heyday of Elgar and Lutyens and the beginnings of the National Trust and *Country Life*. The inter-war period witnessed the birth of the Council for the Protection of Rural England, and a cult of the countryside (incarnated in the image of Stanley Baldwin leaning

over a gate to scratch his pigs' backs). In our own times, preservationist fervour has produced campaigns around Mentmore, Calke Abbey, and the raising of the Mary Rose.

> All this adds up to a recognizable and distinctive public mood, which has twice come and gone, and which is now firmly entrenched in Britain once again: withdrawn, nostalgic and escapist, disenchanted with the contemporary scene, preferring conservation to development, the country to the town, and the past to the present.[10]

It is one thing, though, to identify the general features of a *Zeitgeist*, but it would be quite another to demonstrate that everyone is actively incorporated in it. There are (or have been?) models which make precisely that assumption: 'base-superstructure' determinism in Marxism for example, or the Hegelian notion of an 'expressive totality'. But neither of these has yet produced an adequate account of the mechanisms by which collectively elaborated forms of consciousness can be decisively and uniformly linked to the consciousness of individuals. So protracted has been the search, so inadequate the results, that one may be forgiven for deciding that it is just not so, and we should try again.

I have argued elsewhere[11] that our problems in trying to understand the cultural significance of the heritage industry are twofold. First, the sign 'Heritage' is now so ubiquitous that we have been misled into the belief that we are dealing with a homogeneous phenomenon. In fact, the cultural institutions, practices and meanings currently gathered under this heading are quite diverse. The newly relocated National Museum of Labour History in Manchester, The National Trust, The Jorvik Viking Centre in York, Camelot Theme Park at Charnock Richard, Wigan Pier Heritage Centre, and a sizeable chunk of the population of Stratford-upon-Avon could all be said to be part of the heritage industry, but each fosters different conceptions of what our 'heritage' is, and how we should regard it. Camelot is run for kiddies and isn't intended to help with National Curriculum attainment targets. Quarry Bank Mill at Styal is run by the National Trust, and is. The Holmfirth Postcard Museum requires a sense of humour; and those who seek an astringent corrective to Heritage's usual bland effacement of the injuries of class will certainly find it in the Merseyside Museum of Labour History. 'THE MISERY' is how National Museums and

Galleries on Merseyside advertises its pleasure – surely enough for any melancholic intellectual.

Our second error has been that we have neglected to ask the punters what *they* think. Gloomily sitting in the Orwell Pub at Wigan Pier, worrying about the fake Tiffany lamps and the genuine space invaders, we have assumed that others share our disorientation and deracination. In fact, when you ask other visitors what they are doing there, it turns out that many of them – especially the older ones – are reminiscing. They do so, not simply in passive deference to Wigan Pier's own construction of Wigan life at the turn of the century, but actively using the displays, reconstructions, and discourse of the actors (who wander around playing early-Edwardian schoolteachers, mill-workers and clerks), as the point of departure for their own memories of a way of life in which economic hardship and exploited labour were offset by a sense of community, neighbourliness and mutuality. One might perhaps call this 'nostalgia', but to do so implies quite a strong notion of 'misrecognition': a judgement that these memories of a lost, urban working-class *Gemeinschaft* are not merely consolatory, but also counterfeit. One hears these tales so often from older people, though, that one is driven to give them credence. They are, to be sure, expressed in the forms of 'popular memory': well-worn tales whose standard phrases signal a culture which had been a smidgin closer to orality than we are now, and which used to provide The Goodies with their stock-in-trade of Northern asceticism: 'When *I* were a lad, we used to 'ave ter walk ter school every day, fifteen mile theer'n'back, in us bare feet, ovver brokken glass.' . . . 'Nobbut fifteen mile? Tha 'ad it reit soft.' Exaggeration is comic, of course, but the lived reality was not. Life was hard; it was good to have neighbours you could depend upon.

There is another subtext at work in the worried criticisms of the heritage industry. Cultural concern is most clearly expressed in those instances where 'heritage' meets 'enterprise'. Admittedly, the literature does include trenchant critiques of the policies of such bodies as the National Trust, the planning authorities, and the conservation lobbies; and again, the complaints are often sensible and pertinent. The preservation of the material past needs to be weighed against the material needs of the present and future; the conservation of country houses for the enjoyment of future generations doesn't preclude the exercise of discretion, nor entail a commitment to provide parish relief for indigent aristocrats. But

though the great and the good of the National Trust might be damned as archaic worshippers of antique social relations and outmoded rural property-rights, or as pestiferous obstacles to the progress of modernity – let alone postmodernity – they cannot be attacked for being entrepreneurs. Real dismay is reserved for the conjunction of 'history' and 'commerce': for the moment of commodification. It is often thus when cultural capital speaks of material capital. The melancholic intellectual has long displayed a gentrified distaste for 'trade'. Speaking again of Wigan Pier, Waldemar Januszczak has asserted that:

> however great Wigan's economic need for a heritage centre, our objections to the heritage industry must be the normal ethical objections to falsehood. The new Wigan Pier's cousin is not the museum but the fairground.[12]

Unsurprisingly, Mr Januszczak finds Liverpool's redeveloped Albert Dock an equally distasteful amalgam of high culture and low commerce. The restored buildings now house shops, pubs, winebars, restaurants, residential accommodation, offices, the Merseyside Maritime Museum, one of Granada Television's studios – and the Tate Gallery Liverpool. The last, he feels, has clearly found itself an inappropriate setting, somewhere in 'Captain Pugwash country', where 'the gallery must compete with the jaunty sea-faring mood that is being cultivated around it in the theme dock (the pizzas in the café opposite have names like The Trafalgar and Bosun's Surprise).'[13]

The dock was first opened by Prince Albert in 1846. It had taken five years to build, and was the masterpiece of Jesse Hartley, the chief engineer of Liverpool Docks from 1842 to 1860. It was designed to accommodate sailing ships carrying no more than 100 tons of cargo and so, as steamships became larger, the Albert Dock became progressively redundant, directly receiving fewer and fewer ships, with goods having to be moved to its warehouses by barge or by road. By the 1920s, it was almost empty; and although it enjoyed a temporary revival during the Second World War, when it provided a base for Naval corvettes, it declined thereafter and was finally closed in 1972. As Grade I listed buildings, its 1.25 million square feet of warehousing could not simply be demolished, and so were left to decay whilst various possibilities were canvassed. In 1976 – a moment of personal anguish, this – Liverpool Polytechnic failed to acquire the Dock for its own use.

In 1981, Michael Heseltine set up the Merseyside Development Corporation which – in partnership with the London-based property company, the Arrowcroft group – undertook the work of restoration. The first stage was completed by 1984, the year of the Tall Ships Race and Liverpool's International Garden Festival.[14] Since then, the site has continued to develop, as has its reputation as a tourist venue. The Tate Gallery opened on 28 May 1988, and between then and 26 April 1990 had received 1,358,435 visitors. The Merseyside Maritime Museum (which charges an entrance fee) has been similarly successful, with over 409,000 paid admissions in 1988; and by that year, according to *Social Trends*, the Albert Dock as a whole had become – with 3.5 million visitors – Britain's third most popular free tourist attraction. (In the context of this essay, it is difficult to know quite what to make of the fact that the first and second places went to Blackpool Pleasure Beach and the British Museum, respectively.)[15]

It must be admitted that a great deal of what is to be found on the Albert Dock seems almost expressly designed to upset critics of the heritage industry. Even the case-hardened might cringe a little at the way in which the Tate Gallery almost rubs shoulders with a shop featuring 'The Hologram Exhibition', and selling not only holograms but other forms of popular ornament, such as 'sandscapes' ('New, exciting, ever-changing, kinetic art'). And near by there is one of those irritating mechanical parrots which entice your kids to shake you down for loose change by way of an ear-splitting whistle and the frank admission that they love the sound of money. I have to admit, though, that I cannot find Mr Januszczak's 'Trafalgar' and 'Bosun's Surprise' pizzas – probably, I suspect, because the café he mentions has now changed its character and become (rather uncertainly) an American Brasserie, featuring such well-known American dishes as the Left-Bank Burger, 'recreating the atmosphere of Montmartre', via toppings of grilled ham and melted cheese. But so what? Prices were a bit steep for Liverpool, but the place was crowded and, in so far as a nosey sociologist could tell by peering at people's plates through the window, the food looked appetizing.

In any case, are we not in danger here of giving way to one of the unexamined assumptions of high-culture disdain for popular culture: what we might call the postulate of semiotic infection or cultural contagion? It always seems to be assumed that in cultural matters, a kind of Gresham's Law operates, where counterfeit

coinage drives out the authentic. On the face of it there seems no reason not to believe the exact opposite: that the presence of the Tate ennobles and elevates the surrounding operations of commercial culture, rather than being debased by them. As it happens, several visitors that I spoke to thought the issue was a red herring, and that the Tate rather kept itself to itself, being neither contaminated by, nor dominating, the rest of the site.

Heritage and fantasy are everywhere, none the less. In some of the larger knitwear shops, the *mise en scène* signifies 'the textile industry' by way of the very same busily frozen, flat-capped mannequins, bales and trollies which, in the Maritime Museum just across the way, signify 'dock work'. 'Timmy Feather's Millshop' anchors its account of the romance of labour in an actual person – one Timothy Feather, the Stanbury Handloom Weaver who, we are told in a wall display, lived his three-quarters of a century in an ivy-covered house at Green Bottom, Stanbury, sharing his bedroom with the principal tool of his trade and – in an inspired appeal from commerce to culture – had been baptized by the Rev. Patrick Brontë, 'father of Charlotte', on 25 July 1825. If this is intended to provoke customers to historical enquiry, it certainly succeeds. How, one wonders, did a poor handloom weaver, born over a decade after modernity had already so affected his trade that the authorities had had to repress the followers of General Ludd with hangings and transportations, manage to found such an impressive undertaking? Did he, one wonders, ever discuss with Charlotte Brontë the plot of *Shirley*, which deals with these stirring events? When did he stop weaving woollen cloth and diversify into knitwear? What does a handloom weaver have to do with a Millshop?

On sale elsewhere, there are old photographs of Liverpool, maritime prints, new Victorian dolls, and old cigarette cards. One stall specializes in 'an exclusive range of old but new works of art'. These are 'Bygone Gems': reproduction enamelled advertising signs – authentically 'distressed' – of the kind that used to be found attached to shop fronts but now appear in pub interiors. 'The Heritage Shop' (*sic*) features 'Ye Olde Post Cards' (35p), Dick Turpin posters, Henry VIII wall plaques, genealogy kits, stick-on stained-glass windows of Elizabeth I, and a number of coffee-table books, including the sublimely titled *Sweet Memories* by Robert Opie: actually an illustrated history of confectionary advertising, but capturing well the appeal of popular nostalgia.

Nor does the Dock disappoint that postmodernist fraction which insists on the fusion of a dehistoricized past with modern technology. One barrow features 'The Albert Dock Birth Certificate', where you can obtain a list of those historical events of the last few hundred years that have taken place on your birthdate – delivered by way of a PC micro-computer and Panasonic printer. Another shop offers collectors of model cars a range of vintage classics under the generic title 'Days Gone By'. Only the recording studio 'Take 1' seems to have refused to view technology through a sepia haze. In a determinedly modern ambience, the studio offers to part Dock visitors from their money by recording them singing along to a backing tape, karaoke-style. Up to three attempts at one recording cost £7.50, or you can go for two recordings at £14.50 – which might turn out expensive if your eight-year-old fancies herself as Kylie Minogue but is possessed of more moderate talents.

I suppose much of the 'heritage' shopping now belongs under the general category of 'gifts'. Those who worry about a postulated growth of consumer consciousness in our society might do worse than to look at what is happening to our notion of 'the gift'. When *I* was a lad, and you gave someone a present, you tried to choose something that you thought they might actually want and this did not rule out the useful, as well as the decorative. Nowadays, 'gifts' have reverted to the purified status of the *sui generis*. They are reduced to unalloyed signification, where what they chiefly signify is their own being as 'gifts'. I suppose this insufficiency has always been there in present-giving, since it is the relationship that is memorialized, rather than the thing itself. But when we were sternly told by our parents that it is 'the thought that counts', we were being reminded that this relationship could be embodied in the least pretentious of objects: that sincerity did not require extravagance. Today, 'gifts' have become so ubiquitous a sub-category of retail shopping as to suggest a society engaged in some gigantic, collective potlatch, whose deliberate and meretricious wastefulness is calculated to induce apoplexy in anyone from a Co-op and chapel culture.

The remaining commercial activities on the Albert Dock are chiefly devoted to the inner and outer persons: food, clothing and adornment. It helps to have a sweet tooth here. Several shops and stalls are devoted to the yummiest confectionery: hand-made chocolates, fudges and candies; and visitors that I spoke to often singled these out as affordable luxuries. Many of the restaurants

and cafés show the preference for foreign food which today reveals, according to your point of view, either British openness to other cultures or contempt for our native cuisine. On the Dock, one can eat American, German, French, Italian, Equatorial Far East, Internationale, and – at last – Scouse. The 'Scouse House' will do you a nice plate of lobscouse with red cabbage, beetroot and bread for £1.90. Lobscouse was originally a sailors' stew of meat, vegetables and hardtack and, as the staple diet of the Liverpool poor, was made with cheap mutton boiled with potatoes and onions. On days when you'd paid the rent or the tally-man, the meat was omitted and the dish became 'Blind Scouse'.[16] I have long believed that the catarrhal quality of the eponymous Scouse accent results from adenoids being pickled in red cabbage, contrary to established medical opinion which maintains that the cause has been traced to the draught blowing through the Mersey Tunnel.

The clothes shops are aggressively *un*-Scouse. Rather, Paris, Rome and Amsterdam appear to be the geographic and cultural points of reference; and prices are held to be high by Liverpool standards. Now an ageing sociologist, who has only recently moved up-market in his tailoring from army surplus stores to Marks & Spencer, can have difficulty in making fine distinctions here; but those of my acquaintance who are knowledgeable in such matters are all agreed that there is a clear intent to provide fashionable, up-market couture. The consensus does not go beyond 'intentions', however, and breaks down along a North/South divide, with Southerners arguing that the attempt to be truly fashionable fails by a subtle, but crucial whisker, and Northerners insisting that it succeeds too well for the pockets of customers. Most of the visitors I interviewed were from the North, and many – often unprompted – shared the canny, regional view.

Adornment extends beyond clothing to jewellery – ranging from costume jewellery to the real stuff. There is more of the former than the latter though, and perhaps this does reflect the fact that, in spite of some revival, Liverpool's living-standards are still below the national average. Despite this, one still finds appeals to popular symbols of conspicuous consumption. One shop is called 'Lady Docker' (Geddit?), which recalls for those of a certain, delicate age, the exploits of Lady Norah and Sir Bernard Docker, whose gold-plated Daimler became, in the fifties, such a usefully condensed signifier of the End of Austerity and the Return of the Vulgar Rich.[17]

Well, what *of* the punters? All this consumer culture – much of it directly addressing 'heritage consciouness' – is presented along three sides of the Albert Dock, flanked at both ends by two very different 'official' institutions of our heritage – the Tate Gallery and the Merseyside Maritime Museum – and housed in restored Grade I listed buildings. What do visitors make of the site? Do they find incongruous the conjunction of its separate elements: consumerism, high culture and specialist history? What does the notion of 'heritage' mean to them? What are 3.5 million of them doing on the Albert Dock, anyway? I asked a few of them and, as I expected, it is often easier to say what they are not doing than what they are.

The first thing that visitors to the Albert Dock are not doing, is that they are not getting depressed. There is nothing melancholic about them. They are enjoying themselves; that is why they are there.

'I think it's great, fantastic, really nice. . . . I just like it. Personally, I like what's being done to the area. I think Liverpool deserves something like this. . . . It's bringing something to Liverpool, isn't it? . . . Excellent; I mean it's bringing the people in, isn't it, and Liverpool's a nice place.' (Man from Prestatyn)

'Nice that [the Maritime Museum]. I like, you know, where they emigrate to Australia and all that. It's dead interesting. . . . It's good that; I think it's gorgeous. You can have a laugh. . . . It's the best thing that ever happened to Liverpool.' (Local woman)

There's an important sub-theme here. Whatever visitors might think of 'heritage' on the Dock, they are all for its 'enterprise' – but rarely in a way of which Margaret Thatcher could approve. The only Conservative politician to get a mention – approving or otherwise – was Michael Heseltine, whose initiative as 'Minister for Merseyside' was praised by a couple from Blundellsands. Elsewhere, the almost universal welcome for the Albert Dock redevelopment is couched, not in terms of the success of individualistic enterprise, but in terms of community action. It is 'Liverpool' that has succeeded, 'Liverpool' which will benefit. One expects this sort of thing from Scouse nationalists, of course. What surprised me was that it was a perception shared by visitors from outside Merseyside, these amongst several others:

'Well, it's a very good heritage, isn't it? I wish we had something like this in Manchester. . . . Pity it's not a bit further inland [where Liverpool's urban dereliction is still to be found].'

'It'll bring a lot of money into Liverpool. . . . They haven't altered a lot. I think it's good for British heritage.' (Young woman art student from Birmingham)

The second thing visitors are not doing, is that they are not worrying about the state of the culture, the spread of *kitsch* consumerism, or misrepresentation of their heritage. Very few expressed such reservations, and no one mentioned 'alienation', 'anomie', 'fragmentation' or any of the other gloomy abstractions by which intellectuals have claimed to account for the putative inadequacies of mass experience. I tried my best to be melancholic, but other visitors constantly cheered me up. Here is a Liverpool woman, with her prospective daughter-in-law from Manchester, telling me what they like about the shops:

(Younger woman) 'Well, they're different.'
'In what way?'
'There's a collection of shops you don't get in city centres'.
'Huh, huh. . .'
'They're different: arty-crafty.'
'Right. . . . Do you often buy?'
'(Older woman) 'Oh, yes, even if it's only a card.'
'Anything else that you buy?'
(Younger woman) 'Pigs.'
'Say again?'
'Pigs.'
(Older woman) 'She's a collector of pigs, you see.'
'So. . .'
(Younger woman) 'It's a hot-spot for pigs.'

The third, and most important thing that visitors to the Dock are not doing, is anything in particular. This is really most important. Academics, journalists, cultural critics, and makers of television programmes tend to be busy, purposeful people intent on improving the shining hour, and they have difficulty in accepting that others might take a more relaxed, less instrumental attitude to the ways in which time can be spent. Most visitors to the Dock amble around relatively aimlessly. On crowded days, it is quite difficult for

an observer to be sure whether particular people are part of a group or not, because the groups are always in fluid motion, as individuals peel off to look at something, only to rejoin, or be rejoined by the main body a minute or two later.

This is not to say that Dock visitors have straightforwardly escaped from the dominant work-ethic. They have not; as is amply demonstrated by the way in which they (and all of us) habitually, if unconsciously, belittle the importance of leisure. Time and again, people begin their account of what they are doing on the Dock with the word 'just'.

> 'Just looking around the shops'. (Two young women from Tuebrook and West Derby)

> 'Just wanted to have a look round'. (Middle-aged couple from Bradford)

> 'Just to stroll round, and look at the Art Gallery'. (Man from Chester)

> 'Just for the day out, you know'. (Local woman)

Even people who have come for a specific purpose, appear to feel guilty if they get diverted from their original goal:

> '. . .what are you here for today?'
> 'We're here to see *The African Queen* [the boat from the film] but we haven't seen it; but we just like walking round. We bought a couple of things as soon as we arrived.' (Two local women, one from Mossley Hill, one from Sefton Park)

What most of these people are doing is 'nothing'. It is rather like the nothing that they used to do when they were kids. As Paul Corrigan has shown in his interviews with Sunderland adolescents, doing nothing is an important activity when there's nothing very much to do. A lot of talking and joking gets done; group ties are reinforced; and there's always the possibility that 'something will happen':

> *Question* What sort of things do you do with your mates?
> *Duncan* Just stand around talking about footy, about things.
> *Question* Do you do anything else?
> *Duncan* Joke, lark about, carry on. Just what we feel like really.[18]

Despite the linguistic similarity – the repeated 'just' that denies that

these activities can be accounted for in purposive terms, most adult visitors to the Dock would deny the comparison. 'Doing nothing' is not something that adults can easily admit to. That is partly, of course, because the very definition of adult existence is one that stresses the centrality of work and responsibility. But – especially for Liverpudlians – there is another reason: adolescents on the street are 'scallies', and the something that often happens when they are just doing nothing is 'trouble' – things get broken (and broken into), vandalism occurs, graffiti gets sprayed, the environment rapidly decays.

What the Dock offers is an adult – and family – space where 'doing nothing' can go on safely and decorously. There, people can talk, joke, share experiences, and reinforce the group and family ties that the weekday world denies or limits; but they can do this in a place where the unexpected is always predictably agreeable: an event rather than a rumpus. The Dock is visibly policed by security guards, and the few unaccompanied children I have seen there got spoken to. 'Talking of destruction', said one woman respondent, summing up the views of many others 'there is no graffiti, and – none of that sort of stuff, is there? No; I'd say that that was conspicuous by its absence.'

A day out on the Dock precisely does ensure that something will happen, because 'there's always something happening' there, something other than was there last time: a stunt for charity, a TV celebrity, a new exhibition at the Tate or the Maritime Museum, or simply the street organ, collecting for Cancer Help. People will tell you that there's always something to do at the Dock, but what they really mean is that there's always something to see. The crucial difference between adolescents and adults who are each 'doing nothing', is that kids finally resolve their boredom by doing something; adults resolve it by looking at something. A male visitor from Chorley made the point crystal clear when asked whether he had revisited one of the more 'Heritagey' elements of the Maritime Museum: a reconstruction of the below-decks accommodation on the *Shackamaxon*, an emigrant ship of the mid-nineteenth century:

'Once is enough.'
'Why's that? Why is once enough?'
'Well, I don't know. They call on you to sort of participate in it. I'm not one for that sort of thing. I just like to stand and look at things rather than take an active part in it.'

There are exceptions. There are those who go to the Dock with very clear purposes in mind, and who stick to their plans. These are often, but not always, the few who are there alone, as individual visitors, and they are generally attending the Tate Gallery or the Maritime Museum. Here is an American art-collector:

'Can I ask you how far you've come today?'
'OK, I came from London. [explains that he is visiting Britain on business] . . . and today's my day out.'
'. . .and have you come deliberately to Liverpool?'
'I came deliberately to Liverpool, deliberately to the Tate.'

This man is a transport enthusiast from Warrington:

'Do you come often to the Dock?'
'Fairly often, yes – about five, six times a year, maybe more.'
'What do you come for?'
'Mainly the ships.'

And this is a young, local doctor and her companion:

'What are you doing on the Dock, today?'
'We went to the Tate Gallery, to see the Bacon Exhibition.'

It is perhaps significant that it is these 'purposeful' visitors who have the most decided views about 'heritage', and about the workings of the Dock more generally. The doctor is critical of its commercialism:

'Do you do any shopping on the Dock, at all?'
'No. It's a rip-off, and it's too commercialized.'
'Do you think this place gives visitors, or residents, a sense of the history of Liverpool at all?'
'I don't think so. It's been too exploited in its commercial aspects. It's all about buying expensive trinkets, all pseudo-French names – a bit out of character.'

Our American visitor disagrees:

'Heritage is real interesting to me. . . . As an American I detest our tendency to do away with it and then start with total new. We are now learning that we can't do that any more.'
'And . . . you're happy to see the commercial development to preserve the history?'
'If that's what it takes to make the continuity, I'll live with it.'

The Warrington transport-buff is equally pragmatic:

> 'Do you think that it presents an accurate and reasonable picture
> of Liverpool's history?'
> 'Well, accurate's a bit of a whatsit. It is a history, let's put it that
> way, rather than an accurate one. It's got to be interesting to
> make people come and look, rather than accurate to the nuts and
> bolts.'
> 'Do you think that's worthwhile, doing it that way?'
> 'Oh, yes. You've got to get the younger people interested, to
> carry on later.'

This last point finds common ground with some of the more
widespread notions of what 'heritage' is about. For many visitors,
the idea of heritage is redolent of abstract knowledge, didacticism,
even of formal education. Lots of interviewees had difficulty in
acknowledging the notion of a material, physical heritage, and on
those grounds tended to ignore the restored dock buildings as
candidates for being part of it; and because heritage is almost
universally held to be 'the past' ('It's what used to be, like years ago,
you know'), the Tate Gallery's exhibitions of modern art were also
excluded. That left the Merseyside Maritime Museum as the
popularly-regarded sole proprietor of 'heritage' on the Albert
Dock:

> 'If you want to see the heritage, they will be seeing that, because
> I'm going to take them to the Maritime Museum.' (Man from
> East Blundell, showing around a couple from Portland, Oregon)

There is a sophisticated version of this argument, which maintains
that the redevelopment of the Dock has actively removed the
buildings themselves from the category of heritage, leaving behind
only the institutional activity of the Museum:

> 'It doesn't really remind me of my heritage; only the Maritime
> Museum bits do. But they're nice buildings, and it's better than
> knocking them down, and they've done them very nicely – but it
> doesn't actually scream "heritage" at me.' (Woman member of
> the National Trust, from Surrey)

Some visitors exhibit a kind of guilty awareness of the fact that
there are these formal, 'cultural' elements to the site which,
somehow, they've just never got around to visiting. I discovered
that even in this resolutely cheerful atmosphere, I could still play

the role of traditional intellectual and go around upsetting people, simply by asking those who had no real intention of visiting either the Tate or the Maritime Museum whether or not they had been there. Almost invariably, those who had to admit dereliction of duty either said they were going right now, or that it was unfortunate that there was so much to see and they'd have to come again. These statements were often accompanied by defensive laughter – especially where the absence concerned Art rather than History, and I eventually decided that this was a kind of ritual spell or incantation, a specific against infectious melancholia.

The elderly have a rather different notion of heritage. For them, the past is more easily pulled through into the present, and for those who have had any connection with Liverpool as a working port, the Dock's former life still lies just behind the sand-blasted brickwork. As at Wigan Pier, older visitors can be readily induced to reminisce; and the stories they tell are not really elements of individual biography, but part of a collectively elaborated popular memory. Their favourite story is how once upon a time the Port of Liverpool was busy and prosperous, and there was work for everyone. The image that is chosen to illustrate this vanished bustle is always the same one: how the river used to be so crowded that you couldn't get across it/see across it/count the ships. If I had a pound for every time I've heard it since I've been in Liverpool, I'd never have to worry about mortgage interest rates again.

'I come from two of Liverpool's oldest families, and my brother worked in all these docks, he was a shipbuilder, an engineer, so – you know – we're Liverpool through and through.'
'And so what kind of memories does it bring back, coming to the Albert Dock?'
'Well, it brings memories, yes. And memories of when the place was all busy. Yes, I know the names of all these docks from my brother. . . . Oh, yes, it used to be packed! From the landing-stage, all the liners along the – oh, yes, it was marvellous! . . . Oh, it was very busy, you know. I remember when I was like that [*indicates knee-height*] and my father brought me, and walking with me along the landing-stage, and – big liners, you know, it was. As you see motor cars now, that's how the liners were, right along the landing-stage. Only it was longer than that, the landing-stage, longer than it is today.' (Lively 83-year-old woman from South Liverpool)

And here's a couple in their seventies, from West Derby, telling essentially the same story:

> 'What does it do then, when you come here, because you knew it as a working dock, didn't you? What does it remind you of?'
> (M) 'What does it remind me of?' [*pause*] 'It reminds me of the old days.'
> (F) 'The old days, yes. The *good days*, as we term them. No worries; we were happy. . .'
> (M) 'It's enough to make you burst into tears when you think of it, because, you know, this river, you couldn't get across there, of a weekend. The ferry-boats were weaving in and out of the big ships, the liners, all the shipping companies, you know. Big cargo vessels, all anchored in the river, waiting to get a berth in the Liverpool docks to unload. And other passenger ships, you know, waiting to embark . . . disembark, I should say.'

In truth, though, few visitors to the Dock are thinking about heritage, history or nostalgia. They will do so, when pressed, with the politeness that the British habitually show towards eccentrics, but their own concerns are different: they are having 'a good day out'. Most would say 'simply' having a good day out, because it is 'just' leisure and not work; but we have already seen that the apparent simplicity of 'doing nothing' requires detailed understanding and explanation. That we can begin to do this, is in itself sufficient rebuke to the current vogue for epistemological nihilism. Ordinary people have not, in their own consciousness, succumbed to postmodern depthlessness and neither should we; but equally, the alternative involves more than a genial reaffirmation of robust common sense. We really do have to aim to situate both our empathy and our science at that difficult point between 'cultural disdain' and 'pseudo-populism'. There can be no accounting for popular culture without some sympathy for its pleasures; there can be no understanding unless we attempt to explain.

What has gone wrong with many of the attempts to understand the heritage industry is that they have invoked the wrong explanatory framework. The point of departure has generally been, not people's intentions and activities, but the meanings and representations that surround them. As a result, we have conflated into a single category a diversity of institutions. Wherever there have been constructions of the past, there we have found 'Heritage'. Had we

begun with visitors' own understandings and activity, the differences between Camelot, the Albert Dock and Beamish would still be visible to us. Accordingly, we should have less difficulty in understanding that many visitors to so-called Heritage sites are relatively unconcerned about 'the past' – and others not concerned at all.

We have assumed, also, that people are not in active negotiation with their symbolic environment, but are passively shaped by it. As Patrick Wright has said, in one of his own contributions to this debate: 'It's that wretched film theory scenario again: people constructed out of representations.' [19] The problem with this wretched scenario is that it has been devised by people who are compulsive readers of texts. They pay close attention to their semiotic surroundings and believe that others do too. Since those who do become semiologists – well able to resist significatory determination – one must assume that it is the inattentive who are at risk: a bit like saying that people who never read *The Sporting Life* are those most likely to become habitual gamblers, or that those who ignore the top shelf in newsagents' shops stand the best chance of being depraved and corrupted.

The alternative is to treat people as active agents interacting with real structures. People make their own cultures, albeit not in circumstances of their own choosing. Amongst those circumstances – within and towards which their activity is directed – are structures of representation; but so too, are structures of class, ethnicity, and gender, along with deliberate economic and political strategies that bear upon these. These things are real. They do not merely exist in discourse. Their reality and their consequences exceed their representation. But people are not merely passively constructed by them. Even in leisure, people act intentionally; although in doing so they may slice the world along a different grain to that expected by the melancholic intellectual.

Were we to begin thus, we should have to return to the Albert Dock with quite different questions. Why, for instance, are there so few black people there, or people alone? Is Dock visiting more a middle-class than a working-class pursuit? Why do visitors apparently see the Dock as a community enterprise rather than an individualistic one? What other kinds of leisure activity do visitors engage in? What does it actually mean to have 'a good day out'; and what, nowadays, has become so bad about a day in? Is it perhaps that people now have to seek in communal 'visiting', the neighbour-

liness they feel they have lost from their real communities? Is that perhaps the sense of 'heritage' that the Albert Dock, the British Museum, and Blackpool Pleasure Beach all have in common?

Chapter 5

The old and new worlds of information technology in Britain

Maureen McNeil

IT AND 'NEW TIMES'

Some left analysts in Britain have heralded information technology (IT) as a major catalyst of new modes of production and distribution – sometimes referred to as 'post-Fordist'.[1] The new 'flexible' modes of production are seen, in part, to have been 'achieved through new technology, and the introduction of programmable machines'.[2] Beyond this, the new technology is seen as creating 'New Times' – dictating the framework for – or, at least, the parameters of – a new politics. What is striking about this reaction to IT is its treatment of the nature and form of technological change in Britain as inevitable and incontestable. While the contributors to *Marxism Today* and the segment of the British Communist party with which it is associated have provided an extensive analysis of the ideological dimensions of the hegemonic programme of Thatcherism, the specific form of the take-up of new technology in Britain is treated as a neutral backdrop to political strategy. More accurately, it is taken as a matter not of contestation, but of adjustment on the Left and the Right.

MRS T MEETS IT

Yet, from other vantage points the marriage of the Thatcherite and the IT revolutions has been assessed as a mismatch. In his review of the Thatcherite regime, Andrew Gamble concludes that, except as the hobby-horse of particular ministers (Kenneth Baker and Geoffrey Pattie), there has been little space for IT policy in its amalgam of liberal economics and Conservative social policy.[3] Some of the research fellows of the Science Policy Research Unit at the

University of Sussex, armed with the tools of Kondratiev long-wave theory and Keynesian economics, also have pressed the point that the Thatcher government failed to comprehend the structural nature of the IT revolution. This failure, they maintain, has resulted in the lack of an adequate policy to construct an appropriate British IT infrastructure.[4] I am not concerned with the merits of such claims here, rather I take them as a signal that there has been nothing inevitable about the form of the British take-up of IT. Despite this significant difference, these interpretations do share with the 'New Times' prognoses an underestimation of the ideological dimensions of Thatcherite IT policy.[5]

This chapter takes issue with these analyses in suggesting that IT has been an important component in the Thatcherite hegemonic project. My rather different interpretation results from viewing Thatcherism, as others have, as an ideological project[6] and, perhaps more distinctively, examining what I consider to be the relatively neglected ideological dimensions of IT innovation in Britain. The common tendency to assess technological orientation either as inevitable, neutral or exclusively economistically has made it difficult to comprehend this important facet of the Thatcherite project. From the perspective of this particular volume, it has also made it difficult to see the complex weaving of enterprise and heritage in and around the British appropriations of IT.

The bulk of this chapter addresses the ideological role that IT has played in the Thatcherite project and the texture of the tapestry of enterprise and heritage fashioned therein. The background for this in the preoccupation with what has come to be known as the 'British disease' is sketched first. I then review three key moments in the take-up of IT in Britain in the 1980s – what I term 'the ideological turn-around'; the public profile of IT entrepreneurs; and IT innovation within the training and education sector. What emerges is a picture of a peculiar national route to IT, which has placed enormous emphasis on the cultural rather than the economic facets of adaptation to the new technology. The final segment of my analysis considers the contestation of the peculiar Thatcherite IT regime. Together with many other Left analysts, I see the 1980s as a period of major international restructuring of capitalism, some of which has been facilitated by IT. The global and universal nature of this transformation can breed considerable political pessimism. It can also encourage a retreat into new forms of consumerist individualism which allows those of us who could experience some

material benefits from such change to celebrate rather than challenge the inequalities it generates. Nevertheless, as Anthony Giddens has argued (without drawing out the political implications) the nation-state remains the paramount global unit and information control one of its main features.[7] This serves as a reminder to me, at least, that we must understand the specific national dimensions of the IT revolution and struggle in and against those specificities.

THE BRITISH DISEASE: IT MEETS BD

The 1980s has been the decade in which British society was diagnosed as ill – suffering from the 'British disease'. Although, as Peter Scott explains, this metaphor of illness became associated with 'a confused and contradictory collection of causes and symptoms',[8] at the core was a reference to Britain's contemporary economic decline as the result of a cultural resistance to industrialism, entrepreneurialism and undiluted forms of modernization. A full-blown account of the origins of this malaise was provided by the American historian Martin J. Wiener.[9] An eclectic collection of sources were scoured in his documentation of the formation and solidification of an anti-industrial 'spirit' in Britain since the Industrial Revolution. The military historian Corelli Barnett echoed Wiener's contention with a much more systematic and original analysis of Britain's economic position.[10] Here was a powerful and appealing interpretation which garnered support across the political spectrum. Wiener's argument drew heavily on the work of left scholars including Raymond Williams and E. J. Hobsbawm. The thesis had close affinities with certain strands of the earlier left analysis of 'the components of the national culture', particularly that of Perry Anderson on the absence of a full-blown bourgeois culture (and revolution) in Britain.[11]

This is not the place for a full consideration of the 'British disease' thesis. A critique of its premises has been provided by Kevin Robins and Frank Webster.[12] What matters from the perspective of this chapter is the widespread circulation of the thesis and the way it shaped the take-up of IT in Britain. Internationally, the Information Revolution was being heralded as the dawning of a new age – the harbinger of changes even more dramatic than those associated with the Industrial Revolution. Against the background of the prevailing interpretation of Britain's economic decline as the

result of cultural inadequacies, the British road to IT has been 'peculiar'.[13] Far more than other national routes into IT, the British route would emphasize the cultural rather than exclusively economic dimensions. In effect, this would mean adaptation to what were considered to be strong components of the British heritage. But, before moving on to the ingredients in this national route to IT, we must review the moral lessons which were drawn from the analysis of the 'British disease'.

The core of Wiener's argument was that Britain's world dominance resulting from the Industrial Revolution had not been sustainable because of the backlash against the values and ways of life associated with that transformation. Beginning with the Romantic poets, continuing with the industrial novels and the essayists of nineteenth-century Britain, through to the late twentieth century there has been a long tradition of British 'cultural critics' of industrialization.[14] For Wiener, it was the 'containment of the cultural revolution of industrialism' which shaped the modernization process in Britain.[15]

Although Wiener was politically eclectic in the sources from which he drew, his message was pointed: the Thatcherite revolution had to be first and foremost a cultural revolution:

> At the end of the day, it may be that Margaret Thatcher will find her most fundamental challenge not in holding down the money supply or inhibiting government spending, or even in fighting the shop stewards, but in changing this [anti-entrepreneurial] frame of mind.[16]

Cultural criticism of industrialism was one tradition which was to be abandoned! Extrapolating from the belief that this 'frame of mind' had inhibited British economic development, it was clear to many that to succeed, full cultural foundations for a technological revolution must also be laid. It is this belief which has been the touchstone of the Thatcherite strategy around IT. My intention is to sketch some manifestations of this orientation. This will be done by considering three main facets of the profile of IT within Thatcher's Britain: the primary ideological reconstruction of the technological revolution, the profile of IT entrepreneurs, and IT and training and education in Britain.

WHAT'S IN A NAME?

In order to comprehend the ideological swings and roundabouts associated with IT in 1980s Britain, it is necessary to go back to 1978. In that year, a BBC Horizon programme – 'When the Chips are Down' (broadcast on 30 March 1978) – generated much public concern about the implications of a new technology – microelectronics. This new technology was presented as the harbinger of dramatic changes within the economic and social structure. Most ominously, it was linked to the spectre of widespread unemployment and job destruction. The impact of the programme was considerable. Even the Cabinet was treated to a special viewing.[17] The following January, the soon-to-be-chairman of the Manpower Services Commission, Geoffrey Holland, was host to a major conference designed to confront the new peril. 'Planning for Automation' was designed to provide a coming together of minds (management, trade union, etc.) for a sober review of how this spectre might be attacked, or, at least, how Britain might live with it.

In 1980 a new term came into circulation which cast the spectre in a rather different light. 'Information technology' sounded cleaner, more optimistic, more attractive. It emphasized the conceptual nature, rather than the hardware, associated with the innovations. The new term was not just a vocabulary clean-up, it signalled a change of perspective – to a more benevolent image of the technology. As Erik Arnold and Ken Guy explain, the new term provided a slogan for government policy[18] and a break with the associations of the new technology with unemployment and other social evils.

This episode epitomizes the elusive nature of the phenomena of IT in 1980s Britain. The ideological dimensions are multiple, even the very naming of the phenomena becomes part of the political negotiations and social constructions. Information technology then is never a pure matter of hardware, it is a medium for the construction of versions of the national interest, of visions of the future and of specific social relations. Yet, the attraction of negotiating many of these loaded ideological issues through IT is that they can masquerade as technical issues, matters of opting for or against progress, and so on.

The ideological shift was solidified during the recession of 1979–83 which resulted in a major loss of manufacturing jobs and cast the

negative prognoses about technological innovation in a new light.[19] The fears of potential job-loss were overshadowed by the immediate employment profile which was seen as due to causes other than new technology. Increasingly, unemployment was associated with lack of competitiveness and the new IT could be embraced as a way out of the recession. Of course, there was no guarantee that economic recovery would mean job restorations or gains, but expectations regarding the new technology flourished and were encouraged.

The positive associations of IT were further amplified through other vocabulary extensions – the 'sunrise' industries, Britain's 'sunbelt' (the area of the country in which the high-skill end of IT industries were concentrated). This industrial revolution was to banish the images of its predecessor – *the* Industrial Revolution – no big, noisy machines, smokestack industries or Dickensian factories. This was the sort of technology which the home counties could and did take into their bosom. It enhanced and accentuated its natural setting – making them into a 'sunbelt'.

Here there was a hidden distinction between the concentration of the high-skill end of IT industries in the 'sunbelt' and the use of IT in traditional industries. In fact, despite the attention given to the 'sunbelt', these regional disparities were sometimes integral to IT development in Britain as illustrated by the fact that the last generation of Sinclair products were *developed* in affluent Cambridge but *manufactured* in impoverished regions of Scotland and Wales.[20] Moreover, the naturalization of this IT environment as the 'sunbelt' – what Doreen Massey describes as 'that swathe of tamed rurality which stretches between Bristol and Southampton and round and up to Cambridge' obscured facets of the hierarchical relations within the British labour market.[21] The proposal that Intel should be located in a depressed area was overturned because such an environment was considered to be unattractive to dynamic, young professionals. In contrast to those who were being told 'to get on their bikes' this privileged group was most able to choose where it would live. This naturalization also deflected attention away from the economic foundations for the industry in its links with London financial institutions and defence establishments.[22]

As Massey explains, this region itself came to have a status and became associated with the cultivation of a new and distinctive style. This style embodied the fusion of enterprise and heritage: high-tech work for the mainly male entrepreneurs during the day,

with country life with their families in the evenings and on weekends.[23] Sinclair and Laura Ashley products were to be integrated into these domestic environments. Here was the best of 'old England' incorporated into the world of high-tech: village (or almost village) lifestyles, Cambridge traditions, etc.[24]

Internationally, IT has spawned a linguistic repertoire which could easily be drawn on in the British context not only to cultivate the burgeoning optimism about the new technology, but to underscore both the new consumer capitalism and some traditional values. The term 'cottage industry' was first applied to IT by Alvin Toffler in his early prospectus for the Information Revolution.[25] This was a particularly appealing image in heritage and homeowner England. Moreover, for some, the new technology promised a restoration of family values of a pre-industrial mode. Shirley Williams, for example, welcomed the prospect that 'Human beings can be made whole again, working and living in the same community. Microelectronics offer the opportunity of reuniting the family, and making commuting an obsolete and unnecessary activity.'[26] Some commentators have taken this further, developing the notion of 'family empowerment' as one of the most promising aspects of IT.[27]

This cosy label of the 'electronic cottage' and its high-tech accompaniment 'teleworker' embody an attractive image. Since the time of Toffler's original conjuring of the term, there has been considerable analysis of its components and heated assessments of the realization of the myth.[28] What is clear, is that there are strong ideological dimensions to this vision as Mike Brocklehurst explains:

> Flexibility and new technology home working are thus juxtaposed: the positive connotations of 'home' being used to reconcile people to what for many will be the casualisation of their work. In this context talk of 'extensive new technology homework' may just be an exercise in agenda setting, an attempt to establish a climate in which flexible patterns of work are seen as inevitable and acceptable and in which the workforce comes to reappraise its attitudes to and expectations of work.[29]

Aside from Brocklehurst's evaluation, such a picture of cottage industry could effectively marginalize fears of unemployment linked to microelectronics.

Moreover, the rosy aura made it difficult to see the problems of

real workers. In particular, when the various dimensions of the 'electronic cottage' are reviewed, those IT pieceworkers (mainly women) emerge, not as privileged, but as subject to the forms of exploitation common in other kinds of homework. As one commentator has put it: 'Just as it is a mistake to believe that working from home leads to freedom and autonomy and an end to supervision, so is it a mistake to believe that new technology automatically improves the economic position of employees.' [30]

Overall, the nomenclature of IT severed connections with earlier, more traditional patterns of work and industry and effectively obscured the social problems associated with the new technology. It was only critics like Ursula Huws (and later, Mike Brocklehurst) who dared to suggest that most 'teleworkers' would indeed be homeworkers – that highly exploited, isolated, largely invisible, mainly female workforce.[31] Likewise, it was only in the work of Doreen Massey that the social and political implications of the IT 'sunbelt' were spelled out – accentuated regional economic disparities and the reinforcement of the north–south prosperity divide in Britain.[32]

1982 was designated as British IT Year. This was yet another signal of the ideological reorientation. A host of special events, a rail-road show which travelled around the country, signalled once again the turn-around: IT was good for Britain. Kenneth Baker was appointed minister with special responsibility for IT and the country seemed set on its course for technological reconstruction.

Thus, we can see that the first strand in the Thatcherite strategy around IT was a turn-around in the popular perceptions of the technological revolution. Not all of this was the original creation of Conservative policy-makers. However, they were able to cash in on much of it and to accentuate the positive gloss on the IT revolution. In this strand, the main investment was in public relations – IT Year, an IT travelling show and a minister with responsibility for IT being the main ingredients. More generally, the shift from microelectronics to information technology opened the way for a linguistic repertoire which highlighted a benign image of this technological revolution – 'sunrise industries' and 'sunbelts', 'cottage industries' and 'teleworkers'. Seen from the perspective of the 'British disease', *this* technological revolution was proceeding the right way round: the cultural foundations were being laid; the cultural critics were being silenced. The benevolent imagery encouraged the belief that this would be a technological revolution without

victims or losers or social costs. Moreover, the new technology was being grafted on to British traditions – the cottage, the nuclear family, home counties lifestyles. Simultaneously, these adaptations enhanced the appeal of some central Conservative entrepreneurial policies such as home-ownership and workforce flexibility. Indeed, as I shall now suggest, it was the positive visions of winners in the IT revolution which danced in the popular imagination.

THE SELF-MADE MEN OF THE 1980s

The IT world is a domain in which multinational giants dominate. IBM, AT & T and less than a dozen other large corporations have spearheaded the IT revolution and realized its profits.[33] The main customers for these large firms are other big corporations, government defence agencies and only then the general public.[34] In his review of the state of IT in Western Europe, Ian Macintosh observed that, amongst European companies, only the Dutch multinational Philips could be considered to be in the running as a major corporate IT force in a domain dominated by American and Japanese firms.[35]

Nevertheless, the British press in the early 1980s presented a rather different image of IT innovation and competition. Judged in terms of the media attention devoted to him in Britain, Clive Sinclair appeared as the leading edge of the IT revolution. The latest 'brain child' of Sinclair enterprises was front-page news and his fortunes constituted an intensely capitalistic soap-opera – every bit as engaging as *Dallas*. Clive Sinclair and, subsequently Alan Sugar, became myths – the 'great white hopes' for Britain's IT future.[36]

The coverage of IT entrepreneurs in Britain was an important vehicle for consumer education and the creation of a mass market for certain IT products. The appearance of Sinclair as a media star was followed by the take-off of the British market in home computers. In the late 1970s easy-to-use home computers appeared on the British market. As Peter Golding and Graham Murdock have observed, the introduction of the improved Sinclair basic ZX model in 1981 and the BBC's launch of the two Acorn models for use with its computer literacy programmes in January 1982 were the signals of the opening of the mass market.[37] At the end of 1981, 200,000 households in the UK had computers. By the end of 1983, there were 2 million such households and Britain had the highest

number of home computers per capita of any nation in the world.[38] By early 1984, somewhere between 11 and 14 per cent of UK households were equipped with these machines.

The evolution of home computers as a mass-market product in Britain is an interesting case study of the interaction between users and producers. The product originated from hobbyist markets. Knowing how the computer worked and building your own model from components constituted the chief activities of the mainly male subculture, which often included clubs, etc. Leslie Haddon has suggested that during the BBC computer literacy series, launched in 1982, women were more attracted to the home computer.[39] The BBC was an important agent in broadening the profile of the machine to include its educational potential. Given this more utilitarian image, women regarded their computer education as a potential benefit for their families, breaking the association with masculine leisure. However, it has been computer games which have come to dominate the market for and use of the home computer in Britain. The IT revolution has meant more 'toys for the boys'.[40] While the likes of Sinclair and Sugar played for international stakes in the IT league, the users of IT were absorbed in imaginary power games on their machines. In Britain, this main appropriation of IT fed off and supplied a male subculture (probably predominantly white, and lower middle-class or upper working-class).[41] As Turkle describes their American counterparts, 'this is a culture of "lusers" [*sic*] who see themselves as an elite . . . they live with the self-image as "lusers" at the same time as they define their relationship to the machine in terms of "winning" '.[42]

In many respects, the publicity given to Sinclair's and Sugar's innovations and careers constituted free publicity for their products and helped to create a new niche in the IT market.[43] In both the public and private realms computers in the early 1980s became the dream machines in which British men invested economically and emotionally. In identifying with Sinclair and his cohorts, many men were seeking assurance that they weren't 'lusers' and also that Britain was not a nation of economic 'lusers'. Clive Sinclair was known to be 'Thatcher's favourite entrepreneur' and, for a period, he was viewed as the British 'David taking on the Goliaths of industry'.[44]

Sinclair and Sugar were, in effect, the prototypes in the popular capitalism the Conservative government pioneered. Their stories were mythical tales of private investment, risk taking, concern for the national interest and reward. The invitation for such involve-

ment in the nation's economy was extended in the calls between 1982 and 1987 for investors in British Telecom, British Gas, British Airways, and British Petroleum as the Tories developed their privatization programme. Hence, the popular engagement with IT entrepreneurs in the early 1980s was an important moment in the education for popular capitalism.

Likewise, the image of these innovators provided a positive gloss on the IT revolution. The products which Sinclair and Sugar marketed were modest items. Orientated around private, individual use, they encouraged the general Tory-sponsored trend in the cultivation of the individual as private consumer. Once again, IT took on a cottagey feel in Britain, thereby banishing its associations with powerful multinationals like IBM or big military applications (Star Wars, etc.).[45] Indeed, Sinclair's one-person vehicle and the home computers were toys for big, well-off boys. Moreover, the British public was made aware of the vulnerability of the innovators and managers – it was they who were at risk in the IT revolution. This was a vital diversion from the plight of unemployed workers in the recession of the early eighties and from the potential problems involved in technological restructuring.

In 1986 a new issue of Samuel Smiles's *Self-Help* appeared.[46] The republished version of this classic of 1859 was abridged and introduced by Sir Keith Joseph, one of Margaret Thatcher's chief deputies. In its original version, Smiles's bible of entrepreneurialism was a belated attempt to counteract the impact of the cultural critics of the Industrial Revolution and to celebrate the achievements of industrial heroes. Joseph's edition for the 1980s was a timely reminder that the Conservative government, as I noted above, was determined to win the cultural terrain in the new technological revolution. Moreover, the publication was also an indication that the Thatcherite revolution was always about the amalgamation of modernization with specific features of Britain's heritage. Britain's entrepreneurs were to be forward looking – men orientated towards the future, but also men steeped in clearly British traditions, who could be lined up with Matthew Boulton and James Watt – as self-made men of the Victorian hue. They were to be men who fitted traditional models of British masculinity.

Seen in this light, Sinclair (and somewhat less obviously, Sugar) were ideal English heroes. More accurately, they were picked up and widely circulated by British media *because* they embodied this forging of the Victorian self-made man and the IT entrepreneur of

the future.[47] Here were modest figures: English public-school boys in adult versions; English tinkers transported into the world of high technology and high finance. Their products, their markets and their ambitions were accessible – train-spotters could easily identify with their goals. The British might like JR on television, but their own, real-life entrepreneurs were to be very different sorts of men! The point here was that a very specific masculine image facilitated British education in IT, the opening up of mass markets for specific IT products, extension of the entrepreneurial vision and engagement with popular capitalism.

THE UNHOLY ALLIANCE: EDUCATION, IT AND 'THE NEEDS OF INDUSTRY'

The first two strands of the British route to IT involved a high investment in public relations and mythical heroes, a third strand was concentrated within the educational sector. Theodore Roszack has noted that, compared to other nations, Britain placed considerable emphasis on IT within education.[48] In Britain, there was a firm and early commitment made to bringing IT into schools and, subsequently, into other levels of education. This has been documented and scrutinized by other commentators.[49]

The late 1970s had witnessed another ideological review – this one focussed on education – but, in many respects, it dovetailed with the analysis of the 'British disease'. In October 1976, James Callaghan launched the so-called 'Great Debate' about education. That debate aired dissatisfactions with the British education system. Its main outcome was to lay the responsibility for Britain's economic decline at the feet of the educational system and to provide ammunition for those who wished to halt the democratization of, and progressive movements within, education.[50] The Conservative government which came to power in 1979 interpreted the 'Great Debate' as a mandate for the deconstruction of the comprehensive education system, the encouragement of private education, and a series of Conservative 'reforms' designed to improve the link between education and industry.

It is impossible to separate out the specific integration of IT within British education in the 1980s from this more general restructuring of education. In this respect, Kenneth Baker's move from the position of minister of IT to that of Minister of Education was indicative. This is also implicit in Kevin Robins and Frank

Webster's designation of the emergence of a 'neo-Fordist strategy for education', which they describe as involving 'an alliance between IT, vocationalism and the "needs of industry" '. They argue that the main features of Conservative 'reform' within higher education were centralization and withdrawal of government finance, in favour of the introduction of market forces. In the first case, the setting up of the National Advisory Board in 1982 was part of this process which has facilitated a general shift towards science, technology (including IT) and business education.[51] In the second, IT has been regarded as a main mediator of this reorientation (administratively and in terms of research and educational provision). The Thatcherite education regime spawned a plethora of initiatives which took as their goal the bonding of industry and education, including (to mention but a few): the Schools Curriculum Industry Project, Understanding British Industry, the Council for Industry and Higher Education and the Young Enterprise Scheme. Within many of these schemes IT had a high profile. In short, the advocacy of IT and support for the closer integration of education with industry became interchangeable. So, for example, the 1984 Report of the Information Technology Skills Shortage Committee (The Butcher Committee) advocated contract education for industry, training partnerships, more business consultancy amongst academics and generally more exchange between industry and education.

What was distinctive about IT's role in this general reorientation of the British education system around industry was that it gave a sense of urgency and national mission to this transformation, whilst proclaiming it as inevitable, or, at least, value-neutral. The Department of Trade and Industry pronounced in 1988 that it was vital 'to ensure that young people become aware of the value of information technology (IT) and that IT is used across the curriculum' because 'where young people are regularly using technology to enter, use and manipulate information at school, they will be better placed to help industry and commerce to compete effectively'.[52] Sir Keith Joseph spoke for many others when he pointed to the need to 'promote the nation's ability to seize the challenging opportunities of a technological and competitive world'.[53] The Information Revolution or, more accurately, the IT international competition which was being heralded made it even more imperative that British education should become industrially orientated. Indeed, much of the policy about IT originated in the Department of Industry rather

than in the Department of Education and Science.[54] Nevertheless, the spectre of an IT revolution made it possible to present much of the Conservative educational reform not as a political programme but as an inevitable trajectory.

Every sector of training and education fell under the aegis of at least one programme which sponsored the development of IT education. The Technological and Vocational Education Initiative which was introduced as a pilot scheme in 1983, became a national programme in 1986. This Manpower Services Commission programme was not restricted to IT. Nevertheless, together with the Micros in Schools (1981–4), Microelectronics in Education (1980–6) Programmes and the Information Technology Initiative (launched in 1982), it guaranteed the investment in IT and the expansion of education in this field. In 1982 the government introduced a programme to increase the provision for IT within universities. This was to extend provision for about 2,500 students in 1983–4 and to allocate 70 of the 240 'new blood' lectureships that were being established in British universities to the field of computer science. The extensive Alvey programme was the main British research initiative designed to bring together industry and higher education to secure innovations which would keep Britain IT competitive.[55] These specific developments were accompanied by broad-based calls for the integration of IT within all sectors and facets of education. So, the Council for National Academic Awards (CNAA) called for 'the development of information technology for education in general', warning that 'no course, in any subject area, should be thought immune from such developments'.[56]

ITECs, science parks and city technical colleges

While major programmes were pumping IT and its claims into all levels of the British training and education system, a few IT projects became flagships of the Conservative 'revolution'. This was true of ITECs,[57] science parks and city technical colleges (the last two were not, of course, exclusively associated with IT).[58] In each case, new technology was touted as the solution to major social problems and the key to urban regeneration. ITECs, which dated from the late 1970s, were invoked as the institution which would make the unemployable technologically skilled and bring down the high unemployment rate of inner-city youth. Science parks were developed as prime sites for co-ordination between industries and

universities, for the mutual exchange of expertise and the encouragement of enterprise. The twenty or so that have been established in Britain follow from an American model, and were expected to bring economic and employment benefits to the urban communities in which they were situated. Finally, city technical colleges, the brain-child of Kenneth Baker, embodied many of the aspirations of Conservative education policy. Through commercial sponsorship, elite, well-resourced educational institutions were to provide intense, specialized technical education.

In all cases, the aspirations for these institutions have far exceeded their achievements. The ITECs have had major problems including the fact that they have not attracted young women.[59] In addition, they have by no means realized their goals of dealing with inner-city youth and unemployment. Jon Turney and others have reported that science parks have not generated significant income, nor been the panaceas some anticipated.[60] To date, city technical colleges have barely got off the ground as an initiative because there has been such a limited willingness on the part of British commercial enterprises to finance them.

Kevin Robins and Frank Webster's evaluation that it is the symbolic, rather than the substantive, value of science parks which has mattered could be extended to apply to all three of these high-profile initiatives.[61] In each case, the Thatcher governments have paraded themselves as in the vanguard of the technological revolution. They have presented themselves as dealing simultaneously with major social problems – unemployment, urban decay, etc. – and doing so with technical fixes, denying the social and political inequalities that are the root of these problems. High technology enterprise has been a substitute for more fundamental initiatives that would have involved tackling the heritage of long-term inequalities in British urban settings.

IT, cuts and scarce resources

The profile of substantial innovation around IT obscured the fact that the educational sector was undergoing substantive cuts. In such circumstances, other programmes, particularly in the social sciences and humanities were being axed, while IT education flourished. Library budgets were cut, the physical environment of schools deteriorated, pupil-teacher ratios increased and teachers' salaries were pushed down.[62] In such a tight financial climate, IT

education was expanding at the expense of other educational priorities.

Any educational innovation linked to technology tends to encourage a preoccupation with hardware.[63] In this particular case, especially given the tightening of educational resources in Britain in the 1980s, this was inevitable. The primary goal for schools became getting the technology and success became measured crudely by budgets for technological innovation or pupil-to-computer ratios. For a period, the goal of a 'microcomputer in every school' was hotly pursued. This itself might suggest that the commitment to IT integration was more symbolic than substantive in that such a distribution hardly guaranteed mass access. Of course, there followed inevitable discussions about the suitability of equipment, compatible software and, even, how the machinery could or should be used. Nevertheless, for local educational authorities and individual schools in Britain during the early 1980s, it was hard to avoid the primary fixation with getting the goods.

Computer literacy

Complementing this fixation with hardware, 'computer literacy' became a buzz-word, up and down the country.[64] This concern must be understood first in relation to the general characteristics of preoccupations with technical measures of literacy. Brian V. Street insists that literacy practices of all kinds 'are located not only within cultural wholes but also within power structures' and that 'the very emphasis on the "neutrality" and "autonomy" of literacy by many writers is ideological in the sense of veiling this power structure'. In short, preoccupation with literacy rates often diverts attention away from the power relations which shape the access to and forms of education. In the case of computer literacy this tendency is intensified as the very association with technology itself seems to be a further link to neutrality. In this sense, the concept of literacy operates as a kind of technical fix – the promise that the goals of 'economic take-off, social mobility, cognitive improvement, etc.'[65] can be realized without tackling the issues of power and political relations.

Moreover, literacy scares have often operated as modes of national mobilization for conservative purposes to police initiatives within education. In the USA this was true in the Cold War period, particularly after the Soviet technological initiatives of

Sputnik, etc. Some analysts have suggested that a similar scare about literacy has been mobilized by right-wing educationalists to justify conservative and technicist forms of education in 1980s America.[66] Certainly, literacy rates are taken as fundamental indicators of 'civilization' and economic potential – low rates being a prime characteristic of 'third world' status. Hence, the mention of literacy rates in the context of fears of British economic decline inevitably generated fears of Britain becoming a third-world country.

These concerns resonate in the recent British preoccupation with computer literacy. Certainly fears of Britain's relative economic and cultural decline are mediated by these debates, and social and political dimensions of education and knowledge tend to be pushed to the sidelines, in the interest of a crude measurement of achievements in one sphere only.

Moreover, the widespread concern with computer literacy helped to push the burden of Britain's position in the IT world simultaneously on to the backs of educationalists and individual citizens. It became the duty of those within the educational system to make sure that new generations of citizens would be capable of making Britain technologically competitive and stopping the process of economic decline. The concept of literacy involves a labelling process – concerned with educatability – a base line of achievement. Hence it becomes the responsibility of individuals to get themselves up to certified standards, and those without such basic skills are seen as radically deficient. The notion of computer literacy is one effective agency for interpellating individuals into the restructuring process – 'their stake in the nation'.[67] It is also a way of 'blaming the victim' – those who are unemployed.[68] Such emphases, of course, precisely discourage the questioning or consideration of what skills are, or what they should be used for – their acquisition becomes the only end and literally a matter of citizen responsibility.

The other side of such responsibility, is, of course, its promise of freedom. The widespread investment in IT and advocacy of computer literacy for the masses is in many respects misleading. As Douglas Noble explains:

it makes no sense to suggest that a minimal understanding of computers will empower an already technologically impotent citizenry. Computer literacy does not provide the public with tools for wrestling control of these technologies from the hands of corporate decision-makers. In fact, it is much more likely that

a focus on minimal technical competence . . . will lead to a sort of pseudocontrol, a false sense that one has power simply because one can make a computer do a little something.[69]

In an assessment of the background of the main corporate heads of British IT firms, Robins and Webster suggest that it is not their technological expertise but their class-based privilege which has resulted in their powerful positions.[70] These assessments highlight the ideological dimensions of such calls for computer literacy. Such calls mystify the skills required by the new technology, whilst maintaining the myth of meritocracy and the denial of class privilege and distinction. Effectively, the notion of 'computer literacy' has spuriously suggested that reward is linked to enterprise and not to the heritage of race, class and gender divisions.

Thus far, I have concentrated on the general significance of the emphasis upon computer literacy. There are further dimensions deriving from the content of the programmes that were actually introduced. As Robins and Webster have argued, there has been a good deal of disagreement about what 'computer literacy' does mean.[71] Given the loaded ideological role that computer literacy occupied, it is not surprising to find that the content has been complementary: ' "computer literacy" and technological literacy programmes . . . engender passivity, acceptance, adaptation'.[72]

External dimensions of the IT revolution in education

It has been obvious that the developments around IT within education which I have been tracing in this section are embedded in the constructions of nationalism. The invocation of computer literacy has become a way of encouraging individual responsibility for the national economic profile. One of a series of MSC adverts to promote the YTS (Youth Training Scheme) programme which appeared in 1987 proclaimed: 'Watch out Japan, Here Comes Spikey Dodds [a YTS trainee]!' Spikey was being recruited to the economic battle of Britain, as part of the cure for the 'British disease'. In a similar, if less obvious way, preoccupation with computer literacy has been a vehicle for interpellating some of the population into the discourses of British nationalism and Thatcherite entrepreneurialism.

Beyond this, it is education which has been expected to carry the burden for Britain's place in the international IT race. Clearly this

has served to scapegoat educationalists for Britain's economic decline, whilst diverting attention away from other potential educational goals and economic strategies (e.g. investment in manufacturing industry, etc.) in a way that is less controversial than some of the more overtly ideological programmes of Thatcher's governments. After all, the Labour Party and the TUC also supported IT education![73]

Internal dimensions of the IT revolution in education

Educationalists are not yet in a position to evaluate the full dimensions of the IT revolution. But it is important to acknowledge that, particularly in the context of diminishing resources for education, the shift towards IT itself has constituted a major restructuring of educational priorities. It would be interesting, for example, to compare the fate of various anti-racist or multicultural programmes during the course of the 1980s with those of IT programmes in various schools, local education authorities, etc.

Resources have been allocated to spheres of education in which men predominate – both as teachers and as students. Within schools, colleges and universities, this restructuring has meant more jobs for the boys. Leslie Haddon has indicated that computer education provided a new trajectory within the teaching profession.[74] We know that it has been mainly men who have benefited from this, but as yet, there has been no major documentation of the impact this has had on promotions, hierarchies, resource allocations, etc. In 1983–4 all the 'new blood' appointments in computer science at UK universities were male.[75]

In addition, there is evidence that for students the gender relations of the IT revolution within British education provide reason for concern. Cynthia Cockburn has observed that: 'When a computer arrives in a school, boys and girls are quick to detect its latent masculinity'.[76] Moreover, according to a recent report, twice as many boys as girls have access to a computer.[77] Even more striking is the fact that while women constituted 25 per cent of the entrants to computer science programmes in UK universities in 1976, they made up only 15 per cent of this enrolment in 1987. Reflecting on the lack of equal opportunities for women in the IT sphere in the UK and reviewing the derioration of women's position in this field in the 1980s, Dr Elisabeth Gerver (Director of the Scottish Institute for Advanced and Continuing Education) com-

mented: 'Our culture continues to define computers as male machines.' [78] Against this general picture, the impact of WISE (Women Into Science and Engineering) Year (in 1984) does not seem significant. Indeed, some of the most promising initiatives for women in IT have been sponsored not by central government but by local authorities, with the support of the European Social Fund.[79]

CONCLUSION: PECULIARITIES AND PESSIMISM

As I have indicated, the IT profile of the Thatcherite project emerged from three ideological cross-currents: the 'Great Debate' on education, the prognoses concerning the 'British disease' and the linguistic constructions of the IT Revolution. Against this background and drawing on the resources these movements mobilized, the British conversion to IT was designated as first and foremost a cultural transformation. Hence, as I have outlined, some of the main government initiatives in this field have been around public relations and education.

However, my intention in this chapter has not been to provide a total overview of IT appropriation in 1980s Britain but rather to provide a sketch which would highlight some of the peculiarities of the British route. My hope is that an awareness of these will challenge some of the presumptions about the Thatcherite revolution and the neutrality and inevitability associated with the 'IT Revolution'.

To begin with, I take my study of IT in 1980s Britain as a reminder that enterprise and heritage were not opposite poles in the Thatcherite hegemonic project. Indeed, in the construction of the mythical IT entrepreneurs, in the attention given to the cultural profile of IT and in other dimensions of IT integration, we see a clear forging of enterprise and heritage cultures. The Thatcherite programme has indeed been a programme of modernization, but one which is very much woven on the loom of English traditionalism. The form of the recent Conservative vision of entrepreneurialism is itself intimately related to the historical analysis of the cultural inadequacis of preceding English bourgeois culture (the 'British disease'). Moreover, there are some threads (for example, the tradition of the cultural critics of industrialism) of British heritage which have been deemed inappropriate for the new cloth.

I have shown that IT comes not as a neutral force for change, but

as the carrier of (minimally) entrepreneurialism, nationalism, versions of masculinity, notions of citizenship and images of meritocracy (with the concomitant denial of class, gender and race divisions). As this suggests, the ideological and technological domains are not as neatly separate as many 'New Times' or 'Post-Fordism' researchers seem to believe. Within popular culture, it would seem likely that the ideological dimensions of the IT revolution will become more obvious since, as Ian Miles *et al.* describe: 'many small businesses and proud parents have discovered that purchasing microcomputers has not resulted in the much-touted improvements in their business performance or their children's educational achievements, that they were led to expect'.[80] Seeing aspects of IT in 1980s Britain in this light, I find it hard to regard 'a shift to the new "information technologies"' or the 'decline of the old manufacturing base and the growth of the "sunrise", computer-based industries'[81] as the neutral background of political struggle or as the reality to which the Left must adjust. Like Judith Williamson, I mistrust views that posit the 'New Times as an unstoppable and autonomous force' or as an 'internally directed set of neutral developments which right and left must then grapple over'.[82]

The miner's strike of 1984–5 and the disputes within the printing industry centred at Wapping in 1986–7 involved IT innovation. The 1980s also witnessed technological transformations in forms of police communication and state surveillance.[83] Notions of an 'Information Revolution' seem something of a bad joke in the face of the banning of trade unions at GCHQ (1983), the *Spycatcher* fiasco, the frequent invocation of the Official Secrets Act to suppress information that was embarrassing to the government (for example, in the cases of Clive Ponting and Sarah Tisdale), restrictions on the BBC and ITV, the exempting of government from data protection legislation, the resistance of Britain and the USA to UNESCO measures to establish a 'new information order' and the general contraction of public access to information in contemporary Britain.[84] Looking back on these developments in 1980s Britain it is impossible to regard IT as a neutral domain. Only political pessimism could encourage the belief that the outcomes of these struggles was (or is) inevitable. The political defeats of the 1980s can be put behind only through new forms of contestation, not through vacating the terrain of struggle.

The age of leisure

Ken Worpole

That 'ace caff with quite a nice museum attached', formerly known as the Victoria and Albert Museum, in the course of making redundant some ten senior academic staff at the end of 1988, issued in one of its many press statements a sentence describing the changes as being the result of having 'to apply the best practices of the leisure industry' to the future running of the museum. In Bath in 1988, crane manufactures Stothert & Pitt, one of the West Country's oldest firms, learned that it was to be broken up and sold by its new owners to release its 15-acre site for redevelopment; high land values had made the site much more valuable for shops, offices and leisure facilities than for traditional manufacturing. Former steel town Corby is soon to become the home of Wonderworld, the 'complete leisure city', which will feature a 4,200-seat concert hall, hotels, luxury villas, sports stadium and golf course, and endless other attractions and spending opportunities. The economic and social restructuring currently being undertaken in the name of 'leisure' in Britain seems to be happening faster than the political process can cope with. Has that much-hoped-for transformation from the realm of necessity to the realm of freedom already arrived?

Spending on leisure in Britain is now worth over £70 billion a year. Unevenly spread, subject to all the continuing inequalities of class, race, gender and geography, nevertheless in total there is more free time and more money to spend on enjoying it than ever before. Much critical thinking in the past has concentrated on inequalities at work, in housing, in education, in life chances; it is now time to think about how we address the problem of inequalities in a world of seeming abundance and free choice. What is the leisure boom really all about?

Well, to start with, it is now almost exclusively defined in terms not of activity, of doing things, but of spending. A recent survey from the Henley Centre claimed that consumer spending in 1987 on leisure was divided between spending on 'Creative Leisure' (3.8 per cent) and 'Non-Creative Leisure' (96.2 per cent). Their definition as to what distinguishes the two kinds of leisure may be contested in many ways; nevertheless, the absolute disparity between spending on participatory and non-participatory forms is fairly stark and certainly disturbing.

Leisure then is defined as spending: on alcohol, on eating out, on books and magazines, on buying radios, television sets and video equipment, on holidays, on admission prices for the cinema, theme parks, spectator sports and so on. Leisure has become yet another economic sector, and therefore much more amenable to the rhetoric of enterprise and business than to the age-old dream of free association, rest from work, play, a feeling of community and the creation of art and culture. In fact for many people in the past leisure actually took the form of active resistance to the disciplines of work, celebrating the good Saint Monday and other illustrious icons of the oppressed. Today one person's leisure is for many others low-paid, part-time and casual work.

For leisure is now described in the trade press, the business pages of the daily papers and in the mission statements of the company prospectuses as more consumer spending, more day trips, more meals eaten, more retail transactions, more jobs created, more investment, and so on: another great British success story for all concerned.

SHOPPING AS LEISURE

One of the most important issues which arises from the new leisure boom is the fairly recent but already commonplace assumption that a major form of leisure in the modern world is shopping. This has been argued by both Right and Left, and not unconvincingly. Shopping for clothes, records, books and furniture is seen as an important part of people's wish to establish their own personal style and cultural identity. But the rapidity with which High Street rental values and capital expenditure costs have now to be recouped through customer flow and turnover means that cultural styles have to change faster at the point of sale than they do at the point of cultural production. Hence pastiche. A clothes designer I talked to in the course of some research on craft industries in the Southern

region in 1988 complained that whereas there used to be only two seasons a year in the shops, they now wanted to change stock six times a year in order to create a faster turnover. To be out of fashion today is not to be wearing last season's outfit but last month's.

Along with the economic imperative of high turnover has come the continuing process of monopolization within the retailing sector, with the same twenty multiples to be found on every High Street and in every shopping mall: Benetton, Boots, Marks & Spencer, Littlewoods, BHS, Mothercare, Habitat, Burton, Dixons, Next, W.H. Smith, and more recently Body Shop, Tie Rack and a few other nationally known names. Britain now has the highest concentration of multiple dominance in Europe; in the UK 83 per cent of the retail grocery trade is controlled by multiples, compared to 26 per cent in Italy, 27 per cent in Sweden and 64 per cent in France. Of the 240,000 retailers in the UK today, the top 500 firms take 75 per cent of all shopping trade, and of that the top ten retailers take a massive 30 per cent. Cinema distribution and exhibition has for a number of years been in the hands of just two companies, Rank and Cannon, and bookselling, though economically buoyant, is now largely in the hands of three giant firms. The locally owned bookshop which may have stocked a higher percentage of books of local and regional interest as well as advertising evening classes, local exhibitions and concerts, and providing a small ads service for local organizations, is fast becoming a thing of the past. In record retailing W.H. Smith (now owners of Our Price and Virgin shops as well) dominates the market.

This shift towards the dominance of retailing by a dwindling number of multiple chains and companies can be seen from the following list I compiled in the spring of 1989 of all of the shops in three out of Bracknell's six town centre shopping parades:

Street A: Mothercare, Abbey National, local newsagents, discount store, Sketchley Cleaners, Early Learning Centre, Tandy, Lunn Poly, Etam, Jewellers Guild, SuperDrug, Laskys, D.H. Evans, Pizza Express, Southern Electricity, Argos, Gas Board, local travel agents, Print Express, Barratt's Shoes, Dorothy Perkins, Rumbelows, discount jewellers, Dollond & Aitchison, jewellers, Harvey's Beds (20 national, 6 local).

Street B: Barclays, NatWest, Midland, Pearl Assurance, Nationwide Anglia, The Leeds, Abbey Motor Insurance, Reed Employment, Woolwich, Diamond Staff Agency, local tobacco-

nist, Halifax, Prudential, Thomas Cook, Lloyds, Jobcentre, Ladbrokes, Brook Street, W.H. Smith Travel, Holland & Barratt, Alfred Marks, discount clothes shop (21 national, 2 local).

Street C: TSB, CAB, empty, NatWest, Victoria Wines, Fineweave Carpets, discount electrical stores, local estate agents, Millets, local motor insurance, Harris Carpets, Curtess Shoes, local dry-cleaners, Woolworths, Bejam, Oxfam, local video hire, local shoe repairs, local estate agents, Bible Bookshop, local fish and chips, Ladbrokes, Kall Kwik, local hardware stores (14 national, 9 local).

What mostly characterizes the local shops is that they are either short-life discount stores, or residual service shops such as those offering shoe repairs, dry-cleaning and estate agent services. The 'repertoire' of goods on offer in the multiple stores is highly standardized, the staff often part-time and untrained, and there is almost no connection any more at a local level between production and consumption. Interestingly the only local input into retailing is through the Oxfam shop and other charity shops, which perform not only a valuable recycling function in the local economy, but also offer the only possibility of finding non-standardized goods.

Yet we are assured that this highly centralized and endlessly replicated array of shops and financial services is a key ingredient of the 'new leisure society'. Something, surely, is wrong. For in Bracknell there are no specialist record shops, no antique shops, no picture framers, no angling specialists, no delicatessens, no independent bookshops or health food shops, no crafts or arts materials suppliers, no brasseries or wine bars, no music venues, no radio or electrical goods repairs, no designer boutiques, no second-hand bookshops, no wine-making or home-brewing shops, no cycle shop, no hand-made pottery suppliers, no hobbies shops, no women's centre or bookshop, no vegetarian restaurant. So what kind of definition of leisure is being used?

Gone too are the many forms of second-hand retailing – particularly in books, records and clothes – which have served the function of sustaining the 'back catalogue' or historical cultural repertoire of past cultural movements and styles: Left Book Club editions, Penguin Specials, City Lights poetry anthologies, local town and topographical guides, regional writers and dialect poets, fifties American and British jazz LPs, sixties folk revival records, seventies Soul, pre-war suits and dresses now back in fashion again, and so on. Without such a second-hand market, for example, the

current 'rare groove' music scene, heavily dependent on forgotten seventies American Funk/Soul albums, would never have been able to get established.

Already criticisms that every town now looks the same are echoed widely, and the thesis that municipal leisure provision equals uniformity now looks less convincing than it did before. The malls and shopping centres are often designed and built by the same construction firm, fitted out to the same specifications by the same design company, and policed by the same firm of security guards. And the private policing of shopping malls may well presage the shape of policing of the wider society to come, with the rapid growth of private firms in the past decade now accounting for there being one private police officer for every one public officer in Britain today. For what is most astonishing about this new age of leisure is how much policing and surveillance it seems to need.

THE PRIVATIZATION OF PUBLIC SPACE

The above would certainly be the view of John Hall, the entrepreneur behind the Metro Centre in Gateshead, the largest shopping centre in Europe and, according to contemporary Conservative rhetoric, first stage of the economic revival of the North-East. Every inch of the Centre and the surrounding car-park is monitored by cameras feeding a bank of video screens in a central security control room; in addition men with binoculars patrol the roof looking out over the surrounding landscape for any sign of trouble or 'undesirables' as they term them. A group of young people jostling each other or playing tag are moved on within seconds of a radio message being sent from the control room to the army of private security staff on patrol on the ground.

The design of the Metro Centre is such that there are no windows looking out on the surrounding Tyneside landscape; this is an architecturally structured private world. And this, quite consciously, is what Hall and his business colleagues see as a model for a future 'orderly society': the poor, the infirm, the unemployed without money, are to be excluded from this consumer paradise. (If Hall could identify them, gays would be excluded too, for he has also recently said that 'What I really think about gays is this: you should put them on an island; encircle them with a fence; and surround the whole place with sharks.' The Church Commissioners own the land the Metro is sited on; Hall is shortly to be awarded an

honorary degree at Newcastle University. He is also currently trying to buy Newcastle United football club.) There is little or no trade union organization amongst the people who work at the Metro Centre, and of course trade unions are not allowed either to recruit or picket in the complex because it is all private property.

And so is Basingstoke town centre, the site of a large shopping complex built on land recently sold by the Town Council to the Prudential Assurance Company. Basingstoke's most recent claim to public attention came in 1987 when the Women's Institute were refused permission to set up a charity stall in the town centre because it might be seen as undermining the business of local stores. Entering Basingstoke from the station, the only pedestrian footway into the town (a subway under the inner ring road) now belongs to the Prudential company who could, theoretically, refuse people access to the town centre if they so wished, a medieval situation if ever there was one. But in many ways much modern urban development is characterized by a conscious evocation of medieval forms: the private estates and shopping centres are designed as closed 'defensible spaces', and often have names embodying Anglo-Saxon references such as Keep, Moot, Point, Gate.

The selling of town-centre sites to private companies is a phenomenon that is rapidly gaining popularity in the energetically privatizing South: Aldershot and Dorchester are among other towns who have taken this decision – presupposing that the era of civic culture has come to an end and that the only important function left for town centres is shopping. The philosophy of the new retailers as expressed in a study by the McColl company, architects and designers of shopping centres, is 'Better a good 12 hours a day environment than a poor 24 hours.' This is almost a call for an evening curfew.

Many of the newer malls are designed without seats in order to deter the non-spending citizen from overstaying his or her welcome. Daytime clashes or altercations between young people and private security guards are not an infrequent occurrence in many centres, which was not the case when shopping was a function of the public High Street. More ominously, as was reported in January 1989, in Southend the council has backed a local traders' plan to employ a private security company to monitor its still public High Street, complete with ten video cameras and 24-hour monitoring, the interests of retailers presumably coming above the interests of citizens.

THEME PARKS AND PLAYGROUNDS

Elsewhere the private sector seems to be calling all the shots. As has already been noted, an ex-steel town, Corby, is to be the site of Wonderworld, a 90-acre £500 million theme park with a £10-per-head entry charge; Battersea Power Station (until the development company refurbishing it ran out of money in mid-1989) was to have catered for 6 million visitors a year paying £3 a head to visit the new leisure park being built there – and spending £25 on themed retailing during the 5–6 hours it was anticipated they would spend there. In presentations to potential investors the developers openly admitted that a key feature of the Battersea project was to 'break up' the family unit into serialized individuals, thus extending their length of stay and increasing their individual 'spend'. Psychologically, group identity is regarded as a negative factor in encouraging greater spending, and therefore it must be designed away.

Cortonwood Colliery, where the miners' strike erupted, may soon be the site of another theme park for the North; Flamingolands, Ocean Villages, Waterworlds, Cascades, and fifty-seven other varieties of private housing and/or leisure complexes are rising from the ruins of our industrial past almost everywhere.

Trail-blazing Torbay Council (the ones who brought you the housing ballot in which a 'no' vote really meant 'yes') have brought off a deal which will create 'Quay West', Britain's first privately controlled beach resort. The site of Crystal Palace, the great public exhibition centre of the nineteenth century, is being restored with taxpayers' money to provide a site for a Holiday Inn hotel and leisure centre, requiring Bromley Council to promote a parliamentary Bill to amend the original Crystal Palace Act to take out all the public access clauses. And as everybody knows, London's County Hall, the home of London government for nearly a hundred years, is to be sold for development as a hotel with shops and leisure provision as part of the same package. In a couple of years' time there will probably be an Aberdeen Steak House on the site of the old council chamber, and a Sock Shop where the Equal Opportunities Unit used to be.

Is it just metropolitan snobbery to criticize all these new developments, another example of the traditional intellectual contempt for the popular pleasures of the people? Perhaps. But rapid developments such as the current leisure boom do not happen in a political

or economic vacuum. In order for the private sector to flourish, the public sector rival (and former innovator) must be constrained, downgraded or made to adopt new principles. It has to be demonstrated 'that there is no alternative'. And this is exactly the pattern of recent years. An alternative tradition of catering for popular leisure has been systematically undermined!

Take for example current changes at the Natural History Museum. Following a visit by seventeen senior managers to Disneyworld in Florida in 1989, major changes have been instigated within the museum to restore attendance figures following a 40 per cent drop in visitors after admission charges were imposed in 1987. The new-look museum (£120,000 was spent on a new logo) will have new staff uniforms, three new restaurants, a new shop and new signposting. Visitors are now called customers in museum press releases, and a representative of the 500 employees at the museum has accused the administration of conscious economic elitism: 'We continually hear of ABC1s [Registrar General's social categories]. It is becoming a high-profile trendy museum. . . . The thing that is insulting to staff is that we are being told that the things we did before were not very good. The Disney approach is good. Fantasy is good.'

Museum charges, savage cuts in adult education spending, residential college closures, cuts in extramural classes, local government cuts in public leisure provision, reduced opening hours (and in some cases, closure) for libraries, reduced spending on parks and gardens, no new capital investment in public facilities, cuts in grants to voluntary arts organizations, legislation to make parents pay for educational visits and trips; all these – direct results of government policy – have been to ensure that the private sector leisure industry will prosper and older traditions associated with the public realm will disappear and die. This is precisely what is happening in broadcasting too: the public service tradition is being undermined in order to allow a deregulated and more profitable market to take over.

LOCAL GOVERNMENT AND LEISURE

Yet leisure takes other forms as well, and here again privatization is encroaching with confidence and speed. Competitive tendering in local government services means that some of the very best of public provision – sports centres, swimming pools, parks and

gardens municipally owned galleries, museums and theatres – could within the next decade be in private hands, and subject to pricing policies that make a clean break with the traditional principle of universal provision and access which, though flawed and often too passively interpreted, meant that there at least was a starting-point for a public culture.

As with the defence of the National Health Service, defence of public-sector leisure provision has to be one of critical defence. For it is clear that the traditional notion of 'universal provision' which after the settlement of 1945 became the watchword of public provision, had been allowed to atrophy from meaning 'something for everyone' to meaning 'we just open the doors and serve whoever comes in'. As a result, in education, in welfare, in health provision, and in public leisure, the most educated, the most mobile and the most tenacious have been the prime users of services, often far ahead of those most in need of them. Policy has failed to adapt to these changing circumstances and unexpected results of 'universality'; seeing the 'public' as an undifferentiated mass of people – particularly in an era of changing lifestyles and identities – has meant failing to see who precisely missed out. The 'Black Report' on the uneven benefits distributed by the National Health Service, the educational research of Halsey, Jackson and Marsden and many others, which has pointed to the continuing over-representation of the middle classes in higher education, have both shown that failure to differentiate, failure to compensate, failure to identify unrepresentative take-up of services, have all contributed to an even greater inequality in the usage of public services than had ever been possibly imagined. Here the Right has outflanked the Left in its attacks on public spending on the arts as being yet another example of the transfer of wealth and resources from the poor to the rich which only market forces can remedy and make equitable again.

When I and some colleagues produced a report on leisure provision in six towns in the South for SEEDS (South East Economic Development Strategy), *On the Town: A Strategy for Leisure and Choice*, we were dismayed to discover that the majority of forms of leisure provision we visited and assessed – sports centres, swimming pools, theatres, youth venues – did no monitoring of their visitors and users and therefore were unable to identify in any way whatsoever who their customers were and, more importantly, who their users weren't! Failure to identify users by

age, geographical location, gender, employed status, single-parent, pensioner, etc., meant that there was no basis for promoting the services to potential new users.

In the one case where statistics were kept – the monitoring of unemployed users of a particular swimming pool – then this group were under-represented at the pool by a factor of 20. A lot of rhetoric about free swimming for the unemployed had failed to have any effect at all; if anything it may well have deterred people. Something was clearly wrong. The service hadn't genuinely been promoted or tailored to meet specific needs. This was also the case with 'women-only' swimming sessions which have proved immensely popular in a number of places and capable of attracting a whole new range of women to swimming, yet which in some places had been programmed at inconvenient times, without a crèche and with male attendants. At one's most generous, let's just say that public leisure provision hasn't yet developed a notion of differentiated audiences, requiring differentiated marketing, pricing and servicing strategies. Yet this will have to come if the public sector is to meet the challenge of privatization in the 1990s.

Leisure consultant Mark Potiriades, planner of the UK's first out-of-town commercially developed and operated leisure centre in Watford, said in 1988 that 'Developers now think the time is ripe to exploit the experience gained over some 15 pioneering years of leisure centre provision by the public sector', presumably meaning that having shown that leisure provision can be popular in many ways, the public sector must now be moved aside in the interests of big business. A number of Conservative local authorities have already privatized their leisure and recreation facilities, and many others may well be forced to. In Bradford the recent Conservative administration considered selling off St George's Hall and the Library Theatre, and privatizing the management of its leisure services, including the Alhambra theatre which was highlighted by the government's 'Action for Cities' programme as an example of successful publicly-led city regeneration.

The government has made some concessions to the demand by local authorities that they be allowed to stipulate some conditions of sale or award of management contract, particularly with regard to concessionary pricing schemes for disadvantaged groups, as well as responding to other social needs. But will Mecca Leisure, Brent Walker, Crossland Leisure, Trusthouse Forte or any of the other large commercial leisure operators ever have the social

vision of Oxford City Council's Recreation Services department, with its 'Health for All' programme involving a widespread campaign of voluntary health and fitness testing, a policy of agreeing target groups for recreation and health promotion services, 'Look after your Heart' initiatives in workplaces and on housing estates, AIDS awareness campaigns in every sports and recreation centre, the promotion of an Oxford 'good eating' guide (a regulatory monitoring scheme on hygiene and food quality in the city's cafés and restaurants), and the involvement of local doctors in promoting the local recreation services? As yet Oxford may be the only town or city in the UK in which a GP can prescribe free swimming lessons in the local authority pool, but let's hope it won't be the last.

The Sports Council, in its excellent report, *Into the 90's*, sees a widening divide between provision for the generally wealthy working population and that for the poorer sections of the community, often unemployed, in urban and rural areas with a declining economic base; arguing that the latter's needs may well be adversely affected by privatization. Some Labour councils have, through inadequately conceived concessionary schemes, given the impression that they are only interested in providing for the disadvantaged, and by default have encouraged the better off to look to the private sector. The key principle surely of any notion of a civic culture is that provision must be for all, even though differentially provided?

Certainly a policy for leisure that only regards leisure as a mode of consumption will simply mirror the inequalities of wealth and power that already exist: if you can't afford it, you can't have it. Yet ironically it is the unemployed, the prematurely retired and the elderly, among others, who have additional time available for recreation and leisure, yet who precisely don't have the disposable income to buy it in the market-place.

LEISURE THROUGH SELF-ORGANIZATION AND CREATIVITY

Yet, as has been demonstrated, state or public provision has not been an unqualified success story. There is a need to develop a new approach to the public and civic realm in education and leisure. And here we come again to those pre-statist socialist ideals of self- of corporate decision-makers. In fact, it is much more likely that

for leisure today? Well of course it is already, although more as a subterranean world then as part of an articulated public or commercial strategy. For Britain is honeycombed with voluntary organizations devoted to an enormous range of popular and specialist arts, sports and leisure activities. They survive against the odds, and often against the indifference of local authorities and government agencies (in which attitude Labour has often been little different from the Conservatives).

Still the most detailed attempt to quantify this world came in *Organising Around Enthusiasms: Mutual Aid in Leisure* by Jeff Bishop and Paul Hoggett. Their study of voluntary leisure organizations in two districts, one in Bristol and one in Leicester, uncovered an enormous range of activity in both. In the former area, a district with a population of 85,000, they were able to count some 300 voluntary clubs and societies, and in the latter district with a population of 68,000 they counted 228 organizations. From aero-modelling to aerobics, morris dancing to mouse fancying, painting classes to pigeon racing, yoga to yachting, they found a diversity of hobbies, interests and skills, which could never be accommodated by the multinational leisure companies. Nationally one might well expect similar levels of participation and self-management, and Jeremy Seabrook's excellent chapter on 'Ordinary passions' in his study, *The Leisure Society*, helps confirm the strength of this tradition.

Surely here is the key to a major historical tradition of leisure that we should aspire to: the question is, then, how to support and resource such a tradition without killing it dead? For ironically one of the quickest ways of destroying the 'voluntary sector' is to flood it with money and consequently professionalize it. This is likely to become a crucial issue for local authorities, as their powers of direct provision are further constrained, and yet as many of them still, rightly, aspire to protect some form of civic culture. In the intensifying ideological struggle over the meaning of 'leisure' in our society, there is some serious new thinking to do, and a lot of paternalistic baggage to throw overboard. For which political parties are yet ready to trust people to do things for themselves? Or, as a leisure boom based on consumption continues, likely to be found arguing for leisure as a voluntary activity?

So if one decides to move away from the notion of leisure as consumption, what might be (and often have been) the character-

istics of leisure as a form of creativity and self-expression? I would suggest these themes:

1 The acquisition of skills, and the pursuit of interests in depth (this surely is the tradition of most amateur hobbies and interests, whether bird-watching, pigeon-fancying, knitting and embroidery, gardening, competitive individual and team sports);
2 A close link with both formal and informal modes of education and self-education – evening classes, weekend schools, Open University, specialist magazines, rallies, conferences and annual meetings;
3 Organization through self-management, through participation in voluntary organizations, local, regional, national and international networking;
4 Participation and expertise moderated by the judgement and approval of peers, rather than external or arbitrary bodies;
5 Sharing of resources and major capital items of expenditure, meeting in other people's houses, in church halls, in library rooms and rooms above pubs, making own equipment, swapping equipment or buying second-hand through specialist magazines;
6 Creating new forms of social and public space where people can meet across class lines (train-spotting, dressmaking), or specifically just among women, or through an ethnic identity, or across a wide age range (chess clubs, photographic societies, yoga classes);
7 Leisure as both home-based and providing networks outside the home for further development and association with peers;
8 Leisure as a major form of self-expression and personal identity – people are more likely to describe themselves as a keen swimmer, photographer or stamp-collector than they are a keen shopper or theme park visitor. In the former the identity is retained by the individual whereas in the latter the identity of the activity is always retained by the providing organization.

Yet a world of 'amateurs' poses problems. The distinction between 'amateur' and 'professional' cultural activity has bedevilled cultural theory in this century (where it has actually been registered), and certainly cultural policy too. The Labour Party has some of its political origins in traditions of cultural self-organization and representation. Yet in power its only policy on the arts has been to finance the Arts Council to fund professional artists and compa-

nies. (The English Folk Song and Dance Society, a cultural aberration to the mandarins, has always been funded by the Sports Council!)

Yet times are changing. The growth of community arts in the 1970s began to enable links to be made with forms of popular leisure and self-representation, particularly in photography, writing, and the development of neighbourhood festivals. The decision at the end of 1989 to merge the Crafts Council with the Arts Council also offers hope to those who may now feel that production for use (woodworking, pottery, knitting and embroidery, weaving, for example) can also be among the validated arts.

I am convinced that it will be much easier to elucidate leisure theory once we have overcome the historic divide between amateur and professional arts and leisure activities, and that specific project should be one of the most important priorities for cultural theory in the next few years. The pleasures of consumption are many, but so bound up are the limits of those pleasures with the economic system they reflect that they are given to us – and taken away – in the most arbitrary of ways. We are always beholden to others for these things, particularly when they come to us simply as commodities produced by an economic system that allows for very little local accountability or control. But if we regard leisure as a form of self-organization, mutual association and popular production, then we are beholden only to ourselves and our peers, and what we can learn to do with our leisure we may one day learn to do with the world beyond.

Chapter 7

'Up Where You Belong': Hollywood images of big business in the 1980s

Judith Williamson

Those qualities of enterprise and initiative which are essential for the generation of material wealth are also needed to build a family, a neighbourhood and a nation which is able to draw on the respect, loyalty and affection of its members.

Douglas Hurd (Home Secretary), 1988[1]

Protestant cultures have a long legacy of investing business enterprise with moral value. 'If God show you a way in which you may lawfully get more than in another way (without wrong to your soul or to any other), if you refuse this, and choose the less gainful way, you cross one of the ends of your Calling, and you refuse to be God's steward.'[2] Thus wrote Richard Baxter in 1678; he spoke a language many would understand perfectly in the 1980s. Yet the values of capitalism and the qualities of 'respect, loyalty and affection' do not always sit well together, and if the late 1980s has been a period characterized by business and 'enterprise' culture, it has also been characterized by a profound sense of moral unease, one which has found no focus or lead from a Left engaged in 'winning back' individualism from the Tories. As so often happens, advertising has been the quickest part of our culture to pick up on this moral anxiety and among the images of go-getting yuppiedom, banking ads in which young men in red braces terrorise fuddy-duddies, glamorized cut-throat competition in series like *Capital City*, we already see ads for the 'Amicable Man' who makes time to be nice to the tea lady and plays with his children, and are offered cars for the 1990s which appear to embody spiritual values rather than those of the boardroom. But the great achievement of Hollywood cinema in this period has been to dramatize both business achievement *and* the social indignation it engenders,

within the same moral framework, a single narrative. The most satisfying (and popular) films are those where success and righteousness dovetail as neatly as in the Home Secretary's wishful words above.

Business-themed films of the 1980s developed, significantly, as life-swap stories. *Trading Places* (1983) is the warm-hearted Christmas tale of Eddie Murphy's rise from street-hustler to financial wizard as two billionaires, for a bet, engineer a switch between his down-and-out street life (Murphy plays Willie-Ray Valentine, a *fake* blind and crippled beggar) and the privileged WASP existence of their nephew and protegé Winthorpe. The immediate outcome of their gamble is that Valentine becomes a meteoric success on the stock market while Winthorpe degenerates to the point of stealing food and threatening to kill people. Obviously, the idea that 'anyone can do it' is a key component of enterprise culture – the basis of countless 'initiative schemes' in the 1980s – but the enormous pleasure produced by the first half of *Trading Places*, as the two men swap lives, comes from the righteous sense of Valentine, poor and black, winning out over a pompous upper-class jerk – and without losing his own values along the way. Social justice and enterprise ideology flow together seamlessly, a perfect form of having your ideological cake and eating it. This idea is underscored by the very last lines of the film. After Valentine and Winthorpe have joined forces to pay back the billionaire Duke brothers by bankrupting them on the trading floor, they celebrate on a tropical island along with their two helpers, a prostitute and their butler. One character asks, 'Shall we have the lobster or the crab?' and the reply comes, 'Why can't we have *both*?'. *Trading Places* itself offers both; on the one hand, an image of business and businessmen as ruthless and, on the other, business as the means by which justice ultimately prevails.

One of the most interesting aspects of the Murphy character's success in *Trading Places* is his apparently natural insight into commodities. When the Duke brothers are initiating Valentine into the world of stock market deals he amazes them by having what seems to be an instinctive sense of its movements, suddenly predicting that pork belly prices are going to keep falling and that they should wait until they drop further before buying. When asked why he thinks this, he comes up with an extraordinary speech:

'It's Christmas time, everybody's uptight. The pork belly prices have been dropping all morning. The guys who have the pork belly contracts are goin' batshit. They sayin', Christmas is right around the corner and I ain't gonna have no money to buy my son the GI Joe with the Kung Fu Grip . . . My wife's gonna stop sleeping with me 'cos I ain't bringin' no money. . . . They out there panicking right now, I can feel it. They yellin', sell, sell, I can feel it. . . . I'd wait until you get to 64 cents then I'd buy.'

They do as he says and rake in a profit. A few scenes later, the apparently clairvoyant Valentine is telling an entranced dinner table, 'The Russian wheat harvest isn't gonna be as bad as everybody thinks. . .'.

On one level it must be said that Murphy plays Valentine as a bluffer and hustler. Nevertheless his extraordinary success is attributed to a combination of common sense ('It's Christmas time. . .') and intuition ('I can feel it. . .') and this notion that the capacity for business success is located deep in the most 'natural' characters' hearts finds expression over and over again in the business films of the 1980s. In *Working Girl*, the Melanie Griffith character is clearly 'a natural'; also drawing on common sense and, crucially, popular culture, she puts together deals on the basis of gossip columns and intuition. When called upon, at the climax of the film, to prove that the idea for the big deal was her own, she presents the 'Suzy' page of a popular chat magazine and shows that her connection between a radio network and the billionaire investor Trask arose from the chance juxtaposition of a society piece on his daughter's wedding and a tiny article about radio. *Working Girl* is another business film that espouses social justice; its working-class heroine wins out over her upper-class-bitch boss (Sigourney Weaver) without ever betraying her loyalty to the girls in the typing pool. At one point in the film Griffith and her lover (Harrison Ford) drink a toast: 'Power to the people', he proposes, and she adds, 'The *little* people'. Nevertheless, it is the biggest person of all in the business world, Trask, who God-like brings about justice, recognizes that Griffith and not Weaver is the 'true' business woman/good person, and makes things right in the end by giving Griffith a top post in his company.

The very littlest people who become successful in business films are *children*, in the spate of child/adult life-swap movies of the 1980s. In *Big*, Tom Hanks makes a wish and suddenly becomes an

adult, while inside he is still himself, a little boy. This film, like *Working Girl*, is fascinating from the perspective of sexual politics but it is significant in relation to business and enterprise for its premise that the ideal consumer is also the ideal business person. The 'big' Hanks, finding he has to work, gets a job with a toy manufacturing company; his career takes off when (being really a child) he starts playing with some toys on display and the boss – another romantically benign yet powerful daddy-figure – joins him in jumping on a giant keyboard. Businessman and consumer make perfect music together; the distance between the two ends of manufacture is collapsed. There is a constant emphasis here on the *product*: as they play ecstatically with the toys one says to the other, 'You can't see this on a marketing report' and the other says dismissively, 'What's a marketing report?'. The film relishes images of Hanks inventing new and successful toys while ignoring graphs and figures he doesn't understand. This theme is echoed in the less resonant life-swap movie *Vice Versa* where a father and son swap bodies; the father works for a musical instrument company and the boy-adult is discovered by the managing director enthusiastically playing the drums on display in the corporate building.

It is not only women, children and blacks who have a natural sense of business. *The Secret of My Success* (1987) brings out this 'natural insight' in the heart of a young white man (Michael J. Fox), a wholesome country lad who starts out as post-boy in a big firm but, by secretly changing into a business suit and pretending to be a senior employee (taking over an empty office, putting up wallcharts and going to meetings) *becomes* what he is pretending to be. Like Melanie Griffith in *Working Girl*, who impersonates her boss while Weaver is laid up after a ski-ing accident, he 'is' a business person simply because he is 'being' one. When Griffith dresses up in Weaver's clothes and puts together a multi-million deal, who is to say that she 'is' still a secretary? Fox's pal in the post-room refers to the big executives as 'suits'; and when Fox changes in the elevator into his suit, that is exactly what he becomes. In a brilliant essay on the gangster film, Robert Warshow has said that 'film presentations of businessmen tend to make it appear that they achieve their success by talking on the telephone and holding conferences and that success *is* talking on the telephone and holding conferences':[3] *The Secret of My Success*, in particular, is a perfect illustration of this point.

There is something profoundly existential in the idea that you

become what you do. Yet in these films there is also a sense that what the characters do (business) becomes endowed with what they are (good). All of them 'show up' the unfairness and dishonesty of capitalism. *Trading Places* reaches its climax with Winthorpe spelling out the unscrupulous methods of the stock exchange. In *Big*, Hanks' best friend (still a kid) comes to visit him in the company office and picks up a toy marked $59.99. 'You know that only costs $10 to make?' says Hanks, letting the audience into a simple Marxist truth. But the fact that he, as an 'innocent', does so well in business tends to suggest that business in a way is innocent too. In *Working Girl* the multi-million dealer Trask is virtue personified (in the film's terms, that is; we hear that he has smashed trade-union activity throughout his industries but in the plot structure he creates all happiness and justice). All the competitiveness and dishonesty of business are, in this movie, off-loaded on the Sigourney Weaver character, the already wealthy schemer who steals Griffith's idea. It is central to the successful marriage of business and ethics in these films that we focus on one *individual* (or occasionally two): the good person who comes from outside the system (Fox grew up on a farm, Charlie Sheen in *Wall Street* comes from a working-class background) and can therefore represent all the values capitalism is shown – initially – to negate. Their success within the system then seems to endow it with precisely those values.

This isn't a simple process, however, because it always leaves the question of where to 'put' the bad values. A Sigourney Weaver figure is one solution. But more broadly, I would say that the very prevalence of life-swap and *doppelgänger* themes in these movies suggests an ambivalence towards, and sense of polarity within, the 'ethics' of business; a recognition that there are deep contradictions within the moral framework each film employs. Nowhere can there be a more baroque combination of the life-swap *and doppelgänger* formats than in the comedy *Big Business* (1988) which involves *two* sets of *identical twins* mixed up at birth. One of the scrambled pairs grows up in the country community whose entire livelihood depends on an industry owned by the city company inherited by the other pair. This allows a separation of values between the financial side of business (City/slick/ruthless) and the production side (Country/quaint/wholesome). Just as the child/adult life-swap films focus heavily on the product – the actual 'stuff' of business – via the consumer, who 'understands' it, so films like *Big Business*,

Baby Boom and, to some extent, *Wall Street*, remind us of manufacture itself, the factories and employees (these even get an honourable mention in the super-financial *Secret of My Success* when a waitress – an ordinary girl – makes Michael J. Fox realize it's bad to close factories down). In *Big Business* the city company is about to close the rural factory and the plot hinges on the country twins coming to town to fight the closure and finding themselves confronted by an identical pair of non-identical twins (both lots played by Bette Midler and Lily Tomlin).

The twin theme is a perfect device for separating out the 'good' and 'bad' facets of business. But it is also a vehicle for discussing what is and isn't inherent – something which deeply preoccupies all these films. Is there such a thing as a genetic yuppy? In *Big Business* both the Bette Midler characters, despite their different upbringings, crave designer clothes and power. Both the Lily Tomlin twins wear 'save something' badges and are vague and non-materialistic. The Duke brothers' bet in *Trading Places* was explicitly about the heredity/environment debate; Valentine's success once given the chance would suggest environment had won, yet the 'naturalness' of his business sense cuts across that theory. *Big Business*, too, operates right on the cusp of these ideas, for the country twins do, in the end, fight successfully for their values despite the inherited leanings towards yuppiedom of one of them. Michael J. Fox's secret of success appears at first glance to be his miraculous costume-changing and the acting out of his business role; yet perhaps it is also in his corn-fed nature because even as a poor boy, he assures us, 'I believe in myself . . . deep inside I know I can do practically anything if I get the chance.'

The fundamental confusion in all these films around the issue of whether success is something 'inherent' or something earned takes us straight back to Calvinism with its central and irresolvable dilemma of whether goodness is inherent in God's predestined Elect, or whether it consists of *being* good, actively working towards one's salvation. This is not merely an analogy. The complicated and contradictory culture within which these films are made and which they so richly rearticulate is a direct legacy of the culture in which writers like Richard Baxter agonized over remarkably similar issues. The lifeswap movies, in particular, are very preoccupied with the sense of the 'real me' inside, and in other ways movies like *Secret of My Success* and *Big Business* are about the discovery of the self, as well as the creation of a lifestyle. The very

notion of lifestyle – one of the key concepts of contemporary culture – is based on the interesting proposition that, since what you have around you is a reflection of your self, changing it will simultaneously change that self, while – paradoxically – expressing what was there already. The great Calvinist question was, if you do good works, are you expressing your inner goodness or does goodness itself consist of doing good works? A 1980s version might be, is the secret of Michael J. Fox's success in his heart, or in his suit?

What is so interesting about this whole double bind is that it perfectly fits the contradiction at the heart of 'enterprise and heritage' culture. At exactly the time when our culture is obsessed with enterprise (a starting from scratch notion, 'anyone can pull themselves up by their bootstraps if they really want to', etc.) we find an equally strong preoccupation with heritage, in other words, with all that is already given. Heritage and enterprise correspond very closely to heredity and environment in the Duke brothers' bet; as they hatch the plan to unleash Eddie Murphy's capacities for enterprise, they are actually drinking in the Heritage Club ('Founded 1776: Liberty and Justice for All' says its brass plaque) to which Winthorpe also belongs. The successful foiling of the Dukes' plans by Valentine *and* Winthorpe represents the perfect combination of enterprise and heritage. Enterprise and heritage need one another in ideological currency because when enterprise seems greedy and cut-throat, heritage can provide *noblesse oblige*; but when heritage appears snobbish and unjust, enterprise can be meritocratic and open. Because of this oscillation, there is no easy ascription of nature to one and culture to the other, and just as the use of life-swaps and twins in these films expresses a sense of contradictory values that might not be resolvable through less complex plotting, so the recurrent city/country imagery in business films (as in the Habitat catalogues of the mid-1980s) fulfils contradictory functions which may shift during the course of a movie.

Baby Boom (1987) provides the best example of this. It opens in the sterile environment of Manhattan yuppiedom, as Diane Keaton and her boyfriend have stop-watch sex in their coldly (i.e. modern) furnished apartment and run top business careers in large companies. Keaton is both promoted to a top post and inherits a baby, which at first she has no idea how to handle. Then she quits work and moves to the country, a quaint New England village where she

buys a rambling house with an apple orchard. *Baby Boom* doesn't, initially, romanticize this set-up; pipes burst, locals are boring, and snow lasts half the year. Nevertheless, visually the film only becomes really luxurious in the country sequences: Keaton and baby drive through a golden New England autumn to their new home and the initial difficulties start to be overcome once she finds a lover (Sam Shepard). The country represents a wholesome alternative to the city and business, but one which still has its drawbacks. The denouement of *Baby Boom* is that in this natural location Keaton also discovers her natural capacity as a mother, and starts making her baby apple sauce from the fruit in her orchard. This sells well in local shops and then – in a montage sequence of ever-larger production lines – expands into a nationally successful business. At this point Keaton is approached by her old company and she has the satisfaction of turning down an offer from the sexist pigs who once demoted her – for the first half of the film shows vividly how incompatible motherhood and the values of 1980s business really are. By the end, however, *Baby Boom* is showing us that Keaton can be a good mother *and* make lots of money; the contradictions are miraculously resolved. The moment she finds her 'natural' self, she starts to grow wealthy: the country becomes profitable, business becomes wholesome, and, once again, moral and financial success coincide.

There is an obvious parallel between the Diane Keaton figure here and someone like Anita Roddick, whose Body Shop chain has been one of the success stories of the business world in the 1980s. In both cases, nature becomes the 'stuff' of business: 'natural' products both sell well and make business itself seem more natural. It is interesting that just at the point when *finance* (the buying and selling of money, a currency about currency) has superseded *manufacture* as the supposed cutting edge of capitalism, mainstream movies about business are focusing more and more on *products* and those who produce and consume them. Perhaps there is an analogy here with the obsession in US politics of the 1980s with 'getting rid of the middleman' – a kind of anti-bureaucratic populism. *Wall Street* (1987), an extremely ambivalent film which tended to glamorize financial wheeling and dealing, nevertheless suggested morally that speculation was bad and 'real work' good. Martin Sheen, as Charlie's natural father and Union Rep in the aircraft company the ruthless surrogate father Gekko wants to destroy, stands in a way for the real world on which the endless

circuitry of high finance rarely touches down. It is intriguing that for vehicles of mass culture in a supposedly postmodern age Hollywood films are remarkably interested in what might be called the stock market's *referents*, the actual things dealt in by big business. And it is the 'real' people, who are close to these 'real' things (radio, pork bellies, cornfields, airplanes, apples) who are shown as having the power to succeed in that slippery world.

This is in itself neither inherently 'progressive' or 'unprogressive': the championing of the 'little people' has long been a dimension of Hollywood morality (perhaps partly a response to its own corporate set-up?) whose apotheosis is found in films like Frank Capra's *Mr Deeds Goes to Town* (1936) or *Mr Smith Goes to Washington* (1939) where moral individuals fight the system and then succeed in the system, ultimately validating it. The business movies I have discussed are very much in this tradition: *Trading Places* is set in Philadelphia among statues of US presidents and endlessly cuts to brass plaques saying things like 'freedom and equality'. The success of western capitalist culture has always hinged on its ability to absorb whatever opposes it. But what has been so striking about the last decade in Britain has been how very little *has* opposed it. In particular, the abdication of a concept of morality (or of any values beyond the material) by much of the Left has fed into a sense of lack, a loss of meaning and depth, which has to some extent been made good by the very popular culture which is meant to be all surface and self-reference. Hollywood's preoccupation with the material world and with direct relationships within it (consumers relate directly to manufacturers; workers directly confront owners) could not be guessed at from the preoccupations of *theorists* of popular culture in the 1980s. During this time it has become increasingly fashionable to regard cultural forms as closed circuits which refer only to one another. Yet I would argue, it is not popular films about business which are becoming increasingly remote from the 'real world' but big business itself; whose remoteness these movies seek somehow both to challenge and to bridge. While the Left in Britain has tended to lose interest in manufacture and, to quite an extent, in the working class, Hollywood movies remind us with some energy that they exist and asks us, in narrative terms, to throw ourselves behind their representatives and root for their triumph.

Working Girl starts and finishes with its heart-rending theme song, 'The New Jerusalem' – '*Oh . . . my heart is aching. . .*' –

which, accompanying the ferry ride to Manhattan at the beginning, suggests a yearning for success and recognition in the big city. But by the end it suggests more: a yearning for righteousness, for moral value. These films, easy to criticize politically, can also prove deeply moving because they are about delving into your heart for the material of business – a process which throws up a range of other qualities and emotions such as courage, loyalty and honesty. The elevation of the righteous (who are also, in these films, the successful) then feels like the arrival of virtuous souls in heaven. The 'success' montage in *The Secret of My Success* has a feel of paradise about it: a landscape of businessmen on sweeping grass hills cut to choral music gives the sense of business taking place in the Garden of Eden, and in *Working Girl* the song's very title, 'The New Jerusalem', suggests a similar idea. One of the key movie-associated songs of the last decade has been 'Take You Up Where You Belong', which played in *An Officer and a Gentleman* as Richard Gere, after becoming an officer, literally picked up his girlfriend and carried her from the shopfloor, out of the factory where she was working. Rising 'up where you belong' can have at once profoundly spiritual and totally material connotations: it involves social betterment – itself a politicizable issue – *and* a sense of 'higher' values, an ethics beyond simple greed. Without recognizing the power of their combination it is impossible to explain, for example, the intensity of the final sequence in *Working Girl* where the camera swirls away from Melanie Griffith – whose first impulse on her promotion is to call her old pals in the typing pool – leaving her high, high up in a tall building as the strains of 'The New Jerusalem' fill the sound-track and the skyline fills our vision: the movie equivalent, surely, of a cathedral roof ringing to the sound of hymns.

There is much that could be said about business imagery in British movies and television during the last decade. Gangsterism, long an American metaphor for big business, has been the focus of the few films which have seriously addressed changing values in the world of finance (*The Long Good Friday, Empire State* and *Stormy Monday* are the most obvious).[4] TV series like *Capital City* have brought us the glamorized private lives of city yuppies. But during this era, it has been Hollywood which has done what the British Left and independent film scene on the whole failed to do: channel and express a real popular moral and spiritual indignation at

capitalist values. Ultimately, of course, it reclaims them for the status quo. Nevertheless, I can think of no other medium where some of the key issues of our time have been so clearly raised and so vividly pictured. Marx wrote in 1847,

> This is the time when the very things which 'til then had been communicated but never exchanged; given, but never sold; acquired, but never bought – virtue, love, conviction, knowledge, conscience etc. – when everything, in short, passed into commerce.[5]

What he said then is still true today. But, bizarrely, at least Hollywood's popular sagas of commerce in the 1980s have been able to name and recognize these qualities, 'virtue, love, conviction, knowledge, conscience'. Until those of us who oppose capitalism seriously take them back into our hearts and minds and language, mainstream culture, with all its faults, will remain their most powerful expression.

Chapter 8

Commerce and culture

Robert Hewison

When, on 31 October 1985, Sir Roy Strong held a press conference to launch a bright new future for the Victoria and Albert Museum, he made a prediction that has had, to say the least, ironic results. The V & A, he said, 'could be the Laura Ashley of the 1990s'.[1]

The image is so striking that it is worth exploring, not just in relation to the V & A, but to the present position of museums in general. As Robert Lumley suggests in *The Museum Time Machine* we may think of the museum

> as a potent social metaphor and as a means whereby societies represent their relationship to their own history and to that of other cultures. Museums, in this sense, map out geographies of taste and values, which is an especially difficult and controversial task when it is necessary radically to redraw the maps in response to major social change.[2]

What has been happening at the V & A and other museums is an emblem of what is happening in society at large.

Sir Roy Strong is no longer part of the future of the V & A, having taken early retirement, but the metaphor lingers on, and it is worth asking first what he himself might have meant by the comparison with Laura Ashley's shops.

He almost certainly meant that the V & A should be as attractive, accessible and thronged as the stores. But there are also hidden – perhaps suppressed – metaphors at work: for instance that the V & A should adopt the values of acquisitiveness, nostalgia and security offered by the styles of Laura Ashley.

Is there not a sociological – even a class metaphor – at work? Surveys show that the more highly paid you are, the more likely you are to visit a museum.[3] Those who buy at Laura Ashley are

more likely to visit the V & A. Sir Roy did not suggest that the V & A should be the C & A of the 1990s.

A more subversive thought is that Sir Roy was voicing a hidden fear that the experience of the past offered by the world of Laura Ashley – which is an empire built on the revival of old designs – is more vivid, exciting and stylish than that of South Kensington.

All these potential meanings, however, are resolved by the ruling interpretation offered by the title of Sir Roy's speech, as given in the press release of the text. This was 'Towards a more consumer-orientated V & A'. Sir Roy was signalling the entry of the V & A into the enterprise culture.

The language of the market structures present thinking about the function and future of museums, as it does nearly all discussions of contemporary cultural activity. It is ironic that while those of *marxisant* persuasion have difficulty in convincing people that we must think of art as a form of cultural production, the non-*marxisant* bureaucracy that manages the arts thinks more and more of the arts as 'product'. Product that is offered to 'consumers', for whose purchasing power the various art forms are increasingly in competition.

The idea that museums are in competition with various other forms of consumption has been around for some time, and at one level the competition is not commercial, but technological. As a system of communication the museum post-dates the printed word and the multiply reproduced image, but pre-dates recorded sound, photography, sophisticated colour printing and film and television. As these rival systems have developed and achieved cultural dominance, the layout of museums has changed from linear displays in glass cases, to room settings and reconstruction, and most recently has begun to include live actors and actresses, animating earlier waxworks and dioramas.

Spatial relationships have also changed. As the term 'open air' museum implies, visitors to museums now enter a three-dimensional space, where a visit to a museum becomes a 'day out', one of a number of leisure options where museums compete with sporting events, the seaside, fun-fairs and so forth for the necessary number of visitors to justify their existence.

But the idea that museums are changing in response to shifting demands from their potential users, though true, is too simple an explanation. They are being *made* to change as a result of economic pressures, which are the result of political decisions. As is well

known, since 1979 Britain has had a government committed to reducing public expenditure as a proportion of the gross national product. Traditionally, however, ever since the British Museum Act of 1753, the great national museums have been a public responsibility, supported by general taxation, and this model was followed by local museums established from the mid-nineteenth century onwards. In both cases access was 'free', in that there was no payment at the point of entry or, as we would now say, the point of consumption.

A combination of mismanagement, economic failure and political manipulation has now thoroughly undermined that principle. The government has deliberately weakened the eleven national museums for which it is directly responsible by funding them at a level that does not keep up with the rate of inflation. At the same time its failure to control inflation – the need for which being one of the reasons given for reducing public expenditure – has made such increases as it has made even more derisory. This second factor affects all publicly funded museums, national and regional. The government chose to mark Museums Year, 1989, with an increase of 2.1 per cent to the national museums. If building funds are excluded, the total increase is just 0.2 per cent, a cut in real terms of £7 million.

With purchase grants effectively frozen since 1984, and inflation and salary increases steadily eroding operating budgets, the major museums also face a huge backlog of building repairs, which, left undone, place their collections in danger. The President of the Museums Association, Patrick Boylan, said in the summer of 1989 that his original estimate that the major museums needed £200 million for repairs had proved 'a wild underestimate'.[4] The extent of the crisis had become such that at the beginning of July 1989 the trustees of the five major London museums wrote to the Prime Minister (who appoints them) to warn that they could no longer maintain their buildings, protect their collections, nor keep all of their galleries open.

The regional museums have also been suffering. University museums are victims of the cuts in university central grants. Museums funded by local authorities have been squeezed by the government as it reduces the rate support grant, and limits by penalty the amount of local taxation they can raise. The government's own assessment was that in 1989/90 local authority spending on museums, galleries and libraries would fall by 3.6

per cent, over 10 per cent in real terms.

Thus museums are being forced into the market-place. If they remain free at the point of entry they must do more to justify their existence by the volume of visitors passing through their doors, and once inside, these must be exploited through the sale of souvenirs, refreshments and so forth. But fewer remain free: the 'voluntary charge' at the V & A means that it is now the last museum in South Kensington's educational Albertopolis not to take a compulsory fee. Charging becomes a means of survival, but visitor numbers fall, increasing the pressure towards 'consumer orientation'. What does not survive is the educational principle behind the policy of free access.

According to Richard Wilding, chief civil servant at the Office of Arts and Libraries until his retirement in 1988, the government's position on charging has been one of neutrality. This was certainly not the case in 1974 when as Secretary of State for Education Mrs Thatcher introduced compulsory charges for all national museums. 'The government require charges to be made', she said.[5]

Wilding has claimed that it is 'an X-certificate, late-night horror story' that the government is deliberately creating a situation where by holding back subsidy, museums have to charge.[6] But that is what is happening, and the hiving off of national museums from direct government control through the introduction of business-minded boards of trustees, following the National Heritage Act of 1983, seems directed at what might well be called the privatization of public museums.

Wilding has said that individual museums will be free to take individual decisions, but the very language he used to deny that charging will become the norm is revealing: 'Museums have different products; they are in different places; they have different markets.'[7]

The immediate competitors of the national and local authority museums are the so-called independent museums, which have sprung up in large numbers and which account for the paradoxical growth in the number of museums at a time of funding restraint. Of the 2,131 museums identified by a Museums Association survey of 1987, half had been founded since 1971.[8] The Association of Independent Museums estimated in 1988 that there were at least 1,250 institutions in the private sector. These statistics however, are rapidly going out of date. According to the Museums and Galleries

Commission, in 1989 a new museum was opening once every fourteen days.

Yet the independent museum's independence from public sector finance is an illusion. Sources of finance include the area councils funded by the Museums and Galleries Commission; local authorities; the government's Urban Programme; Urban Development Corporations; the English Tourist Board; the National Heritage Memorial Fund; the European Economic Community Regional Development Fund. For most of the 1980s cheap labour was available through the Manpower Services Commission. The Policy Studies Institute report on the economic importance of the arts showed that the non-national, non-local authority museums it surveyed gained 53 per cent of their income from public funds.[9]

As Ian Robertson has pointed out in the *Museums Journal*

> Very few independent sector museums have raised sufficient capital to generate the revenue needed to pay the kind of salaries which would attract appropriate qualified staff to man the services to a proper professional standard. Indeed, it is fair to assert that in the vast majority of cases of independent museums providing this daily service to visitors, there is a substantial input by way of grant-aid or annual payments from one or more public authorities.[10]

The true 'independence' of these museums of recent foundation is their independence from the traditional educational and social welfare motivations that launched the museum movement in the nineteenth century. They perceive themselves as part of the leisure and tourism business, and have no inhibitions about charging – which they must do anyway, since they have a pressing need to generate revenue. This again means that they have to be as inventive as possible in their displays, entertainment is an overriding consideration in their presentation, and they have to be ruthless in extracting cash from the visitor. The need to satisfy business sponsors that they can draw the crowds is a contributing factor.

The ultimate logic of the new type of museum is the museum that has no collection, the Heritage Centre. Here the original purpose of having a museum, which was to preserve and interpret a significant number of objects, has been almost entirely displaced by the desire to give the visitor some kind of more or less pleasurable 'experience'. The significant finds from the archaeological dig that

produced the Jorvik Viking Centre could be displayed on the top of a single table. But that is not the attraction that draws so many visitors, any more than it is the industrial bric-à-brac and domestic bygones that is the attraction of Wigan Pier.

The real paradox of the 'consumer orientation' that is being forced on museums of whatever type of foundation is not simply that ideas of education have been supplanted by ideas of consumption, but that museums, in addition to being objects of consumption, are also units of production.

A new museum is not only one of the convenient ways of re-using a redundant mill or factory. It is treated as a form of investment that will regenerate the local economy that has decayed as a result of the closure of that mill or factory. That is why it is relatively easy to find capital to set up a new museum. Museum projects are a useful means of cleaning up a derelict environment prior to commercial investment in the area, and the relative costs of job creation are impressive: it has been calculated that while the cost of creating a job in manufacturing is £32,000, and in mechanical engineering £300,000, the cost of creating a job in tourism is put at a mere £4,000.[11]

The acknowledged crisis in museums is the product of the general crisis of values that has been provoked by the rise of the enterprise culture. On one side are the material arguments. Museums are a business like any other: they have assets they must manage, account sheets they must balance, and they make a major economic contribution to the tourism and leisure industry that has grown up as manufacturing has declined. On the other are the social arguments: that museums are educational institutions, that their purpose is an increase in public knowledge – not private profits – and their function is to serve the social good. As some of their nineteenth-century founders would have it, they contribute to the suppression of drunkenness and vice.

The social arguments deploy the word 'value' in a very different way to the material arguments. That is the root of the current cultural confusion. But there are certain values which are not reducible to balance-sheet terms. These are scholarship, stewardship, and a sense of identity. By scholarship is meant the disinterested study of the materials of the past, and the honest interpretation of their significance to the present. By stewardship is meant the responsible conservation of those materials. And it is by

the examination of the materials of the past that we are able to arrive at some notion of where we are in the present. This idea of a location in the multiple narratives of history helps us to achieve a sense of identity: personal, regional, national.

It would be naïve to believe that these values are themselves value-free. That is why there is a fourth social value to be discovered in a museum's function. The great collections formed from the eighteenth century onwards reflect the imperialist energies of an avaricious nation-state: the lines of glass cases in the marble and terracotta halls of Albertopolis suggest the onward march of industrial progress while ignoring the price paid at home and abroad. The 'national identity' might be read as privileged, aristocratic in taste, bourgeois in business practice. All too often there is only one historical narrative, and that is recited by someone who is white, male and middle-class.

It is difficult to escape such ideological predispositions, but there is no reason why museums should not adopt a critical function, and interrogate the past as well as preserve it. And if we question the past, we may be encouraged to question the present and so arrive at a more dynamic sense of identity, neither nostalgic nor nationalistic, but critically engaged in shaping the future.

At another level – since an educated workforce, free of drunkenness and vice, is a more productive workforce – there seems no reason why these social values could not be reconciled with those of the balance sheet. But balances are calculated on an annual basis; culture takes a longer view. So far, the enterprise culture seems to have asserted the material over the moral when it comes to goods.

If we wish to discover where the values of the enterprise culture are leading us, we need to look no further than the 'consumer-orientated' V & A. In January 1988, following Sir Roy's resignation, Mrs Elizabeth Esteve-Coll became director. But Sir Roy's prophecy was none the less fulfilled with astonishing speed.

In the summer of 1988 the V & A became, first the Sotheby's of the 1980s, with a pre-auction display of Elton John's *memorabilia*, and then the Habitat of the 1980s, with the launch of the V & A/ Habitat collection, marketing updated versions of textile designs in the museum's archive. It subsequently became the Burberry's of the 1980s, with a sponsored display of rainwear, and in 1989 the Sock Shop of the 1980s, with a similar display in the textiles department. By then Saatchi & Saatchi – note that Maurice Saatchi is a trustee

of the V & A – had been hired to persuade the public that the V & A was 'An ace caff with quite a nice museum attached'.[12] The V & A also lent out paintings for a promotion in Harrods. In October 1988 Sir Roy's prophecy achieved its apotheosis when the museum's marketing manager, Charles Mills, declared that the V & A 'should always be seen as the Harrods of the museum world'.[13] Perhaps that is why *Marketing Week* described Mr Mills as the museum's 'prize exhibit'.[14]

But there is a more serious side to the developments at the V & A. On 26 January 1989 the trustees were given less than half an hour to read a proposal for the restructuring of the museum's curatorial system, to which they then agreed. The museum's individual collections were to be subsumed into two departments, and curatorial duties were to be separated between scholarship and 'housekeeping' – the physical management of the collections. These proposals had the full support of Richard Wilding of the Office of Arts and Libraries, and it is clear that there was strong pressure from the OAL to carry them through. The immediate effect of this restructuring, which left the purely administrative, non-curatorial personnel untouched, was that nine senior curatorial staff, including five heads of department, were offered 'voluntary' redundancy. Eight, under pressure, accepted. The initial £300,000 these redundancies cost was found, ironically in view of the V & A's problems, from the building and maintenance budget.

The protests that followed severely damaged the standing of the director, who faced formal votes of no confidence from her staff. One trustee, Professor Martin Kemp of St Andrews University, resigned, protesting that trustee bodies 'have increasingly become mirrors of government policy'.[15] The effect has not simply been on reputation and morale. The damage to scholarship quickly became evident. In May 1989 the V & A told the Museums and Galleries Commission that it 'no longer has any expertise' in 'lace of any date', or 'embroidery from 1560 to 1840'.[16] The keeper of textiles, Tina Levey (responsible, incidentally, for the Sock Shop display) was among the eight curators made redundant.

The redundancies did not appear to make any impression on the V & A's financial problems. In May 1989 the director estimated that the salaries bill would amount to 103 per cent of the expected government grant for the coming year. To clear the backlog of maintenance and repairs would cost £50 million, with a further £75 million needed in the next ten years.[17] The ultimate absurdity was

reached in November, when *The Times* reported that a sub-committee of the trustees set up to study the new staff structure had concluded that it was unworkable.[18] The individual collections would not be merged, and would continue to have separate heads of department. These, however, would be appointed at a lower salary grade. It is difficult not to conclude that the whole affair was a cynical manoeuvre to get rid of people opposed to the introduction of the enterprise culture.

So far, the enterprise culture has failed to save the V & A. The problems are too great to be solved by anything other than a political decision to spend large amounts of public money. This case was silently conceded in November 1989 when the Minister for the Arts substantially increased the previously posted grants for the national museums and galleries. It might be argued that, like the National Health Service, the V & A is too old and encumbered a relic of the welfare past for the enterprise culture to be able to solve its problems – except by selling off the collections, as the trustees are empowered to do.

The enterprise culture needs a new kind of museum more adequately to reflect its values. And in 1982, like some museum mutant, just such a new model began to grow within the viscera of the V & A itself. This was the Boilerhouse Project. Now mature, it has left South Kensington and, fully fledged, settled on the south bank of the Thames at Butlers Wharf, where in July 1989 Mrs Thatcher opened its doors as the Design Museum.

Although it comes into the category of that late twentieth-century paradox, the museum of modern art, the Design Museum is a good example of the new museum economy. Its principal capitalization of £7 million has come from the private Conran Foundation, whose funds derive from the stock market flotation of Sir Terence Conran's Habitat chain in 1981. It is expected to cost £1.5 million a year to run, of which one-third is to come from entry charges, one-third from the Conran Foundation, and one-third from sponsorship. But we should note that the political sponsorship the project has received from Mrs Thatcher has been matched with public funds: £100,000 from the English Tourist Board towards capital costs, £20,000 from the London Docklands Development Corporation towards the cost of a ferry service, and a grant from the Department of Trade and Industry of £650,000 over the first three years.

It seems that there is a certain synergy between the philanthropy of the Conran Foundation and the commercial interests of its principal benefactor. The Design Museum is an extension of the sphere of cultural consumption that Sir Terence has made distinctly his own, from Habitat, to Heals, to Mothercare and British Home Stores, combined in the Storehouse Group, plus architecture – Conran-Roche; publishing – Conran-Octopus, and the ultimate form of cultural consumption, the Bibendum restaurant. Such interests have made him an obvious choice as a trustee of the V & A.

The Design Museum, albeit indirectly, serves to stimulate the kinds of consumption that are in its sponsors' interests: Perrier, Olivetti, Sony, Coca-Cola, Courtaulds, Kodak, Addis, Apple, FIAT, Black & Decker. And quite directly, the museum is at the centre of a £200-million Conran development site, Butlers Wharf. A redundant warehouse has been rebuilt as pastiche Bauhaus, and serves as a form of cultural gentrification to prepare the way for the as yet unbuilt hotel, immediately downstream, and the as yet unbuilt 'Spice Quay' (in fact offices) immediately upstream. Its sparkling retro-modernism is architecture as advertising: an ace museum with quite a nice development attached.

It is not surprising, then, to find that the Design Museum's first 'agenda setting' temporary exhibition should have had as its theme 'Commerce and Culture'.[19] Sir Roy's prediction is no longer a rhetorical flourish but an established fact, for the argument of the exhibition was that the elision of commerce and culture is virtually complete. The bold type used on the placards that papered the exhibition belied any caveats. 'One day, maybe, stores and museums will become the same . . . with everything for display, inspection and sale.'[20]

The idea that there might yet be a difference between commerce and culture (a term which significantly was nowhere defined) is dismissed as 'a recent prejudice. It would be incomprehensible to a medieval craftsman or a Renaissance prince, as it will be to a designer of the 21st century.'[21] It would be incomprehensible, of course, because medieval and Renaissance society had no mass production or consumption as we know it, so unless we are about to return to an artisan economy and religious culture, the historical reference is specious. The accompanying catalogue points out that one of the responses to industrialization was the assertion of values that were critical of commerce, but these are dismissed as romantic, elitist, and *passé*.

Civilisation is not really under threat. . . . On the contrary, the synthesis of commerce and culture is a unifying process, bringing together the two appetites for consumption of knowledge and of goods which were once artificially separate.[22]

At the same time, however, the exhibition did admit to a certain unease. 'When shopping becomes a pastime and not a requirement for survival, when architecture becomes packaging, when "designer" becomes a priest, there is a crisis in culture which vigorous commerce cannot completely disguise.'[23]

Nor can the Design Museum. However earnestly the exhibition's author, Stephen Bayley, may protest against museum ideology, his entire cabinet of commercial curiosities has an aestheticizing effect. He told *The Times*: 'you have to concede that if you are an educational body you have to make choices'.[24] The recognition that the Design Museum does have an educational function reintroduces all the cultural issues that are alleged to have disappeared, for the moment choice comes into the frame for other than straight commercial reasons – choices that are aesthetic, critical, educational – then a cultural decision has been made.

This confusion has been built into the building. The very language of the Design Museum changes as you move between floors. On the ground floor it aspires to the marble modernity of an Italian railway station, on the next floor to the discourse of current affairs, but the model is none other than the now déclassé Design Centre. And on the top floor, the study collection, we are back, for all of the interactive computers, in a series of linear arrangements that recall the historical didacticism of the Science Museum, with bicycles instead of aircraft. And there are rows of glass cases.

Lurking within the converted warehouse at Butlers Wharf is the ghost of Henry Cole's Museum of Manufactures, evicted from South Kensington when the V & A took what Bayley calls its 'antiquarian'[25] turn. It is dressed in the rags of aesthetic and educational motivations that the rhetoric of the Design Museum tries to discard. All the pretended moral neutrality of this rhetoric achieves is a fetishizing of the objects the galleries contain.

Design itself, which, says Bayley, is no longer simply about technical considerations or questions of appearance, but about ideas and experience, is the ultimate object of this fetishization. Design, he says, 'is the critical intelligence co-ordinating supply and

demand', and has a more secure future than literature or the fine arts.[26] Before our eyes we see design become a commodity, ready to be marketed as style. This is the final piquancy of Sir Roy Strong's metaphor. The V & A – the original design museum – will be the Laura Ashley of the 1990s because there will be no difference between them. A visit to a museum will have become just another commodity. Laura Ashley and the V & A, Habitat and the Design Museum, will simply be competitors in the same vast cultural market-place.

If then, stores and museums are becoming the same, 'with everything for display, inspection and sale', what is the commodity that the museums of the enterprise culture are putting on the market? The Situationists called it Spectacle, Umberto Eco has called it Hyperreality, Jean Baudrillard has called it Simulation, Fredric Jameson has called it Historicism. All agree that image has replaced reality, and that we now live in a world of simulacra: perfect copies of originals that never existed.

The Situationist argument, which is repeated in Fredric Jameson's essay 'Post-modernism, or the cultural logic of late capitalism', is that the latest stage of capitalism has been a massive internal expansion, the invasion and restructuring of whole areas of private life, leisure and personal expression. (This invasion, it might be added, includes the restructuring and commodification of private memory itself, something that is very evident in the new folk and industrial museums which seek to reproduce 'the way we were', and where individual memories are erased by the collectively reconstructed image of a period.)

In his essay 'Travels in hyperreality' Umberto Eco describes this restructuring in terms of a deliberate replacement – and all his examples are taken from the extraordinary Disneyworlds, waxworks and museums of the United States. In Austin, Texas, he visits a full-scale model of the Presidential Oval Office, 'using the same materials, the same colours, but with everything obviously more polished, shinier, protected against deterioration'.[27] The result is that

Absolute unreality is offered as real presence. The aim of the reconstructed Oval Office is to supply a 'sign' that will then be forgotten as such. The sign aims to be the thing, to abolish the distinction of the reference, the mechanism of replacement. Not

the image of the thing, but its plaster cast. Its double, in other words.[28]

Jean Baudrillard has argued that, as simulation replaces representation, reality disappears:

> This would be the successive phases of the image:
> – it is the reflection of a basic reality
> – it masks and perverts a basic reality
> – it masks the *absence* of a basic reality
> – it bears no relation to any reality whatever: it is its own pure simulacrum.[29]

Fredric Jameson sets contemporary representation within what he calls 'post-modernist hyperspace', which he associates with 'flatness or depthlessness, a new kind of superficiality in the most literal sense'.[30] His concern is with contemporary art and architecture, but this depthlessness also applies to the past. 'Historicism', he writes, 'effaces history'.[31] Past styles are referenced at random for an idea of the past which exists entirely in the present.

> It is for such objects that we may reserve Plato's conception of the 'simulacrum' – the identical copy for which no original has ever existed. Appropriately enough, the culture of the simulacrum comes to *life* in a society where exchange-value has been generalized to the point at which the very memory of use-value is effaced, a society of which Guy Debord has observed, in an extraordinary phrase, that in it 'the image has become the final form of commodity reification'.[32]

Following Eco, he argues that the past is effaced by its own image, and we are 'condemned to seek History by way of our own pop images and simulacra of that history, which itself remains forever out of reach.' [33]

As far as museums are concerned, these simulacra pass as Heritage, a perfect copy of a history that never existed. The effacement of history and the commodification of the past was summed up in a remark by the organizer of one of the Armada anniversary spectacles of 1988. He said, 'If you've got something to sell, then package it up, and sell it, and what's history if you can't bend it a bit?' [34]

History is gradually being bent into something called Heritage,

whose commodity values run from tea towels to the country house. Its focus on an idealized past is entropic, its social values are those of an earlier age of privilege and exploitation that it serves to preserve and bring forward into the present. Heritage is gradually effacing history, by substituting an image of the past for its reality. At a time when Britain is obsessed by the past, we have a fading sense of continuity and change, which is being replaced by a fragmented and piecemeal idea of the past constructed out of costume drama on television, re-enactments of civil war battles and mendacious celebrations of events such as the Glorious Revolution, which was neither glorious nor a revolution.

Yet this pastiched and collaged past, once it has received the high gloss of presentation from the new breed of 'heritage managers', succeeds in presenting a curiously unified image, where change, conflict, clashes of interest, are neutralized within a single seamless and depthless surface, which merely reflects our contemporary anxieties. If there is any illusion of historical perspective in this image, it is usually the pastoral perspective surveyed from the terrace of a country house.

The museum, indeed history itself, has always tended to record the achievements and values of the dominant class. All that the new wave of industrial and folk museums has done is to co-opt industrial and agricultural labour experience into the picturesque, bourgois image of the past. As Donald Horne remarks in his book *The Great Museum*, 'What is presented is an industrial revolution without the revolution.' [35] There seem to be no winners, and especially no losers. The open story of history has become the closed book of heritage.

The sponsors and executives of the Design Museum may claim, with justification, that their concern is with the future, that they are modernists seeking to escape the entropic nostalgia of the heritage industry. But the values they celebrate, the commodification of culture, the fetishizing of consumption, serve to promote the marketing of history as heritage, because commerce and culture, we are told, have become the same thing.

The time has come to argue that commerce is *not* culture, whether we define culture as the pursuit of music, literature or the fine arts, or whether we adopt Raymond Williams's definition of culture as 'a whole way of life'.[36] You cannot get a whole way of life into a Tesco's trolley or a V & A Enterprises shopping bag.

There is something paralysing about having to acknowledge that the past is ultimately unknowable, and that whatever image of the past we care to construct in our museums cannot be objective, however scrupulous we may be about acknowledging our cultural conditioning. But it must be attempted. To do so requires the assertion of moral values, over against those commodity values which are not merely the theoretical result of the cultural logic of late capitalism, but the very practical result of the political and economic logic of the contemporary Conservative government.

This does not mean that museums should return to nineteenth-century forms of display or policies for acquisition, any more than we should return to the nineteenth-century forms of production and exploitation that are preserved for the entertainment of tourists in industrial museums. We need an argument for transformation, which sees the monstrosity of what is going on, but recognizes what energizes it: a desperate desire for a *past of some kind.*

A museum, with its social responsibilities of stewardship and scholarship, is an institution in a position to resist the process of commodification relentlessly urged by the enterprise culture. But it can only do so, in the case of national and locally funded museums, if people are prepared to argue more forcefully that that which is communally owned should also be communally funded, and that general and local taxation is the instrument. Museums are items of social property, and they have a value, not to the consumer, but to the community. We need a more community-oriented, not 'con-sumer-orientated' V & A.

But if we are to offer a past, in terms of a collection of objects and their interpretation, then we must attempt to maintain some kind of critical distance, as opposed to the depthlessness of heritage interpretation, and some idea of historical time. To that end the moral values of education must be asserted over against the production values of entertainment. It may turn out that such a didactic assertion will closely parallel the principles on which museums were founded in the first place, but the end should be different. Both the simulacrum of Heritage and the great national narrative of Victorian and Edwardian history must be replaced by a version of the past that does not exclude conflict and change (the hidden agenda of Heritage being to exclude these irritants), and which admits the existence of contingency, the possibility of accident, and the reality of winners and losers. As Iris Murdoch has written, 'Reality is not a given whole. An understanding of this, a

respect for the contingent, is essential to imagination as opposed to fantasy.' [37]

Museums, like history – or as we should have it, histories – are acts of the imagination. Heritage is a fantasy, the commodification of our past and present means that in the enterprise culture, we surely do know the price of everything, and the value of nothing at all. If the V & A is to be the Laura Ashley of the 1990s, then the Design Museum is the Habitat of the twenty-first century.

Post-script Since the completion of this paper, Terence Conran's property company, Butler's Wharf, has been placed in administrative receivership. The Design Museum remains open at the time of going to press.

Chapter 9

Over our shoulders: nostalgic screen fictions for the 1980s

Tana Wollen

> To articulate the past historically does not mean to recognise it 'the way it really was'. It means to seize hold of a memory as it flashes up at a moment of danger.
>
> Walter Benjamin[1]

> Do you want to pick a fight with someone 100 times your own size? How do you stand outside a historical event that has got *you* wrapped around in glorious 70mm or the amplitudes of widescreen and Technicolour?
>
> Harlan Kennedy[2]

The past has multitudinous caparisons. It can be experienced and perceived through stories and photographs, through lessons at school, through the architecture, land and townscapes around us, through books and newspapers, through feature films, through television documentaries and dramas. Recent interest in how the past reasserts its presence has left some of the most significant aspects of contemporary life outside the frame of its regard. The auratic histories now held by landscapes, stately homes, monuments and artefacts are at last coming in for closer scrutiny, but the fictions on film and television in which an array of pasts are so immediately represented to so many, have received the most cursory of critical glances.[3] Reasons for this evasion, for why the forms in which the past is most commonly experienced and enjoyed have been put to one side while the manifestations of history 'proper' get tackled, would themselves be worth exploring. However, this chapter has a different purpose.

Although references will be made to particular films and television programmes the analysis will be of a more general kind. Differences between the contexts of their screening will not be

taken into account, nor will they all be considered equally. The general term 'screen fictions' will be used to cover feature films produced for cinema exhibition and films and serials produced for television. That so many of these fictions, produced in Britain in the 1980s, dealt with the past will be undisputed: *Gandhi* (1982); *Chariots of Fire* (1981); *Brideshead Revisited* (1981); *A Passage To India* (1984); *A Room with a View* (1986); *Jewel in the Crown* (1982); *Another Country* (1984); *Hope and Glory* (1984); *Dance with a Stranger* (1984); *Another Time Another Place* (1983); *A Private Function* (1984); *Personal Services* (1987); *Wish You Were Here* (1988). The list suggests that it has been difficult to make British fictions about the present. The main concerns of this chapter will be to examine how such fictions shape collective memories, how they have represented particular histories and how they have become part of a wider enterprise, namely the reconstruction of national identity.

This has been a decade in which definitions of what it is to be British have been viciously contested. The Falklands/Malvinas war in 1982 and the miners' strike in 1984 were the most overtly political arenas where the whips of patriotism cracked. An 'enemy' thousands of miles away served a powerfully symbolic purpose, of rallying hearts, minds and troops behind a Britain some were desperate to believe 'Great' again, so that allegiances to a class in struggle, to the ideals of working communities, could be construed as treacherous to the national interest. While the paths to national righteousness were cleared by Exocet and baton there was, in fictional terms at least, a disavowal of the coercion used to forge national unity.

The British feature films and television dramas in the early 1980s, heartily acclaimed for their lavish productions of times bygone, can, quite correctly, be seen as a new line in the nostalgia which the 1970s had found so marketable. In retrospect however, a more complex set of political relations between past and present can be traced in them. The idylls of rural life – the 'pressed flower approach to the past'[4] – still found their way into the mainstream screen fictions of the 1980s, but Akenfields, larks rising to Candleford and the country diaries of Edwardian ladies became rather less tenable once the 'enemies within' had started fighting their quarter.

In such embattled and fissured years uncertainty seems to make pressing the need for connections with the past. The prevailing impression of Britain in the 1960s, for instance, is of intense

celebration and of investment in the present. Popular screen fictions of that decade seem to brazen their contemporaneity – but perhaps that is only because the 'Swinging Sixties' have since become nostalgic fictions for the decaying eighties! Nevertheless, in screen fiction between 1981 and 1985 there would seem to be a set of ambivalent impulses driving the search for connections with the past. On the one hand there is respite in the burrow: the straining present can blow itself to bits while we snuggle back. On the other hand the present needs explaining, or at least it needs to be placed in a context, so that we can make better sense of what is going on. It needs to be framed and focused to ease the confusion of our gaze.

The looking back and the blocking out are both aspects of what Patrick Wright calls the 'dislocating experience of modernity' which lends an urgency to the business of interpreting our times. While interpretation of the past might give us 'a sense of our historical existence' the very pace and diversity of modernity makes that historical sense a very slippery rug. 'No wonder, that "historical memory" should sometimes seem to slip out of kilter with the present, continuously raising ghosts and anxiously holding old answers up against the disorientating light of new questions.'[5] Perhaps no wonder then, that these disturbing years should see welcomed such luminous historical fictions.

In making sense of the past these fictions also have an existence in the present (if only because their narratives can be understood): through these fictions the present puts its stamp upon the past. Whether the connections they make emphasize the past's difference (things ain't what they used to be), or its endurance (some things just never change), by moulding it for our comprehension, these fictions haul it back for our investigation. How the scope of that investigation may be limited by their narrative structures and by the critical contexts in which they appear will be discussed later in this chapter. But whether these fictions were dismissed or embraced, they bind together questions of the past and of belonging: at the heart of their narratives the pleasures of belonging and of identification are on offer. For some, the recognition of 'Our Island Story' will filter through well-lit and orchestrated scenarios. For others, identification with particular characters, or curiosity as to how the knots and plot get untied, will bait them through an autumn season. Those for whom these particular pasts are not 'our times' can at least claim the serial as 'our favourite' or, 'our Tuesday

night in'. Moreover, these films and television products could be claimed as the flagships of a reviving national industry when most other industries were heavily in decline.

Loss of empire and decline of the heavy industries accompanied by strident claims made by oppressed voices and dissatisfactions with the welfare state, all whittled away at gains long taken for granted. What was happening in the 'old country'? What did 'Britain' stand for and what did it mean to be British? Defining the national has become imperative.

> As socialism, liberal constitutionalism and imperialism – the great overarching doctrines of state formation – trickle away, their former imbibers wake up to find that their hold on the national imagination is shaky in yet another respect. None of these doctrines any longer offers a convincing account of exactly who the British are.[6]

Thus Jonathan Clark begins his argument for a more patriotic basis for history in the National Curriculum. Where the Left has pondered questions of cultural identity in terms of a variety of historical formations and in terms of *difference*, the Right has had a singular project: to incorporate everyone under the same category, to render multitudes as one and the same, not as a straggled set of others. History is to be about one nationhood.

While it would be foolish to cast all the mainstream British screen fictions under discussion as entirely 'right-wing', their retrospection holds nationhood exclusively in its sights. Their nostalgia yearns for a nation in which social status is known and kept, and where difference constitutes rather than fragments national unity. To an American reviewer, British screen fictions of whatever political provenance seemed tediously self-obsessed:

> Britain has the means of escaping this psychological hall of mirrors, this endless self-communion, by loosening its fixation on 'British' subjects. It's no surprise that a country that has lost its wealth and its political power, a country seized with insecurity and ravaged by strikes, should take refuge in hugging its past or dyspeptically trying to shake truths out of its present. It's a way of keeping alive an endangered identity. But if cultural identity has any meaning at all, or any hope of staying alive, it must be able to walk, talk and function when not fastened to nationalistic subjects.[7]

If homesickness – the original meaning of the term nostalgia – is adhered to here, then British screen fictions of the early eighties were symptoms of a very severe case. They were testimonies of a sickening for home, but what 'home' was, or who belonged to it, were very unclear. Britain seemed to have been squashed into the south-east corner of England and the hearth gods were the breezy middle-classes who languished in sumptuous *ennui*, putting their best feet forward and often (so the scripts would lead us to believe) straight into their mouths. The nostalgia here is a sickening for a homeland where there is endless cricket, fair play with bent rules, fumbled sex, village teas and punting through long green summers. British identities have been subsumed under a particular version of Englishness. The one nation here is inhabited solely by those for whom 'one' is that personal pronoun preferred for its exclusivity even as it presumes to include you, thereby brooking no argument. 'Hegemony is a game in which all can join', concludes Jonathan Clark. He sees no need to add that there are winners and losers.[8]

Although these fictions are predominantly nostalgic, at the heart of their wistful sumptuousness there are occasional hints of something rotten. The regret is not so much that these times are irretrievable but that admissions have to be made about the shadier parts. Some admissions can be fudged through the conventions of fiction. Narrative pull, the complexities of characterization and a moving sound-track can alleviate the severity of dispassionate critiques. If the establishment can be shown to own up from time to time, then those very British virtues of decency and fair play can be repaired.

Mussabini, Abrahams and Liddell are all outsiders in *Chariots of Fire*: they have to earn their belonging. Since they are not quite the right sort they cannot claim it, but nor is it offered: it has to be won through effort. In spite of the corrupt old dons, the obstacles and the prejudice, the film manages to make belonging seem worth it. Abrahams and Liddell might have different reasons for wanting to win, but by winning for Britain they show that they can change the nation by claiming its prize. They show that the ancient citadel can be changed from within, that it can accommodate outsiders without the walls tumbling down. Patriotism is the resolution to social division and conflict here and it makes the ideal ingredient for a successful feature film: highly charged, irrational, it is an emotion anyone can own, whatever their status. David Puttnam 'was attracted by the story of Harold Abrahams and Eric Liddell

because it showed two men with a fundamental respect for patriotic British values, whose individual quest for glory forced them to stand up against a bigoted establishment'. *Chariots of Fire* marked for Puttnam 'a return to the style of emotionally committed filmmaking'. The revolt against established bigotry is an individual one, sustained by a 'quest for glory' and a love of country. Just the right kind of stirring stuff for the movies, and *Chariots of Fire* took the British film industry 'a long way from zero'.[9]

Conversely, perhaps it is the inability to value tradition, in spite of being surrounded by the valuables of heritage, which is at the root of Sebastian's decadence, and the cause of his incapacity for action. Belonging cannot be taken for granted, nor should it be squandered, which is why *Brideshead* for all its *noblesse oblige* is a truly Thatcherite text. The trappings of great wealth, as enjoyed in *Brideshead*, fitted contemporary aspirations. City yuppies bought imitation Aloysius bears, practised the Sebastian drawl, and champagne had never had it so good. The televised fiction made good times lost instantly accessible and while the fiction showed old wealth corrupting and sapping its inheritors, the new entrepreneurs could taste its flavour without shouldering the burden of ancient class allegiances.

In the 'Raj revival' fictions, it is women who have access to a keener conscience and because they have less to lose are made less anxious by historical inevitability. Mrs Moore is the acceptable face of British colonialism in the film (and in the novel) *A Passage to India*, shamed by her son Ronnie's civil service conformity. (Nigel Havers, who played Ronnie, was the know-all in a current set of Lloyds Bank commercials.) In *Jewel in the Crown* it is Daphne Manners who 'crosses the bridge' and whose story haunts Sarah Layton. They are both 'good sorts', for whom the fuss and bother of chaps' protocol obscures the view. The Amritsar massacre of 1919 invades Aunt Mabel's sleep, while Barbie prays quite desperately for the saving of God's grace. *Jewel in the Crown* has a more troubled and less nostalgic edge than the other fictions, but that says more about acceptable levels of political critique in mainstream culture and about the range of other fictions available for comparison: 'it is surely only recently that anybody would have considered the attitudes informing *Jewel* to be suitable for a British mass medium'.[10] How many British Asians could consider *Jewel in the Crown* a nostalgic fiction? The welcome it received for its 'frank and honest' approach only makes the 'blacking up' of Ben Kingsley

in *Gandhi*, of Alec Guinness in *A Passage to India*, and of most of the cast in *The Far Pavilions*, so much worse.

Any critique *Jewel in the Crown* is able to make of the colonial heritage founders on the intractables of race and class. Ronald Merrick is the man the nation loved to hate, which, given his racism and uptight sexuality, might have been encouraging. His male-volence seemed to issue, however, from that sin so originally English – having a chip on the shoulder. As was so often pointed out, he was not quite 'our sort'. His homosexuality is a mark of his cruelty and of his inability to love, unlike the love of Charles and Sebastian in *Brideshead* which motivates some thirteen episodes and is yet disavowed as homosexual precisely because it can be called 'love' in those well-educated, classical tones. In the end Merrick's behaviour cannot be read beyond the bounds of his lower middle-class character. His come-uppance coincides with the British withdrawal to their Home Counties, but Merrick is one of those individuals for whom we have to apologize, in the apprehensive hope that the rest of us were not really like that.

There are strains in these fictions then, when troubling memory frays nostalgia. In these fictions the upper and middle-classes re-examine their ascendancy and find it not all that glorious. Could more be expected of British screen fictions in the early 1980s? In a lonely critique of the 'Raj revival', Salman Rushdie argued that since the mould was the same, the same flab got turned out. It was the white characters who provided most points for identification, their actions which motivated the main narratives, thereby excluding other narratives and other points of view. 'The form insists that they are the ones whose stories matter, and that is so much less than the whole truth that it must be called a falsehood.'[11] Simon Hoggart, differentiating between history related through documentary and history related through fiction, still failed to notice whose history gets repeatedly told. 'We can't take post-imperial guilt to the point of pretending there never was an empire.'[12]

Ultimately, the professional exigencies of producing 'quality' TV drama could not be reconciled with a critical examination of the past. From a distant vantage the results are a sorry sight:

What we find are the inner sores of self-laceration and ghastly internal bleeding. Far from being celebrations of Empire, except visually, these films are severe reproaches to British history. While our ears and eyes swoon to the éclat of majestic scenery,

lovely costumes, and gosh all those elephants, our souls are being told to stay behind after class and get a ticking off for treating our colonial subjects so badly. For carving up other nations and leaving them to put the pieces together. For snobbery, cruelty and oppression.

Here is double standard movie making in its most ambitious and appalling form – it's like being asked to bend over a luxurious perfumed ottoman while being given six of the best with teacher's cane. There's a love–hate relationship with the Empire in British cinema that's totally unresolved. Intellectually, we agree to eat humble pie about our imperial past. Emotionally, the impact of the India movies is to make us fall head over heels in love with the dear dead old days, when even Britain's villainies were Big; when even its blunders and failures had tragic status; and when, if we had nothing else, goddammit, at least we had glamour.[13]

The inter-war years become, in the early eighties, a period of quintessential, enduring Englishness that can be reproduced time and again. Alan Tomlinson writes about the ahistorical tone in which the actual events of *Chariots of Fire* are related.

Set on the eve of the modern period, the film evokes a visually trans-historical Britain, a sense of environments and institutions almost beyond history. Doing this in terms of the Olympic ideal too – modernity's attempt to carve out a classical pedigree for itself – the film offered up to North American viewers a simple story of human endeavours, set in the landscapes of a Tourist Guide to the Old Country.[14]

One of the ironies in the nostalgic project of these fictions is that popular cultural forms are used to invite identification with a world which would have frowned upon them. The England represented is one still untainted by the 'mass' media and their capacity to 'level down'. England in these fictions is the old country, largely innocent of American imports, where traditional good taste and the right values solidly persist.[15] These particular cinema and television products are marked with that 'best of British' quality guarantee. By proving that mass audiences can enjoy 'serious' drama they are self-declared un-American products and can enjoy commercial success almost by virtue of their tacit effacement of themselves as mass media.

Chariots of Fire, Brideshead Revisited and *A Room with a View* are all nostalgic in that their pasts were represented as entirely better places. This abstraction of place from the present, its reordering into a palatable past, allows, as Tony Bennett suggests, a peculiar complacence. Bennett writes of how museums recuperate worked landscapes, but what he says would apply as well to the screen as to museums: 'this . . . is not just any countryside but that distinctly bourgeois countryside of the mind in which the present emerges uninterruptedly from a past in which the presence and leading role of the bourgeois is eternally naturalized'.[16] The prevalence of still and moving photographic images in our times, moreover of particular kinds of images, helps more than any museum can to naturalize particular versions of the past.

In our century photographic images have given the past a living presence. Photographs of the dead now appear on headstones, as though the image can more powerfully impress the departed upon the memories of those still here. Our memories of what happened are largely determined by the photographic records we have kept. The codes of the family snapshot album have become so well established that there are set occasions which have to be photographed so that they can be remembered: weddings, holidays, parties. Photographic images have become the means by which future nostalgias can be planned for. 'I wonder how many people remember things who don't film, don't photograph, don't tape', the voice-over muses in Chris Marker's *Sans Soleil*. The immediacy of the photographic image vacillates us between a now and a then. Old photographs or films can be sharp reminders of what has been and gone, but contemporary images of the past retrieve lost time and make it present again. Michael Wood distinguishes between the modes of nostalgia

> provoked by an old photograph say, and the nostalgia provoked by a movie that looks like an old photograph. In the one case, a piece of the past is experienced as lost; in the other, a general sense of loss makes us look around for a piece of the past that will suit our present feelings. We haven't lost it because we have only just made it up.[17]

Photographic images therefore have a unique capacity to give the past an active existence in the present, and those which are seen by vast numbers of people construct popular memories shared on a significant scale. It would be useful here to map the different routes

that *history* and *memory* take to the past. History has a discipline in its construction of a body of knowledge that constitutes 'the past', albeit methodologies and perspectives change and the body has a constant and protean growth. History belongs to writing. Memory on the other hand is produced by recollection and belongs to the oral transmission of personal or local identities which do not require public or written forms of verification. Whereas history is 'work', and for some a profession, memory is non-selective, it can belong to everyone. This is why film and television fictions matter politically, especially when issues of national identity are at stake.

How then can we locate screen fictions along these distinctive routes to the past: are they history or memory? Since they are not writing, do they belong to the oral tradition preserved by memory? Can they, in their photographic immediacy and 'amplitude', be considered a more vivid kind of history? Can their producers and directors be thought of as historians? Although the screen cannot possibly show everything 'as it really was', the popularity of these dramas lies, apart from their narratives and characterizations, in their claims to historical authenticity, and to the pleasures gleaned from their discovery of times lost from view.

As dramatic narratives they are not the work of history-the-discipline, but these fictions allow millions access to knowledge about history through representation.

> All accounts of the past tell stories about it, and hence are partly invented . . . story-telling also imposes its exigencies on history. At the same time, all fiction is partly 'true' to the past; a really fictitious story cannot be imagined, for no one could understand it. The truth in history is not only the truth about the past; every story is true in countless ways, ways that are more specific in history and more general in fiction.[18]

Film and television fictions can then be said to generalize the 'truth' about history, both through the 'exigencies' of the strategies which make them function as narratives, and through the distribution of those narratives on a vast scale. In that these fictions make the historical available to so many, and invite participation and involvement in their narratives, they could be said to democratize historical knowledge. However, the terms and limits of that democratization need to be explored.

For Roger Bromley fictional narratives dehistoricize history. Subjects are taken 'outside of history and into "story"'.[19] As part of

the oral tradition and as shapers of memory, screen fictions might be said to reassert the significance of the private in public. The reliance of narratives on individual characters means that while characters can become representative of social types because they are individuals with particular psychological make-ups and motivations, they cannot represent historical forces or social contradictions. This exclusion of the social and historic as a consequence of narrative amounts to what Bromley calls a process of 'organized forgetting' which continues even while the narrative works to provoke and satisfy the desire to be informed.[20]

Although it would not be denied here that narratives exist in dominant or subordinate relations to each other, and while Bromley's arguments are persuasive, they assume that somewhere there lies a 'true' history, a comprehensive account, rendering the most arcane of complexities clear. Such fictions, it would be argued, are merely duping instruments of the bourgeoisie. This ignores the differences between cultural or political identity and identification in the imaginary. It cannot adequately account for the different levels of engagement audiences make with these fictions, and presumes the absolute ideological effectivity of texts. Where fictions lead people's thoughts and dreams does not always correspond with the ground on which their feet are set.

Even if there are audiences whose 'real' class relations are masked by nostalgic fictions, is this masking permanent, or as temporary as the film or programme? 'Politically aware' audiences may well enjoy these 'dubious' fictions for their narratives, because they love hating particular characters, or because they are intrigued as to how relationships develop within the complexly constructed world. There may be others to whom these fictions give access to historical periods or to events they did not know about before. There are scores of reasons why audiences have found pleasurable identifications in these narratives, which may well lie outside their own identities of class, race, age or gender. The critical hype aside, it has to be acknowledged that millions who do not belong to the foppish English upper middle classes watched, and presumably enjoyed, these nostalgic representations of the past. Why they did so cannot be explained solely by applying a class analysis to fictional content. Clues need to be sought in the links these fictions had with particular cinematic and televisual traditions, and in the critical responses made available to audiences which were used to relate these texts to their times.

British screen fictions of the early eighties revamped notions of excellence as the hallmark of British production. Here was quality on the screen, not as extravagant as Hollywood, but expensive none the less, and here were the historical costume dramas the British do so well. *Chariots of Fire* and *Brideshead Revisited* could be seen to challenge Hollywood dominance with the lavish gravity of a British heritage in much the same way as Alexander Korda had done with *The Private Lives of Henry VIII* in 1933. Many of these screen fictions were adaptations of English literary classics (even though some of them were modern classics), lending these 'mass' media products the patina of high cultural values and respectability: *Brideshead Revisited, A Room With a View, A Passage to India, The Raj Quartet*.

Delivering this heritage were the most established of British actors, many of them cast in more than one film or serial: Laurence Olivier, John Gielgud and Claire Bloom (*Brideshead Revisited*); Peggy Ashcroft (*A Passage to India* and *Jewel in the Crown*); Rosemary Leech (*A Room with a View* and *Jewel in the Crown*); Maggie Smith (*A Room with a View* and *A Private Function*); Alec Guiness (*A Passage to India*), Denholm Elliot (*A Room with a View*). The best of British screen acting was also transfused with new blood: Tim Piggot-Smith, Charles Dance, Geraldine James, Ben Cross, Jeremy Irons, Nigel Havers, Anthony Andrews, Helena Bonham-Carter, Art Malik and Susan Wooldridge. With an ear to English diction and with the art of deft characterization, the realism of these productions was firmly rooted in what the British middle classes call Art. The scripting and characterization were the elements reviewers singled out for praise, relocating these *screen* fictions in a *theatrical* tradition. Ray Goode, the lighting cameraman who worked on both *Brideshead Revisited* and *Jewel in the Crown* was mentioned only once, in one review.

The prolific attention which greeted both *Brideshead* and *Jewel in the Crown* was almost entirely complimentary; in fact, by the time reviewers got to see *Jewel* their superlatives seemed exhausted. *Brideshead* won a record eleven nominations for the Prime Time Emmy Award in the US and soon became shorthand for the very best of British television. It was 'monumental', 'seductive', 'sumptuous', 'lavish'. Re-reading these reviews years later, it seems as though viewers must have been quite starved. 'The opening episode on its own qualifies it to occupy a place at that head of that column of British realistic television drama serials which includes

such memorable work as *The Forsyte Saga, Elizabeth R* and *The Testament of Youth*', ran the *Financial Times*.[21] Even the *News of the World* recommended *Jewel in the Crown* over *The Thorn Birds* (transmitted at the same time on BBC1), and so did the *Glasgow Herald*: 'The sprawl of *The Thorn Birds* has become a chronic slouch.'[22]

What reviewers most admired about these fictions were their complexities of characterization and of narrative, and their production values. They gave audiences more to think about, and that, according to the reviews, made them better than the 'mushy' romance and 'unashamedly old-fashioned adventure' found in *The Thorn Birds* (1983) or *The Far Pavilions* (1984). Appreciated here then was the weightiness in these dramas, their 'raising the tone' rather than 'levelling down'. Although some critics found both *Brideshead* and *Jewel* slow and the dialogue ponderous, in the end it was these qualities which so distinguished these fictions:

> Most of all, it [*Jewel*] conveys what the English call 'restraint', that repression of emotion so well served by social dialects, and our awareness of what is going on behind what Daphne says and the expectation that at any moment it might erupt.[23]

Even if they were 'restrained', the unusual visual pleasure these productions gave television audiences must account for their popularity. Budgets of £5 million for each serial and location shooting on film made texture, rather than the cut and thrust of plot, give these fictions their distinction, and since anticipation accompanied audiences' identification with characters, producers could be fairly confident of securing loyalty to *Jewel* for most of its run.

As 'quality' television *Brideshead Revisisted* and *Jewel in the Crown* crossed broadcasting boundaries. The BBC had been traditionally associated with quality productions and now, here was a commercial company, based in Manchester and famous for *Coronation Street*, earning commercial and critical success. Ferdinand Mount expressed the anxiety to which this gave rise: 'People of the better sort are indignant that the BBC, which usually does "our" brand of soap, has abandoned them.'[24] Granada was cueing the BBC to pull its quality socks up. 'Yet, like the Waugh adaptation before it, this Scott serial is setting a standard to which every other television drama production should aspire. It is doing the job the BBC should be doing.'[25] To the chagrin of producers at

Granada, surveys showed that a majority of the audience assumed the BBC had produced *Brideshead* and *Jewel* after all. This was hardly surprising, given that Granada's productions drew on what audiences had come to expect from 'good' television. The company had enhanced, rather than challenged, a staid dramatic tradition. Raymond Williams pointed to this circularity in British culture when he wrote that

> there has remained a certain parasitism on established forms and styles, often most noticeable when the 'industry' has taken itself most seriously and produced 'serious' films Moreover, deference towards the forms and styles of the established culture seems continually to re-establish itself within cinema, for predominantly social and artistic reasons.[26]

He might have added commercial reasons, for in spite of Granada's production budgets (widely publicized and massive for British television at the time), the finer traditions of British acting, literariness and heritage were good marketing material.

If the past is a 'foreign' country, and the country an 'old' one, then cinema and television provide ideal means of getting there. Television especially is a kaleidoscope for armchair tourists, bringing to audiences places and times they would never get to otherwise. The exoticism of Indian colour and landscape in the Raj revivals, the summer green of England or Tuscany were sure to buck the spirits on winter evenings. In these fictions television's most significant function was as a temporal, rather than a geographic courier. Authentic replication of the past guaranteed a naturalistic truth about the olden. Costumes, houses, furniture, cars and accent had to be just so.

In *Brideshead* the rooms Evelyn Waugh had occupied at Oxford were used and a great deal was made of an 'unreal' prop in order to show how painstaking attention to detail had been. The eggs that Sebastian offers at breakfast were not actually plovers eggs, but painted to look the part with expert advice from the Egg Marketing Board. Thus a television production marketing a particular kind of cultural heritage could keep its realism intact and avoid the accusation of threatening an endangered natural heritage. Paradoxically, the acting was universally lauded although it was made quite clear that not much had been necessary. 'The casting had to be perfect. We needed actors with a very exact sense of social class. They had to understand it and get the nuances right.'[27]

Through a defunct class and old things, an ambiguous relation-
ship with the past is secured. In an 'old country' they have status by
virtue of their precedence and because they provide a trail of clues
which leads to the present. The old made visible gives a sign of firm
anchorage in enduring values, crucial to a stable sense of identity.
Made visible, the old provides a symbolic display of high culture.
No matter to the viewer an exact chronology, since the well-worn
objects and long-tended gardens of yesteryear lend an educated
tone and bespeak discriminating good taste. The old's allure gets
buffed by its screen appearance. Not only is it laid out before us,
without our having to discover it, but we are also relieved of having
to experience the past 'the way it really was'. The irony is that our
'experience' of the past is only made possible by watching the new
media represent it.

Screen fictions, like other paraphernalia about the past, are
acquirable consumer commodities. It is not just that audiences can
witness other lives, other times and elsewheres at the screen's
remove, it is also that the screen can present the past in such 'an
intense and plausible' way that audiences can almost partake of it.[28]
That a resurging interest in museums concurs in the early 1980s
with these fictions is no mere coincidence, nor is the growth of tour
operators offering package holidays to India – from fifteen in 1979
to seventy by 1984.[29] In showing a bourgeois past replete with
objects and leisure, these fictions both declare those times and
inequalities as dead and buried yet display them as presently
available. Times are different now, they say, the gaps more easily
bridged between rich and poor, black and white. The bridging,
however, is partly a consequence of the increased purchasing power
audiences have, their growing capacity to acquire commodities.

Now, while it is undoubtedly true that most people are better off
than they were, commodity acquisition in everyday life is by no
means unanimously enjoyed. While these fictions say the past has
disappeared their own 'quality' rests on the endurance of old values
and on their displays of the kind of lifestyles for which all the
accoutrements can now be bought. Their production values are as
seductive as advertisements and invite the same wealth-taken-for-
granted perspective as the Sunday supplements. Derek Granger,
Brideshead's producer, had a fairly clear idea of who the serial was
for: 'I will predict that *Brideshead* will have the highest proportion
of AB viewers ever on TV.'[30] Here, truly, was the past as
commodity.

To say that nostalgic fictions dominated British screens during the 1980s would be untrue. They were undoubtedly the most marketable of fictions, loudly acclaimed and resourcefully distributed, but they were not the only ones made. While their representations of history blotted out the representations of others, new fictions and rediscovered histories were also screened.

Channel 4, despite its shortcomings, opened broadcasting to new talents. There were great productions across the TV networks which shed entirely different lights on the question of national identity: *My Beautiful Laundrette* (Channel 4); *Handsworth Songs* (Channel 4); *Boys from the Blackstuff* (BBC1); *The Singing Detective* (BBC1); *Edge of Darkness* (BBC2); *Tutti Frutti* (BBC2). *Distant Voices Still Lives*, released in 1989, interrogates and resists the nostalgia that memory makes too easily of the past. The answer is not simply to market these fictions more energetically and more effectively (although that is part of an answer), because a more powerful remedy is required, a deeper sickness has to be shaken off. What the *old* country is and who belongs *there* are questions which should stop being the ones so obsessively asked. On the screens before us, desperately needed, are all those fictions, yet to be made, by those who are *here* regardless. We need their contemporary stories, their perspectives on futures that are not bound and knotted by a very British parochialism. All those old ghosts need to be left behind.

Chapter 10

Echoes of empire: towards a politics of representation

Yasmin Ali

> As a child in Karachi I did not view our coming to Britain as an uprooting experience. Far from it. The prospect of travelling to Britain filled me with excitement and a sense of adventure, the thrill of being in Europe, of seeing a country that just a few years before my birth had ruled mine.
>
> Najma Kazi, 1988[1]

> Peel Square is more of a terrace than a square. It has the date 1851 and a loyal crown. It is now Asian: the empire has come home.
>
> Paul Barker, 1981[2]

The British empire had many echoes in the 1980s. The quotations above capture the essence of two conflicting views; but they have one thing in common – a sense of irony. The ambivalence expressed in the ironic tone has been a key element of the 1980s; a decade characterized by shifting social and political alliances, and the slow, steady inversion of older symbols and meanings. In this essay the intention is to explore such changes; to ask how identities have come to be formed, expressed and contested.

The argument to be advanced is that in order to understand how popular culture has embraced, or at least reflected, a multiracial Britain it is necessary to place these changes in the context of the competing discourses around 'race', nation, ethnicity and identity that have characterized the decade. 'Race' refers to the politics of colour, arising out of the ideological uses of biological theories of race. Ethnicity is used to refer to cultural differences between groups which are used as a basis for mobilization. There *has* been some discernible response to black pressure-group demands for less

marginalization and stereotyping of black minorities in, for example, soap opera or advertising, although there is arguably still much to be done. But there has also been a lessening of interest by black groups in such questions and a rise of concern for autonomous cultural expression. Such a change has been brought about by a complex set of interrelationships which this essay will attempt to uncover. Much simplified, what appears to have happened in the decade is a shift in the characterization of some minority communities from being 'black' or 'immigrant' (depending on political perspective) to 'ethnic'. Such a change has also affected perceptions of white indigenous 'ethnicities'. In the movement from 'black' to 'ethnic', it will be suggested, the Right has been more adept than the Left in its handling and understanding of the politics of the cultural changes taking place in communities originating in some of the countries of the old empire.

At the beginning of the 1980s 'communities originating in some of the countries of the old empire' would have been expressed unselfconsciously as 'black communities'. At the end of the decade 'black' is a much more contentious label than it was previously. 'Black' in its British usage was intended to convey a sense of a necessary common interest and solidarity between communities from the old empire (or the New Commonwealth); it was a usage predicated on the politics of anti-racism. As such, 'black' 'became "hegemonic" over other ethnic/racial identities' in the late seventies and early eighties.[3] The moment was not to last. From within marginalized communities and from without there was, in the 1980s, a steady assault upon this fragile hegemony.

The assault was no co-ordinated campaign of common purpose. Rather it was reflective of a number of unrelated and sometimes mutually antagonistic debates encompassing black cultural politics, anti-racism/multiculturalism, the growth of ethnicism, the laments for England of both the sentimentalist left and the social authoritarian right, and the rhetoric of 'popular capitalism'. At times these debates, and their social and cultural products, have come to look like a comic distorting mirror held to the dominant discourses of 'enterprise' and 'heritage', as minorities (and those who sought to appeal to them) looked for a 'protestant ethic' reborn in Islam, or a defence of 'ethnic heritage', or a static, ossified view of cultural identity and its social purposes.

Stuart Hall has suggested that 'the black experience', as it has been constructed, was

an analysis formulated . . . in terms of a critique of the way blacks were positioned as the unspoken and invisible 'other' of predominantly white aesthetic and cultural discourses This analysis was predicated on the marginalisation of the black experience in British culture.[4]

Such marginalization has largely taken the form of absence or stereotype. Hence black pressure politics through much of the 1980s focused upon those two aspects of marginalization. The Black Group of the Campaign for Press and Broadcasting Freedom (CPBF), a pressure group concerned with the structures of owner-ship and control of the media, typified this approach, linking the absence of representative numbers of black journalists and other media workers with the poor coverage of black issues and racist stereotyping of what coverage there was. In a 'Media Racism' supplement to *Free Press*, the journal of the Campaign for Press and Broadcasting Freedom, press coverage of unrest in Handsworth in September 1985 was analysed in terms of white journalism's stereotyping of black people, and black people's instinctive suspicion of the motives of the press.

> the *Sun*'s Ian Hepburn: 'I tasted race-hate violence first hand when I was mugged and kicked by a 15 strong mob of West Indian youths' (11/9/85).
> Only towards the end of this emotive piece does the reader find out what they were after: not Hepburn's money, nor his life, but – on discovering he wrote for the *Sun* – his notebooks.[5]

The demands of the Black Group of the CPBF as a pressure group can be summarized as including the employment of more black workers in the press and broadcasting, coupled with the main-tenance of external pressure to 'democratize' the media so that they are able to reflect more accurately black experience.[6]

Certainly stereotyping has been remarkably consistent across a range of media, but arguably its effects have not been solely to place black people at the margins of an unchanging dominant culture. Stereotypes have also been employed to construct an image of a 'new' Britain, or more usually England; urban, multiracial, and often alien and disturbing. Where 'alien', the vision has not usually been in the form of the Powellite warnings of the 1960s, a cautionary tale of what the future might bring, but a wearisome exploration of the here and now.

The Paul Barker comment on Peel Square in Bradford quoted at the opening of this chapter is from an interesting example of the genre. Part of a series on 'Britain Observed' in *New Society* in 1981, Barker's piece is a short descriptive essay on a walk around Bradford at the beginning of the 1980s. He begins his journey in a public park where, amidst the white drunks, only Asians 'use the park as [its Victorian benefactor] . . . intended'. Family groups 'promenade', their sons looking as though they 'do well at school'. Asian children play in the streets as mythical children in the Pennine towns were ever intended to do. In the city centre, however, the picture is more sombre as Barker visits the Metro Interchange, a combined bus and railway station.

There is a set of public lavatories down below, by the bus section. A group of black boys are hanging around waiting for them. Some elderly whites, waiting for their buses, watch them with apprehension. It has the feel of bus stations in America.[7]

Asians are here constructed as peaceable, family-centred people, keen on education, religious, and enterprising (the article makes reference to the mosques and the names of Asian businesses which line the Bradford streets). Their presence in Bradford is a parody of another age; they are the respectable working class, god-fearing, the 'nation of shopkeepers' of a mythological Victorian age. 'Blacks' (Afro-Caribbeans), on the other hand, are presented as an antithesis to the Asians. Barker describes some young black women he sees in the bus station in sharply contemporary terms as poised, self-confident, smartly dressed, evoking the image of Afro-Caribbean women as the competent backbone of the community, whilst the young men are aimless, 'hanging around', frightening the 'elderly whites'. The scene is said to be reminiscent of America, and presumably of its history of racial violence.

The white working class does not avoid stereotyping in this postmodern urban montage where Victorian values with brown faces sit incongrously alongside the bus stations of Atlanta, Georgia. If young, whites are often portrayed as racist and violent,

a typical anti-Paki attacker is unskilled, white, living in a council house, unemployed and with little prospect of work . . . he was, academically, a failure. Many Asian fellow students of this typical white youth have done well at school: his black colleagues have done just as badly.[8]

If older, whites may be dying repositories of an old homogeneous working-class culture, as in Jeremy Seabrook's description of a man in the Black Country,

> He was feeling a bit low that Friday night: but as he started to talk he found new animation and energy; something vibrant and moving – a feeling for the natural world, a love of England that has nothing to do with the patriotism of those who own it. . . . There is something in his love of birds that is deep and passionate, part of that secret, defensive culture of the working class.[9]

Seabrook's leftist English patriotism, and his romanticization of the working class, has strong parallels with sentiments expressed by, for example, the social authoritarian New Right in the *Salisbury Review*. This is something to be considered at greater length below.

More commonly in the early 1980s parts of the Left used the stereotype of the black person as 'more English than the English' as a kind of 'witty' inversion of values; ironic positive discrimination. The attitude is exemplified in Angela Carter's view:

> The legendary British virtues of tolerance, decency and fair play are rarely manifested by the media, to such an extent one could easily think the new commonwealth had inherited them all. For these qualities are far more amply demonstrated by people of Asian and West Indian origins, in the face of the most intolerable abuse, violence and prejudice.[10]

All this is not to suggest that the stereotype of the Asian, in particular, is universally benign. Once again in Bradford, in an article by David Selbourne in *New Society*, an Education Policies Development Officer for Bradford City Council is described, when talking about the multiculturalist education policies of the council, as 'sounding like a good district officer in darkest India, several upper middle class cuts above *The Jewel in the Crown*'s Merrick'. The city is 'a bazaar', changed utterly and tragically in Selbourne's coarsely bitter prose:

> In 1933, Priestley, looking back to 1914, lamented how 'miles of semi-detached villas had been built where once I rolled among the gigantic buttercups and daisies'. Today . . . the buttercups have become kebabs and the daisies chapatis, in an urban wilderness as bleak as anything in Britain.[11]

In this vision people from the Indian sub-continent cease to be enterprising; a stereotype from the 1960s (the Pakistani whose only words of English are 'National Assistance'), combines with a Seabrookian image of a nobler indigenous working-class culture to create an early example (1984) of a vision of Bradford and of Asian people that was to become commonplace in newspaper and television coverage of the *Satanic Verses* controversy in 1988–9. A further quotation makes the point clearly:

> as the local economy goes under, the welfare network of public and voluntary provision . . . spreads across the city to replace the old world of production. It is a labyrinth of casework agencies, family service units, and neighbourhood advice centres; a jungle of mutual dependencies between the providers and their clients, which is known as the welfare system. And that in a local culture proud of its working class traditions of self reliance.[12]

The 'dependency culture', the portrayal of public sector workers as parasitic, and the distant vision of another, better England sinking under the burden, combine here to link the multiracial inner city with the anti-enterprise culture that the age of Thatcherism had pledged to eradicate. On this terrain parts of the Left representative of the sentimentalist strain in British Labourism are rooted to the New Right of 'enterprise', and the old right of 'heritage'. The reasons why this may be so are complex and multifarious, but one central reason was, perhaps, identified by Paul Gilroy:

> Discourses of nation and people are saturated with racial connotations. Attempts to constitute the poor or the working class as a class across racial lines are thus disrupted.[13]

Significantly the Selbourne article quoted above was written to provide 'background' to the then current controversy in Bradford over an article by a local primary school headmaster, Ray Honeyford, printed in the ultra-Conservative journal, the *Salisbury Review*.

The *Salisbury Review* and its key writers and associates on the academic wing of the New Right have been successful in taking their variant of 'ethnic absolutism' (to use Paul Gilroy's telling phrase) to influential audiences as well as a wider public. The *Salisbury Review* itself is a small circulation journal addressing itself to the Conservative intelligentsia, but through newspaper

columns such as Roger Scruton's in *The Times*, and particularly through the *cause célèbre* created by the response to Ray Honeyford's articles 'Multi-ethnic intolerance', and 'Education and race – an alternative view', it has managed to obtain an influence out of all proportion to the size of its readership. Significantly, however, its influence has been different from that of many of the other right-wing pressure groups and 'think tanks' that mushroomed in the 1980s. Where the Adam Smith Institute, for example, has been able to demonstrate its influence through government adoption of its radical policy recommendations in such fields as transport, or local government, the key *policy* recommendation of the *Salisbury Review* group in relation to the 'race'/nation debate – 'repatriation' of non-white Britons, or a retrospective change from citizen to *gastarbeiter* status – remained conspicuously absent from the Conservative political agenda during the 1980s. Contrast John Casey's view that

> the West Indian community is *structurally* likely to be at odds with English civilisation . . . [Asians] by their large numbers, their *profound* difference in culture . . . are most unlikely to wish to identify with the traditions and loyalties of the host nation.[14]

with the Conservative Party's 1987 General Election manifesto:

> Immigrant communities have already shown that it is possible to play an active and influential role in the mainstream of British life without losing one's distinctive cultural traditions.[15]

The major contribution made by the *Salisbury Review* group and their friends has not been to add their preferred policies to the Conservative agenda, but rather to assist in the Conservative appropriation and inversion of the moral force of 'anti-racism'; a key task for Conservatism in the latter half of the 1980s in particular. When, on election night 1987, Margaret Thatcher declared that the next target for the Conservatives in her third term in office would be 'the inner cities', this meant not merely economic regeneration, or policies designed to alleviate their chronic social problems, but a drive for 'hearts and minds', including black hearts and minds, similar to the one believed to have been so successful in capturing the votes of the skilled working class in 1979 and 1983. This is not to suggest that there has been a Conservative change of heart since Margaret Thatcher's overtly racist comments about being 'swamped' by 'alien cultures' in 1978. What is clear, however,

is that following numerous changes to nationality and immigration laws in the 1980s, there was little electoral need further to appease the white racist vote, and much to be gained in urban marginal constituencies from courting the new minorities.

Anti-racism as a current in the politics of the Left was predicated upon the presumption of a unity of interest between those who were the victims of racism. The problem inherent in anti-racism was thus a belief that a shared experience of oppression and marginalization in Britain, coupled with the still very recent and painful experience of British colonialism, was sufficient to overcome historical, cultural, religious, and linguistic differences *between* black communities; in other words, the 'ethnic' factor. In India, Africa and the Caribbean the British had assiduously promoted 'ethnic consciousness' as an effective means of social control, and the historic roots of ethnic antagonisms are deep, and still often live. In the late 1970s and early 1980s, a high point of black solidarity, *class* was perhaps the major factor underpinning the success of the anti-racist enterprise. Since then two forces in particular have acted to weaken the basis of black solidarity. First, there is the simultaneous success and failure of anti-racism. Its failure is marked by the abolition of the Greater London Council and the Metropolitan Counties whose experiments in providing a positive identity and effective policies for the multiracial locality were thwarted by the greater power of a centralizing Conservative government antagonistic to their popularity. Anti-racism's success was in gaining widespread acceptability for certain limited aspects of its mission, as Conservative and other local councils adopted high-profile 'equal opportunities' policies, as a Conservative Lord Chancellor introduced race awareness training for new magistrates, and as official government information in the late 1980s began to look like GLC material from the early part of the decade (the Community Charge or 'poll tax' information leaflet is a good example, with its multiracial cast of sari-clad young professionals and Sikh plumbers dancing along the bottom of the pages).[16]

A second factor in the weakening of black unity is the fact that cleavages have begun to open up *within* communities as they become affected by the class, gender and other pressures that were previously submerged by the newness and marginality of those communities.

The heightening of 'ethnic' identity and its politicization began on the Left but was paralleled on the Right by those who wanted a

'non-*racialist*' means of defending English identity. Enoch Powell, in his denial of racist motivation, speaks for many on the Right who approve his position on questions of 'race'. He answered critics who saw his views as racist in a 1969 interview:

> if by a racialist you mean a man who despises a human being because he belongs to another race, or a man who believes that one race is inherently superior to another in civilisation or capacity for civilisation, then the answer is emphatically no.[17]

It is an answer which has always been unsatisfactory given the implications of the repatriationist line; even a 'traditionalist' Conservative critic discussing the *Salisbury Review* group's obsession with repatriation observed that

> it is so difficult to envisage any practical measures which would achieve the apparently desired results of racial or cultural homogeneity – or none which can be mentioned in the polite society we wish to keep one foot in.[18]

Nevertheless the disclaimer against racism, however empty, is important in so far as it enables the differences between sections of the Right to be elided in practice.

The common view of English national identity in the *Salisbury Review* is that it is *rooted* in the historical experience, culture, religion and language shared by those who are of 'this sceptr'd isle', and that it cannot be conferred by the acquisition of a passport or even a generation's residence (nor, apparently, can it be lost by 'kith and kin' in white colonies or ex-colonies). Englishness is thus seen as something 'natural', intuitive, it is 'felt'; as such it fits the standard definition of an ethnic group as something that is 'inclusive', and which may be a basis for mobilization.[19] It follows on consistently from this view that anti-racism, with its underlying insistence upon the necessity of class unity, is viewed as fallacious and dangerous.

A favourite pejorative phrase of the Right is 'the race relations industry'; industry in this context is used ironically, as in the assumption made in the David Selbourne article referred to above that 'genuine' industry, both in the sense of worthy effort and manufacturing production, is being stifled by the presence of 'race relations' professionals. To Ray Honeyford they are 'Asian and West Indian intellectuals . . . [and] political extremists with a background of polytechnic sociology' who practice an 'inverted

McCarthyism'.[20] Anthony Flew and Roger Scruton develop in separate pieces a more sophisticated analysis, concentrating upon the success then enjoyed by anti-racists in promoting usage of the term 'black' to refer to a variety of different groups. Scruton's tactic, writing in his capacity as a newspaper columnist, is to ridicule the term by developing an *argumentum ad absurdum* whereby he 'proves' that as part of a 'persecuted minority' of educated whites he is therefore 'black' according to the usage of the term adopted by the Inner London Education Authority. Flew, writing in the *Salisbury Review*, develops a point that has been a commonplace observation amongst anti-racist educationalists,[21] that educational 'underachievement' by different ethnic groups differs substantially in both kind and extent, thus 'proving' that ethnicity, i.e. cultural difference, not 'race', is the key variable in their performance.[22] The assault upon the inclusive use of the term 'black' is of particular importance, because it parallels a similar assault by Asian and African-Caribbean ethnicists (to be discussed below), and it is thus a site upon which the Right has been able to foster alliances with minorities. The terrain upon which all of these arguments are developed is, significantly, education. Education is often a critical battleground in the contestation of both national, and cultural nationalist, identity, and citizenship. The social history of the United States of America, or the continuing battles over education and language in South Africa, are testament to the salience of education to oppressed groups. Education was also to become a central area of Conservative Party policy in the 1980s.

The *Salisbury Review* group was thus not alone in its elevation of ethnicism *over* anti-racism. Anti-racism has at no time been a coherent analysis of British society in its own right. Rather it has been informed by, and shaped by, a variety of currents in the politics of the Left, and its life as an 'ism' has been most vigorous in popular usage. Consequently the distinction between 'anti-racism', with its implicit class politics, and 'multiculturalism', with its ethnicist perspective, was often blurred in rhetoric and in practice. The line dividing strictures against 'ethnocentrism' from ethnic absolutism is thin. Thus the campaign against the inclusive usage of the term 'black' began from within the 'black' communities. Nor was it universally a rearguard action against the Left. 'Ethnic' broadcasting provides an interesting example as an area in which there were a number of legitimate grievances. The BBC had co-opted a section of the Asian middle class into local radio and

television without addressing the question of whether their new staff were representative of the communities to which they were broadcasting. The results were sometimes to broadcast programmes in one 'community' language to a local audience made up largely of speakers of another language. Even where this was not the case, the low budgets (sometimes no budgets) of these programmes left that section of the middle class with the leisure time and the money to support their hobby to dominate a medium that was often successful in reaching more than 80 per cent of its target audience.[23] Campaigns on the language issue have had some success in changing BBC policy, although not all are happy with the outcome that English is now the dominant language of Asian 'ethnic' broadcasting. The question of class remains real and unresolved; in communities in which there are often few structures for democratically accountable leadership to emerge, in which the 'community leader' remains a key broker between community and white authority, domination of the media by those self-same community leaders and their families continues to be problematic.

In other words, what such a case illustrates is that an issue which fused contests around class with those around language was open to resolution *only* around the language question. Ethnicity was thus opened up as a viable focus for mobilization because it was able to achieve results quickly, unlike millenarian class politics. The demands of ethnic mobilization were achievable because they were usually perceived by those who needed to accede to the demands as limited and unlikely to disturb the balance in existing power structures. As a Bradford Education officer was quoted as saying in 1984: 'We have trained people to shout, provided that they shout acceptable slogans ... *Halal* meat, mother-tongue teaching. The issues where we can deliver.'[24]

Indeed, ethnic mobilization had the capacity also to *strengthen* traditional power structures *within* communities. The transient political success of anti-racism through the policies of some local councils in the early 1980s had put pressure on communities to democratize. Grant aid to voluntary social services and arts groups, for example, created alternative platforms to those monopolized by the 'community leadership' system, and the accountability which those occupying the new platforms sometimes had to demonstrate to their co-workers or supporters provided a different political model. 'Community leaders' in this period adopted some of the language and tone of anti-racism, but following the political defeat

of some of anti-racism's flagship authorities, the lessons learned were sometimes put into practice for a very different purpose, and with very different political allies.

Education continued to be at the centre of what was turning into a Left/Right battle across racial lines. The Right (individuals, like Caroline Cox or Anthony Flew, Ray Honeyford) and pressure groups like the Parental Alliance for Choice in Education (PACE) long having fought a rearguard action against the comprehensive system, had chosen to make anti-racist/multicultural education (the two are, characteristically, never differentiated) an exemplar of what was alleged to have caused a decline in standards in the state sector. Coupled with a Conservative Government commitment to 'increase parental choice',[25] this was to become a powerful lobby. Through the upsurge in ethnicist consciousness, the Right was able to recruit conservative elements in black communities to their cause. The outcome was the creation of some strange alliances; PACE, for example, felt able to support white parents in Dewsbury in West Yorkshire who withdrew their children from a school with a large number of Asian pupils, Headfield Church of England Primary School, whilst also lending support to Asian parents in the town who wanted to gain local authority support for an Islamic girls secondary school, Zakaria School, in neighbouring Batley.[26] The anti-racist conception of a necessary *black* alliance was also mirrored, but subverted, by the creation of ethnicist black alliances, as in the call for an end to anti-racist and multicultural education issued jointly by the Islamic Cultural Centre, the headteacher of the Seventh Day Adventist John Loughborough School in North London, and a Chinese 'community leader', who was quoted as saying 'We are sick and tired of all this anti-racism.' The group also voiced support for the abolition of the Inner London Education Authority, which had long been a favourite target for the Right.[27]

The campaign against the use of the term 'black' is, perhaps, the most symbolic of the political and cultural changes wrought in the 1980s. Black unity was not only being undermined by the conscious ethnicist strategies of ideologists of varied pigmentation; it was also being strained 'on the streets'. The stereotype of Asians as having praiseworthy Thatcherite virtues such as a *'culture of entrepreneurship'*,[28] was gaining currency among black people, as certainly intended. As Salman Rushdie observed in a talk on the Channel 4 *Opinions* programme in 1982 entitled 'The New Empire within Britain':

I have been told by Tory politicians that the Conservative Party seriously discusses the idea of wooing the Asians and leaving the Afro-Caribbeans to the Labour Party, because Asians are such good capitalists.[29]

The success of that mission is illustrated in the case of a spectacularly unsuccessful Pakistani small-businessman in Blackburn, Lancashire, whose minimal capital, long hours of work and paltry returns placed him on the edge of subsistence. He told Martin Harris, researching a background piece on the 1983 general election, that he had decided to vote Conservative at the election.

'It is the first time' he says. 'But few things made me change my mind. Tory Party want you to be well off, just like them. They are for a person getting better off. Other thing my religion. Christian religion says rich person cannot pass through eye of needle, but Moslem religion says do trade whenever you can.'[30]

Misplaced optimism has never been hard to find among the poor; what is significant here is the explicit linkage made between voting Conservative, having business aspirations, and religion. The Bank Top and Brookhouse district of Blackburn, one of the town's poorest areas using any indices of deprivation, and traditionally a Labour stronghold, went on in the 1989 County Council elections to elect Abdul Bhikha as a Conservative councillor, against the national and regional trend. As the local evening newspaper observed on the day of Bhikha's victory, 'The Tories played a smart card in putting up a Muslim candidate – one with firm mosque connections.'[31]

The linkage between Asians and business has also gained currency among other blacks, and has surfaced as an issue in situations of urban unrest. In a consideration of the attacks upon Asian shops which occurred during the Handsworth riots of 1985, E. Ellis Cashmore observed from both the American and British experiences that 'Minority groups often measure their own success by that of other minority groups, and inter-ethnic rivalries can often result.'[32]

There are, of course, also more positive reasons why the British use of the label 'black' and the political imperative it implies has been unattractive to African-Caribbean people. Varieties of black cultural nationalism with long histories in the Caribbean and North America, as well as Africa, have been influential in providing a

cultural and political corrective to the particular forms of racism and marginalization inflicted upon them in Britain and its former colonies. Black nationalism, it is worth noting, has also been a politically highly ambivalent form of ethnicism.[33]

In such a context the success of the campaign against the use of the term 'black' was assured in the late 1980s. Tariq Modood has been a leading campaigner, since the publication of an influential article in *New Community* entitled ' "Black", racial equality and Asian identity'.[34] Recognizing that the term 'Asian' is itself problematic, he states that it is 'Roughly [applicable to] . . . those people who believe that the Taj Mahal is an object of their history'.[35] The force of Modood's argument is constrained in the *New Community* article, addressed as it is to those whom he may have presumed to have been a hostile readership of 'race relations' professionals. Less restrained was an article in the *Guardian* in which he appears to acknowledge the racism implicit in his position. Commenting upon the attention paid to right-wing demands for a stark choice between repatriation or assimilation, he says:

> Yet the left is blind to its own brand of assimilationism, which may be characterised as 'Become Black and fight racism!' When Asian communities evaluate the choices on offer – become quasi-whites or quasi-blacks – the former seems less resistable [*sic*] and more attractive in its rewards.[36]

At the time of writing his *Guardian* article, Modood's battle had effectively been won. A number of local councils, notably in London, had under local pressure dropped the anti-racist usage of the term 'black', and in December 1988 the Commission for Racial Equality (CRE), a particular target of Modood's wrath in *New Community*, changed its recommended ethnic monitoring categories 'after wide consultation'. Asian was no longer to be a subdivision of Black. Instead Indian, Bangladeshi, Pakistani and Chinese became 'colourless' categories.[37] The change was intended in part to bring the CRE question into line with that agreed for the 1991 Census, the first to include an ethnic monitoring question, but was principally a response to the campaign of which Modood was a leading spokesperson.

Surveying the decade, it is clear that questions of identity, including national identity, have been of major importance in the cultural politics of Britain. The reasons why this has been so are

many, but they are not always connected in origin, even if they are closely bound together in terms of outcome. For the Right, itself an often uneasy coalition, the question is one of many, once thought irrelevant or anachronistic, reopened by the Thatcherite assault upon the legitimacy of the post-war consensus. These questions range from a desire to 'remake' the retreat from empire so as to reinstate an England innocent of post-imperial obligations, particularly those to black people (*Salisbury Review* group *et al.*), to a desire to subvert and appropriate the hitherto taken-for-granted allegiance of new social groups to the Left (the Thatcherite 'modernizing' mission). In practice these two apparently contradictory positions have proved mutually reinforcing.

The Left as a whole has found it far more difficult to intervene in these debates. The success of the Conservative's populist attack upon anti-racism, as an element in the assault upon 'the loony left', put a demoralized Labour Party on the defensive about what was, in any case, an extremely one-sided relationship with black communities (collecting the loyal black vote). Those sections of the Left who remained loyal to anti-racism found it an increasingly difficult and troublesome path, as, for example, in the case of a highly critical report on the implementation of anti-racist education produced by a multiracial commission of inquiry into the murder of a pupil at a Manchester secondary school. Perhaps most troubling of all for the Labour Party was not the growth of urban unrest in some multiracial areas (the riots of 1981 and 1985 could be portrayed as vindicating Labour criticisms of the Thatcher government's record on the inner cities), but the groundswell of ethnicist demands, for example around Islamic education, or above all, the reaction to publication of Salman Rushdie's novel *The Satanic Verses*, which came into stark and apparently irreconcilable conflict with other axioms of Labour belief. The celebrated Conservative election poster of 1983, 'Labour Says He's Black; We Say He's British', haunted Labour as it ended a decade uncomfortable with both the concept of blackness and that of Britishness.

It was perhaps outside the terrain of electoral politics or policy that the most revealing and significant interventions were being made. Films made by or with black people have been particularly important in putting the light and shade into what had been too often hidden, stereotyped or marginalized experiences. Very different films like *Passion of Remembrance* or *My Beautiful Laundrette* were able to confront or discomfort black as well as white audiences

by engaging with a 'politics of representation' more subtle and challenging than either the old black radicalism or ethnicism. Comedian Lenny Henry, himself often accused of trading on black stereotypes, punctured the 'Raj revivalism' of films and television series like *A Passage to India* and *Jewel in the Crown* with a serial spoof called 'The Jewel in India's Passage', in which the *memsahibs* were unintelligible 'aliens' and the Indian servants were co-conspirators with the audience – 'us'. *The Satanic Verses*, a novel that it has now become almost impossible to discuss simply as a piece of fiction, was addressed centrally to questions of migrant and post-migration experience, its British scenes satirizing, but also thereby affirming, a new, cosmopolitan Britain.

These more complex, sometimes ambivalent, multi-faceted views of Britain, however different they are from one another, share a set of knowing references to Britain's imperial past and its echoes in the present. They subvert the heritage of empire, as in another part of the culture the post-war settlement was subverted in the name of the 'enterprise culture'. The massive advertising campaigns for successive privatizations of public corporations took images of national unity from the Second World War and after – the era of nationalization – and turned them inside out. The climax of the British Gas campaign, for example, saw 'the British people' gathered around the island's shores and hilltops lighting beacons; presumably to celebrate the victory of 'popular capitalism' over socialism. The style – national unity in regional and ethnic diversity – was subsequently taken up in advertising across a range of products, from pension companies to paint. The high-street clothing chain, Benetton, launched a series of advertisements, seemingly multiracial and internationalist, which looked very much like some of the images connected with the GLC's Anti-Racist Year (1984). Less lyrical, but perhaps as significant, a building society's television advertisements even stole Hanif Kureishi's launderette as a familiar symbol of urban Britain. The most enthusiastically 'Thatcherite' of national museums, the Victoria and Albert Museum, saw it as apposite to choose to move its collection of Indian art to a disused mill in Bradford, a city which has recently marketed its new 'ethnic heritage' by offering 'gourmet Indian food' package tours alongside its holidays in 'Brontë country'. All this to complicate further a society in which the numbers of reported incidents of racial harassment and attacks were continuing to rise rapidly, in which the evidence of discrimination in employment, housing,

education and the legal system was mounting, and in which immigration and nationality laws were applied with harsh inconsistency in cases ranging from Viraj Mendis to Zola Budd.[38]

That a review of debates around national and cultural identity should reveal diversity, contradiction and confusion should not be surprising. As a Conservative commentator, Ferdinand Mount rightly observed in an important article in the *Spectator*, 'Hypernats and country-lovers',[39]

> When a politician invokes 'national identity', he is not referring to something fixed and 'pre-political'; on the contrary, he is helping to *make* something, often by manipulation of the evidence of history or geography, and what he makes may well have a momentous impact on events for good or ill.

Mount argues that there is nothing inherently conservative about patriotism or the rhetoric of Nation and 'race', just as there is nothing inherently 'unconservative' about difference and diversity. On the contrary, Mount believes that the conservative *tradition* is mocked by 'nationalism of the hyped up, obsessive kind'. Paul Gilroy, in the context of a brief consideration of the 1984–5 coal dispute, suggested that

> There is no reason why a political language based on the invocation of national identity should be the most effective where people recognise and define themselves primarily in terms of *regional* or *local* tradition.[40]

It is a form of reasoning of which Mount approves; his 'heart sinks' upon hearing such 'shatteringly bogus' terms as 'Britons' or 'Britishers', and he approves 'provincialism' which he sees as 'not concerned with excluding non-belongers'. Warming to his theme, Mount cites a pantheon of conservative luminaries to prove his case, in a passage that deserves to be read in full:

> The traditional alternative model of country-love . . . may be called the Serial or Little-Platoon model, from Burke's formula: 'To be attached to the subdivision, to love the little platoon we belong to in society . . . is the first link in the series by which we proceed towards a love to our country and to mankind.' . . . Balfour thought that 'some combination of different patriotisms is almost universal among thinking persons', and that the patriotisms ought to reinforce each other. Since conservatism

teaches that human society demands structure and hierarchy, any creed which concentrates all human energies and loyalties upon one institution or stops at national boundaries and scrawls over the rest of the world '*Here be Tygers*' cannot be conservative in the full Burkean sense.

Writing not just at the end of the 1980s, but in the week in which the Islamic government in Iran issued a death threat against Salman Rushdie which had been greeted approvingly by some British Muslims, Mount demonstrates in the clearest terms the extent to which the Right has appeared capable of infinite flexibility in its mission of renewal in the 1980s.

In the many contests around questions of identity in the 1980s bold, uncompromising positions have been struck, but beneath the protagonists' feet the ground has been shifting dizzyingly. The resulting synthesis, still emerging, still contested, looks very different from any single position discussed above. The 1980s has been a decade of contradiction and change in which a fascination with issues of ethnicity and race has spanned the political and cultural spectrum. Within the mêlée, growing stronger, are the new voices of Retake, Black Audio-Film Collective, Sankofa, and others; and writers like Hanif Kureishi (whose travel writing on Bradford contrasts starkly in its relaxed and knowing realism with the fevered imaginings of some white visitors to the city), Caryl Phillips and, of course, Salman Rushdie. Stuart Hall has spoken, astutely, of 'entering a new phase'; it is 'a change from a struggle over the relations of representation to a politics of representation itself'.[41] The 'struggle over the relations of representation' though it is not yet over, echoes strongly the legacy of empire in its 'us' and 'them' colonial relations. A politics of representation is altogether a more complex, more interesting and more open challenge for the future.

Chapter 11

Re-imagining the city

Franco Bianchini
and Hermann Schwengel

The development of British cities in the course of the 1980s can be described through a series of seeming contradictions, such as those between urbanism and anti-urbanism; Europeanization and Americanization; regeneration and further decline; public and private space; the new interest in active citizenship and the erosion of local autonomy.

After an examination of this series of 'paradoxes' in 1980s British urban development, this chapter makes tentative proposals on how to articulate urban regeneration strategies for the 1990s, encompassing programmes for local economic development, the revitalization of the public realm, the redefinition of urban planning, and the fostering of participatory forms of local democracy.

THE 'CULTURE' OF BRITISH CITIES IN THE 1980s

Urbanism and anti-urbanism

As Martin Wiener has convincingly argued,[1] the cultural tendency which we describe here as 'anti-urbanism' has deep historical roots in English society. David Boyle observes that although the phrase 'inner city' – which in the 1980s evoked images of alienation, disorder, fear, squalor and decay – was not coined until the 1970s, the 'inner city problems' of poverty, crime, disease and dirt are clearly recognizable throughout English history.[2]

Particularly in the case of London, escape to the suburbs, the countryside, or smaller towns and cities was one of the most common responses to real or perceived problems of the deterioration of the urban quality of life.

Peter Kellner provides a lucid summary of the argument that the

combination of de-industrialization and new technology is under-mining the economic rationale of cities and enabling more and more urban dwellers to escape to rural 'electronic cottages':

> Many organisations . . . find that modern technology makes it possible to separate policy work (which often still needs to be done in a major city, but which employs few people) from administrative and clerical work (which can be done almost anywhere and employs many people). This is opening the way to some remarkable cost savings It used to be the case that goods and services could be provided more efficiently if the people who supplied them worked closely together. Cities offered their residents a bargain: we shall provide the work and the wealth if you put up with the dirt and the danger. . . . Suddenly the centuries-old rationale for cities is vanishing. Residents depart, their retreat being sounded not by trumpets but by the warble of electronic pulses.[3]

The 1980s have seen the continuation of the post-war trend towards the suburbanization and domesticization of life, which has been visible among both the increasingly spatially segregated urban 'underclasses' and among the more affluent.

In the case of the urban poor, opportunities for participation in urban public social life have been undermined by a combination of factors. The most important was probably the further deterioration in the relative economic position of low-income groups, due to long-term unemployment, deskilling, the erosion of welfare bene-fits, council rent increases and the introduction of the poll tax in 1989–90.[4] Factors more specifically related to leisure and social life included the increasing cost of out-of-home entertainment com-pared with its home-based equivalent (for instance, the cost of home videos from 1983 to 1988 increased by 4 per cent, as against a 23.5 per cent increase in the price of cinema tickets over the same period),[5] fear of crime – which appears to be common to all social classes, particularly among women and the elderly[6] – and in-adequacies in the provision of public transport, which have become more serious after deregulation in 1985.

In the case of the more affluent, the extraordinary proliferation of out-of-town superstores, shopping centres, multiplex cinemas and other leisure facilities significantly reduced the need to use the facilities of the city centre. In the urban core itself, moreover, office complexes and indoor shopping malls in many cases became

increasingly predominant, for a range of reasons, including the temptation for local authorities to obtain much-needed new revenue through land sales and the increases in rateable value promised by new private developments. The result of these processes was severely to limit the potential of city centres to act as catalysts for public social life.[7]

The 'anti-urban' tendencies outlined here, however, coexisted in many cases with a new interest in urban design and architecture, and in the 'soft infrastructures' of urban living and working. There were in the course of the decade examples of successful revitalization schemes in or near the centres of cities like Glasgow, Bradford, Liverpool, Swansea and London, which featured the construction not only of new offices and shops, but also of new housing, cultural and leisure facilities. Major new city-centre developments of this kind are also either being planned or already in progress in Newcastle, Manchester, Birmingham, Cardiff and many other places.

The new city-centre developments in 1980s Britain reflected the collapse of comprehensive views of the urban 'system', which was largely a product of disillusionment with the planning experience of the 1960s and 1970s. The emphasis in the 1980s was on the design of individual buildings, rather than on the planning of the whole. There was, in other words, a shift from modernism to postmodernism not only in architectural style, but also in terms of attitudes towards space, which was no longer regarded as a totality to be shaped according to the needs of a wider social project. The 1980s city-centre developments tended to view the urban fabric as a collection of fragmented, discrete and autonomous spaces. In David Harvey's words, urban design in this context 'simply aims to be sensitive to vernacular traditions, local histories, particular wants, needs and fancies, thus generating specialized, even highly customized architectural forms'.[8]

Social projects aimed at the 'mass public' of the modernist era were replaced by the emergence of the new art of 'place marketing', which can safely be described as one of the most significant responses to processes of urban economic restructuring in 1980s Britain. In many old industrial cities new 'flagship' schemes (for instance, new hotels, convention centres, glitzy indoor shopping malls, museums, theatres and concert halls, cultural districts, prestigious office buildings and residential complexes, or mixed-use developments combining two or more of these elements) were

essential instruments in the place marketing process. Cities used 'flagships' to attempt to find for themselves new niches in national and international markets, and to appeal to such specialized audiences as public and private sector investors, developers, tourists, convention organizers and 'speciality' shoppers.[9]

The 'new urbanism', in short, in many places was primarily an exercise in the creation and marketing of 'urban villages' and other self-contained, customized urban environments, often with a strong emphasis on 'exclusiveness'. Broadly speaking, the process was not underpinned by any notion of the need to re-create a democratic urban public domain, or of how these 'fragments' of regeneration should be integrated into the rest of the city.

Europeanization and Americanization

These two trends, which in the urban policy debate are sometimes set up against each other, have interacted in 1980s British urban development.

At a policy level, the American model has clearly been the most influential. Interest in US urban policy mechanisms among British political elites can be traced back to at least 1969, when the introduction by the Wilson government of the Urban Programme was clearly inspired by President Lyndon Johnson's policy responses to the black uprisings of the summer of 1967. The American influence on British urban policy intensified in the course of the 1980s, due chiefly to political affinity between the Reagan and Thatcher governments, which shared an emphasis on seeking private sector solutions to problems of urban economic restructuring and on a reduced role for public expenditure. More specifically, the Urban Development Grants (UDGs) introduced by the Thatcher government in 1982 were modelled on the Urban Development Action Grants (UDAGs) in the USA, while the Training and Enterprise Councils (TECs) proposed by the Conservative government in a White Paper of December 1988 found their main inspirations in the American Private Industry Councils (PICs).

In addition to modelling aspects of its urban strategies on specific US policy instruments, the Thatcher governments espoused a wide range of American ideas – including the concept of 'leverage planning', on which the introduction of the UDGs was based, and the notions of public-private partnership and corporate social

responsibility – which in the course of the decade occupied a prominent place in the urban policy debate.[10]

The American influence on the style and forms of development in Britain was also important, as shown not only by the corporate towers of Canary Wharf on the Isle of Dogs or by the massive Broadgate complex on the edge of the City but, perhaps more significantly, by the mushrooming of indoor 'festival shopping' malls like the Metro Centre at Gateshead, and mixed-use waterfront developments like Liverpool's Albert Dock. There is evidence that officials from Liverpool's Merseyside Development Corporation and the developers involved in the conception of the Albert Dock made numerous visits to American 'festival markets' with urban heritage features like the Inner Harbor in Baltimore and Quincy Market in Boston, which the Albert Dock in its final form closely resembled.[11]

Yet at the same time the pressure of Europeanization on many British cities was also very visible. Particularly in the case of Glasgow, which in 1987 was designated by the government as the UK choice as 'European City of Culture' for 1990, the 'European' theme became an important 'place marketing' tool. A brochure produced by Greater Glasgow Tourist Board for the 1990 celebrations, for example, declares that 'Glasgow doesn't really feel like a British city. . . . Glasgow looks like a European city. And feels like one.' The brochure listed among the attributes making Glasgow 'a great European City becoming even greater' the atmosphere of the recently opened Princes Square shopping centre ('an air of opulence reminiscent of La Galleria in Milan'), and of the refurbished Merchant City quarter ('the rich blend of old and new creating a neighbourhood in which to live, work and play'), in addition to more abstract, city-wide qualities like 'rich culture' and 'style'.[12]

Europeanization shaped urban development in Scotland probably more strongly than in the rest of Great Britain. This was partly due to the existence of a long tradition of cultural exchange between continental Europe and North of the border, which is clearly visible also in the characteristics of the Scottish urban form. But a key factor was probably the parallel and related resurgence of Scottish nationalism and Europeanism in the second half of the 1980s, fuelled by growing popular dislike of Thatcherism and accompanied by an intensification of efforts (at all levels: among professional 'civic boosters' as well as among football fans abroad)

to present to the outside world an image of Scotland which was clearly distinct from that of England.

European influences, however, were visible also in the development of English cities. Since the early 1970s, in places like Stockholm, Copenhagen, Freiburg, Stuttgart, Lyons, Grenoble, Vienna, Bologna and Rome, local authorities had adopted strategies aimed at encouraging local residents to 'rediscover' their city. Generally speaking, the aim of these strategies was to make the city centre(s) safer, more accessible and more attractive for all citizens, through policies which encompassed cultural animation, pedestrianization, traffic calming, and improvements in street lighting and public transport. European policy approaches influenced different cities in different ways. The 1981–6 Greater London Council, for instance, introduced a cheap fares policy for London's underground and bus services, and a summer cultural animation programme which – according to some commentators – were inspired by Swedish and Italian examples respectively.[13] In Sheffield, the plan to transform Tudor Square, in the heart of the city, into 'a place for people in which events, both planned and spontaneous, can be enjoyed'[14] saw as its model the public squares created in cities like Florence and Siena during the medieval and Renaissance periods. Plans for other European-style foci for public social life emerged also in places like Newcastle, Bradford, Manchester, Birmingham and Cardiff.

It is interesting to note that even American urban design consultancies with subsidiaries in Britain like LDR International – who, in the course of the 1980s, worked in Edinburgh, Manchester, Liverpool, Birmingham, Cardiff, Nottingham, Bristol, Plymouth and other cities – acknowledge the uniqueness of public spaces in the historic centres of continental European cities as one of their main sources of inspiration.[15]

We could conclude that, in terms of shaping British urban development in the 1980s, Americanization has been a far greater force than Europeanization, despite a strong continental European influence on urban design and architectural ideas, often adapted to the British context through the filter of American firms. There is a real danger, however, that the Europeanization of urban design, if it is not accompanied by a process of Europeanization also in urban policy, will only produce the co-existence within the same city of small 'islands of regeneration' with growing social polarization and injustice. The Europeanization of urban policy – which we shall

discuss more thoroughly later – should, at least, involve the recovery of local autonomy and local economic development powers, housing desegregation initiatives and new investment in training, research, technology, public transport, communications and other essential infrastructural elements.

Regeneration and decline

In the course of the 1980s, the Thatcher governments encouraged the regeneration of areas within old industrial cities through a range of policy mechanisms and initiatives. These included grants aimed at leveraging private investment,[16] three 'waves' of Urban Development Corporations (UDCs),[17] the designation of twenty-five Enterprise Zones combining the principle of relaxing planning controls with the provision of rates 'holidays' and tax allowances for mover firms, and financial support, particularly through Derelict Land Grants, for Garden Festivals held in Liverpool, Stoke-on-Trent and Glasgow.[18]

To what extent have these policy initiatives actually achieved 'regeneration'?

The notion of 'regeneration' adopted was primarily property- and land-based. One of its central aims was to break the spiral of economic decline, and to improve external perceptions of the whole city or of a particular area within it, often through the use of prestigious 'flagship' buildings as symbols of renewed dynamism and confidence. At this level, the achievements of regeneration strategies varied between cities but were, on the whole, considerable.

Property-led regeneration strategies helped cities to attract new investment and skills, to boost demand for development, to expand tourism and other consumer service industries, to mobilize and motivate local 'growth coalitions', and, lastly, in some cases even to gain additional recognition of the city's needs and potential from funding agencies.[19]

All these achievements, however, were severely limited precisely by the narrowness of the concept of 'regeneration' which was adopted. This concept prioritized physical renewal and largely failed to lay the foundations for long-term solutions to the economic and social problems of inner city areas. For instance, Michael Parkinson's review of the work of the London Docklands Development Corporation concludes that:

little attention has been paid to providing the training, jobs or low income housing to meet the needs of the original residents . . . the low income community has paid many of the economic, social and environmental prices of regeneration while deriving relatively few of the benefits.[20]

Developments in London cannot easily be compared with those in provincial cities, but there is evidence that also in places like Glasgow, Bradford and Liverpool, the regeneration of sections of the urban core was accompanied by further deterioration in the environment, the quality of life and the relative economic position of residents of particular inner city areas and peripheral housing estates.[21]

According to one interpretation, the urban regeneration strategies of the 1980s did not genuinely engage with problems of social deprivation, and performed a function which can be described as primarily 'symbolic': a model of policy-making in which, for example, the key motive for the Government 'to intervene in "those inner cities" [is] to be seen to be doing so.'[22]

David Harvey has gone even further, by arguing that the aim of urban regeneration strategies is to mobilize 'every aesthetic power of illusion and image . . . to mask the intensifying class, racial and ethnic polarisations going on underneath'.[23]

It seems fair to conclude that, while property-led urban regeneration strategies have largely not been conceived as deliberate instruments for social and political diversion, the tendency to give priority to prestigious and highly visible urban renewal projects and to high-profile 'place marketing' initiatives absorbed large quantities of public sector resources – both human and financial – and, to some extent, shifted the attention of policy-makers and the public away from the question of the serious worsening of the quality of life for considerable but increasingly segregated, and therefore less visible, minorities of local residents.

A related problem is that tourism, the convention industry, retailing, and some of the other service industries on which cities are basing their regeneration strategies may well not be able to guarantee long-term economic viability, since they are liable to suffer from increasingly fierce inter-urban competition and from economic downturns determined by forces which are outside the control of the city itself.

Public and private space

In the course of the 1980s the distinction between public and private space became less and less clear, with the emergence of 'private public spaces': that is, privately owned and managed spaces offered for public use. The proliferation of this kind of space was in some cases presented as an extension of public space, and therefore of opportunities for public sociability and for the development of local citizenship and identity. In fact it is probably more appropriate to interpret the 'private public space' phenomenon as a sign of a tendency towards the privatization of public space.

The mushrooming of indoor shopping malls was one of the most visible and widely discussed examples of the creation of new privately owned and controlled spaces for public use. Management policies and styles differed considerably from city to city or, within the same city, between different developments. It is, however, probably legitimate to conclude that the new shopping centres' management policies were characterized by a tendency to confine public life to 'certain locations, certain hours and certain categories of "acceptable" activities',[24] and by an ethos which Paul Hirst has described as 'the invasion of compulsory suburban morality'.[25] Hirst quotes the case of Basingstoke town centre, which is largely owned by Prudential Assurance, who also manage the town's largest indoor shopping mall. The Prudential's management style provoked negative reactions among some visitors and residents, exemplified by the following letter to the *Guardian* (13 June 1988):

> The Prudential has taken upon itself the right to deny access to anyone it chooses to see as 'undesirable'. This extends to the intimidation of any individual or group seen to be unacceptable by its private security forces. In recent weeks such action has moved beyond harassment of anybody remotely fitting the category of 'punk' to include students engaged in project field studies. . . . Just what does 'citizenship' mean in a privatized town?

In short, in some city centres the paramount need to create a safe and attractive environment for shoppers led to the virtual disenfranchisement from city life of young people with low spending power and of other – generally low-income – residents, whose appearance and conduct did not conform to the moral codes of well-ordered consumption enforced by shopping centre managers, in many cases with the active support of local authorities.

The range of forms of behaviour and of uses of space which management could approve of was probably even narrower in the case of out-of-town shopping centres. They tended to allow even less room for casual meetings, unplanned and spontaneous happenings, and personal interpretations of space than their city centre-based counterparts.[26]

The creation of privately owned and managed spaces within cities was often accompanied by the introduction of systems of electronic surveillance in remaining 'public' areas. Bournemouth Borough Council, for example, introduced in 1986 a closed circuit television (CCTV) surveillance scheme along 6 miles of seafront, while Plymouth City Council adopted a CCTV system to monitor large sections of the city centre.[27]

The undeniable drive towards privatization and private control should, according to some, be positively embraced rather than resisted. The Adam Smith Institute, for instance, in their report *Streets Ahead*,[28] propose the establishment in Britain of private homeowners' associations modelled on the American 'Common Interest Developments' (CIDs), endowed with wide powers over the control, maintenance and surveillance of residential streets. Yet there are serious problems with CIDs, of which about 125,000 exist today in the USA. Evan McKenzie describes CIDs as 'bastions of the white middle class . . . offering homogeneous population, physical security, stable housing values, local control, and freedom from exposure to the social ills of the cities'.[29] In return for these benefits, CID residents have to live by a set of rules contained in all deeds through a system of restrictive covenants which is administered and enforced by a board of unpaid directors. The law regards CIDs as voluntary associations but, as McKenzie observes, the logic according to which CIDs are set up 'turns social contract theory on its head. Instead of a group of individuals banding together and consenting to live by a set of rules of their choosing, we have the reverse: first the rules, then the houses, then the people.'[30]

Homeowners' associations can offer a positive contribution to the regeneration of cities by encouraging people to take greater control over their own lives and greater interest in public affairs, beyond the boundaries of the association itself. The main problem with most CIDs is that their long-term aim appears to be secession from the rest of the community, with the establishment of totally autonomous, privatized 'cities within the city'. CIDs can pose a

threat to democratically elected local government not only because of their size and their income – which the US Department of Housing and Urban Development estimates at about $20 billion in 1990 – but also for their potential for bloc voting, and therefore for political lobbying. They are increasingly pressing for exemptions from property taxes, which are used by local governments to pay for services, some of which are directly provided by the CID itself. McKenzie concludes that in some areas the exemption of CIDs from local property taxes

> could potentially bankrupt many cities and counties . . . CIDs . . . have the potential to exacerbate the real conflict that is developing in many metropolitan areas between urban centers and their surrounding suburbs. Unemployment, inequality, crime, drug abuse – these are all seen as city problems for which the CID resident has no responsibility – social, financial, political or otherwise – except the responsibility for escaping them.[31]

In conclusion, under the twin pressures of commodification and privatization 'a narrower range of "strangers" are met in public space, and, increasingly, experiences of public life are with a more homogenous group of others.'[32] It is clear that any attempt at re-imagining urbanity must involve the creation of alternatives to the 'privatized city' scenario, through the revitalization of the public domain and of local political participation.

'Active citizenship' and the erosion of local autonomy

We would argue that the growing interest in the notion of 'citizenship' among both Right and Left in the British political climate of the late 1980s stemmed from the recognition that it could act as a useful bridging concept in the age-old dichotomy between individualism and collectivism.

In the Labour Party's case, the new debate around citizenship signalled a concern to link welfarist notions of collective provision and universal access with the new language of individual freedom and choice: a tension which is apparent in *Meet the Challenge, Make the Change*, the policy review document approved at the party's conference of October 1989.

In the case of the Conservatives, the debate on the concept of 'active citizenship' emerged in the spring of 1988, in the aftermath

of the budget in which Chancellor Nigel Lawson reduced the top income tax rate from 60 per cent to 40 per cent. Pronouncements on the subject of citizenship by the two most important Tory politicians outside the Cabinet, Michael Heseltine and Norman Tebbit, were matched from within the Cabinet by Education Secretary Kenneth Baker, Home Secretary Douglas Hurd, and the Prime Minister herself.[33]

For the purposes of this chapter we shall concentrate on the debate within the Conservative Party, since our aim is to highlight the nature of the relationship between the party's notion of citizenship and the Thatcher governments' attitude towards local democracy.

There were variations in emphasis between the definitions of citizenship adopted by different Tory politicians, but all definitions shared the objective of attempting to respond to public anxiety about the social effects of the Thatcher governments' free-market model of economic development. The debate on 'active citizenship', in short, can be interpreted as the Conservatives' attempt to regain the moral high ground without putting into question the funda-mental economic and political tenets of Thatcherism.

This is clearly what emerges from a speech by Home Secretary Douglas Hurd to his Witney constituency party in April 1988. Hurd asserted that Conservatives

> are interested in promoting the interests of the active and responsible individual – not of the selfish. This represents the moral high ground on which we shall be pleased to do battle. . . . Successful people owe their fellow citizens a share of their time and money voluntarily given.[34]

Hurd's speech makes it clear that material prosperity is the very precondition for the existence of active citizenship: in Thatcherite rhetoric, active citizens (Hurd's 'successful people') are implicitly counterposed to the 'passive citizens' who are recipient of various forms of state benefits. A *New Statesman* editorial could therefore legitimately conclude that citizenship for the Conservatives 'is for the few . . . it has to be earned; it has been privatised'.[35]

The Conservatives' definition of 'active citizenship' emphasized charitable giving, voluntary work, and other forms of philanthropic activity. It derived from individualistic moral responsibility, and did not recognize other possible interpretations of citizenship which

prioritize the eradication of social inequality, the fostering of political participation, the extension of effective rights and entitlements to wider sections of the community, and the transfer of power from the centre to locally based and accountable elected bodies.[36] There is ample evidence that the espousal of 'active citizenship' by the Conservative Party was accompanied by the Thatcher governments' systematic centralization of power and erosion of local autonomy. These trends were apparent in all fields of policy.

The control by central government over local government finance increased in three stages. The first was the introduction of 'block grants' in 1980, which penalized those local authorities spending above a certain, centrally determined level. The second was the setting up of limits to local authority rates, introduced in 1985–6 in eighteen authorities. The third crucial step, in 1990, was the replacement of domestic rates with the poll tax or community charge, in Scotland in 1989 and in England and Wales in 1990. The introduction of the tax was followed by the 'charge capping' of twenty (Labour) local authorities in April 1990 and, perhaps more significantly, was accompanied by the transfer to central government of the competence to set the level of non-domestic rates, and to organize their collection and distribution to local authorities.

In the field of education and training, at least two initiatives are worth mentioning: the transfer of control over the setting of teachers' pay and conditions from local authorities to central government in 1987, and the Education Reform Act 1988. The Act gave schools the possibility of 'opting out' of local authority control, introduced a central government-controlled 'national curriculum', abolished the Inner London Education Authority, and transferred the funding of polytechnics to a new, centrally appointed Polytechnics and Colleges Funding Council.

In the field of housing, with a 1988 Act the Government enabled tenants to opt out of local authority control, and to set up Housing Action Trusts (HATs) to take over and improve blocks of local authority stock.

As far as urban economic development is concerned, reforms which reduced or took away local government powers included the relaxation of local authority financial and physical controls in the areas of twenty-five designated Enterprise Zones, the setting up of the non-elected Urban Development Corporations, and the introduction of a centrally administered City Grant scheme which,

unlike its predecessors, the Urban Development and Urban Regeneration Grants, effectively bypassed local authorities.

Other important reforms were the 1988 Local Government Act, which forced local authorities to put out the provision of many kinds of basic services to competitive tender and, most significantly, the abolition of the Greater London Council and the Metropolitan County Councils in 1986.[37]

There is no single historical explanation for this remarkable centralization programme. Its different elements have different origins. One of the most important was certainly the Conservative government's priority to reduce public expenditure, which led to the imposition of greater central control over local authority finance.[38]

It is undeniable, however, that there were also political and ideological motives behind the Conservative government's attack on local autonomy.[39] Some of the political and ideological conflicts between central government and local authorities in the 1980s were precisely conflicts about different definitions of citizenship. As we have seen, the Conservative definition emphasized economic rights – the freedom to own, buy and sell – which were complemented by optional, individual philanthropic activity. In this sense, the Conservative attack on such local authorities as Sheffield City Council and the Greater London Council in the first half of the 1980s can be seen as the Government's response to local experiments 'with new, more inclusive definitions of citizenship which included sensitivity to minority demands',[40] and which therefore were regarded as ideologically dangerous and politically destabilizing by the Tory leadership.

At the same time, Conservative-controlled local authorities like Wandsworth, Westminster and (since September 1988) Bradford vigorously pursued local privatization programmes, with an emphasis on the cost-effective delivery of services accompanied in some cases by a limitation both of the number of Council meetings and, more generally, of opportunities for the public scrutiny of local authority activities. The experience of the more radical Thatcherite urban local authorities can indeed be described – by borrowing a phrase used by Zygmunt Bauman with reference to Thatcherism's overall political objectives – as a local ' "exit from politics" strategy'.[41] Such a strategy, in Bauman's words:

demands that more and more families and individuals buy

themselves off from the areas of public deprivation . . . so that they may feel less urge to press for their improvement. It demands, in other words, that the satisfaction of collective needs be sought through individual appropriation and consumption.[42]

The crisis of Thatcherism opens up possibilities for a progressive re-imagining of citizenship, local autonomy and local democracy. It is, however, remarkable that neither Thatcherism nor the emerging alternatives to it have so adequately linked the debate about citizenship with debates on the future of cities or, more narrowly, on future forms of local government and urban economic re-generation. The linking up of the debate on cities with the debate on citizenship will be an important critical task for the 1990s. The concluding section of this chapter will make some initial proposals on how to proceed, starting from the recognition that one of the legacies of the 1980s is a whole universe of voluntary activism and self-organization (for instance, tenants' groups and community enterprises), the growth of which was often favoured by the erosion of the powers of local authorities under Thatcherism.

RETHINKING 'URBAN REGENERATION'

One of the possible scenarios for the city of the future emerging from our description is profoundly disturbing. Our account suggests that narrowly defined property-led urban regeneration strategies can produce a city characterized by the crisis of both urbanity and social cohesion.

Urbanity is being further eroded by market-led processes of privatization of public space and of standardization of functions and uses and, to some extent, also of style and design solutions.

Very similar processes are undermining social cohesion, increasing social polarization and spatial segregation by social class, and leading to commodification of the uses of space.

Local democracy, potentially an important vehicle for re-creating civic identity and social cohesion, is at the same time being devalued, through a process of centralization of power, increasing disaffection with the political process among the growing urban 'underclasses' and, as Bauman has observed, through the provision of incentives to the more affluent to 'buy themselves out' of politics.[43]

In this possible city of the future, the uses of 'heritage' would

often only represent a feeble attempt to reconstruct some common identity in the face of potentially explosive social tensions and conflicts.

We shall argue that, in order to avoid the dangers of this scenario, future urban regeneration strategies will have carefully to balance and integrate their economic, physical, cultural, symbolic, social and political dimensions. We can illustrate some of the connections between these six dimensions of urban regeneration by discussing aspects of possible strategies for local economic development and for the revitalization of the urban public realm.

Developing the local economy

As suggested earlier, in many cities during the 1980s the physical, economic, cultural and symbolic dimensions of urban regeneration were indeed integrated into strategies aimed at developing local consumer service industries, expanding tourism, attracting inward investment, maximizing pressure for development, and improving external perceptions of the locality.

However, given the serious limits of this model of economic development – which we have already discussed – it is appropriate here to examine an alternative strategy, the objectives of which would be to strengthen indigenous productive capacity (for instance, through investment in training, education, enterprise development, research and technology) and, more generally, to reduce reliance on variables outside the city's control.

We shall consider two different aspects of the implementation of such a strategy. The first is the development of local 'cultural industries' – a term which, in its widest definitions, can include anything from the pre-electronic performing and visual arts to film, broadcasting, electronic music, design and fashion, and even the tourism, leisure and heritage industries.[44]

Second, we shall argue that the 1980s emphasis on the importance of local 'elites' and individual entrepreneurial spirit should be combined with a wider project of revitalization of the city's complex social dynamics.

Consumption-oriented and image-led strategies were the main contexts in which the cultural industries were used in urban regeneration in 1980s Britain.[45] Urban economic development strategies for the 1990s should increasingly recognize the potential of the concept of the cultural industries not only to assist the

conversion of cities into service-based economies, but also to revitalize local productive capacity in highly skilled, high value-added manufacturing sectors. This could happen in at least two ways. Firstly, organic links could be established between, on the one hand, local designers, visual artists and craftspeople and, on the other, small firms operating in such sectors as clothing and textiles, footwear, furniture and ceramics.[46] Second, those cities which are attempting to create locally controlled structures for the monitoring, management and commercial exploitation of indigenous cultural talent – mainly in contemporary cultural industries like electronic music, film and broadcasting – could link up with universities and other local research institutions to explore the possibility of developing innovations in, for instance, music recording and telecommunications technology.[47]

Particularly in the second half of the 1980s, the role of key local public and private sector decision-makers in the process of urban regeneration – embodied in the public–private partnership model, of which at least a dozen examples were established in Britain in the course of the decade[48] – was seen as central. Public–private partnerships could probably perform a much more effective role in urban regeneration if they were an integral part of a wider institutional network of local interests, including not only business and local authority decision-makers but also community enterprises, neighbourhood groups, trade unions, and voluntary associations. Such broadly based networks could emerge from a process of mutual re-education and discussion between the local public, private and voluntary sectors, focused upon the formulation and implementation of specific urban regeneration projects. These networks would facilitate community access to decision-making, and could help create a climate of opinion which would adequately recognize the importance for economic development of investment in education, training, research, improvements in urban infrastructures and in the local quality of life.

Revitalizing the public realm

A strategy for the revitalization of the public realm could have a positive impact on the city's social dynamics and on economic development, in that it could help create the conditions both for the establishment of the networks of local interests summarily des-

cribed earlier and for enhancing the city's ability to create spaces for economic innovation.

A revitalization strategy, however, would not be primarily economic development-driven, but rather part of a programme for improving local public social life.

But what do we mean by the 'public realm'? The public realm, or public sphere, certainly does not coincide with the public sector. The public realm is the sphere of social relations going beyond our own circle of friendships, and of family and professional relations. The idea of the public realm is bound up with the ideas of expanding one's mental horizons, of experiment, adventure, discovery, surprise.

Revitalizing the city centre: principles and assumptions

A programme for the revitalization of the public realm would involve, first of all, the recreation of vitality in the city centre, or in other accessible areas of the city where a 'critical mass' of events and activities could be achieved. As we have seen, large geographical communities in peripheral estates and inner-city areas have been left behind in the process of regeneration. Re-creating a public realm in the city centre is one of the ways in which we can begin to move towards more balanced cities. We do not discount the importance of providing, or of empowering local people to create, facilities for public social life in deprived neighbourhoods away from city centres. But the provision of better facilities in these neighbourhoods should not be acceptable as a substitute for enabling everybody to participate in the life of the city centre.

A strategy for the revitalization of the public realm should be focused on the city centre for at least three reasons. First of all, the city centre is usually the hub of the local transportation network, and therefore is more accessible than other locations. Second, at its best the city centre crystallizes the *essence* of a city. It is in the city cente where the uniqueness of, for example, the history, culture and architecture of a city is most manifest. Third, the city centre is often seen as 'neutral territory' by the city's different geographical communities. The city centre is, therefore, a potential place for commonality, where some form of common identity could be constructed and where different ages, classes, ethnic groups and lifestyles could meet in unplanned, informal ways.

Access

City amenities should be accessible to all sections of the local community. Widening access will involve the development of a range of fast, reliable, safe and affordable public transport systems, running late into the night, and the removal of whatever other physical, economic and emotional barriers may exist. As a consequence of this, a strategy for the democratization of access will have to address issues like the need to improve street lighting, safety in car-parks and open spaces, childcare provision and community policing. More particularly, on the question of economic access, it is imperative that participation in public social life should be considered as an entitlement, an extension of citizenship, rather than something you can share in only if you can afford it. It is therefore important that a range of free and affordable activities should be available.

Density, diversity and vitality

Re-creating density through the establishment of sizeable, non-ghettoized residential communities in the city centre is a precondition for the success of any revitalization strategy. Diversity and flexibility should be fostered in patterns of land and retail ownership, housing tenure, working, leisure and cultural activities, as well as in the provision of shops, civic amenities and public spaces. Cities should be endowed with a public space strategy which would properly recognize the importance of providing 'transitional' or 'hanging about' spaces, and of what Michael Walzer describes as 'open-minded spaces'.[49] A public space strategy should be co-ordinated with a cultural animation strategy, one of the central aims of which would be to enhance the quality of evening life and the economic activities associated with it (the 'evening economy').

Building a sense of place and fostering public awareness of the urban environment

Greater sense of place could be built by beautifying cities with new, interesting and stimulating shapes, artworks in public places, views and landmarks. Urban design, townscape planning and architecture should also improve the city's 'legibility' and 'imageability',[50] and

should find ways of linking past, present and future which do not degenerate into 'museumization'. There should be strategies to encourage public awareness of the city's architecture and of its natural environment. Care for the urban natural environment should be reflected in all aspects of urban policy – for instance, by reducing traffic congestion, noise and pollution, and by encouraging walking, cycling and the 'greening' of the city.[51]

To conclude, recreating a sense of place will involve the formulation of urban design strategies based on conceptual models of the city which are, in turn, founded on notions of civic life and the public realm. The absence of such models is indeed one of the reasons for the frequent relapsing of contemporary British architecture into 'heritage' solutions, and for the 'fragmentation' of cities which – as shown earlier – has characterized the urban regeneration process in the 1980s.[52]

Activating two-way forms of communication

The revitalization of the urban public realm is not exclusively about the provision of a variety of opportunities and environments for face-to-face interaction, on which we have concentrated so far. New communication technologies, which are often described as one of the principal forces contributing to the contemporary erosion of urbanity, have the potential to activate lines of two-way communication. These include teleshopping for the elderly and the disabled, civic videotex information systems, and on-line access to local authority assemblies.[53]

Re-defining planning

In order to implement the programme for the development of the local economy and the revitalization of the public realm briefly described here, the discipline of urban planning will have to become more holistic. Planning will have to be much more rooted in the understanding of how cities are *lived*, and of the place the locality occupies both in national and international markets and in popular consciousness. Only such an understanding will enable planners to identify the multifarious resources which can be exploited in the regeneration process, and to conceptualize essential strategic questions about the future(s) of the city. Planning, in short, will have to concentrate more on *users* and less on *uses*, more on *ends* and less

on *means*, and will have to recognize the usefulness of moral-practical and expressive-aesthetic forms of knowledge, rather than just cognitive–instrumental.[54]

Planning should see its primary objective as being to improve the quality of life for local residents. As a recent report has argued,[55] an explicit commitment to revitalizing cultural and public social life in cities should precede and support the formulation of any strategy for the expansion of tourism. Similarly, 'place marketing' strategies should be aimed not only at potential tourists, investors and other outsiders, but also at residents. As we have seen, in cities all over Britain, large numbers of local residents feel unsafe going out after dark – a perception in some cases reinforced by the local media with their sensationalist representations of the dangers of the city centre at night – to which local authorities could respond with appropriate campaigns.

To conclude, it may be appropriate to quote David Boyle's description of the approach to urban regeneration adopted by the Washington-based Partners for Livable Places:

> Quality of life is not a goal, towards which cities can strive – it is a process. . . . No more blueprints and artists' impressions of the City of the Future – regeneration has become an ongoing process, hence the emphasis on 'participation'.[56]

The notion of 'regeneration as process' should be complemented by a model of planning which Patsy Healey describes as 'planning as debate':

> It involves systematically interlinking the terrain of scientific reasoning, moral and political philosophy, and expressive-aesthetic appreciation as the diverse demands, assertions and claims of different interests and groups are identified and considered. In this way, the parties concerned both learn about the range of issues and values at stake, and discover how far, and how, collective action may be undertaken.[57]

In defence of (local) politics

The corollary of the notion of 'planning as debate' is the revaluation of local politics and local autonomy.

The British experience of the 1980s strongly suggests that there is a need to develop a notion of 'urban regeneration' incorporating

Manuel Castells' three historical goals of progressive urban social movements:

1 . . . a city organised around its use value, as against the notion of urban living and services as a commodity . . . ;
2 . . . the search for cultural identity [and the] defence of communication between people, autonomously defined social meaning and face-to-face interaction, against the monopoly of messages by the media, the predominance of one-way information flows and the standardisation of culture on the basis of increasingly heteronomous sources . . .;
3 . . . the search for increasing power for local government, neighbourhood decentralization and urban self-management in contradiction to the centralized state and a subordinated and undifferentiated territorial administration.[58]

Use value, local control and the preservation of cultural identity are indeed three objectives which should inspire any attempt at re-imagining local democracy. These objectives will not be attained by social or political engineering, but rather by creating multiple structures of local accountability and real opportunities for political participation. Radically increasing the powers and resources of democratically elected and locally accountable urban and regional governments will be necessary but not sufficient. The process of local democratization will also have to encompass the empowerment of local communities through devolution of powers to community groups and support for community development projects, as well as effective user representation on the management boards of decentralized urban public services, and the establishment of consultation mechanisms which, for instance, would make the planning system more responsive to the citizens' demands and ideas.

New forms of liaison between civil and political society will have to be invented: through the local media, the education system, and the creation of neighbourhood and community councils.[59]

Paul Hoggett and Robin Hambleton have argued that, in order to democratize the local political system, 'the very task is to change the process whereby . . . politicians, once in power, assume an absolute prerogative over all public debate and decision making.'[60] They suggest that channels for political involvement should be created for people whose impulse for collective action arises from

social identities which do not correspond to the boundaries and categories of party politics:

> They are the identities of neighbourhood and community, of common interest (e.g. cyclists, dog owners), of common experience (e.g. women who care for dependent relatives, parents of school-age children), of 'common consumership' (e.g. public transport users, library users) and, perhaps above all, of the common experience of exclusion and discrimination.[61]

We certainly agree that local democracy should be constantly nurtured by the politics of identity, self-organization and community action. Yet there is a risk that grassroot movements will offer only a limited contribution to local democratization, if they concentrate exclusively on pursuing their own, self-contained objectives. Grassroot movements, in short, should attempt to show how relevant their actions and ideas are to improving the quality of life of the wider community and to reforming the system of local government itself, in order to trigger off a broader politicization process.[62]

Cities will be re-imagined in democratic forms only by creating the conditions for the emergence of a genuinely public, political discourse about their future, which should go beyond the conformist platitudes of the 'visions' formulated by the new breed of civic boosters and municipal marketers.

Notes

Introduction: Great Britain Limited

1 *The Idea of a Christian Society*, London, 1939, quoted in M. J. Wiener, *English Culture and the Decline of the Industrial Spirit 1850–1980*, Harmondsworth, Penguin, 1985, p. 115.

2 C. A. R. Crosland, *The Future of Socialism*, quoted in T. Blackwell and J. Seabrook, *A World Still to Win: The Reconstruction of the Post-War Working Class*, London, Faber & Faber, 1985, p. 164.

3. John Curtice, 'Tories face steep climb back to popularity', *Sunday Correspondent*, 4 March 1990, p. 2.

4 These are official government figures for unemployment; however the basis for the calculations has changed several times in the course of the decade as various categories of people have been excluded from them. In 1987–8, for example, well over half a million people on various government training schemes were excluded from the figures.

5 Clive Woodcock, 'Enterprise – the watchword of the eighties', *Guardian*, 28 December 1989.

6 See Alan Walker and Carol Walker (eds), *The Growing Divide: A Social Audit 1979–1987*, London, Child Poverty Action Group, 1987, p. 89 and p. 29.

7 The 'people's war' thesis is developed by Angus Calder in *The People's War: Britain 1939–45*, London, Jonathan Cape, 1969.

8 See Fred Halliday, *The Making of the Second Cold War*, London, Verso, 1983, p. 138. By 1989 both Britain and the USA had increased their rates of growth, while the USSR experienced a major reduction. The figures for 1989 were: USSR, 1.5 per cent, USA, 2.7 per cent, Britain, 2.5 per cent; Dudley Fishburn (ed.), *The World in 1990*, London, *Economist* Publications, 1989, p. 101.

9 The first cruise missiles arrived at the Greenham Common military base in November 1983.

10 Mikhail Gorbachev, *Perestroika: New Thinking for Our Country and the World*, London, Fontana/Collins, 1988, p. 240 and p. 12.

11 See 'The Third World in the international community', in Gorbachev, op. cit., pp. 171–89.

12 Between 1979 and 1987 housing and overseas aid were cut by, respectively, 55 per cent and 15 per cent; see Walker and Walker, op. cit. p. 89.

13 Margaret Thatcher, 'The Brian Walden interview', *Sunday Times*, 8 May 1988.

14 *Daily Express*, 26 July 1982, quoted in Anthony Barnett, *Iron Britannia: Why Parliament Waged the Falklands War*, London, Allison & Busby, 1982.

15 Samuel Smiles, *Self-Help. With Illustrations of Conduct and Perseverance*, 1859. The book was reprinted in 1986 with an introduction by Sir Keith Joseph, a member of Thatcher's Cabinet and a key contributor to the programme of the New Right; for further discussion of Smiles' book and its significance see Chapter 5 below.

16 From a speech given at Cheltenham on 3 July 1982 and quoted in full in Barnett, op. cit., pp. 149–53.

17 Walker and Walker, op. cit., p. 62.

18 ibid.

19 John Palmer, 'Tory MEPs fear moves to oust them', *Guardian* 13 January 1990.

20 New rules limiting participation in political activity, and the public expression of political views by more senior Local Authority officers, came into force in 1990 in the Local Government Housing and Finance Act.

21 These figures are the 1990 forecast, from Dudley Fishburn (ed.), *The World in 1990*, London, *Economist* Publications, 1989, pp. 99–109.

22 Raymond Williams, *Towards 2000*, London, Chatto & Windus, 1983, p. 247.

1 Tradition and translation: national culture in its global context

1 R. Samuel, 'Introduction: exciting to be English', in R. Samuel (ed.), *Patriotism: The Making and Unmaking of British National Identity*, vol. 1, London, Routledge, 1989, p. xxxii.

2 P. Wright, 'Re-enchanting the nation: Prince Charles and architecture', *Modern Painters*, 1989, vol. 2, no. 3, p. 27. On Prince Charles's ideas about business in the community, see, for example, his article, 'Future of business in Britain', *Financial Times*, 20 November 1989.

3 B. Richards, *Images of Freud: Cultural Responses to Psychoanalysis*, London, Dent, 1989, pp. 38–9.

4 ibid.

5 E. W. Said, 'Representing the colonised: anthropology's interlocutors', *Critical Inquiry*, 1989, vol. 15, no. 2, p. 216.

6 ibid., p. 218.

7 H. Bhabha, 'Beyond fundamentalism and liberalism', *New Statesman and Society*, 3 March 1989, p. 35. On the Rushdie affair, see L. Appignanesi and S. Maitland (eds), *The Rushdie File*, London, Fourth Estate, 1989.

8 E. W. Soja, *Postmodern Geographies: The Reassertion of Space in*

Critical Social Theory, London, Verso, 1989. See also M. Dear, 'The postmodern challenge: reconstructing human geography', *Transactions of the Institute of British Geographers*, 1988, vol. 13, pp. 262–74; D. Gregory, 'Areal differentiation and post-modern human geography', in D. Gregory and R. Walford (eds), *Horizons in Human Geography*, London, Macmillan, 1989; On the importance of geography, D. Massey and J. Allen (eds), *Geography Matters!: A Reader*, Cambridge, Cambridge University Press, 1984.

 9 See M. Hebbert, 'Britain in a Europe of the regions', in P. L. Garside and M. Hebbert (eds), *British Regionalism 1900–2000*, London, Mansell, 1989.

10 N. Smith, 'The region is dead! Long live the region!', *Political Geography Quarterly*, 1988, vol. 7, no. 2, p. 150.

11 See K. Robins, 'Reimagined communities: European image spaces, beyond Fordism', *Cultural Studies*, 1989, vol. 3, no. 2, pp. 145–65; D. Morley and K. Robins, 'Non-tariff barriers: identity, diversity, difference', in G. Locksley (ed.), *Information and Communications Technologies and the Single European Market*, London, Belhaven, 1990 pp. 44–56; D. Morley and K. Robins, 'Spaces of identity: communications technologies and the reconfiguration of Europe', *Screen*, 1989, vol. 30, no. 4, pp. 10–34; I. Paillart, 'De la production des territoires', *Mediaspouvoirs*, 1989, no. 16, pp. 58–64.

12 See S. Sontag, 'L'Idée d'Europe (une élégie de plus)', *Les Temps modernes*, 1989, no. 510, pp. 77–82.

13 M. Rustin, 'Place and time in socialist theory', *Radical Philosophy*, 1987, no. 47, pp. 30–6; J. A. Agnew and J. S. Duncan (eds), *The Power of Place*, Boston, Unwin Hyman, 1989.

14 On globalization, see J. Chesneaux, 'Désastre de la mondialisation', *Terminal*, 1989, no. 45, pp. 9–14; J. Chesneaux, *Modernité-Monde*, Paris, La Découverte, 1989.

15 See Serge Latouche, *L'Occidentalisation du monde*, Paris, La Découverte, 1988.

16 See B. Harrison, 'The big firms are coming out of the corner: the resurgence of economic scale and industrial power in the age of "flexibility"', paper presented to the International Conference of Industrial Transformation and Regional Development in an Age of Global Interdependence, United Nations Centre for Regional Development, Nagoya, Japan, 18–21 September 1989.

17 K. Ohmae, 'Managing in a borderless world', *Harvard Business Review*, 1989, vol. 67, no. 3, p. 153. See also K. Ohmae, 'The global logic of strategic alliances', *Harvard Business Review*, 1989, vol. 67, no. 2, pp. 143–54; K. Ohmae, 'Planting for a global harvest', *Harvard Business Review*, 1989, vol. 67, no. 4, pp. 136–45.

18 T. Levitt, *The Marketing Imagination*, London, Collier Macmillan, 1983.

19 For discussion and critiques of Levitt, see the special issue of *Journal of Consumer Marketing*, 1986, vol. 3, no. 2; the special issue of *Revue française du marketing*, 1987, no. 114; A. Mattelart, *L'Internationale publicitaire*, Paris, La Découverte, 1989, ch. 3.

20 S. Winram, 'The opportunity for world brands', *International Journal of Advertising*, 1984, vol. 3, no. 1, pp. 17–26.

21 K. Robins and M. Hepworth, 'Electronic spaces: new technologies and the future of cities', *Futures*, 1988, vol. 20, no. 2, pp. 155–76.

22 On world cities, see J. Friedmann and G. Wolff, 'World city formation: an agenda for research and action', *International Journal of Urban and Regional Research*, 1982, vol. 6, no. 3, pp. 309–43; J. Friedmann, 'The world city hypothesis', *Development and Change*, 1986, vol. 17, no. 1, pp. 69–83.

23 S. Shamoon, 'Mickey the Euro mouse', *Observer*, 17 September 1989.

24 Quoted in N. Fraser, 'Keeping the world covered', *Observer*, 12 November 1989. See also C. Schneider and B. Wallis (eds), *Global Television*, New York, Wedge Press, 1988.

25 J. Hughes, A. Mierzwa and C. Morgan, *Strategic Partnerships as a Way Forward in European Broadcasting*, London, Booz Allen & Hamilton, 1989; 'The entertainment industry', *Economist*, 23 December 1989. On global advertising corporations, see A. Rawsthorn, 'Internationalism, the watchword of the new cadre of global marketing groups', *Financial Times*, 7 December 1989; M. Kavanagh and S. Brierley, 'Media on the move', *Marketing*, 2 November 1989, pp. 28–32.

26 Quoted in C. Brown, 'Holston exports', *Broadcast*, 13 October 1989, p. 44.

27 S. Wagstyl, 'Chief of Sony tells why it bought a part of America's soul', *Financial Times*, 4 October 1989; G de Jonquieres and H. Dixon, 'The emergence of a global company', *Financial Times*, 2 October 1989.

28 Levitt, op. cit., pp. 30–1.

29 For discussion of *Magiciens de la Terre*, see the special issue of *Third Text*, 1989, no. 6; E. Heartney, 'The whole earth show: part II', *Art in America*, 1989, vol. 77, no. 7, pp. 91–6.

30 C. Fusco, 'About locating ourselves and our representations', *Framework*, 1989, no. 36, p. 13. On the appropriation of ethnic art, see A. M. Willis and T. Fry, 'Art as ethnocide: the case of Australia', *Third Text*, 1988–9, no. 5, pp. 3–20. See also K. Owusu, 'Voyages of rediscovery', *Marxism Today*, July 1989, pp. 34–5.

31 N. Ascherson, 'Europe 2000', *Marxism Today*, January 1990, p. 17.

32 On locality and localism, see A. Jonas, 'A new regional geography of localities?', *Area*, 1988, vol. 20, no. 2, pp. 101–10; on regionalism, A. Gilbert, 'The new regional geography in English and French-speaking countries', *Progress in Human Geography*, 1988, vol. 12, no. 2, pp. 208–28.

33 On the 'flexible specialization' thesis, M. Piore and C. Sabel, *The Second Industrial Divide: Possibilities for Prosperity,* New York, Basic Books, 1984; P. Hirst and J. Zeitlin (eds), *Reversing Industrial Decline? Industrial Structure and Policy in Britain and her Competitors*, Oxford, Berg, 1989; P. Hirst and J. Zeitlin, 'Flexible specialisation and the competitive failure of UK manufacturing', *Political Quarterly*, 1989, vol. 60, no. 2, pp. 164–78; the special issue on 'Local industrial strategies' of *Economy and Society*, 1989, vol. 18, no. 4. For discussion and critique, see A. Amin and K. Robins, 'The re-emergence of regional

economies? The mythical geography of flexible accumulation', *Environment and Planning D: Society and Space*, 1990, vol. 8, no. 1, pp. 7–34; A. Amin and K. Robins, 'Jeux sans frontières: verso un'Europa delle regioni?', *Il Ponte*, 1990, vol. 46 (forthcoming).

34 See A. Cochrane (ed.), *Developing Local Economic Strategies*, Milton Keynes, Open University Press, 1987; A. Cochrane, 'In and against the market? The development of socialist economic strategies in Britain, 1981–1986', *Policy and Politics*, 1988, vol. 16, no. 3, pp. 159–68.

35 Wright, op. cit.; Prince of Wales, *A Vision of Britain: A Personal View of Architecture*, London, Doubleday, 1989; C. Jencks, *The Prince, the Architects, and New Wave Monarchy*, London, Academy Editions, 1988.

36 D. Ley, 'Modernism, post-modernism, and the struggle for place', in Agnew and Duncan, op. cit., p. 60.

37 A. Pred, 'The locally spoken word and local struggles', *Environment and Planning D: Society and Space*, 1989, vol. 7, no. 2, pp. 211–33.

38 C. F. Alger, 'Perceiving, analysing and coping with the local–global nexus', *International Social Science Journal*, 1988, no. 117, pp. 321–40.

39 Quoted in W. Scobie, 'Carlo, suitor to La Grande Dame', *Observer*, 14 February 1988.

40 Wagstyl, op. cit.

41 Brown, op. cit., p. 44.

42 Home Office, *Broadcasting in the '90s: Competition, Choice and Quality*, Cm. 517, London, HMSO, 1988, p. 42.

43 Department of Trade and Industry, *DTI – the Department for Enterprise*, Cm. 278, London, HMSO, 1988 p. 3. See also M. J. Wiener, *English Culture and the Decline of the Industrial Spirit, 1850–1980*, Cambridge, Cambridge University Press, 1981.

44 For an extended discussion of the 'British disease' and of the counter-offensive being waged by the protagonists of enterprise culture, see K. Robins and F. Webster, *The Technical Fix: Education, Computers and Industry*, London, Macmillan, 1989, ch. 5.

45 S. Lash and J. Urry, *The End of Organised Capitalism*, Cambridge, Polity Press, 1987, pp. 86, 101–2.

46 H. Häussermann and W. Siebel, *Neue Urbanität*, Frankfurt, Suhrkamp, 1987. See also *An Urban Renaissance: The Role of the Arts in Inner City Regeneration and the Case for Increased Public/Private Sector Cooperation*, London, Arts Council of Great Britain, 1987.

47 M. Mayer, 'Local politics: from administration to management', paper presented to the Conference on Regulation, Innovation and Spatial Development, Cardiff, 13–15 September 1989, pp. 12–13. See also J. Esser and J. Hirsch, 'The crisis of fordism and the dimensions of a "postfordist" regional and urban structure', *International Journal of Urban and Regional Research*, 1989, vol. 13, no. 3, pp. 417–37; D. Harvey, 'Flexible accumulation through urbanization: reflections on "post-modernism" in the American city', *Antipode*, 1987, vol. 19, no. 3, pp. 260–86; D. Harvey, 'From managerialism to entrepreneurialism: the transformation of urban governance in late capitalism', *Geografiska Annaler*, 1989, vol. 71B, pp. 3–17; D. Harvey, *The Condition of*

Postmodernity, Oxford, Basil Blackwell, 1989, ch. 4; G. J. Ashworth and H. Voogd, 'Marketing the city', *Town Planning Review*, 1988, vol. 59, no. 1, pp. 65–79.

48 Even if it is the case that 'the serial reproduction of the same solution generates monotony in the name of diversity', D. Harvey, 'Down towns', *Marxism Today*, January 1989, p. 21.

49 I. Page, 'Tourism promotion in Bradford', *The Planner*, February 1986, p. 73.

50 J. Whelan, 'Destination Newcastle', *Intercity*, November 1989, p. 26.

51 B. Foster and D. Williams, 'Farewell to Andy Capp', *Observer*, 4 June 1989. See also, P. Young, 'Lets drive out Andy Capp!', *Evening Chronicle* (Newcastle), 22 November 1989; R. Baxter, 'Comment Thatcher a tué Andy Capp', *Politis*, 1989, no. 60. pp. 46–9.

52 See P. Hetherington and F. Robinson, 'Tyneside life', in F. Robinson (ed.), *Post-Industrial Tyneside: An Economic and Social Survey of Tyneside in the 1980s*, Newcastle upon Tyne, Newcastle upon Tyne City Libraries and Arts, 1989, pp. 189–210.

53 G. Radice, 'Fujitsu: just what we need in the NE', *The Journal* (Newcastle), 12 April 1989. For a more critical discussion of Japanese influence, see S. Crowther and P. Garrahan, 'Corporate power and the local economy', *Industrial Relations Journal*, 1988, vol. 19, pp. 51–9.

54 M. Conte-Helm, *Japan and the North East of England: From 1862 to the Present Day*, London, Athlone Press, 1989.

55 See M. Pickering and K. Robins, ' "A revolutionary materialist with a leg free": the autobiographical novels of Jack Common', in J. Hawthorn (ed.), *The British Working-Class Novel in the Twentieth Century*, London, Edward Arnold, 1984, pp. 77–92; M. Pickering and K. Robins, 'Between determinism and disruption: the working-class novels of Sid Chaplin', *College English*, 1989, vol. 51, no. 4, pp. 357–76.

56 L. Gofton, 'Back to the future', *Times Higher Education Supplement*, 20 January 1989.

57 T. Gitlin, 'Postmodernism: roots and politics', *Dissent*, Winter 1989, p. 101.

58 P. Emberley, 'Places and stories: the challenge of technology', *Social Research*, 1989, vol. 56, no. 3, pp. 755–6, 748.

59 R. Sennett, *The Uses of Disorder*, Harmondsworth, Penguin, 1971, p. 15.

60 D. Sibley, 'Purification of space', *Environment and Planning D: Society and Space*, 1988, vol. 6, no. 4, p. 410.

61 W. E. Connolly, 'Identity and difference in global politics', in J. Der Derian and M. J. Shapiro (eds), *International/Intertextual Relations: Postmodern Readings of World Politics*, Lexington, Mass., Lexington Books, 1989, p. 329. On the logic of identity, see also E. Said, 'Identity, negation and violence', *New Left Review*, 1988, no. 171, pp. 46–60.

62 I. Baruma, 'From Hirohito to Heimat', *New York Review of Books*, 26 October 1989, p. 43.

63 S. Hall, 'New ethnicities', in *Black Film, British Cinema*, London, Institute of Contemporary Arts, 1988, p. 30.

64 E. Said, 1989, op. cit., p. 225. See also, E. Said, 'Reflections on exile', *Granta*, 1984, no. 13, pp. 157–72.
65 E. Wolf, *Europe and the People Without History*, Berkeley, University of California Press, 1982, p. 387. See also T. Mitchell, 'Culture across borders', *Middle East Report*, July-August 1989, pp. 4–6.
66 T. Brennan, 'Cosmopolitans and celebrities', *Race and Class*, 1989, vol. 31, no. 1, pp. 4, 9.
67 S. Rushdie, 'Imaginary homelands', *London Review of Books*, 7–20 October 1982, p. 19.
68 D. Hebdige, 'Fax to the future', *Marxism Today*, January 1990, p. 20.
69 H. Kureishi, 'England, your England', *New Statesman and Society*, 21 July 1989, p. 29.

2 Mediating tradition and modernity: the heritage/enterprise couplet

With thanks to the staff of the library at the MSC (renamed the Training Agency in October 1988) who were most helpful in answering queries.

1 Evidence and arguments concerning the general economic and political circumstances indicated here can be found in a number of recent publications. Of these, among the most recent and widely cited at the time of writing are David Harvey, *The Condition of Postmodernity*, Oxford, Oxford University Press, 1989, and Philip Cooke, *Back to the Future: Modernity, Postmodernity and Locality*, London, Unwin Hyman, 1990.
2 The most comprehensive commentaries upon the 'heritage' phenomenon in Britain to date are Robert Hewison, *The Heritage Industry*, London, Methuen, 1987 and Patrick Wright, *On Living in an Old Country*, London, Verso, 1985. Other important, related texts are David Lowenthal's splendidly documented study of the cultural uses of 'the past', *The Past is a Foreign Country*, Cambridge, Cambridge University Press, 1985, and a collection of articles on historical representation, Robert Lumley (ed.), *The Museum Time-Machine*, London, Routledge, 1988. See also the useful overview by Raphael Samuel, 'Introduction: exciting to be English' in R. Samuel (ed.), *Patriotism: The Making and Unmaking of British national Identity, Volume 1: History and Politics*, London, Routledge, 1989, pp. xviii–lxvii.
3 From the general statement of aims for the HET, cited, in this instance, on the programme for the National Presentation Ceremony for the 1987 Sandford Award Winners, held at Wigan Pier on 25 March 1988.
4 An 'official' history of the National Trust has recently been published. Despite its tactful approach to criticism of the Trust, it documents various institutional shifts and crises in considerable and useful detail. See John Gaze, *Figures in a Landscape*, London, Barrie & Jenkins, 1988.
5 Advertisement for membership in *Guide to English Heritage Properties*, English Heritage, 1989.

6 Patrick Cormack, *Heritage in Danger*, London, New English Library, 1976, pp. 11–12. Quoted by Wright, op. cit., p. 8, and also by Hewison, op. cit., p. 32.

7 Wright, op. cit., pp. 81–7.

8 This is brought out well, both in its relationship of contrast and of complentarity with the 'industrial', in Tony Bennett's discussion of Beamish Open Air Museum, County Durham. See 'Museums and "the people" ', in Lumley, op. cit., pp. 63–85.

9 We have discussed this aspect of 'heritage' in more detail and with more examples in John Corner and Sylvia Harvey, 'Heritage in Britain: designer history and the popular imagination', *TEN–8*, Spring 1990.

10 This complex enjoyed a very high degree of success during the 1980s. In 1987 it was made a 'World Heritage Site', having won the Museum of the Year award and the European Museum of the Year awards in the late 1970s, before 'heritage' developed into a national cultural phenomenon.

11 Both this and the following quotation are taken from display boards in Mill building at Quarry Bank Mill, Styal, Cheshire.

12 Lowenthal, op. cit., p. 403.

13 Lumley (ed.), op. cit., p. 58.

14 This phrase provides part of the title of one of his most widely cited essays, 'Drama in a dramatized society', first given as an inaugural lecture at the University of Cambridge in 1974. Its latest reprinting is in Alan O'Conner (ed.), *Raymond Williams on Television*, London, Routledge, 1989, pp. 3–13. More recent speculations on the nature of dramatic representation in historical display are to be found in Umberto Eco, 'Travels in hyperreality', in *Faith in Fakes*, London, Secker & Warburg, 1986; reprinted in *Travels in Hyperreality*, London, Picador, 1987.

15 In some respects, this approach follows on from the more limited imaginative popularizations of *son et lumière*, well established as part of public displays at ancient monuments during the 1950s.

16 A very great number of museums now have publicity containing these or similar invitations. An increasingly popular method of honouring the promise is the mechanical 'ride'. This gives visitors an intense witnessing experience whilst having the advantages of regulating the duration of the visit, controlling the visitor's perspective on the display and minimizing damage to the exhibits. It has the disadvantage of destroying almost completely the possibilities for relaxed, 'own time' contemplation.

17 For a stimulating argument concerning the dangers of regarding 'heritage' as a cultural monolith, with no variation in its articulation or its effects, see Adrian Mellor, 'Whose heritage?' in *Journal of the North West Labour History Group*, no. 14, 1989, pp. 1–12. See also the interview-article by Tim Putnam and Patrick Wright, 'Sneering at theme parks', *Block*, 15, 1989, pp. 48–55. This comments perceptively both on the lumping together by critics of differently motivated and organized projects having a 'heritage' character, and on the risk of critique slipping into an 'educated snobbery'.

18 Waldemar Januszczak, 'Romancing the grime', *Guardian*, 2 September 1987.

19 Hewison, op. cit., p. 9.

20 Wright, op. cit., p. 143.

21 Kenneth Minogue in the *Daily Telegraph*, 8 February 1977; quoted in R. Levitas (ed.), *The Ideology of the New Right*, Polity Press, 1986, p. 75.

22 Margaret Thatcher, 'The Brian Walden interview', *Sunday Times*, 8 May 1988.

23 Mikhail Gorbachev, *Perestroika: New Thinking for Our Country and the World*, London, Fontana/Collins, 1988 p. 282 and p. 284.

24 See MSC, *Annual Reports* for 1980–1 and 1986–7, Sheffield, MSC.

25 See MSC, *Annual Report*, 1986–7, p. 52, and *Enterprise Allowance Scheme: A Report on Value for Money*, Sheffield, MSC, 1987, p. 1.

26 Clive Woodcock, 'Enterprise – the watchword of the eighties', *Guardian*, 28 December 1989.

27 Sue Hepworth, *How Clients and Others Perceive MSC: A Review of Some Recent Research Findings*, Sheffield, MSC, 1987, p. 23.

28 *Enterprise in Higher Education: Guidance for Applicants*, Sheffield, MSC, December 1987.

29 *Enterprise in the Polytechnic of Wales: A Programme for the Development of an Enterprise Culture*, Polytechnic of Wales, Politechnig Cymru, May 1988, title page and p. 1.

30 *What is TVEI?* London, Training Agency, 1989.

31 'Enterprise and education initiative', *Single Market News*, Department of Trade and Industry, no. 2, Spring 1989, p. 28.

32 Alan Walker and Carol Walker (eds), *The Growing Divide: A Social Audit 1979–1987*, London, Child Poverty Action Group, 1987, p. 29.

33 Neal Ascherson, *Games with Shadows*, London, Radius, 1988, p. 129.

34 From a speech delivered in Blackburn on 1 June 1987; quoted in Suzanne MacGregor, *The Poll Tax and Enterprise Culture*, Manchester, Centre for Local Economic Strategies 1988, p. 22.

35 MacGregor, op. cit., p. 54.

36 Richard Luce, speech to the Council of Regional Arts Associations, Newcastle upon Tyne, July 1987 (delivered shortly after the Conservative election victory in June). Extracts from the speech were published in *Yorkshire Artscene*, August 1987, pp. 6–7.

37 These figures and comments are drawn from a BBC *Panorama* programme, 'Getting the Message Across', broadcast 4 September 1989.

38 MSC *Annual Report, 1986–7*, p. 49.

39 *Single Market News*, Spring 1989, p. 25.

40 David Lodge, *Nice Work*, London, Secker & Warburg, 1988; Zoe Fairbairns, *Closing*, London, Methuen, 1987.

41 Terry Eagleton argues, in a harsh critique of this novel, that it is anti-theoretical and anti-feminist; 'The silences of David Lodge', *New Left Review*, no. 172, November/December, 1988.

42 For an extremely interesting analysis and critique of another popular enterprise novel, *A Woman of Substance* (Barbara Taylor Bradford,

1979), see Estella Tincknell, 'Enterprise fictions – Women of substance', in S. Franklin, C. Lury and J. Stacey (eds), *Off-Centre: Feminism and Cultural Studies*, Unwin-Hyman, 1990, forthcoming.

43 Conservative Party Manifesto, *The Next Step Forward*, 1987.

44 This has been true not only for the large numbers dependent solely on social security payments, but also for the many low-paid within the workforce. In 1986, 42.3 per cent of the British workforce fell below the Council of Europe's minimum 'decency threshold' for wages; see Walker and Walker, op. cit., p. 29.

45 Vicomte de Chateaubriand 'Avenir du monde', *Revue des deux mondes*, 15 April, 1834; quoted and translated in D. Owen Evans, *Social Romanticism in France, 1830–1848*, Oxford University Press, 1951, p. 3.

3 Where horses shit a hundred sparrows feed: Docklands and East London during the Thatcher years

Thanks to students in the Department of Cultural Studies at the Polytechnic of East London, particularly Bolu Heather and Sarah Lovelock; and to Sandra Buchanan, formerly of the Docklands Community Poster Project: the views expressed are mine alone. For those who are curious the chapter heading comes from Gramsci's 'Americanism and Fordism', and refers to the parasitic forces which feed on the backward cities of the Italian south.

1 John Redwood, *Popular Capitalism*, London, Routledge, 1989, p. 144.

2 For an entertaining analysis, Dick Hobbs, *Doing the Business: Entrepreneurship, the Working Class and Detectives in the East End of London*, Oxford, Clarendon Press, 1988.

3 David Buckingham, *Public Secrets: 'EastEnders' and its Audience*, London, BFI, 1987, pp. 12–20. Michael Grade's memories are worth recording: 'I knew it was going to be a monster hit. All my experience told me so, my professional instincts honed over the years in the heat of the battle. I knew from the first three or four minutes it was going to be a monster'.

4 *The Times*, 3, 9, 10 and 13 March 1970. The island of the Isle of Dogs is not an island; but then nor is Pimlico south of the river, *pace* Michael Balcon.

5 The flavour of the moment can be discerned in Jim Slater, *Return to Go. My Autobiography*, London, Weidenfeld & Nicolson, 1977. The unedifying denouement of Slater's career came in 1975.

6 *The Times*, 17 June 1981.

7 *Independent*, 7 December 1987. See too Michael Heseltine, *Where There's a Will*, London, Hutchinson, 1987, and for a marginally less glowing assessment, Julian Critchley, *Heseltine, The Unauthorized Biography*, London, Coronet, 1988.

8 *Listener*, 3 December 1987.

9 *Guardian*, 29 March 1989.

10 In February 1987 a train defied the safety systems, went through some

buffers and was left hanging over a road. When the Queen formally opened the railway the following July a number of commentators took the opportunity to commend her courage.

11 Two other developments should be noted. Four months after her experiences with the railway the Queen opened the London City airport sited by the Royal Docks, the first new airport to be built in Britain (against huge popular opposition) for forty years. Second, once Murdoch made the running and shifted his print-plant from central London to Wapping – his employees outflanked by new technology and the tactics of a classic lockout – other newspaper owners made the move East, and the printers faced the same fate as dockers, steelworkers and miners.

12 See, *inter alia, Hansard*, House of Commons, 1 July 1981. The precise figures contained within these assurances appear to have varied.

13 *Independent*, 7 December 1987.

14 For an interesting assessment, John Punter, 'The contradictions of aesthetic controls under the Conservatives' *Planning Practice and Research*, September 1986.

15 *Building Design*, 19 June 1987 (special issue on Docklands).

16 It is tempting to see Quinlan Terry as Architect Royal to Mrs Thatcher. It was he who was chosen to refurbish Number 10. English Heritage opposed his plans, particularly as they affected Mrs Thatcher's boudoir: 'Spirally fluted columns are traditionally associated with divinity. . . . They usually flank the martyria or mausolea of saints or occasionally the tombs of kings (the Lord's anointed). Their use in a boudoir is most inappropriate' (*Independent*, 20 June 1989).

17 'More Britons now work in hotels than in coal mines and car factories combined. England's tourist authorities hope that their industry will double its income to £20 billion a year by the early 1990s', 'Making history pay', *Economist*, 1 August 1987. But with its usual dispassionate voice the journal warns: 'If Britain is to become a living museum, its warders should remember that exhibits have feelings too.'

18 *New York Times*, 18 April 1988; see too *Financial Times*, 23 September 1987; *U.S. News*, 14 March 1988; *Independent*, 30 March 1988; *Time*, 18 April 1988; *Evening Standard*, 19 April 1988; *The Planner*, mid-month supplement, April 1988; and *Independent*, 1 August 1988. For an insight into the prototype of such developments, New York in the seventies, nothing can compete in sheer egotism with Donald J. Trump with Tony Schwartz, *Trump: The Art of the Deal*, London, Century Hutchinson, 1987. And for recent plans to extend further new developments down as far as the Thames Barrier, *Evening Standard*, 8 August 1989.

19 *The Times*, 18 December 1987.

20 *Independent*, 26 September and 7 December 1987; and see *East Side Story*, BBC2, first broadcast 3 December 1987. Of interest too is Sebastien Kinsman, 'Confessions of a commodity broker', *New Statesman*, 19 February 1988: the stress of working the futures markets was offset by 'tremendous drinking bouts' consuming 'drinks of special

toxicity because time was short' – a favourite being the Jack Hawkins Depth Charge.

21 So, in a crass way, was the organization Class War, which offers the undiluted version of an essential East End composed of the dispossessed, fighting by any means the incursions of rich and powerful interlopers. See its occasional bulletin, *East Ender*. Of course this allows the situation to be perceived as a police problem; as Deputy Assistant Commissioner Wyn Jones, the commander of police operations at News International, commented, *sotto voce*: 'We are aware of people like Class War' (*Independent*, 26 September 1987).

22 Hobbs, op. cit., p. 217; and 'Charles leads City safari to East End', *Guardian*, 2 July 1987.

23 *Guardian*, 8 April 1989.

24 *Guardian*, 18 August 1988; for a rosier view, *Daily Telegraph*, 8 February 1988.

25 A number of these were initially inspired and supported by the GLC; see, *inter alia, The People's Plan for the Royal Docks*, London, Newham Docklands Forum and the GLC Popular Planning Unit, 1983. One of the more dramatic popular interventions, the People's Armada which sailed up the Thames on 17 April 1984, had the misfortune of having to compete for media space with the Libyan embassy siege.

26 *Newham News*, October 1987; *Financial Times*, 30 September 1987.

27 Ted Johns, director of the Association of Island Communities, *Herald Tribune*, 7 January 1988.

28 Stuart Hall, *The Hard Road to Renewal: Thatcherism and the Crisis of the Left*, London, Verso, 1988, p. 164.

29 *Time*, 18 April 1988; *New York Times*, 18 April 1987.

30 'Black Monday's effects on bankers' pay', *Financial Times*, 13 April 1988; *Guardian*, 7 December 1988, reporting the 450 sackings at Morgan Grenfell on the morrow of the firm's Christmas party.

31 *Independent*, 14 September 1988; *Guardian*, 13 September 1988; *Observer*, 14 February 1988.

32 *The Times*, 23 August 1989.

33 *Sunday Times*, 6 August 1989; *Guardian*, 15 August 1989. The gloom was heightened by the collapse of Kentish Homes, responsible for the most prestigious housing complex of all, Cascades. As one estate agent reflected sadly: 'You can no longer open up a portakabin on Sunday afternoon and sell an entire development to speculators.'

4 Enterprise and heritage in the dock

1 F. Fukuyama, 'The end of history' and 'Marxism's failure', *The Independent*, 20 and 21 September 1989. (Excerpts from the original publication in *The National Interest* (USA), Summer 1989.)

2 See especially the writings of Foucault, Deleuze and Guattari, and Lyotard. For an exceptionally lucid account of the work of these (and

others) see M. Sarup, *An Introductory Guide to Post-Structuralism and Postmodernism*, London, Harvester Wheatsheaf, 1988.

3 G. W. F. Hegel, *Philosophy of Right* (1820), Oxford, Oxford University Press, 1976, p. 13.

4 J.-F. Lyotard, *The Postmodern Condition: A Report on Knowledge*, Paris, 1979; UK edition, Manchester, Manchester University Press, 1986.

5 G. Stauth and B. S. Turner, 'Nostalgia, postmodernism and the critique of mass culture', *Theory, Culture & Society*, 1988, vol. 5.2/3, p. 524.

6 The key text is R. Hewison, *The Heritage Industry: Britain in a Climate of Decline*, London, Methuen, 1987.

Other printed contributions, in alphabetical order by author's surname, have been: N. Ascherson, 'Why "heritage" is right-wing', *Observer*, 8 November 1987, p. 9; N. Ascherson, ' "Heritage" as vulgar English nationalism', *Observer*, 22 November 1987, p. 9; U. Eco, 'Travels in hyperreality', in *Faith in Fakes*, London, Secker & Warburg, 1986; J. Iddon, (ed.), *The Dodo Strikes Back*, proceedings of a conference at St Mary's College, Strawberry Hill, 1988; W. Januszczak, 'Romancing the grime', *Guardian*, 2 September 1987, p. 9; R. Lumley, (ed.), *The Museum Time-Machine*, London, Comedia/Routledge, 1988; P. Norman, 'Faking the present on Fantasy Island', *Weekend Guardian*, 10–11 December 1988, pp. 2, 3, and 22; P. Norman, 'Made up in Britain', *Listener*, 25 January 1990, pp. 8–9; P. Norman, *The Age of Parody*, London, Hamish Hamilton, 1990; P. Wright, *On Living in an Old Country: The National Past in Contemporary Britain*, London, Verso, 1985.

Broadcast television programmes have included: 'The Heritage Business', *Up North*, BBC2, 16 March 1988; 'Past for Sale?', *Chronicle*, BBC2, 11 October 1989; 'Theme Park Britons', *Signals*, Channel 4, 11 October 1989; 'Fantasy Island', *Notes in the Margin 1980–89*, BBC 2, 25 January, 1990.

7 Hewison, op. cit., p. 9.

8 Cheshire County Council, *Tatton Park: The Mansion*, 1987, p. 38.

9 D. Cannadine, *The Pleasures of the Past*, London, Collins, 1989, Fontana p/b edn, 1990, p. 257.

10 ibid., pp. 258–9.

11 A. Mellor, 'Whose heritage?', *Journal of the North-West Labour History Group*, Bulletin 14, 1989–90, pp. 1–12.

12 W. Januszczak, op. cit., p. 9.

13 W. Januszczak, in *Architect's Journal*, July 1988, cited in D. Pearce, *Conservation Today*, London, Routledge, 1989, p. 86.

14 Pearce, op. cit., pp. 84–90. Merseyside Tourism Board, *The Albert Dock Liverpool: An Easy Guide*, pamphlet, n.d.

15 *Social Trends 20*, London, HMSO, 1990, p. 159. Thanks to staff members for attendance figures at the Tate Gallery Liverpool and the Merseyside Maritime Museum.

16 F. Shaw *et al.*, *Lern Yerself Scouse: How to Talk Proper in Liverpool, Vol 1*, Liverpool, Scouse Press, 1966, pp. 7–10.

17 P. Lewis, *The Fifties*, London, Heinemann, 1978, pp. 34–5.

18 P. Corrigan, *Schooling the Smash Street Kids*, London, Macmillan, 1979, p. 127.
19 P. Wright (interviewed by Tim Putnam), 'Sneering at the theme parks: an encounter with the heritage industry', *Block*, 15, 1989, p. 54.

5 The old and new worlds of information technology in Britain

I would like to thank John Corner, Sylvia Harvey, Sonia Liff and Kevin Robins for their helpful comments and suggestions for the revisions of this chapter.

1 See: Communist Party, *Manifesto for New Times*, London, Communist Party, 1988; *Marxism Today* (Special issue on 'New Times'), October 1988.
2 R. Murray, 'Life after Henry (Ford)', *Marxism Today*, October, 1988, p. 11.
3 A. Gamble, *The Free Economy and the Strong State*, London, Macmillan, pp. 126, 226.
4 For a recent version of this, see I. Miles, H. Rush, K. Turner and J. Besant, *Information Horizons: The Long-Term Social Implications of New Information Technology*, Aldershot, Edward Elgar, 1988.
5 To my knowledge the strongest critiques of the failure to challenge the ideological dimensions of the interpretation of recent technological change have come from Anna Pollert and Judith Williamson. See A. Pollert, 'Dismantling flexibility', *Capital and Class*, Spring 1988, vol. 34, pp. 42–75; J. Williamson, 'Even new times change', *New Society and Statesman*, 1989, vol. 2, no. 57, pp. 32–5.
6 See S. Hall, *The Hard Road to Renewal: Thatcherism and the Crisis of the Left*, London, Verso, in association with *Marxism Today*, 1988; Gamble, op. cit. especially pp. 20–5.
7 A. Giddens, *The Nation-State and Violence*, (volume 2 of *A Contemporary Critique of Historical Materialism*), Cambridge, Polity Press, 1987.
8 'The British disease and its cures', *Times Higher Education Supplement*, 15 August 1986.
9 M. J. Wiener, *English Culture and the Decline of the Industrial Spirit, 1850–1980*, Cambridge, Cambridge University Press, 1981.
10 C. Barnett, *The Audit of War: The Illusion and Reality of Britain as a Great Nation*, London, Macmillan, 1986.
11 P. Anderson, 'Components of the national culture', in A. Cockburn and R. Blackburn (eds), *Student Power: Problems, Diagnoses, Action*, Harmondsworth, Penguin, 1969.
12 K. Robins and F. Webster, *The Technical Fix: Education, Computers and Industry*, London, Macmillan, 1989, pp. 67–9.
13 I am borrowing here from the title of E. P. Thompson's article. 'The peculiarities of the English' 1965, reprinted in his *The Poverty of Theory and Other Essays*, London, Merlin, 1978.
14 To use Raymond Williams's term from his classic, *Culture and Society, 1780–1950*, 1957, Harmondsworth, Penguin, 1963.

15 Wiener, op. cit., p. 158.

16 ibid., p. 166.

17 See M. Ferguson, 'The challenge of neo-technological determinism for communication systems, industry and culture', in M. Ferguson (ed.), *New Communication Technologies and the Public Interest*, London, Sage, 1986, p. 68, n. 7.

18 E. Arnold and K. Guy, *Parallel Convergence: National Strategies in Information Technology*, Westport, Conn., Quorum Books, 1986, p. 6.

19 I am grateful to Sonia Liff for bringing this point to my attention.

20 See I. Adamson and R. Kennedy, *Sinclair and the Sunrise Technology: the Deconstruction of a Myth*, Harmondsworth, Penguin, 1986, p. 12.

21 D. Massey, 'The shape of things to come', *Marxism Today*, April 1983, p. 24.

22 ibid., pp. 24–5.

23 Interesting comparisons might be made between this lifestyle and pattern of gender-relations and those associated with nineteenth-century entrepreneurs studied by Leonore Davidoff and Catherine Hall. See L. Davidoff and C. Hall, *Family Fortunes: Men and Women of the English Middle Class, 1780–1850*, London, Hutchinson, 1987.

24 Adamson and Kennedy comment on the power of the links with Cambridge in the appeal of Sinclair's products; op. cit., pp. 240–1.

25 A. Toffler, *The Third Wave*, 1980, New York, Bantam, 1981.

26 S. Williams, *A Job to Live: the Impact of Tomorrow's Technology on Work and Society*, Harmondsworth, Penguin, 1985, p. 69.

27 See R. A. Wakefield, 'Home computers and families: the empowerment revolution', *The Futurist*, September–October 1986, vol. 20, no. 5, pp. 18–22.

28 See T. Forester, 'The myth of the electronic cottage', *Futures*, June, 1988, vol. 20, no. 3, pp. 227–40; I. Miles, 'The electronic cottage: myth or near-myth? A response to Tom Forester', *Futures*, August 1988, vol. 20, no. 4, pp. 355–66; J. Stanworth and C. Stanworth, 'Home truths about teleworking', *Personnel Management*, November 1989, pp. 48–52.

29 M. Brocklehurst, *Homeworking and the New Technology: The Reality and Rhetoric*, Special Issue of *Personnel Review*, 1989, vol. 18, no. 2, p. 63.

30 ibid., p. 36.

31 See U. Huws, *The New Homeworkers: New Technology and the Changing Location of Work*, London, Low Pay Unit, 1984; *Telework: Impact on Living and Working Conditions*, Dublin, European Foundation for the Improvement of Living and Working Conditions, 1984; 'Terminal isolation', in Radical Science Collective (eds), *Making Waves: The Politics of Communications*, London, Free Association Books, 1985; Brocklehurst, op. cit.; Stanworth and Stanworth, op. cit. Of course, there are important distinctions to be made amongst the kinds of workers who use IT in the home, particularly between 'pieceworkers' (mainly female) and those who choose to work partly at home (mainly male). For this and other distinctions, see note 29.

32 Massey, op. cit.

33 Robins and Webster, op. cit., 1989, pp. 90–4.
34 ibid, p. 92.
35 I. Macintosh, *Sunrise Europe: The Dynamics of Information Technology*, Oxford, Basil Blackwell, 1986, p. 67.
36 On the mythologizing surrounding Sinclair, see Adamson and Kennedy, op. cit.
37 P. Golding and G. Murdock, 'Unequal information: access and exclusion in the new communications market place', in Ferguson, op. cit., p. 77.
38 L. Haddon, 'The roots and early history of the British home computer market: Origins of the masculine micro', unpublished Ph.D. thesis, Imperial College, University of London, 1989, p. 142; see also Adamson and Kennedy, op. cit., p. 143.
39 Haddon, op. cit.
40 See G. Skirrow, 'Hellevision: an analysis of video games', in C. MacCabe (ed.), *High Theory/Low Culture: Analysing Popular Television and Film*, Manchester, Manchester University Press, 1986; R. Silverstone, D. Morley, A. Dahlberg and S. Livingstone, 'Families, technologies and consumption: the household and information and communication technologies' (CRICT Discussion Paper), 1989, pp. 67–81; Haddon, op. cit.
41 Adamson and Kennedy, op. cit., p. 121.
42 S. Turkle, *The Second Self: Computers and the Human Spirit*, London, Granada, 1984, p. 213.
43 Adamson and Kennedy maintain that Sinclair's own PR machine was formidable and that this was detrimental to the long-term prospects for his companies. See Adamson and Kennedy, op. cit.
44 ibid., p. 9.
45 ibid., p. 192.
46 S. Smiles, *Self-Help with Illustrations of Conduct and Perseverance*, abridged by G. Bull, with an introduction by Sir Keith Joseph, Harmondsworth, Penguin, 1986.
47 Although it should be noted that Adamson and Kennedy, at least, raise serious questions about Sinclair's entrepreneurial skills; op. cit., p. 10.
48 T. Roszack, *The Cult of Information: The Folklore of Computers and the True Art of Thinking*, New York, Pantheon Books, 1986.
49 See P. Linn, 'Microcomputers in education: living and dead labour', in T. Solominides and L. Levidow (eds), *Compulsive Technology: Computers as Culture*, London, Free Association Books, 1985; K. Robins and F. Webster, 'Higher education, high tech, high rhetoric', in ibid., 'Dangers of information technology and responsibilities in education', in R. Finnegan, G. Salaman and K. Thompson (eds), *Information Technology: Social Issues: A Reader*, London, Hodder & Stoughton, in association with the Open University, 1987.
50 See Centre for Contemporary Cultural Studies Education Group, *Unpopular Education*, London, Hutchinson, 1984.
51 Robins and Webster, op. cit., 1989, pp. 119–21.
52 Department of Trade and Industry, *DTI – the Department for Enterprise*, Cmnd. 278, London, HMSO, 1988, p. 20.

53 *Hansard*, 26 March 1985, p. 122.

54 Linn, op. cit., p. 78.

55 The Alvey programme was established to stimulate IT research on intelligent knowledge based systems (IKBS), the man/machine [*sic*] interface (MMI), software engineering, very large-scale integration (VKSI) and computing architectures. Government support financed 50 per cent of the input of the industrial partners and 100 per cent of the academic partners through the Science and Engineering Research Council. Spending on this programme for 1986–7 was estimated to be £29 million. See J. Shepherd, 'Industrial support policies', *National Institute Economic Review*, November 1987, vol. 122, p. 69. For an account of the Alvey programme and its follow-up in the establishment of the Information Engineering Directorate, see T. Walker, 'Son of Alvey', *Times Higher Education Supplement*, 17 June 1988, pp. i–ii. Walker's assessment of Alvey clearly illustrates the way IT became a medium of industry–education bonding: 'The Alvey programme was very effective in helping people to collaborate: companies, universities and government departments' (p.i). See also Robins and Webster, op. cit., 1989, p. 134.

56 CNAA, *Policy Statement: Implications of the Development of Information Technology for CNAA Undergraduate Courses*, Publication 2a/27, 27 December 1982, London, Council for National Academic Awards, 1982.

57 Information Technology Education Centres.

58 This is not to say that the Thatcher governments necessarily originated all of these projects, nor that they weren't integrated into local government strategies of Labour Councils (as was true of some science parks). The fact remains that these initiatives, whatever their origins or specific local forms, became associated with Thatcherite entrepreneurialism.

59 A 1984 survey showed that they had less than 20 per cent female trainees. See G. Chivers, 'Information technology – girls and education: a cross-cultural review', in M. J. Davidson and C. L. Cooper (eds), *Women and Information Technology*, Chichester, John Wiley, 1987, p. 17.

60 Turney reported on a review drawn up by economic development consultants Segal Quince Wicksteed for the MSC. See J. Turney, 'Science parks fail to bring home industrial bacon', *Times Higher Education Supplement*, 27 April, 1987, p. 10. For a critique of the logic of science parks, see also D. Massey and R. Meegan, 'Profits and job loss', in D. Massey and R. Meegan (eds), *Politics and Method: Contrasting Studies in Industrial Geography*, London, Methuen, 1985, pp. 139–40.

61 Robins and Webster, op. cit., 1989, p. 134.

62 ibid; see also Robins and Webster, op. cit., 1987.

63 B. Street, 'Models of "computer literacy" ', in Finnegan, Salaman and Thompson, op. cit.

64 Robins and Webster, op. cit.; 1987, 'Computer literacy: the employ-

ment myths', *Social Science Computer Review*, Spring 1989, vol. 7, no. 1, pp. 7–26.

65 Quotations from Street, op. cit., pp. 36, 37.

66 See B. A. Scott (ed.), *The Liberal Arts in a Time of Crisis*, New York, Praeger, 1990.

67 Robins and Webster, op. cit., 1987, p. 145.

68 Robins and Webster, 1989, 'Computer literacy'.

69 Quoted in Robins and Webster, op. cit., 1987, pp. 151–2.

70 ibid., pp. 152–3.

71 Ibid.

72 Robins and Webster, op. cit., 1985, p. 54.

73 Labour Party, *Labour and Information Technology*, London, Labour Party, 1985; see also Linn, op. cit., pp. 58–9.

74 See Haddon, op. cit.

75 'Computers programmed to ignore women', *Times Higher Education Supplement*, 21 April 1989.

76 *Machinery of Dominance: Women, Men and Technical Know-How*, London, Pluto Press, 1985, p. 170. See also Chivers, op. cit.

77 *Guardian*, 25 February 1988.

78 'Computers programmed to ignore women', *Times Higher Education Supplement*, 21 April 1989.

79 The women's workshops in Cardiff and East Leeds are examples of such workshops. See C. Cairncross, 'New skills for workshop women: On the spot nursery facilities make new technology training scheme unique', *Equality Now*, 3, Summer 1984, Manchester, Equal Opportunities Commission, 1984; S. Cox and A. Swarbrick, 'Women and technology: review of training initiatives', *Work and Stress*, 1987, vol. 1, no. 3, pp. 285–91.

80 Miles, Rush, Turner and Besant, op. cit., p. 7; see also Linn, op. cit., p. 61.

81 S. Hall, 'Brave new world', *Marxism Today*, October 1988, p. 24.

82 Williamson, op. cit., p. 35.

83 See D. Campbell and S. Connor, *On the Records: Surveillance, Computers and Privacy*, London, Michael Joseph, 1986.

84 On this last point, see Golding and Murdock, op. cit.

6 The age of leisure

Bibliography:

Bianchini, F., *et al.*, *City Centres, City Cultures*, Manchester, Centre for Local Economic Strategies, 1988.

Gardner, C. and Sheppard, J., *Consuming Passion. The Rise of Retail Culture*, London, Unwin Hyman, 1989.

Landry, C., Montgomery, J. and Worpole, K., *The Last Resort: Tourism and 'Post-tourism' in the South-East*, Stevenage, SEEDS, 1989.

Seabrook, J., *The Leisure Society*, Oxford, Basil Blackwell, 1988.

Lumley, R. (ed.), *The Museum Time-Machine*, London, Routledge, 1988.

Bishop, J. and Hoggett, P., *Organising Around Enthusiasms*, London, Comedia, 1986.

7 'Up Where You Belong': Hollywood images of big business in the 1980s

1 Douglas Hurd, 'Citizenship in a Tory democracy', *New Statesman*, 27 April 1988, p. 14. The language of this article is quite remarkably similar to Richard Baxter's: elsewhere in it Hurd claims that 'private property . . . buttresses personal responsibility, by harnessing man's acquisitive instinct to the demands of *stewardship*' (my italics).
2 Richard Baxter, *Christian Directory*, 1678 edn, vol. 1, p. 378b.
3 Robert Warshow, 'The gangster as tragic hero' (1948), in *The Immediate Experience*, New York, Atheneum Books, 1970, p. 132.
4 It would be unfair not to mention in this context Lezli-Ann Barrett's *Business as Usual* (1987) which – not a gangster film – deals with a trade union harassment case; or Amber Films' *T. Dan Smith* (1987) which looks at local business corruption. Nevertheless, neither of these deals with 'high' finance and neither could honestly be called 'popular'.
5 Karl Marx, *The Poverty of Philosophy*, 1847.

Filmography

Baby Boom, Dir. Charles Shyer, 1987, USA.
Big, Dir. Penny Marshall, 1988, USA.
Big Business, Dir. Jim Abrahams, 1988, USA.
Empire State, Dir. Ron Peck, 1987, GB.
The Long Good Friday, Dir. John MacKenzie, 1980, GB.
An Officer and a Gentleman, Dir. Taylor Hackford, 1981, USA.
The Secret of My Success, Dir. Herbert Ross, 1987, USA.
Stormy Monday, Dir. Mike Figgis, 1987, GB.
Trading Places, Dir. John Landis, 1983, USA.
Vice Versa, Dir. Brian Gilbert, 1988, USA.
Wall Street, Dir. Oliver Stone, 1987, USA.
Working Girl, Dir. Mike Nichols, 1988, USA.

8 Commerce and culture

1 R. Strong, 'Towards a more consumer-orientated V & A', typescript press release, Victoria and Albert Museum, 1985.
2 R. Lumley (ed.), *The Museum Time-Machine*, London, Routledge, 1988, p. 2.
3 ibid., p. 217.
4 *Museums Journal*, July 1989, p. 8.
5 Lumley, op. cit., p. 91.

6 R. Wilding, 'Financing museums: current and future trends', *Museums Journal*, December 1985, p. 122.

7 ibid.

8 Museums Association, *Museums UK: The Findings of the Museums Data-Base Project*, compiled by David Prince and Bernadette Higgins-McLoughlin, London, Museums Association, 1987, p. 26.

9 J. Myerscough, *The Economic Importance of the Arts in Britain*, London, Policy Studies Institute, 1988, p. 37, table 3.3

10 Ian Robertson, 'Financing museums: the view of a professional', *Museums Journal*, December 1985, p. 125.

11 Lumley, op. cit., p. 22, n. 38.

12 The slogan of a poster and television campaign on behalf of the V & A during the autumn of 1988.

13 *Independent*, 22 October 1988.

14 *Marketing Week*, 4 November 1988.

15 *Independent*, 27 February 1989.

16 *Observer*, 21 March 1989.

17 *Museums Journal*, July 1989, p. 8.

18 *The Times*, 9 November, 1989.

19 Stephen Bayley, *Commerce and Culture: From Pre-industrial Art to Post-industrial Value*, London, Design Museum, 1989, p. 7.

20 Exhibition placard, 'Commerce and Culture'; cf. Bayley, op. cit., p. 7.

21 Exhibition placard, 'Commerce and Culture'.

22 Bayley, op. cit., p. 8.

23 ibid., p. 77.

24 *The Times*, 17 June 1989.

25 Bayley, op. cit., p. 63.

26 ibid., p. 113.

27 Umberto Eco, 'Travels in hyperreality', in *Faith in Fakes*, London, Secker & Warburg, 1986, p. 7.

28 ibid.

29 Jean Baudrillard, *Simulations*, New York, Semiotext(e), 1983, p. 11.

30 Fredric Jameson, 'Post-modernism, or the cultural logic of late capitalism', *New Left Review*, no. 146, July/August 1984, p. 60.

31 Jameson, op. cit., p. 65.

32 ibid., p. 66, Guy Debord's *La Société du spectacle* was published by Buchet/Castel, Paris, 1967.

33 Jameson, op. cit., p. 71.

34 *The Times*, 30 January 1988.

35 Donald Horne, *The Great Museum: The Re-presentation of History*, London, Pluto Press, 1984, p. 111.

36 Raymond Williams, *Culture*, London, Fontana, 1981, p. 11.

37 Irish Murdoch, 'Against dryness', reprinted in Malcolm Bradbury (ed.), *The Novel Today: Contemporary Writers on Modern Fiction*, London, Fontana, pp. 30-1.

9 Over our shoulders: nostalgic screen fictions for the 1980s

1 Walter Benjamin, 'Theses on the philosophy of history', in *Illumina-tions*, London, Jonathan Cape, 1970, p. 257.
2 Harlan Kennedy, 'The Brits have gone nuts', *Film Comment*, August 1985.
3 The main sources for my arguments in this chapter are: Richard Johnson, Gregor McLennan, Bill Schwarz and David Sutton (eds), *Making Histories*, London, Hutchinson, 1982; David Lowenthal, *The Past is a Foreign Country*, Cambridge, Cambridge University Press, 1985; Patrick Wright, *On Living in an Old Country*, London, Verso, 1985; Robert Hewison, *The Heritage Industry*, London, Methuen, 1987; Roger Bromley, *Lost Narratives*, London, Routledge, 1988; Robert Lumley (ed.), *The Museum Time-Machine*, London, Routledge, 1988.
4 Bromley, op. cit., p. 25.
5 Wright, op. cit., p. 16.
6 Jonathan Clark, *Education Guardian*, 18 July 1989.
7 Kennedy, op. cit.
8 Clark, op. cit.
9 David Puttnam, quoted in '*Chariots* begins at home', *AIP & CO*, no. 35, Nov.–Dec., 1981.
10 *Financial Times*, 4 December 1983.
11 *Observer*, 1 April 1984.
12 *New Society*, 5 April 1984.
13 Kennedy, op. cit.
14 Slide notes on *Chariots of Fire, BFI Education*, May 1989, p. 11.
15 A more detailed account of the threat 'Americanization' posed can be found in Dick Hebdige, 'Towards a cartography of taste', in his collection *Hiding in the Light*, London, Routledge, 1988.
16 Tony Bennett, 'Museums and "the people" ', in Roger Lumley (ed.), *The Museum Time-Machine*, London, Routledge, 1988.
17 Michael Wood, quoted by Bromley, op. cit., p. 146.
18 Lowenthal, op. cit., p. 229.
19 Bromley, op. cit., p. 60.
20 ibid, p. 23.
21 *Financial Times*, 14 October 1981.
22 *Glasgow Herald*, 14 January 1984.
23 *Times Educational Supplement*, 13 January 1984.
24 *The Times*, 13 February 1984.
25 *Daily Telegraph*, 30 January 1984.
26 Cited in James Curran and Vincent Porter (eds), *British Cinema History*, London, Weidenfeld & Nicolson, 1983, p. 19.
27 Derek Granger, quoted in *The Glasgow Herald*, 7 January 1980.
28 Lowenthal, op. cit., p. 258.
29 *Guardian*, 7 April, 1984.
30 Derek Granger, quoted in *The Times*, 23 September, 1981.

10 Echoes of empire: towards a politics of representation

1 Najma Kazi, 'Conflict', in Zhana (ed.), *Sojourn*, London, Methuen, 1988.
2 Paul Barker, 'Britain observed 3 – In ethnic England: Bradford', *New Society*, 15 October 1981.
3 Stuart Hall, 'New ethnicities', in *Black Film, British Cinema*, ICA Documents, London, Institute of Contemporary Arts, 1989, pp. 27–31.
4 ibid.
5 *Free Press*, no. 32, December 1985.
6 The Black Group of the Campaign for Press and Broadcasting Freedom broke up acrimoniously following a dispute over allegations of racism in the non-renewal of black staff contracts, in a financial crisis in 1987.
7 Barker, op. cit.
8 David Stephen, 'Who are the Paki-baiters?', *New Society*, 4 August 1983.
9 Jeremy Seabrook, 'Mrs Thatcher's poor', *New Society*, 26 January 1984.
10 Angela Carter, 'So there'll always be an England', *New Society*, 7 October 1982.
11 David Selbourne, 'The culture clash in Bradford', *New Society*, 26 april 1984.
12 ibid.
13 Paul Gilroy, *There Ain't No Black in the Union Jack*, London, Hutchinson, 1987, p. 56.
14 John Casey, 'One nation – the politics of race', *Salisbury Review*, no. 1, 1982.
15 *The Next Step Forward*, Conservative Party Election Manifesto, 1987, p. 59.
16 The English Community Charge Leaflet alone carries these images, although the same information applies to both England and Wales. The Welsh leaflet, bi-lingual, but otherwise apparently indistinguishable in terms of graphic design, loses all images of 'obviously' non-European figures.
17 Martin Barker, *The New Racism*, London, Junction Books, 1981, p. 161.
18 Ferdinand Mount, 'Hypernats and country-lovers', *Spectator*, 18 February 1989.
19 Michael Banton, *Racial and Ethnic Competition*, Cambridge University Press, 1983, p. 106.
20 Ray Honeyford, 'Multi-ethnic intolerance', *Salisbury Review*, no. 4, Summer 1983.
21 See the Swann Commission Report, *Education for All*, 1985, or annual examination figures produced by the Inner London Education Authority.
22 The Flew and Scruton articles are discussed in Gill Seidel, 'Culture, nation and race in the British and French New Right', in Ruth Levitas (ed.), *The Ideology of the New Right*, Oxford, Polity Press, 1986.

23 Yasmin Ali, 'Television and anti-racism', unpublished paper presented to the International Television Studies Conference, London, 1986.

24 Selbourne, op. cit.

25 *The Next Step Forward*, p. 19.

26 *Independent,* 4 January 1989.

27 *Guardian*, 8 February, 1989.

28 Pnina Werbner, 'How immigrants can make it in Britain', *New Society*, 20 September 1985.

29 Salman Rushdie, 'The new empire within Britain', *Opinions*, Channel 4, December 1982.

30 Martin Harris, 'In pursuit of the Asians', *New Society*, 2 June 1983.

31 *Lancashire Evening Telegraph* 5 May 1989.

32 E. Ellis Cashmore 'What lay behind the Birmingham riots', *New Society*, 13 September 1985.

33 See Manning Marable, *Race, Reform and Rebellion*, London, Macmillan, 1984, and *How Capitalism Under-developed Black America*, London, Pluto Press, 1983.

34 Tariq Modood, ' "Black", racial equality and Asian identity', *New Community*, vol. 14, no. 3, Spring 1988.

35 ibid., p. 397.

36 Tariq Modood, 'Alabama Britain', *Guardian*, 22 May 1989.

37 Commission for Racial Equality Press Release, 7 December 1988.

38 Viraj Mendis, a Sri Lankan political activist who feared harassment or danger if he was deported back to Sri Lanka, became the focus of an unsuccessful campaign to keep him in Britain after he sought sanctuary in a Manchester church. Zola Budd, a South African athlete, gained British citizenship in less than a fortnight in order to compete in the Olympic Games. Subsequently she returned to live in South Africa.

39 Mount, op. cit.

40 Gilroy, op. cit., p. 54.

41 Hall, op. cit., p. 27.

11 Re-imagining the city

The authors wish to thank Jon Dawson of Liverpool University's Centre for Urban Studies, for his comments and suggestions on an earlier version of this chapter. Many of the ideas developed in the second section of the chapter derive from conversations with Liz Greenhalgh, Charles Landry, John Montgomery and Ken Worpole of Comedia Consultancy, London, with whom Franco Bianchini is working on *Out of Hours: Improving Urban Public Social Life During and After Working Hours*, a study of thirteen British towns and cities sponsored by the UK branch of the Calouste Gulbenkian Foundation.

1 Martin Wiener, *English Culture and the Decline of the Industrial Spirit 1850–1980*, Cambridge, Cambridge University Press, 1981.

2 David Boyle, *Building Futures*, London, Allen, 1989, pp. 8–9.

3 Peter Kellner, 'Electronic requiem for our cities', *Independent*, 14 August 1989. See also Kellner's article on the deterioration of the

quality of life in London, 'A capital example of British rot', *Independent*, 7 August 1989. For a critique of the 'electronic cottage' see Kevin Robins and Mark Hepworth, 'Electronic spaces', *Futures*, 20, 1988, pp. 95–117.

4 On council rent increases in the South East, see Kate Miller, 'Tenants' bitter pill', *Guardian*, 28 February 1990. On the impact of the poll tax on low-income groups, see Kate Flannery, *More Than Just a Poll Tax*, Manchester, CLES, 1987, pp. 55–7.

5 Data from Henley Centre for Forecasting, *Leisure Futures*, Summer 1989, p. 44.

6 See summary of surveys in Stephen T. Atkins, *Critical Paths: Designing for Secure Travel*, London, Design Council, 1989, p. 8. See also Rosemary Betterton, *A Local Policy for the Arts: the Kelvin Estate Geographical Project*, Sheffield, Sheffield City Polytechnic, 1988. The report includes a survey of the factors preventing the residents of a large council estate in Sheffield from going out in the evening.

7 On the retailing-led process of restructuring of cities, see Mark Fisher and Ken Worpole (eds), *City Centres, City Cultures*, Manchester, CLES, 1988 (especially pp. 25–37) and John Montgomery, *Trade Winds*, Stevenage, SEEDS, 1987. On the growth of multiplex cinemas see *Cultural Trends*, 1, 1989, p. 6.

8 David Harvey, *The Condition of Postmodernity*, Oxford, Basil Blackwell, 1989, p. 66.

9 See Franco Bianchini, Jon Dawson and Richard Evans, 'Flagship projects in urban regeneration', paper presented to the 'Property-led Urban Regeneration' seminar, University of Newcastle upon Tyne, March 1990.

10 On the American influence on 1980s British urban policy, see Michael Parkinson and Dennis Judd, 'Urban revitalisation in America and the UK – the politics of uneven development', in Michael Parkinson, Bernard Foley and Dennis Judd (eds), *Regenerating the Cities: The UK Crisis and the US Experience*, Manchester, Manchester University Press, 1988, pp. 1–8. See also Timothy Barnekov, Robin Boyle and Daniel Rich, *Privatism and Urban Policy in Britain and the United States*, Oxford, Oxford University Press, 1989, pp. 1–13. On public-private partnerships see Alan Harding, 'Public-private partnerships in the UK: some key issues', paper presented to the 'Public-Private Partnerships' seminar organized by the Town & Country Planning Association, Wakefield, December 1989.

11 Barnekov, Boyle and Rich, op. cit., p. 193.

12 Greater Glasgow Tourist Board, *Renaissance*, Glasgow, n.d., pp. 5 and 11.

13 On the influence of policies adopted in Stockholm and Rome respectively on the GLC's public transport and cultural animation strategies, see David Kogan and Maurice Kogan, *The Battle for the Labour Party*, London, Kogan Page, 1983, p. 170, and Raphael Samuel, in *New Left Review*, November–December 1985, p. 19. On traffic calming and pedestrianization strategies in European cities see TEST, *Quality Streets*, London, TEST, 1988.

14 RHWL Partnership, *The Lyceum Theatre and Tudor Square, Sheffield*, Sheffield, March 1988, p. 41.

15 Kim N. Way, LDR International, interview with F. Bianchini, 20 March 1990.

16 The key instruments for 'leverage' were the Urban Development Grants (UDGs), which were introduced in 1982 and were replaced in 1987 by the Urban Regeneration Grants and in 1988 by City Grant. The equivalent of the UDGs in Scotland was the Local Enterprise Grants for Urban Projects (LEG-UP) system, which was administered by the Scottish Development Agency.

17 The first two UDCs were the London Docklands and the Merseyside Development Corporations, which were established with the 1980 Local Government, Planning and Land Act. The second wave of UDCs, launched in 1987, included Tyne & Wear, Teesside, Trafford Park, the Black Country and Cardiff Bay, while the smaller and more city-centre-based UDCs of the third wave were established during 1988-9 in Leeds, Central Manchester, Sheffield and Bristol.

18 The first Garden Festival took place in Liverpool in 1984, followed by Stoke-on-Trent (1986), Glasgow (1988), Gateshead (1990), and Ebbw Vale (1992).

19 On Glasgow see Robin Boyle, 'Private sector urban regeneration: the Scottish experience', in Parkinson, Foley and Judd (eds), op. cit., pp. 74-92. On the experience of the London Docklands and the Merseyside Development Corporations, see Michael Parkinson and Richard Evans, 'Urban Development Corporations', in Michael Campbell (ed.), *Local Economic Policy*, London, Cassell, forthcoming. On Bradford see Jean Hunter, 'A National Museum in an inner city role', in Trevor Boden (ed.), *Cities and City Cultures*, Birmingham, Birmingham Film and Television Festival, 1988, pp. 21-4, and Richard Donkin, 'A "grim and resolute city" turns to seduction', *Financial Times*, 8 April 1989.

20 Michael Parkinson, 'The Thatcher government's urban policy 1979-89: a review', in *Town Planning Review* 1989, vol. 4, p. 32.

21 On Glasgow see Bob Holman, 'Why poverty kills', *Guardian*, 12 July 1989; Stuart Cosgrove and Duncan Campbell, 'Behind the wee smiles', *New Statesman & Society*, 16 December 1988; Robin Boyle, op. cit. and 'Glasgow's growth pains', *New Society*, 8 January 1988; Bill Bryson, 'Glasgow isn't Paris, but', *New York Times Magazine*, 9 July 1989, pp. 34-65. On attempts at community-led revitalization of Glasgow's peripheral estates, see Jon Dawson, 'Housing co-operatives: from housing improvement to economic regeneration?', University of Liverpool, *Centre for Urban Studies Working Papers*, no. 9, May 1989. On Bradford see Peter Dunn, 'The hungry poor fail to bounce back', *Independent*, 2 December 1989. On Liverpool see Richard Meegan, 'Paradise postponed: the growth and decline of Merseyside's outer estates', in Phil Cooke (ed.), *Localities*, London, Unwin Hyman, 1989, pp. 198-234, and Michael Parkinson, 'Leadership and regeneration in Liverpool: confusion, confrontation or coalition?', in Dennis Judd and

Michael Parkinson (eds), *Leadership and Urban Regeneration: the European and American Experience*, Newbury Park, CA, Sage, 1990.

22 Fred Robinson, 'Urban "regeneration" policies in the late 1980s: who benefits?', Centre for Urban and Regional Development Studies, University of Newcastle upon Tyne, *Discussion Paper* series no. 94, December 1989, p. 2.

23 David Harvey, 'Down towns', *Marxism Today*, January 1989.

24 Jan Gehl, 'A changing street life in a changing society', *Places*, Fall 1989, p. 8.

25 Paul Hirst, *After Thatcher*, London, Collins, 1989, pp. 155–6.

26 Patrick Hannay, 'Close to the edge', *Architects' Journal*, 18 May 1988, p. 54. On the Metrocentre (the giant shopping and leisure complex near Gateshead), see Patrick Hannay, 'Till wealth do us part', *Architects' Journal*, 6 January 1988. Hannay writes: 'every shop, café and sign location is aimed at planned, controlled and well policed consumption. There is no room for youths "cruising" the malls. No social gathering or happening will grow here spontaneously' (p. 29). Hannay goes on to compare the Metrocentre with the 1970s Killingworth Centre in Longbenton, a council estate in North Tyneside with car-ownership and unemployment levels of 15 per cent and 33 per cent respectively: 'the irony is that the age that conceived Killingworth was one of centrally planned utopias for all. Sadly the conception was executed at a distance with little love or style, and with inadequate resources devoted to its management in use In contrast . . . [the] Metrocentre can quite openly claim to be a centrally planned utopia for the lucky majority. Its bland exterior almost symbolically ignores the existence of life beyond itself' (op. cit., p. 31).

27 On CCTV schemes in Bournemouth and Plymouth respectively, see Stephen T. Atkins, op. cit., p. 63, and James Dalrymple, 'City welcomes constant watch of a Big Brother', *Independent*, 15 August 1989. See also, for a discussion of some of the implications of the new electronic surveillance systems, Robins and Hepworth, op. cit.

28 Nicholas Elliott, *Streets Ahead*, London, Adam Smith Institute, 1988.

29 Evan McKenzie, 'Morning in Privatopia', *Dissent*, Spring 1989, p. 257.

30 ibid., p. 258.

31 ibid, pp. 259–60.

32 Michael Brill, 'An ontology for exploring urban public life today', *Places*, Fall 1989, p. 30.

33 See Colin Hughes, 'Tories search for a theme', *Independent*, 30 April 1988.

34 Douglas Hurd, quoted in Hughes, op. cit.

35 *New Statesman*, 15 April 1988.

36 On the Tory debate on citizenship see also Douglas Hurd, 'Citizenship in Tory democracy', *New Statesman*, 29 April 1988; John Patten, 'Launching the active citizen', *Guardian*, 28 September 1988; David Gow, 'Active citizenship urged as a subject in GCSE', *Guardian* 28 September 1988; Michael Ignatieff, 'Caring just isn't enough', *New Statesman & Society*, 3 February 1989; John Gyford, 'There's more to life than shopping', *Chartist*, October–December 1989.

37 On the erosion of local government powers under the Thatcher governments, see Tony Travers, 'The threat to the autonomy of elected local government' (on which our reconstruction is largely based); Alan Harding, 'Central control in British urban economic development programmes', and Jim Bulpitt, 'Walking back to happiness? Conservative Party governments and elected local authorities in the 1980s', all in Colin Crouch and David Marquand (eds), *The New Centralism*, Oxford, Basil Blackwell, 1989. The book examines the historical, ideological and political peculiarities of the centralization process in Britain by comparing it with experiences and processes of decentralization in West Germany, France, Italy and Scandinavia. A special issue of the *European Journal of Political Research* (vol. 16, no. 4, July 1988) demonstrates that centralization in Britain is running against the trend towards decentralization not only in Western Europe, but also in the USA in the Reagan period.

38 Michael Parkinson, 'The Thatcher government's urban policy 1979–89: a review', op. cit., pp. 9–10.

39 See, for example, the elegant formulation of the government's position on 'municipal socialism' by former Environment Secretary Nicholas Ridley: 'You cannot have a free-market government using public spending for doing what is properly within the public domain, and, at the same time, municipal socialism, with its ideology that there should be public ownership of land, of enterprise, houses and other buildings, because the two are in conflict. So if they insist on pursuing municipal socialism we will redirect our resources away from local authorities' (quoted in *Independent*, 1 October 1987).

40 Phil Cooke, *Back to the Future*, London, Unwin Hyman, 1990, p. 136.

41 Zygmunt Bauman, 'Britain's exit from politics', *New Statesman & Society*, 29 July 1988, p. 38.

42 ibid. Geoff Mulgan writes that the Conservative-controlled council in Bradford attempted 'to project an idea of the city as a corporation providing a defined set of services to its "consumers" and dividends to its shareholders' ('A tale of new cities', *Marxism Today*, March 1989, p. 23). The idea is developed further by the Adam Smith Institute in their report *Wiser Counsels: The Reform of Local Government*, London, Adam Smith Institute, 1989.

43 Bauman, op. cit.

44 The concept of 'cultural industries' was put forward as an instrument for local economic policy-making by Nicholas Garnham in 'Concepts of culture, public policy and the cultural industries', his keynote contribution to the conference 'Cultural Industries and Cultural Policy in London', organized by the Greater London Council and held at London's Riverside Studios in December 1983. For a discussion of the origins of cultural industries strategy, see Franco Bianchini, 'GLC R.I.P. Cultural policies in London, 1981–1986', *New Formations*, 1, 1987, pp. 111–13.

45 See Franco Bianchini, 'Urban renaissance? The arts and the urban regeneration process', in Ben Pimlott and Susan MacGregor (eds),

Tackling the Inner Cities?, Oxford, Oxford University Press, forthcoming.

46 Examples of this kind of intervention are provided by the mushrooming of fashion and design centres supported by a variety of public and private sector sources in Newcastle, Gateshead, Leeds, Sheffield, Manchester, Nottingham and Hackney. See Eileen Davenport and Peter Totterdill, 'Fashion centres: an approach to sector intervention', in *Local Economy*, Spring 1986, pp. 57–63.

47 See, for instance, the proposals in Sheffield to create links between the Cultural Industries Quarter, established by the City Council's Department of Employment and Economic Development during 1986–7, and the adjacent science park, to initiate research into the development of new technology in image and music recording.

48 See Alan Harding, op. cit.

49 Michael Walzer, 'Pleasures and costs of urbanity', *Dissent*, Summer 1986.

50 On the concept of 'imageability' see Kevin Lynch, *The Image of the City*, Cambridge, Mass., MIT Press, 1960.

51 On the 'greening' of cities see Bob Smyth, *City Wildspace*, London, Shipman, 1987; David Nicolson-Lord, *The Greening of the Cities*, London, Routledge & Kegan Paul, 1987; Colin Ward, *Welcome, Thinner City*, London, Bedford Square Press, pp. 96–102.

52 See Kevin Robins and Sue Wilkinson, 'The imaginary institution of the city', paper presented at the 'Property-led Urban Regeneration' seminar, University of Newcastle upon Tyne, March 1990.

53 For specific examples see Mulgan, op. cit., p. 21.

54 The distinction is based on Jurgen Habermas's 'modes of reasoning', quoted in Patsy Healey, 'Planning for the 1990s', University of Newcastle upon Tyne, *Department of Town and Country Planning Working Papers*, 7, 1989, p. 18. See Healey (ibid) also for a critique of the 'use-oriented', rather than user-oriented, nature of traditional approaches to planning.

55 Charles Landry, John Montgomery and Ken Worpole, *The Last Resort: Tourism, Tourist Employment and 'Post-Tourism' in the South East*, Stevenage, SEEDS, 1989.

56 David Boyle, op. cit., pp. 143–4. On the approach to urban regeneration adopted by Partners for Livable Places, see *Shaping Growth in American Communities*, Washington, Partners for Livable Places, n.d.

57 Healey, op. cit., p. 7.

58 Manuel Castells, *The City and the Grassroots*, London, Edward Arnold, 1983, pp. 319–20.

59 The recently established community councils in Middlesbrough, for example, were successful in getting community development projects off the ground and in contributing to small but significant increases in turnout at local elections. See Paul Hoggett, 'Tenant power in Middlesbrough', *Chartist*, July–September 1989, p. 18.

60 Paul Hoggett and Robin Hambleton, 'Local heroes', *New Statesman & Society* 5 May 1989, p. 17.

61 ibid., p. 16.

62 'Glasgow for People' and 'Birmingham for People' are two examples of pressure groups attempting to channel the expression of different grassroot and resident interests into alternative plans for the development of their respective cities. Glasgow for People – established in opposition to plans for major extensions to the urban motorway network – is supported by local Labour Party wards, public transport users' groups, environmentalist associations, community councils and residents' associations, while Birmingham for People (BfP) concentrates on informing voluntary and community groups in the city about major urban development plans, and in putting forward alternatives. During 1989 BfP has produced three important documents: *What Kind of Birmingham?*, *Towards a Better Bull Ring. A People's Plan*, and *Women in the Centre. Women, Planning and Birmingham City Centre.*

Index